A LIFE
IN PICTURES

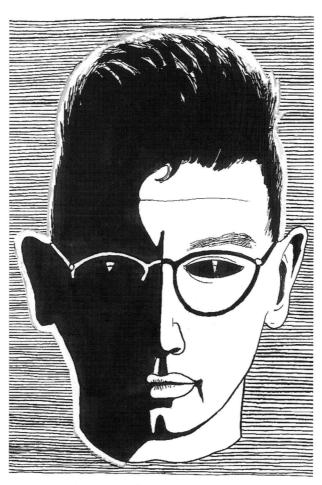

Self Portrait at Sixteen, 1951,
ink drawing on paper, 30 x 21 cm

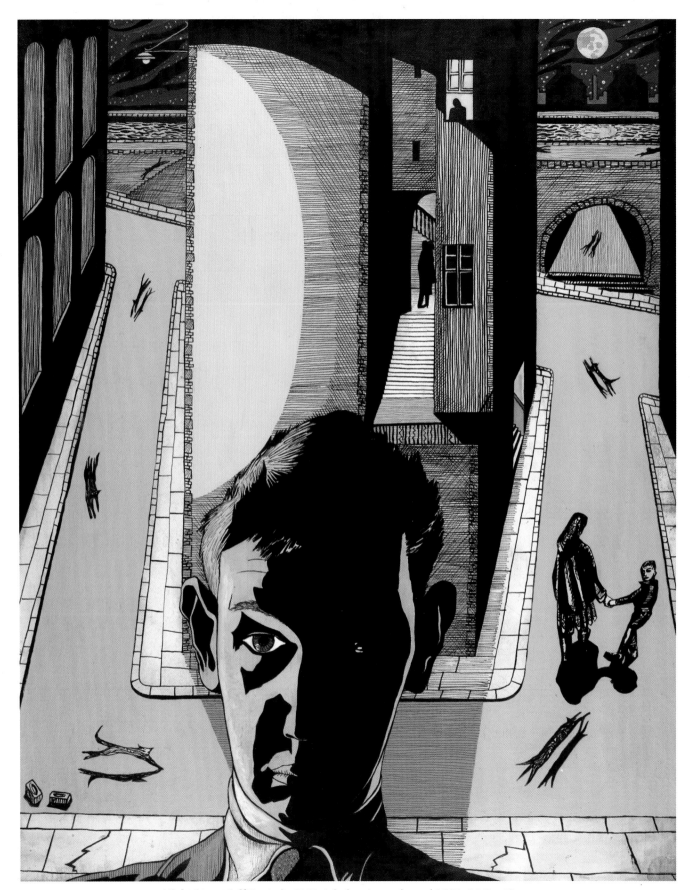

Night Street Self Portrait, 1953, ink drawing, coloured 2006, 54.5 x 43 cm

A LIFE IN PICTURES

ALASDAIR GRAY

Self Portrait by Gray from letter to Robert Kitts,
1955, pencil on graph paper, 21 x 15 cm

EDINBURGH 2012

Canon▌▌gate

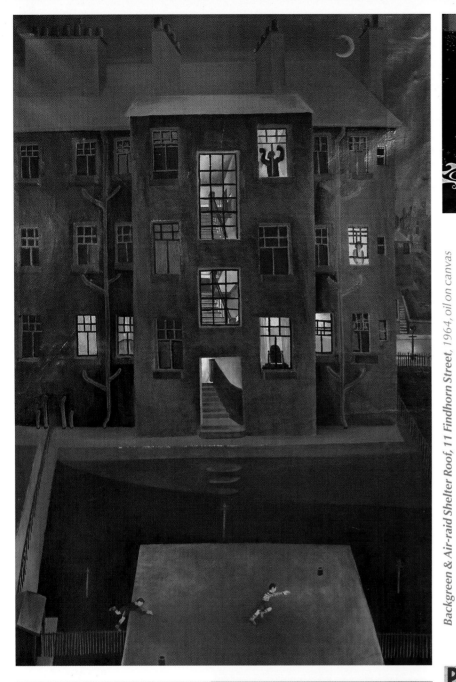

Backgreen & Air-raid Shelter Roof, 11 Findhorn Street, 1964, oil on canvas

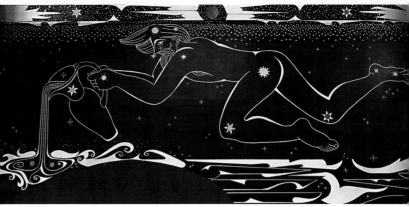

The Watercarrier and Capricorn, *2003, emulsion, Oran Mor ceiling, Glasgow*

THIS PAPERBACK EDITION PUBLISHED BY CANONGATE BOOKS IN 2012

1

COPYRIGHT © ALASDAIR GRAY, 2010

THE MORAL RIGHT OF THE AUTHOR HAS BEEN ASSERTED

FIRST PUBLISHED IN GREAT BRITAIN IN 2012 BY CANONGATE BOOKS LTD,
14 HIGH STREET, EDINBURGH EH1 1TE

WWW.CANONGATE.TV

GRATEFUL ACKNOWLEDGEMENT IS MADE TO FABER AND FABER,
FOR PERMISSION TO REPRINT FROM *STATION ISLAND* (1984) AND
PREOCCUPATIONS (1980) BY SEAMUS HEANEY.

*BRITISH LIBRARY CATALOGUING-IN-PUBLICATION DATA
A CATALOGUE RECORD FOR THIS BOOK IS AVAILABLE ON
REQUEST FROM THE BRITISH LIBRARY*

ISBN 978 1 84767 140 0

TYPESET IN OPTIMA BY SHARON McTEIR,
CREATIVE PUBLISHING SERVICES, OLDHAMSTOCKS, DUNBAR

CORRECTIONS AND IMPROVEMENTS TO THE FIRST EDITION
BY ROBERT DALLAS GRAY, GLASGOW, 2011

PRINTED AND BOUND IN MALTA BY GUTENBERG PRESS LTD

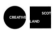

Andrew Aged 7 & Inge's Quilt, *1972/2009, painted drawing on brown paper*

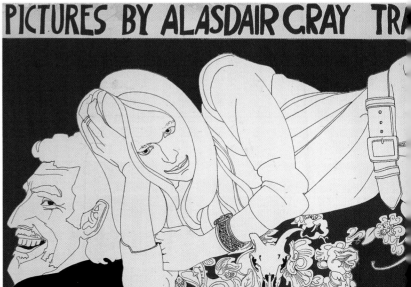

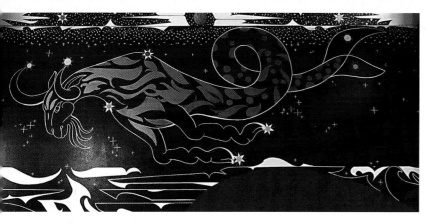

Right: Box Head, 2006, pen and paint on corrugated card

Behind a Mansion in Partick, 1959, gouache and oil on wooden board

FOR MORAG

Poster for exhibition in Edinburgh, 1969, dyeline print

RSE GALLERY 9 JULY 15 AUGUST

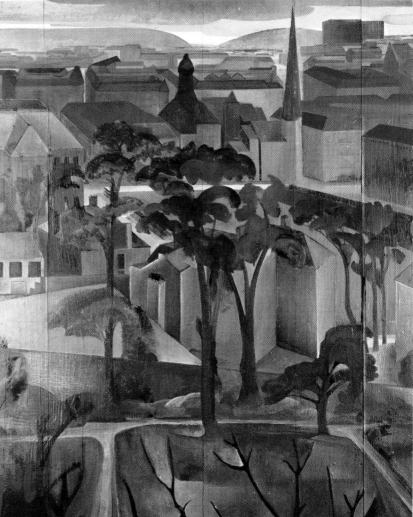

TABLE OF

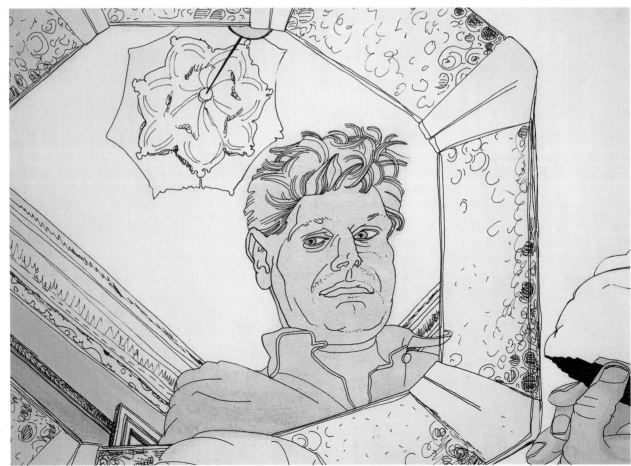

Self Portrait with Yellow Ceiling, 1964, ink drawing on paper, 28 x 40 cm

CONTENTS

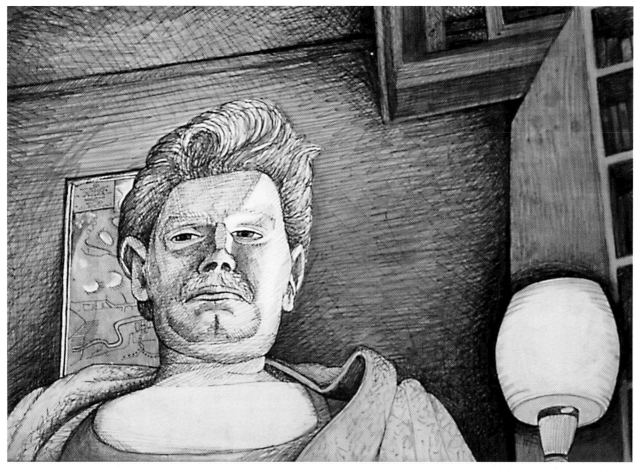

Self Portrait with Lamp, 1973, ink, pencil, watercolour, acrylic on paper, 28 x 40 cm

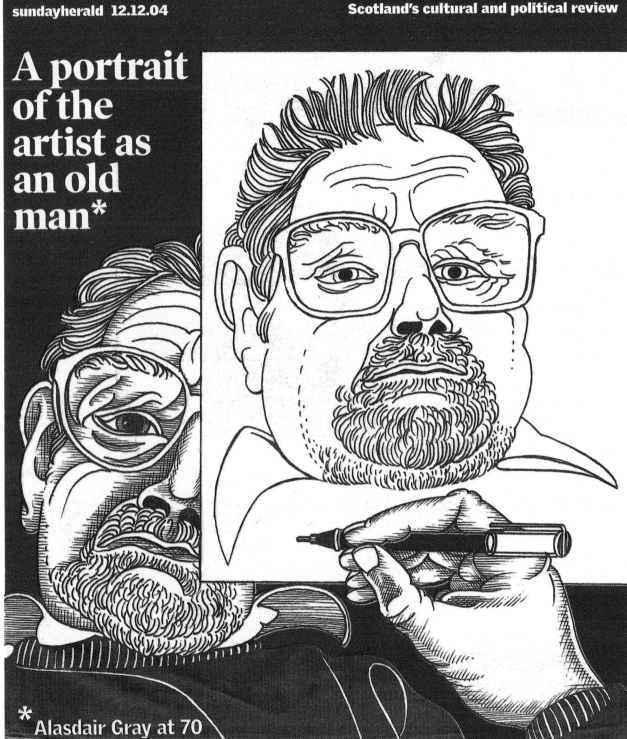

Portrait of the Artist as an Old Man, 2004, magazine cover, 36 x 27 cm

SEVEN DAYS

sundayherald 12.12.04

Scotland's cultural and political review

A portrait of the artist as an old man*

* Alasdair Gray at 70

FOREWORD

I WAS BORN on 28th December 1934 when very few wives gave birth in maternity hospitals, and only professional people and tradesmen who owned a firm had telephones. My mother's labour pains had begun much earlier that day, a Friday, so my dad cycled off to fetch help instead of cycling to work as usual. After his departure my mother, distressed, walked to the home of her own mother who lived two blocks away, but my granny, who had borne three children including a boy who died aged nine, panicked and told her to go away. Mum went home and got help from Mrs Liddel, the neighbour in the flat beneath ours who had been a nurse before her marriage to a postman. In the double bed of our front bedroom (there was a smaller one at the back) I first experienced spasms of the body ejecting mine, followed by the painfully conscious need to suck and expel air that teaches us to breathe and cry. My birth certificate says I was delivered at 9 hours 50 minutes p.m. Dad arrived soon after and described his failed attempts to bring back a doctor or midwife. Mum told me years later that she was hurt by what seemed more interest in his own troubles than in hers. He was probably trying to clear himself of guilt at having been practically useless.

Our mind, soul, nature, character (there are many words for it in every language) is shaped by the totality of our experiences, so could also be called our entire memories. The earliest experiences shape us most and are remembered subconsciously, because they happen in our first year when our nerves have not grown insulation that lets us distinguish between touch, sight, sound, taste, smell, warmth and the lack of these. Knowledge of my own most formative months is all hearsay. Feeding babies from bottles was fashionable in the 1930s but Mum and Dad had more modern ideas. She wished to breastfeed me but had to stop because one of her nipples did not yield milk. I cried a lot, once so continuously that a doctor was called in who, after a careful examination told my mother, "What you have here is a crying baby." My sister Mora, born two years after me, agrees that our Mum was not given to much cuddling or caressing. Some psychologists think asthma starts with struggles to draw breath while screaming hopelessly for a mother's attention, in a state of rage and horror. I was five when the first asthma attack came and the longest of them were after her death in 1952, so there may be truth in that Freudian theory, though Mum never neglected me.

She lived when even women married to unskilled labourers were called *housewives*, because their work at home was a full-time job, so my first five years before going to school were mainly in my mother's company. I always received a goodnight kiss in the evenings when she tucked me into bed. I know this because whenever we had quarrelled I remember deciding to punish her by *not letting her kiss me*, but always accepting the kiss at the last moment.

She must have told or read me all the stories on which pantomimes are based, for I can never remember not knowing tales in which poor, oppressed people like *Cinderella* or *Aladdin* become powerful and loved through a magic gift. The first illustrated book I remember was Hans Andersen's tales about many poor oppressed people, many magic events but few happy endings. She must have read me *The Little Match Girl* and *The Brave Tin Soldier* which are good preparations for the tragedies of adult life, and *The Tinderbox* whose hero, an unemployed soldier, becomes king after first being a murderer, profligate wastrel and rapist, though Andersen avoided shocking details. From our wind-up gramophone I learned the usual nursery rhymes with their simple, cheerful tunes. I am still haunted by the songs she sang accompanying herself on our upright piano, especially the sad sweetness of the Highland ones in Kennedy-Fraser adaptations. Love of music had taken her as a girl to Carl Rosa opera performances, made her a member of Hugh Roberton's Orpheus Choir, and led her to sing *The Keel Row* and *Coming through the Rye* in amateur concerts. She taught me that gaps between people can be bridged with words and music. And pictures! When able to handle pencils, crayons and paper I received them from parents who both liked me using them. Pictures and stories were the closest I could get to the magic that might make me powerful and loved.

But why did quarrels happen? Why did I want to withhold the goodnight kiss? I think food was the cause – my refusal to eat *without even tasting it* anything soft and white Mum served me. She was proud of belonging to a class who could give nourishing, well-served meals to their children, so rejecting her food was worse than rejecting a kiss. My rejections were obstinate. Mum never struck me or Mora so we were spanked by Dad when he returned from work.

He disliked that task (he told me later), but Mum never questioned his doings outside the home so he supported her management within it.

A friend once told me her infant daughter did not think her dad went elsewhere when he left home in the morning, but went out like a candle flame beyond the front door, solidifying there in the evening when he returned. I too felt my dad was not permanent or essential. Every day but Sunday he left the house before I had breakfast, coming back in the early evening before teatime and my bedtime shortly after. I knew his absences were due to *work* because one evening he brought home geometrically-cut sheets of cardboard, and told me that during the day he had cut them out of bigger cardboard sheets. He showed how each sample could be bent and folded into a different size of cardboard box. It seemed a dull business – why should he or anyone make empty cardboard boxes? I might have been interested had he shown them with labels attached. I liked anything with small areas of bright colour that my small eyes could easily see – the game of Tiddlywinks with its celluloid discs of pure blue, green, yellow, red, played on a board of the same heraldic colours. When Dad came home for *dinner* on Saturday (a meal that richer people called *lunch*) he gave me and my sister a Saturday Penny which could then buy many sweets. The pennies he gave were always new enough for the copper to shine like gold. At Christmas our livingroom had bright blue, green, orange, yellow, red paper decorations; gold and silver tinsel; a frieze around the walls above

the picture rail with a continuous view of snow-covered rooftops at night, with Santa Claus on every fourth roof putting a female doll into a chimney pot, while his sleigh and reindeers waited on a rooftop behind. Mum used spare moments to embroider, make rugs with strips of bright wool and patterned fabric, paint small flowers on glassware, attach blooms of coloured wax to dead twigs, but her biggest transformations were in cookery. I was fascinated by her way of turning grotesque things from butcher and grocer shops into food that was not soft and white, often by mixing powders and crystals with butter, eggs and fruit. Before washing the mixing bowls she let me scrape out with a wooden spoon and eat what had not gone into baking pans. The raw mixtures were so sweet that I wondered why she bothered baking them into biscuits and cakes. Other good times were when I sat near her playing with paper, scissors, pencil and crayons. On one such day I made my first book.

At that time British postage stamps showed only the monarch's head on a red, blue or green ground, according to price. With scissors from Mum's sewing box I cut stamps off discarded envelopes and gummed them to pages in a small notebook – she must have given me notebook and gum and shown how to use them. I was happy with the result. Then Dad, pleased to find I had made myself a philatelist, bought me a packet of varied foreign stamps, one of transparent

paper hinges, a big album with a different nation's name heading each page, a magnifying glass and tweezers. I resented his intrusion into my dealings with the woman in my life, which were painless, apart from quarrels over food. Freud says formative early memories become subconscious because we find them too painful to remember clearly. Quarrels with Mum, the beatings by Dad they resulted in are described more fully in *Lanark*, my first novel, and may have been worse than I recall. A neighbour told me after Mum died that I sometimes ran to my granny's house for comfort, and loved Granny so much that after her death I was found weeping at her door. How touching! I was about three when she died and hardly remember her, though she appears in family photos.

Though I resented Dad's interference he kept giving me things: a desk like a small business executive's which he had made (not bought) with a wide lid, drawers and bookshelf. I still own, dilapidated by use, his present of ten pale grey Wills's Cigarette Picture-Card Albums, each 6 by 5½ inches. Dad smoked a pipe so must have bought the cards separately and slotted them onto the pages himself. These bright wee glossy pictures showed Wild Life of the Fields and Woods / Life of the Sea Shore / British Butterflies / Gardening Hints / Dogs / Railway Equipment et cetera. I felt I owned the world in these little albums where everything looked new, fresh, understandable.

I was learning that I could have what I wanted if it was in words, pictures or songs, which are the only dependable form of magic.

Spiral Tube Worms, Wills's Cigarettes

Lady cyclist 1939, Player Cigarettes

Marsh Mallow, Wills's Cigarettes

The "Queen Mary", Wills's Cigarettes

SPIRAL TUBE WORMS

LADY CYCLIST, 1939

MARSH MALLOW.

THE "QUEEN MARY"

One: Family Photographs, 1915–52

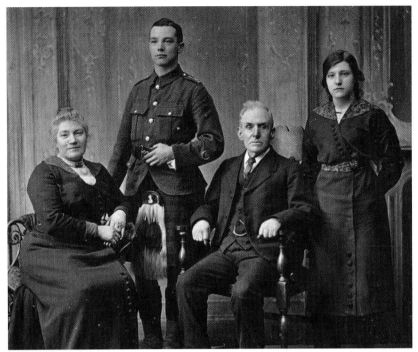

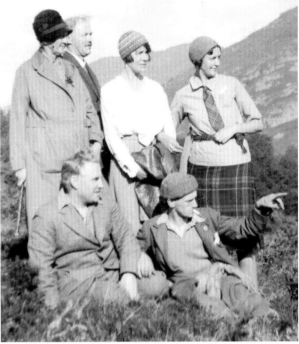

Family Gray: Jeannie Stevenson, Alex Gray, his dad Alex & Agnes Gray, 1915

Standing, family Fleming: Minnie Needham, her husband Harry Fleming, their daughters Amy & Annie, circa 1930

A FAMILY PHOTOGRAPH from 1914 or '15 shows my father, Alex, in his Black Watch uniform, with khaki kilt standing beside his father and mother, who died long before I was born. At first a weigh-bridge clerk at the Glasgow docks, Dad was just 18, so old enough to join the army when war was declared – he bought his first pipe and tobacco with his first pay. His dour, hard-faced father was a kind man and industrial blacksmith in Bridgeton, then Glasgow's east manufacturing quarter. Also an elder of a Congregationalist church, he taught Sunday schools and was a friend of Keir Hardie, the first Labour MP to enter Westminster. His sweet, plump, motherly wife had been a power-loom weaver before marriage, an excellent housewife after. Also in the group is a sturdy young girl, my Aunt Agnes, who worked all her life behind the counter of a bakery on London Road and never married.

In the 1914–18 war my dad lost faith in his parents' God but they never quarrelled about that loss. His father had admired Gladstone and Keir Hardie – was both a Liberal and Labour Party supporter. In post-war Glasgow my dad naturally became a Socialist and the works of George Bernard Shaw converted him to Fabian, non-revolutionary Socialism. After a spell in Stobhill Hospital he received a small government pension for a shrapnel wound in the stomach, and held a job in Laird's box-making factory until the Second World War. He joined the Ramblers' Federation, Holiday Fellowship and other non-profit-making societies formed by people of many social classes who liked the inexpensive pleasures of walking, cycling and climbing. He was a founder member of the Scottish Youth Hostels Association, did unpaid work as a hill guide and secretary for the Camping Club of Great Britain's Scottish Branch. When climbing Sgurr Alasdair in Skye he was told the mountain's name was Gaelic for Alexander, so it was given to me.

He met his wife in a small Holiday Fellowship group climbing Ben Lomond. Her name was Amy Fleming and a photograph shows her with her mother and father, Minnie Needham Fleming and Harry Fleming on the left, and on the right her younger sister, Annie. Minnie and Harry came from Northampton, where he had been a foreman boot-maker. He had also been an active trade unionist, and was sacked for it and put on the English employers' blacklist. He found work by coming with his wife to Scotland, where their daughters were born. The photograph shows all four with two Holiday Fellowshippers, probably in the hills near Carbeth that overlook the Blane Valley. The sturdy man squatting in the heather is Bill Ferris, Dad's philatelist friend, who had a weekend hut at Carbeth. My father is not in the picture but may have held the camera because he was a keen photographer and filled albums with photographs he took when hillwalking and climbing.

Page 4
*Family
Photographs*

*Alex & Amy
Gray,
circa 1932*

*Alasdair Gray &
Granny Fleming,
1936*

*Minnie & Harry
Fleming in their
back garden,
circa 1932*

*Alasdair Gray &
Granny in same
back garden,
1935*

My mother Amy was a shop assistant in Campbell, Stuart and MacDonald's clothing warehouse before marriage, becoming a housewife afterward for reasons already given. She loved music and when the opera came to Glasgow astonished her less daring younger sister (my Aunt Annie) by having a different boyfriend take her to it several nights in one week. She sang in Hugh Roberton's Orpheus Choir and (I repeat) I am still haunted by the words and tunes of the songs she sang at home. Her wide circle of women friends contained most neighbouring houses, for she had a pleasant discretion that never passed on malicious gossip, so was trusted by some who distrusted each other. She shared that trait with her husband. Only my sister and I knew her austerer side. The photograph of me as a baby like an overfed young Winston Churchill was taken with my granny in the back garden of her semi-detached council house on Cumbernauld Road. I hardly remember this care-worn English woman, Minnie Needham who married carefree Harry Fleming, though the upper photo of us a year or two later in a photographer's studio suggests we were close. My determined look recalls the time when, about two years old, I could say what I wanted, but not why.

After the evening meal we called *tea* I pestered Mum and Dad to take me to the kitchen and stand me on a stool before the shallow sink where dishes were washed. (A deeper sink beside it was for washing clothes, and me too

before I was big enough to be dipped in the lavatory bath.) I demanded a mixing bowl, knife, cabbage leaf, sliver of soap, milk and other ingredients. I cut up the hard ones and mixed them in the bowl with the rest, expecting a wonderful transformation, perhaps thinking no such mixture had ever been made before. I remember staring down at little dark green squares of cabbage and white flakes of soap, puzzled that they stayed obstinately themselves and were not combining into something new. I was obviously trying to work magic. Seventy-three years after that failed experiment I am amazed by my parents' tolerance. They were the sanest, least religious folk I ever met, with no irrational prejudices. They gave me magical stories, knowing children liked them, but never suggested miracles were possible. By the age of nine my wish to be a wizard had become the wish to be a great scientist and inventor of spaceships.

The Gray family lived in the tenement shown below. The middle window in the gable belongs to the living room of our three-room-and-kitchen flat. Mrs and Mr Liddel lived below us, as I have said, and above us Mrs and Mr Barclay, he being our local newsagent and tobacconist. Across the landing from the Barclays lived the Steele family, whose father was a printer for the *Daily Express* newspaper; across from us lived Mrs Bunting, a widow, across from the Liddels were Mrs and Mr Marchant, whose job I did not know or think about. I believed that he, like everyone else in Riddrie, belonged to the British upper class – the makers of things, nurses, postmen, shop-keepers, printers and their wives who kept the country going. Schoolteachers, doctors, civil servants also lived in the kind of tenement and semi-detached villa where my family and grandparents lived. Riddrie was one of the first Glasgow housing schemes built in 1930 under the only Socialist measure

passed by the first short-lived Labour government. Like many first things of its kind (Elizabethan stage plays, Hollywood comedy films), it was also the best. It stood between two good public parks, contained a variety of shops, churches and schools, municipal bowling greens, a well-equipped library, allotments, gardens and a tree-lined boulevard. It had no pubs but nobody I knew wanted them. Years passed before I realized Riddrie was not a classless cross-section of Socialist Britain. It housed tradesmen, professional folk and literate labourers who had made the Labour Party our local government, partly because private landlords had been charging them high rents for poor accommodation. So these better-off folk were first to be allocated homes in the new schemes. Later schemes were built more cheaply, with fewer amenities. Blackhill, frankly called a slum clearance scheme, was divided by the Monkland Canal from Riddrie.

*Family
Photographs*

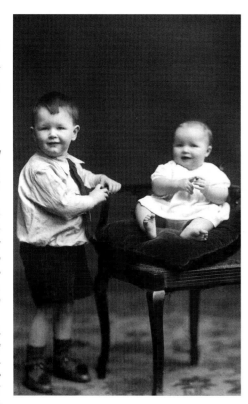

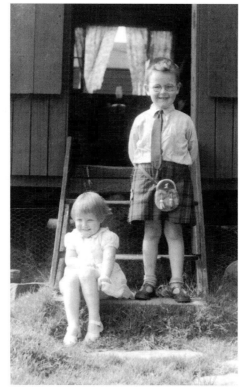

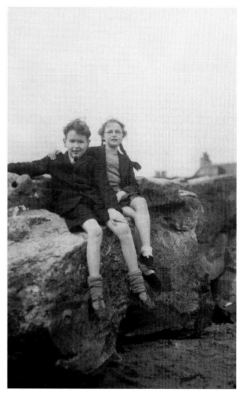

*Alasdair and
Mora Gray,
1937 or 1938*

*Sister &
brother &
Holiday
Fellowship
hut on hillside
above Balloch,
1938 or 1939*

*At Millport,
capital of Big
Cumbrae,
Firth of Clyde
islands, 1945
or 1946*

*Alasdair Gray
studying* The
Miracle of Life
*[see chapter 2,
page 11],
circa 1937*

Mum or Dad probably posed me with a book for a photograph but I obviously enjoyed the pose. I think the book was *The Miracle of Life*, a book of essays about natural history, evolution and the human body illustrated with fascinating photographs and pictures. The body's inner functions were shown as a combination of telephone exchange and chemical factory designed to extract oxygen from air and nourishment from food and circulate them in the blood while pouring out waste, but it showed nothing of sexual reproduction. At an early age Mora and I were told we had come from our mother's body when smaller and found the idea amusing as we imagined ourselves occupying a small furnished livingroom in her stomach.

World War Two brought painful shortages to the prosperous British classes but full employment and better jobs to many lower wage earners. The Grays were at their most prosperous from 1942 to '44, when Dad became manager of a hostel for munitions workers in Wetherby,

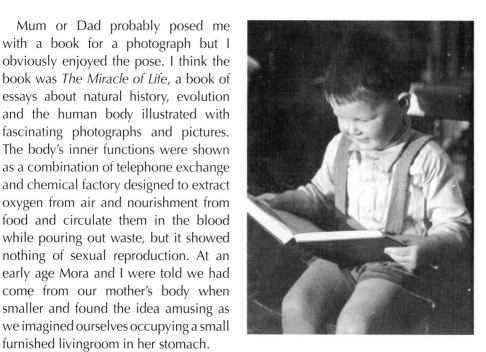

Yorkshire, because his voluntary work for Scottish youth hostels and the Holiday Fellowship proved he was fit for that. We can be seen here in the garden of the manager's bungalow. In Wetherby Mora took dancing lessons: here she is dressed as a Sunbeam. I joined the Church of

England choir because it paid me two shillings a week for attending it and rehearsals. I also enjoyed the singing. Until ten I usually wore a kilt. Though the only boy with one in Riddrie Primary, I was only mocked for it at the primary school in Stonehouse, a mining town we were evacuated to before Wetherby. Here it was accepted because folk thought all Scots wore them. On my first day an older boy told me, "If anyone's bashin' you, just let me know." I amicably disagreed with classmates about the *r* in *bird* and similar words. Like most English they never pronounced it. Like most Scots I did, and by insisting on doing so have perhaps come to prrronounce my *r* more distinctly than if I had never left Glasgow.

I believe the happiest period of my mother's life was the months of being the wife of a well-paid manager. She sang in hostel concerts organized by my Dad, and was a popular member of the Wetherby Women's Institute. Two women whose wages were paid by the

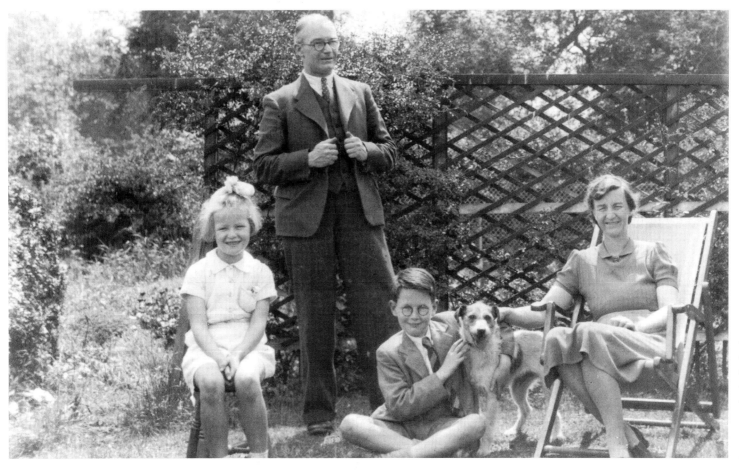

The Gray family in garden behind the manager's bungalow, munitions workers' hostel, Wetherby, Yorkshire,
circa 1943

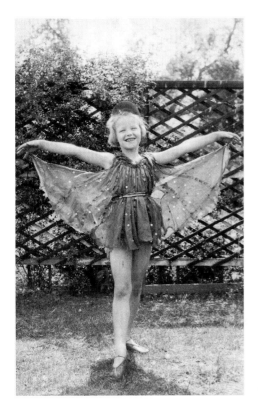

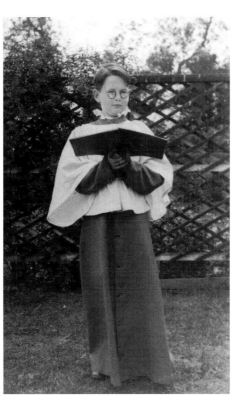

Ministry of Munitions helped her with housework. One of them, Ethel, asked Mum if she could come to Scotland and serve her after the war, and was told that after the war Mum would probably be no richer than herself, and there was no room for a servant, even in a Riddrie municipal tenement. When the war ended and Dad's job stopped, before we returned to Scotland, the Wetherby Women's Institute gave her a patchwork bedcover on which every member had embroidered their signatures in a different colour of thread or wool.

Back in Glasgow Dad was unwilling to return to his box-cutting machine. His applications for middle-class jobs failed so he became a labourer on a building site then, through friendship with the site clerks there, was employed by the Scottish Special Housing Association as a costing and bonus clerk.

Mora as a sunbeam; Alasdair, the Church of England chorister
Both circa 1943

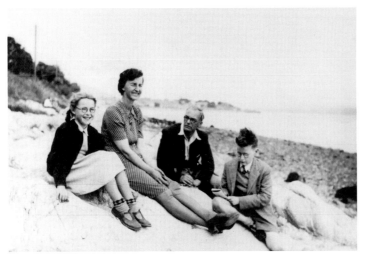

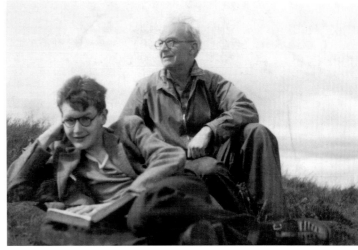

A day trip outing to Dunoon, circa 1945

Alasdair & Alex on Earl's Seat, Campsie Fells, circa 1952

With camera activated by a time-switch on a tripod Dad photographed himself and family on weekend outings, when I usually posed as an intellectual with notebook or library book. This was not a wholly phoney act. When eight I started writing and illustrating wee stories and verses which Dad typed, and when twelve I won a Scottish BBC competition that let me read some on *Children's Hour*. But he wanted me to go walking, climbing and cycling with him. I used occasional bad asthmatic bouts to avoid doing these things because he understood them better than me – eventually Mora became his main out-of-doors companion – but whenever I submitted to his guidance I enjoyed the hills. Despite which I went with him to Earl's Seat on the summit of the Campsies with Maisie Ward's biography of G. K. Chesterton, got from Riddrie Public Library, and insisted on reading during our rests.

In 1949 or '50 Dad's lower post-war wage made Mum decide to take a job in a hat shop, then as clerk in Collins the Publishers office, Cathedral Street. She weakened with what her doctor thought was a menopausal illness. After several months she asked for another opinion and cancer of the liver was diagnosed. On a warm day when I was seventeen we sat together in our back green. I had hurt her by failing to get a school leaving certificate in Latin, then a necessary qualification for Scottish universities. Since her death I have been incapable of taking any examination seriously. In our back green I also sat with her kind and witty sister, my Aunt Annie, who lived long enough to be proud of me as Writer-in-Residence in Glasgow University.

Amy & Alasdair behind 11 Findhorn Street, Riddrie, circa 1951

Amy's sister, Annie Miller and nephew, circa 1953

Two: Childhood Books, 1937–49

WHEN VERY YOUNG I drew every scene with a firm brown, horizontal line at the foot of the paper representing ground, and a blue horizontal line representing the sky at the top, for I thought the outer world had a floor and ceiling like our home. Dad destroyed this primitive model of the universe by explaining that the earth resembled a golf ball turning round the sun, represented by a table lamp. This bored and annoyed without convincing me, but destroyed my notion of the sky as a protective ceiling, because I now saw that if it existed there must be more space above. A religious dad might have told me there was a Heavenly Riddrie above the sky where my dead granny now lived. I remember also drawing a giant who had captured many princesses, but because I could then only draw stick figures with featureless buttons for heads (alright for the giant, not for beautiful women)

I drew circles attached by lines to his body. When asked what I was drawing I said, "a miller running to the mill with sacks of corn". I only recently worked out how a pre-school urban child knew how flour was made. Dad thought all questions a child asked should be honestly answered. On country walks he bored me by using a little pocket book to identify trees by the shape of their leaves, years later telling me he had no interest in botany, and bought the book because I kept asking the names of trees. A story I liked, *The Tinderbox*, contains three magic dogs who help a poor but ruthless soldier abduct a princess and seize a kingdom. One dog has eyes as big as millstones. I must have asked what millstones were, been told, and thus enabled to invent an innocent fiction to disguise one I was ashamed of. Why was I ashamed of rape fantasy years before knowing of sexual intercourse? Perhaps I identified the princesses with

my mother, though she was so much the climate I lived in that I hardly saw her as an individual before her death. When I was ten or eleven I sometimes entertained her in the evening with stories and drawings while she knitted or sewed, but stopped when sexual fantasies invaded my imagination and sexual frustration drove me out at night to walk about in the loneliest places near our home, as I had no girlfriend and was too socially awkward to visit cafés that were then teenagers' social clubs. But she made me feel women are a safer sex than men, for it was never she who spanked me.

My parents were glad when my vocabulary, knowledge and work pleased others, especially my teachers, but they never praised me for these things in case I grew proud, because pride is liable to downfall. They called attempts to draw attention to *myself* instead of my work "showing off", and discouraged that. At

1. Acherontia atropos (Death's Head), Britain. 2. Amesia sanguinea, N. India. 3. Erasmia pulchella, India, China. 4. Ophideres fullonica, Africa, Asia, America, Australia. 5. Minodes dircolor, W. Africa. 6. Chrysiridia madagascariensis, Madagascar. 7. Brahmaea wallichii, China. India, Borneo. 8. Egybolis vaillantana, Africa. 9. Attacus atlas (Atlas Moth), India, China, Ceylon. 10. Daphnis nerii (Oleander Hawk Moth), Britain, Asia, Africa. 11. Zygaena filipendulae (6-spotted Burnet), Britain. 12. Glaucopsyche cyanea, N. India.

The sun pouring radiant energy directly upon the rugged, fissured surface of the planet Mercury. A dead, cold sphere without an atmosphere, Mercury is the nearest known planet to the sun, and its vast stretches of lava spit by vertical chasms, its steep slopes, and giant craters recall a lunar landscape. Sunlight blazes down continuously from an almost black sky sprinkled with stars, for according to some astronomers, there is no night

The dominant feature in the landscape of Venus, densely packed cloud masses, obscures the sunlight and hides the steep sides of the gigantic peaks which project upwards sometimes for more than 25 miles

A peaceful scene on the earth, showing the sun on the same scale as in the two pictures given above

SUN: THE GREAT LUMINARY AS SEEN FROM ITS THREE NEAREST PLANETS
A.—To face page 7208

FLAGS OF THE NATIONS, INCLUDING THOSE ADOPTED AFTER THE GREAT WAR

The Harmsworth Universal Encyclopaedia, 1933 edition, 24 x 16 cm

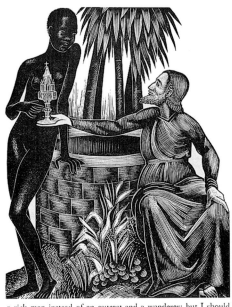

**Adventures of
the Black Girl in
her Search for
God**, *Bernard
Shaw, 1932,
designed &
illustrated by
John Farleigh,
20 x 13 cm*

a rich man instead of an outcast and a wanderer; but I should
not have found God."
"My father beat me from the time I was little until I was big
enough to lay him out with my knobkerry" said the black girl;

social gatherings they liked me to sing 'The Skye Boat Song' (my party piece) or recite puerile verses I had written, or take part in political arguments, because that was giving people something, not deliberately drawing them to *me*. Yet from infancy Mum and Dad clearly wanted me to become very clever, as is shown by a childhood event I cannot recall, but Dad told me about years after.

When I was four or five he had read me Shaw's *The Adventures of the Black Girl in Search of God*, a fable of comparative religions in which a black girl, converted by a missionary to faith in a one-and-only God, searches for him through the African bush. She meets a series of white people, old and young, who claim to be God, or variously describe Him, explain Him or

tell her to do without Him. At last she meets Voltaire and Bernard Shaw who persuade her to stop searching for God and do His will by cultivating her own garden – that part of the world we can improve by working with each other through Socialism. He must have read me that book because I had heard God referred to by playmates in our back green, or perhaps on a BBC broadcast,

The Miracle of Life, *editor Harold Wheeler, Odhams Press Ltd, 1938, 25 x 17 cm*

The Jabberwock illustrated by John Tenniel from Alice Through the Looking Glass, *Lewis Carroll, 1871, 19 x 12 cm*

because I knew no adults who talked of Him. Dad said I kept asking him if the next God would be the real one. I must have forgotten all about this because the story bored me as much as his little books of tree identification, unlike *The Tinderbox* or *Snow Queen*. His reading must have struck me as a lecture and I wanted to get my knowledge without having it injected. Luckily our house had bookcases where I dug it out by enjoying pictures in a 12-volume

Harmsworth Encyclopaedia and *The Miracle of Life*, a natural and prehistoric history and human anatomy book.

These enlarged without contradicting the fantasy fictions I enjoyed in other illustrated books. I was delighted to discover how fantastically different our world had been at different times in the past, and that our galaxy contained an unknown number of other worlds where perhaps anything I could imagine might happen. When

Just So Stories by Rudyard Kipling, *illustrations by the author, 1902, 19 x 12 cm*

Just So Stories, *Rudyard Kipling, pictorial initial by the author, 1902, 19 x 12 cm*

The Rose and the Ring, *William Makepeace Thackeray, illustrations by the author, 1854, 17 x 11 cm*

11 or 12 I found for myself Dad's copy of *The Adventures of the Black Girl in Search of God* and thoroughly enjoyed its story and pictures, for the reading I most enjoyed had both, whether tales of magic or history or science. I loved tales that embraced several genres, like the cartoon adventures of Rupert Bear in Christmas annuals where fairies, dwarves, boy scouts, talking animals, a Chinese conjurer, an eccentric inventor led Rupert wildly astray but always got him home in time for bed. I enjoyed *The Dandy* and *The Beano* – the main comics for British under-12s in those days – with such grotesque characters as Big Eggo (an ostrich), Lord Snooty and his Pals, Desperate Dan and Freddy the Fearless Fly. I liked books of wide geographical and historical sweep and do not know when I found many I liked

8 HERE BEHOLD THE MONARCH SIT,

the print-shops: he was Valoroso the Magnanimous, Valoroso the Victorious, Valoroso the Great, and so forth; —for even in these early early times courtiers and people knew how to flatter.

This royal pair had one only child, the Princess Angelica,

who, you may be sure, was a paragon in the courtiers' eyes, in her parents', and in her own. It was said she had the longest hair, the largest eyes, the slimmest waist,

best had been illustrated by their authors – Kipling's *Just So Stories*, Lofting's *Doctor Dolittle* tales, Thackeray's *Rose and the Ring*, Edward Lear's *Nonsense Rhymes* and Hendrick van Loon's *Story of Mankind* and *Home of Mankind*. I learned the main shapes of the world's continents from a toy globe of the

WITH HER MAJESTY OPPOSITE 9

beauty; and governesses used to shame their idle pupils by telling them what Princess Angelica could do. She could play the most difficult pieces of music at sight. She could answer any one of *Mangnall's Questions*. She knew every date in the history of Paflagonia, and every

other country. She knew French, English, Italian, German, Spanish, Hebrew, Greek, Latin, Cappadocian,

world on which I plotted the course of the *Nautilus* in Verne's *20,000 Leagues Under the Sea*.

Orthodox Jews, Christians and Mohammedans learn that the universe is a book written by God in which people are good or bad characters. Books taught me that repulsive things and ideas could be made manageable in stories and pictures, though for years I could not re-read *Alice Through the*

"Rigged himself up like a tree"

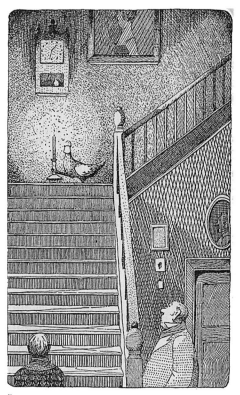

" AND IN HER RIGHT FOOT SHE CARRIED A LIGHTED CANDLE ! "

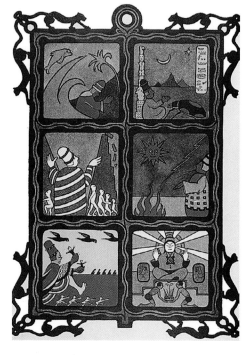

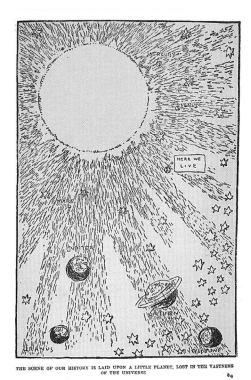

THE SCENE OF OUR HISTORY IS LAID UPON A LITTLE PLANET, LOST IN THE VASTNESS OF THE UNIVERSE

84

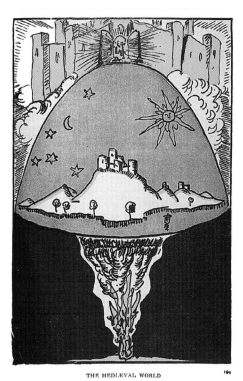

THE MEDIÆVAL WORLD

194

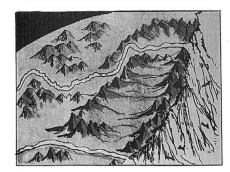

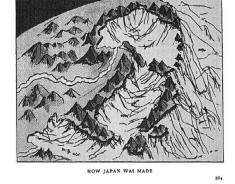

HOW JAPAN WAS MADE

384

The Scene of Our History is Laid Upon A Little Planet; The Medieval World; How Japan Was Made, Hendrick Wilhelm van Loon, 1946, 21 x 13.5 cm

Looking Glass without trying not to see the picture of the Jabberwock. Its buck teeth, antennae, feathery claws and three-button waistcoat seemed as horrid as an engraving in Pouchet's *The*

Universe of a caterpillar being eaten from inside by ichneumon grubs.

I enjoyed escapist fantasies well into my teens, when Dad's *Collected Plays of Bernard Shaw* and H.G. Wells' early science fantasies prepared me for more adult reading. Dad subscribed to

A TOWER OF BABEL

THE ATLANTIC

NINEVEH

THE PACIFIC

A Tower of Babel; Nineveh; The Atlantic; The Pacific, from **The Home of Mankind,** *Hendrick Wilhelm van Loon, 1949, 21 x 13.5 cm*

Rupert the Bear, *circa 1930, Alfred Bestall, 21 x 13.5 cm*

Page 14

*Childhood
Books*

*The Gates
of Paradise*,
William Blake,
three emblems,
1793,
17 x 10 cm

*The Horse's
Mouth,* Joyce
Cary, author's
frontispiece,
1944,
18 x 11 cm

a book club, *The Readers' Union*, so every month a volume arrived by post that I never foresaw or expected but eventually read – Orwell's *1984*, Denton Welsh's *A Voice Through a Cloud*, Bowen's *The Death of the Heart*, *The Best of Hemingway*, *The Best of James Joyce*, Waley's translations of Classical Chinese poems and that comic epic, *Monkey*. But the most potent influence was *The Horse's Mouth* by Joyce Cary. He drew this frontispiece for the Penguin paperback edition – it was not in the first copy I read in the late 1940s. It is shown below because the novel's atmosphere is in this pub interior – in the sardonic resignation of the hero among his mockers – in the full-bodied barmaid almost lazily lifting a bottle to

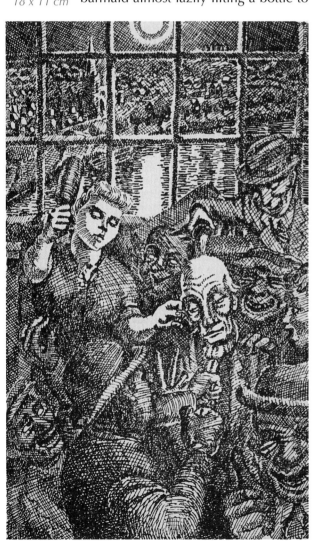

WHAT IS MAN?
*The Sun's Light when he unfolds it
Depends on the Organ that beholds it.*

strike one of them down – and in the moon reflected in the Thames beyond the window.

Set in 1938 it describes the last weeks in the life of an old artist who cares for nothing much but the great painting he tries to make while pennilessly surviving by sponging on friends or robbing a former mistress. Years earlier he had been a successful painter of oil colours, but discovering the work of William Blake moved him to paint big murals of a kind Blake regretted never being commissioned to paint. Gulley Jimson cannot get commissions either since the only folk with faith in his art are a cobbler and postman who think it right to respect outcast intellectuals, and an ugly stammering boy who wants to be an artist. This very funny, high-spirited story persuaded me that making a fine work of art for people who did not want it was the greatest thing I could do. *The Horse's Mouth* quoted so much of Blake's exciting verse that I found in Riddrie Public Library a book containing *Songs of Innocence and Experience* and the minor prophetic books. In a cheap

WATER
Thou Waterest him with Tears

Everyman edition I found his illustrated *Gates of Paradise*. In the great Mitchell Public Library by Charing Cross (mostly built with money Andrew Carnegie donated circa 1900) I found facsimiles of his hand-coloured books, with the illustrations and commentary on the *Book of Job*.

These were huge boosts to mature free thinking. Blake's verses and drawings do not amount to a system because he thinks all big systems are political or religious traps used by the rich and powerful to manage others – for their own good of

*At length for hatching ripe
he breaks the shell*

EARTH
He struggles into Life

AIR
On Cloudy Doubts & Reasoning Cares

FIRE
That ends in endless Strife

The Gates of Paradise, William Blake, four emblems, 1793, 17 x 10 cm

Infant Joy from *Songs of Innocence* by William Blake

course! Blake's pictures and writing deal with good and beautiful things while condemning governments and churches that promote mere obedience as a virtue, while using warfare, poverty and hunger to compel those who disagree. Blake, like Robert Burns, never doubted what babies and the wisest people know: what naturally feels good and bad is good and bad, before suppression of these natural feelings perverts them.

I was well aware of my own perversity. Like many children I was obsessed with torture fantasies. American comics

AGED IGNORANCE
Perceptive Organs closed, their Objects close

(being sold for the first time in Britain) showed a lot of these because the USA publishers' moral code allowed pictures of glamorous women wearing very little, but forbade showing them in amorous clinches, so their adventures involved physical violence and bondage instead. There is violent action and some bondage in Blake's art but no perversity, though his men and women, often floating or leaping through space, are usually naked. When fifteen or sixteen I discovered Aubrey Beardsley and loved the way he made innocent fun of mild perversity. He drew naked bodies beautifully, but also enjoyed inventing fantastic costumes for them to dress and undress in. I studied his illustrations along with Blake's in the Mitchell Library, and failed in attempts to make pictures combining Beardsley's solid blacks with Blake's rich colouring.

But *The Horse's Mouth* also prepared me for a difficult future. The character of Jimson was partly based on J.D. Fergusson (whom Joyce Cary met in Edinburgh), and partly on Stanley Spencer, but these painters had enough money not to suffer for their art. Jimson was shown wrestling with the penury undergone by Van Gogh and Gauguin. I later learned that Michelangelo, Rembrandt, Cézanne,

**The Comedy of
the Rhinegold**,
*Aubrey
Beardsley,
title page to
unpublished
book,
circa 1896,
28 x 21 cm*

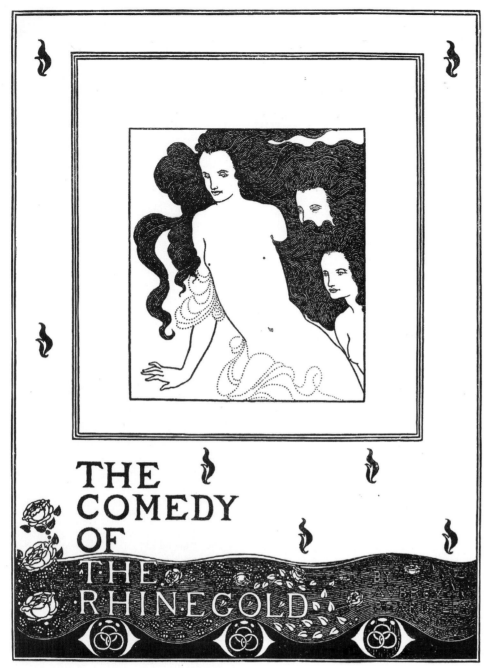

When babies start focusing their eyes all they see is amazing novelty. Wordsworth's *Ode on Intimations of Immortality in Childhood* tells how this lovely sense of the world "fades into the light of common day". All educations must prepare us for pain but some do it too thoroughly. Life becomes *daily grind* – painful acceptance. I was taught that the universe and evolving life there should be a grand setting for an adventurous future, though like many teenagers I often felt lonely. I shared no sport with other youths, was fascinated by girls but afraid to touch them so never went to dance halls. I had friends but only talked freely to them one at a time, so was not asked to parties. But the chaotic inner feelings and ideas (some splendid, some horrible) that made me socially awkward were, I knew, the essential raw materials of art. I became sure I could paint and write any big thing I imagined, if allowed time to work on it long and hard enough. This confidence in my artistic abilities and contempt for my character or social *self* – except as a source of raw material – is perhaps frequent among artists, and helps us survive in societies with no use for us.

Note that the pictures I most loved and learned from all had clear outlines. I must have feared or distrusted anything vague or liable to shift and depart. Making a picture is one way of stopping some shapes of things changing – stopping *time* as long as the picture lasts. It is not strange that over the years I became more and more fascinated by the difficulty of depicting moving water and clouds, and those times of day and weather that Turner (that other great Cockney William) painted so wonderfully well.

This union of confidence in work with a highly interested, but basic contempt for my *self* is frequent among artists, and perhaps many other folk.

though never poor, also suffered terrible defeats. In a late notebook Leonardo asked himself "What has been done? Tell me if anything was ever done?" The statue that would have proved him a sculptor as great as Michelangelo was destroyed by French soldiers using it as target practice and his only mural, *The Last Supper*, was crumbling when he completed it. In a derelict chapel Jimson finally paints a great mural on the theme of the *Creation*, persists in painting it as municipal workmen demolish the building. He falls from the scaffolding and, badly injured, is carried away in an ambulance when the adventure of his life (and death, which quickly follows) strikes him as comic. He bursts out laughing and a nun tells him, "You should be praying, not laughing." He replies, "It's the same thing, Mother" – a wonderful end to a book and a life.

Three: Miss Jean Irwin, 1945–52

IN 1945 WE came home to Riddrie. In Wetherby I had played with other boys of my age, climbing trees, making dens in bushes, damming streams. I had a mental map of what was then a small market town on the Great North Road after it crossed the River Wharf, with the hostel my Dad managed, racecourse to the east, the school and church on a cross-roads to the west. From walks and cycle rides I knew the countryside around it with the villages Bilton and Bickerton. I was now old enough to discover that Riddrie was one suburb of a huge smoky industrial city where my family was an unimportant detail – Glasgow was too big for me to mentally grasp.

Dad's unsuccessful efforts to get a better job than cutting boxes on a machine, Mum's worry about money and the future were also depressing. He found relief most evenings in unpaid secretarial work for the Camping Club of Great Britain (Scottish branch) and in weekend climbing and camping excursions on which he would have loved to take us all. Mum could no longer enjoy these. I could but usually refused to go because I hated being guided by his greater knowledge and experience of open-air life. I also had the excuse of very bad bouts of mainly facial eczema alternating with asthma attacks. These enabled me to stay at home in the small bedroom, at the small version of a senior executive's desk Dad had made when his hobby was carpentry. Here I sat scribbling pictures and illustrating stories of magical worlds where I was rich and powerful, fantasies nourished by escapist literature borrowed from Riddrie Public Library, early Disney cartoon films, BBC radio dramatizations of Conan Doyle's *Lost World* and H.G. Wells' *War of the Worlds*.

One day Mum put some of my scribblings in a handbag and took me by tram to Kelvingrove. She had read in a newspaper that Miss Jean Irwin held an art class on Saturday mornings in Kelvingrove, and I believe she hoped (though she never said so) that this class would get me out of the house and give me more friends. Children in it were supposed to be recommended by teachers, but my mum was an independent woman. A half-hour tram ride brought us to Kelvingrove, not yet open to the general public, but she swiftly got admission from an attendant who explained where to go. We went up broad marble stairs and along to a marble-floored balcony-corridor overlooking the great central hall, and I heard exciting orchestral music. At the top of more steps we saw twenty or thirty children busy painting at little tables before very high windows, painting to music from a gramophone, as record players were then called. I drifted around looking at what these kids painted while Mum showed my scribbles to Miss Irwin, who let me join her class.

For the next five years Saturday mornings were my happiest times. This once-a-week sense of unusual well-being partly came from dependence on appliances like those in most British homes which, apart from the lighting, were mostly pre-electric. Our hot water taps drew on a tank behind the coal fire that warmed our living room. Baths were not taken casually and Friday was my bath night. Mum washed clothing in a deep kitchen sink, rubbing it a piece at a time on a ribbed glass panel in a wooden washing board, squeezing water out by

Miss Irwin's class, circa late 1940s

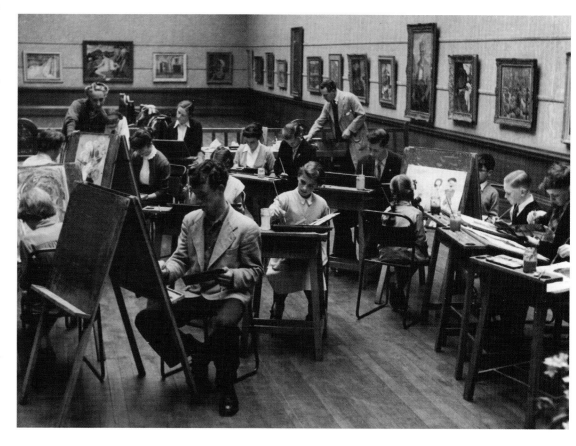

passing it with one hand through a small mangle (which we called The Wringer) into the shallower sink, while turning with the other a handle that made the cylinders revolve. Bedclothes were then hung to dry on our back green clothes lines, other clothing on the kitchen pulley or a clothes horse before the living-room fire. After that she ironed them. Washing machines only became common in Britain halfway through the 1950s. Mum may have worked hard enough to give me a change of clothes twice a week, but I only remember how fresh newly laundered socks, underwear and shirt felt when I dressed on Saturday morning.

If the day was warm enough to go without a jacket I felt the whole city was my home, and that in Kelvingrove I was a privileged part of it. The art class children came an hour before the public were admitted, I was always earliest and could therefore take the most roundabout way to the painting place, starting with a wide circuit through the ground floor.

I first turned right through a gallery with a large geological model of Strathclyde near the door. It had a pale blue river, firth and lochs, and layers representing rocks painted to show how the valley and hills had been laid down in prehistoric times – pink sandstone predominated. Beyond were glass cases of fossils, including an ichthyosaurus, and uncased models. The tyrannosaurus was most impressive, and a great ugly fish with two goggle eyes near the front of his head instead of one each side, and big human-looking buck teeth. I left that gallery by an arch under the skull of a prehistoric elk with antlers over six feet wide.

Then came modern natural history, the shells and exoskeletons of insects and sea-beasts, a grotesque yet beautiful variety showing the unlimited creativity of the universe. Some I hardly dared look at and would have preferred them not to exist. A spider crab had legs splayed out as wide as the antlers of the elk. Then came stuffed birds and animals in cases with clues to their way of life. I seem to remember a fox bringing a pheasant's wing in its mouth to small foxes under a shelf of rock or under a tree root. Big animals were in a very high gallery behind large glazed arches. An elephant with its young one, a giraffe and gazelle had a painted background of the African veldt; an Arctic scene had walrus, seal and polar bear with fake snow and ice floes. A Scottish display had stag, doe and fawn, capercailzie and grouse among heather.

I have no space to describe my delight in the sarcophagi, ornaments, carvings and models of the Egyptian gallery – the splendid model samurai seated in full armour before the ethnography gallery with its richly-carved furniture, weapons and canoe prow from Oceania and Africa – the gallery full of large, perfectly detailed models of the greatest ships built on Clydeside. The ground floor displays assured me that the world had been, and still was, full of more wonderful things than I could imagine for myself.

After these wonders there was relief in the long, uncluttered floors of upstairs galleries in one of which our art class was held, but I always approached it through as many others as possible, so became familiar with the paintings on permanent display, though my preferences were distinctly juvenile. I loved two huge Salvador Rosa landscapes with biblical titles (one of them *The Baptism in the Jordan*) showing rivers flowing between rocky crags overhung by wildly knotted trees. I wanted to jump into this scenery and play there when the tiny figures of

The Three Wise Men, 1950, ink and gouache on paper, 41 x 51 cm

a cellar, and would likely have agreed with Ruskin that Rembrandt painted nasty things by candlelight. Twenty years passed before I saw that a great draftsman and equally great colourist had painted that ox in a range of subdued tones far beyond my capacities.

What of the art class and its teacher? Jean McPhail, a fellow pupil in those days, describes her thus: *Jean Irwin was an unmarried woman, belonging to the World War One generation which lost its men on the battlefields of Europe. Early in her career she became deeply interested in developing the creative talents of children and she set up and ran a free art class on Saturday mornings for children, especially for those from disadvantaged backgrounds.* I did not know that anyone in the class was disadvantaged, but like every teacher whose help I appreciated she gave me materials and let me do what I liked with them. After the first two classes I cannot remember painting any subject she gave, unless she suggested a Christmas nativity scene, thus inspiring the picture of the three wise men, which shows my cynicism about wisdom when it beholds a miracle. She may also have suggested

Scylla and Charybdis, 1951, gouache on paper, 36 x 28 cm

Jesus, saints and apostles had cleared out. Noel Paton's *The Fairy Raid* delighted me too by mingling the Pre-Raphaelite details of a moonlit woodland with several sizes of supernatural races, from courtly fairies almost human in scale down through dwarves and goblins to elves smaller than toadstools. In those days there was a whole wall of Burne Jones paintings, at least four, showing the adventures of Perseus which I had read in Kingsley's *The Heroes*. In 2008 the only

one exhibited shows Danae standing sadly while behind her the brass tower is built for her imprisonment. When 17, on a visit to Glasgow City Chambers, I saw the rest on the walls of a corridor, so Glasgow town councillors still enjoy them or they are in storage. I admired the glowing detail of Dutch still lives but did not know why people who could enjoy real fruit, flowers et cetera wanted pictures of them; nor did I see the beauty of Rembrandt's butchered ox hanging in

Young Boy and Paint Box, 1951, ink on paper, 33.5 x 25.7 cm

my ink drawing of the small boy at a desk facing mine. I tackled any theme that excited me, painting free-hand in poster paint without a preliminary sketch, or else making an ink drawing and tinting it with watercolour. Craving miracles and magic I illustrated episodes from Homer's *Odyssey*, Greek legends and the Bible and am sorry to have lost pictures of Christ walking on water, Penelope unweaving, Circe making pigs of her guests and a Jabberwock unlike Tenniel's. I drew and painted with a freedom I have hardly ever enjoyed since. Soon each new picture had a difficult beginning, starting with my efforts to unite Beardsley's crisp black and white areas with Blake's mysteriously rich colours. In the library of Dad's pal Bill Ferris I found a book of Hieronymus Bosch's pictures in colour, and was entranced by his Hells, and sinister Eden, and huge *Garden of Earthly Delights*. From then on any state bordering on Hell or Paradise fascinated me as a pictorial subject.

In taking my prolonged private excursion through the galleries to the class one morning I found three or four upstairs rooms hung with all the greatest paintings and prints of Edvard Munch which I have since only seen in books. Munch painted Hell in the rooms and streets of Oslo, a city I saw was very like Glasgow, where very often the richest colours were in sunset skies. Munch, like adolescent me, was obsessed with sex and death. All his people, even those in crowds passing along pavements, looked lonely, all the women seemed victims or vampires. His white suburban villa, shown at night by street lighting, was appallingly sinister but not fantastic. He proved that great art could be made out of common people and things viewed through personal emotion.

Two Hills – originally called *The City* – combined parts of Glasgow that had come to excite me. I loaded the nearer hill with a kirk, school, tenements, towers I had seen on Park Circus, and

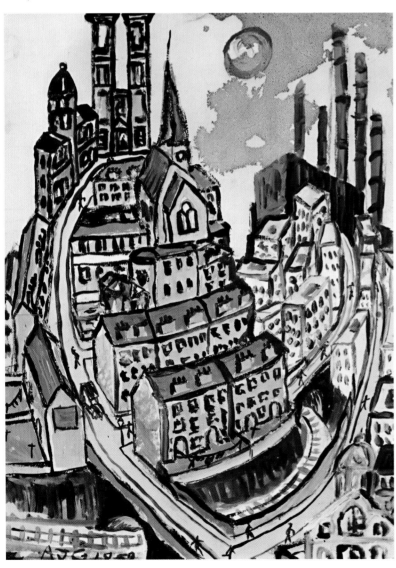

GLASGOW ART GALLERY AND MUSEUMS

SCHOOLS MUSEUM SERVICE

THE CITY ALASDAIR GRAY (17)

EXHIBITION 1951 — 1952

PAINTINGS BY CHILDREN OF THE SATURDAY

ART CLASS

3rd MAY to 17th MAY, 1952

CORPORATION OF THE CITY OF GLASGOW

tied them by a railway line to a further hill with a housing scheme beneath a dark factory based on Blochairn Iron Foundry near Riddrie. In those days the soot-laden skies over Glasgow on moist, cold, windless days often seemed like a grey ceiling, with the sun an orange or crimson disc in the centre. (In the autumn of 1951 for several days a pair of sunspots were visible on it.) My *Two Hills* city picture, painted freely in poster colour, led to my only disappointment with Miss Irwin. She wished to reproduce it on the cover of the class yearly exhibition catalogue, and before it was photographed for reproduction a friend persuaded her to repaint the foundry roof so that it appeared seen from above like smaller buildings before the chimney stacks. This stopped the angle of the dark foundry roof sloping toward the sun and towers beyond, ruining the composition. I had combined two different perspectives, sometimes called viewpoints. In the 15th century Ghiberti and Donatello invented a perspective ruled by a geometrical vanishing point, since when most western artists before the 20th century found it useful. Good ones still made pictures combining many views that did not conform to single vanishing point perspectives, while ensuring most verticals and horizontals did; but academic art teachers taught the rule as if it should never be broken. At Whitehill, my ordinary day school, schoolteachers had taught me that rule without insisting on it. Later, at Glasgow Art School, I met teachers of painting who did – they belonged to a late 19th-century academic tradition that urged everyone to paint like Velasquez with some early Impressionist freedom of brushstroke. One of them thought modern art had started going wrong with Cézanne's still lives, which flagrantly broke the single viewpoint rule – he had not noticed the landscapes

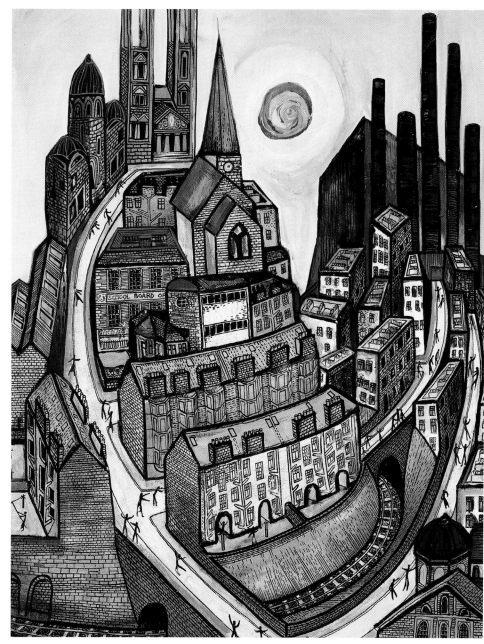

The City: Version Two, gouache, pen and ink on paper, 1951, 42 x 30 cm

behind the *Mona Lisa* did so too, and that the ceiling and floor of the room where Jan Arnolfini and his wife stand have different vanishing points. In the *Two Hills* city picture I had combined different vanishing points instinctively. From then on I did so deliberately. The final version of the picture is the result of two reworkings, made years later by repainting some areas and taming most by drawing round them in ink.

Seeing how much she had shocked me Miss Irwin apologized, and was too good a friend for me to bear a grudge. She lent me a big book with colour plates of work by the great Flemish masters which delighted me as much as the visions of William Blake. How different they were! Blake's men and women are gods and goddesses acting in mysteriously colourful universes lit by impossibly huge suns, and enact glorious, sombre or terrifying mental states. Blake, like Michelangelo his teacher, thought elaborate clothes and furniture were devices commercial

painters (like *Sir* Joshua Reynolds) used to flatter wealthy patrons. I agreed with him before I started enjoying the well-lit landscapes and rooms of the Van Eycks, and Van der Weyden and Memlinc with floors of beautiful tiles, well-laid planks and richly-woven carpets, yes, and panelled walls and carved furniture, richly-woven tapestries and views across gardens and bridges to houses and towers of grandly built cities. The people occupying these spaces usually wore rich robes, but often had the careworn faces seen even among prosperous citizens in a big city. The great Flemish painters were then portraying a mercantile society in which even the wealthiest folk appreciated how the goods they enjoyed were made. The separation between owners and craftsmen was not the gulf it became in the time of Rubens, whose main patrons were monarchs. The Flemish masters taught me that anything or anyone in the world, carefully looked at and drawn, is a good subject for art and therefore (as I still believe) beautiful. The artists of the Sienna and Florence republics could have taught me the same, but I liked the ordinary-looking Flemish folk more than the graceful Italians. Study of Van Eycks' reproductions left me knowing that every detail of furniture and ornament in a room can appear beautiful if painted with a loving care that, years later, I brought to some pictures of domestic interiors, but only had time to complete a few of them as I wished.

Jonah in the Fish's Belly now only exists in a black and white photograph, though the original was an ink drawing tinted with watercolour. I wanted to emulate Blake's *Book of Job* illustrations by also making a biblical book one of mine, so naturally I began by reading the shortest, and was delighted to find the *Book of Jonah* had less than three pages, and was the only Old Testament book where God shows himself both merciful and humorous. The photograph was reproduced in the *Glasgow Evening Times* newspaper above the caption, *Artist Alasdair's Whale of a Picture*, giving me a taste of that intoxicating publicity which turns stale as fast as it fades.

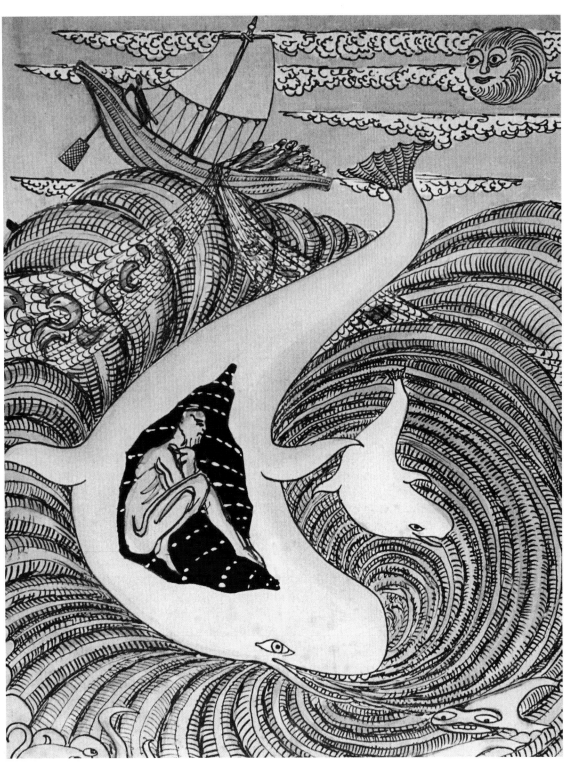

Jonah in the Fish's Belly, *1951, pen and watercolour on paper, photograph of original work, now lost, 42 x 30 cm*

Four: Schoolboy Work, 1947–52

THESE TWO PICTURES were made according to the rules of the Scottish Department of Education's Art Inspectorate. The subject for a picture was given along with a piece of paper, then the student ruled round it a half inch margin at the top and sides, then at the foot a three-quarter inch margin in which the student's name, class and number were written. When I became an art teacher years later I knew another who spent at least half an hour making his class draw these margins with parallel eighth-of-an-inch-apart lines at the foot between which their name, class, school and exact date had to be neatly lettered before their imaginations were told to work freely inside that careful frame. Luckily my own teachers were less inhibitive and only wanted pictures with such margins to show visiting inspectors. I could not take such ordered pictures seriously so filled the space with cartoon figures outlined in pencil, then drawn over with ink, then tinted with watercolours.

The Card Players was given to me as homework. To show the cards occupying the table top in an interesting way, I placed them end to end like dominoes, greatly annoying my father and mother because there was no such card game. I thought my picture made an interesting pattern out of several kinds of people, and if the game they were playing did not exist, such a game could be invented along the lines I had indicated.

At first, half the teaching I got at Whitehill Senior Secondary School struck me as useless because not enjoyable. I was taught Latin because it was an entrance qualification to Glasgow University, and my parents wanted me to go there. The Latin text we used was Julius Caesar's *Gallic Wars*, and I loathed both warfare and Caesar. In Maths I appreciated the logical spaces of plane geometry, but when told algebraic equations were *rational* and *irrational*, *possible* and *impossible*, I stopped struggling to understand symbols grouped under such misleading adjectives. In Science classes I enjoyed experiments like those showing how great heat expanded water into steam and great cold contracted it into ice, but it became a matter of memorizing tables of elements and their combinations. I could only remember what I enjoyed because remembering more was a waste of mind, so with teachers who *could not* occupy my mind I surreptitiously doodled designs for alternative worlds on the brown paper jackets we had been ordered to put on our schoolbooks. This put me in danger of The Belt, then an often used instrument of torture. The only time it was used on me I nearly fainted, which probably saved me from further punishment. I was never rebellious or cheeky, just firmly absent-minded, so teachers of subjects I disliked accepted my poor exam results though my parents did not. I was freed from organised games and swimming by fits of asthma and eczema, while teachers of History, English and Art thought highly of my classwork. In my last two Whitehill years the head Art teacher, Robert Stuart, let me take any materials I wanted to paint anything I wished, only once murmuring that the examiners would like to see some carefully shaded pencil drawings of plaster casts. I ignored that suggestion. Until supplied with living people to draw, I preferred to paint from imagination.

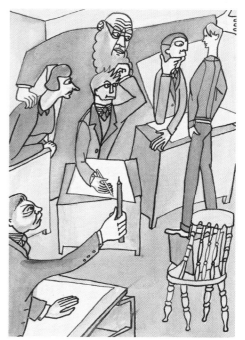

Drawing Class, circa 1950, ink and watercolour on paper, 21.5 x 15 cm

The Card Players, 1951, pen and watercolour on paper, 21.5 x 15 cm

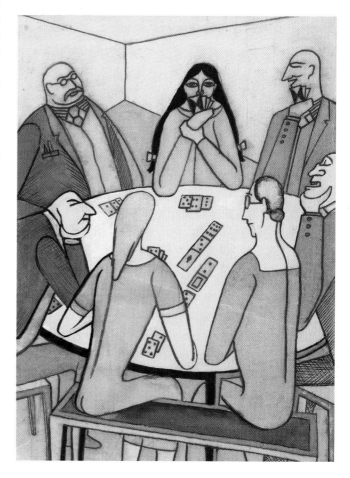

Page 24

*Schoolboy
Work*

St Christopher,
*1951, ink and
watercolour on
paper,
42 x 30 cm*

My love of magic and miracles that made everyday life more exciting inclined me to make pictures of religious subjects, the more far-fetched the better. I also liked the clear outlines and strong colours of early Renaissance artists who painted such things. Mr Stuart's art room had a lovely row of postcard colour reproductions of these along one wall. I maybe depicted Saint Christopher because he had been the selfish giant my most infantile part wished to be, before he started working for any who needed his help and grew good enough to carry a child who was God. Water, hair, hands and knees were suggested by Japanese prints, and the landscape beyond him by Tolkien's *Hobbit* illustrations. The picture works as an overall pattern though the giant's figure is impossibly grotesque. No teachers complained of me twisting bodies to fit my compositions. But I knew the distortions hid my inability to draw figures well. Egyptian, Greek, Renaissance artists *and* William Blake had painted vigorous people without much distortion and with no loss of imaginative force. I wanted to gain that glorious ability.

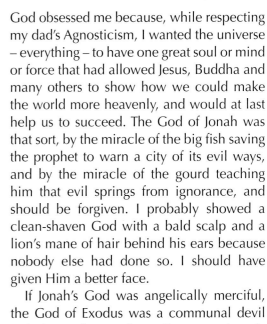

And the Lord God prepared a gourd...

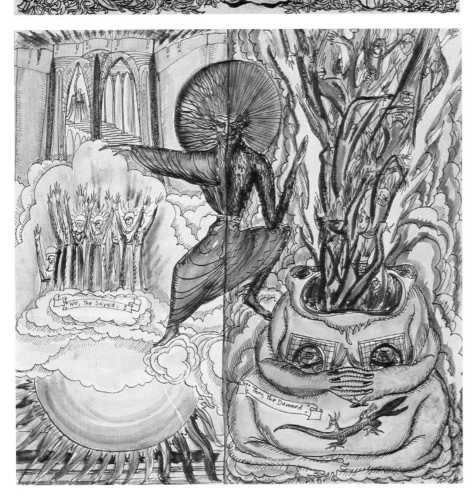

We, The Saved.

Thou the Damned.

God obsessed me because, while respecting my dad's Agnosticism, I wanted the universe – everything – to have one great soul or mind or force that had allowed Jesus, Buddha and many others to show how we could make the world more heavenly, and would at last help us to succeed. The God of Jonah was that sort, by the miracle of the big fish saving the prophet to warn a city of its evil ways, and by the miracle of the gourd teaching him that evil springs from ignorance, and should be forgiven. I probably showed a clean-shaven God with a bald scalp and a lion's mane of hair behind his ears because nobody else had done so. I should have given Him a better face.

If Jonah's God was angelically merciful, the God of Exodus was a communal devil ordering refugees from Egypt to invade Palestine and exterminate the natives. Yet Assyrian inscriptions, history books and newspapers show such devils were commanding other nations then, and ever since. I had many arguments with a Christian school friend who found nothing wrong with the Exodus Jehovah and thought people's evil actions were due to a false yet powerful god, the Devil. I believed the universe could only have one guiding soul with many aspects, and Christians who divided it into a good God and bad Satan, who would both at last have most people tortured for ever in Hell, were setting up the schizophrenic deity shown here.

In 1950 or '51 my teachers and parents accepted I would never pass a Latin or Maths exam and enter university, and would probably become a local civil servant because nobody leaving secondary school in Scotland could start earning a living as an artist. This left me over a year to study and paint what I wished. In a history essay on the Industrial Revolution I mentioned Parliamentary Acts that turned common land into private property, driving families out of cottage industries into quickly built factory towns where steam-powered machines allowed cruel exploitation, which happened because wealthy folk strove to get richer fast, and ignored the misery they gave others.

And the Lord God Prepared a Gourd, 1951, ink and gouache on paper, 20 x 21 cm

Heaven and Hell (We the Saved – Thou the Damned), 1951, ink and gouache on paper, 27 x 27 cm

*A Personal View of
History: The Ice Age;
The Stone Age; Human
Sacrifice; Babylonian
Science; Moses on Sinai:
The Moral Law; Greek
Civilization, 1950, ink and
gouache on paper,
15 x 21 cm/21 x 15 cm*

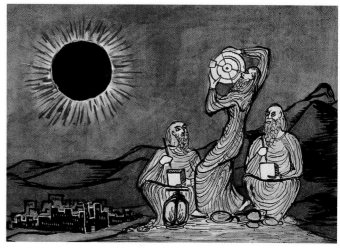

My History teacher said my essay was "too personal" – it passed a moral judgement historians should avoid. We amicably disagreed about this and he suggested I put my views into a lecture for the Whitehill Literary and Debating Society, of which I was a very vocal member. These pictures were made to illustrate that lecture, being shown on a screen by an unwieldy projector called an epidiascope. Starting with The Ice Age and Stone Age man, the story of mankind followed with Keystone Cops rapidity. The worst of city life appeared as Human Sacrifice, the best as Babylonian Priests recording an eclipse, having devised an alphabet and calendar that made writing history possible. Moses on Sinai, leader of wandering Arab tribes who believed in One God, carved out a strong moral law for them on a stone tablet. Greek Democracies achieved greater freedom of new thought, poetry, drama, art and philosophy, which Roman Imperialism partly destroyed and partly (by adoption) prolonged.

Between Roman Imperialism (to the left) and the Dark Ages (beneath) came The Sermon on the Mount, with Jesus telling the people of that vast, slave-based empire that every human soul was equally valued by God. He was a moonlit figure on a low pinnacle, preaching to upturned faces and seen from behind. (I have never been able to imagine Jesus from in front.) But I lost that picture. Then came Monastic Learning, The Feudal System, James Watt's Steam Engine and The Industrial City. The final picture was to be The Triumph of Socialism, showing Riddrie's Municipal Public Library. I thought this well-planned, well-stocked public library was a triumphant example of local egalitarian democracy. Here, even more than in Whitehill Senior Secondary School, I had been able to give myself exactly the education I wanted, so thought anybody who could read and think would be able to get it there too. Every district of Glasgow and Britain now had such free libraries. A just civilization was finally being established.

Page 27
1947–52

A Personal View of History: Roman Imperialism; The Dark Ages; The Monk; The Feudal System; The Engineer; The Industrial City, 1950, ink and gouache on paper, 15 x 21 cm/ 21 x 15 cm

Monkland Canal, Blackhill Locks, circa 1950, ink and wash on paper, 15 x 21 cm

I could not draw Riddrie Public Library. It held a multitude of books I had found exciting, but the building was part of Riddrie Housing Scheme, the kind of good, pleasant, normal place where I thought everyone should live. But my imagination was not excited by the tree-lined boulevard, the shrubberies and bowling green from which streets radiated between houses with well-kept gardens, and converged on the highest building, which was Riddrie Primary School. It had been planned and almost wholly built shortly before I was born so gave me no solid sense of the past until, when 12, I discovered the Monkland Canal curving round it up the four huge water-stairs of Blackhill Locks. This quarter-mile of huge stone casemates and embankments was slowly turning derelict. If Rome had a modern housing scheme like Riddrie, and a young boy there had no knowledge of the Roman past, he would have felt as I did on suddenly coming upon the Colosseum. This canal proved people here had once done gigantic things, so might do them again – a wonderful idea.

In the spring of 1952 my mother died soon after her 50th birthday. Most parents kill our infantile faith that we can have anything we want. Mum and Dad left me sure that I could make anything I wanted in words and pictures. I had started imagining a series of pictures called *Acts of God*, showing miraculous biblical episodes happening in present-day Glasgow, from the Garden of Eden to the Apocalypse. No boy of seventeen could start to make a living by his art in Scotland. My Leaving Certificate passes in Art and English (said Dad and the Whitehill Headmaster after earnest discussions) qualified me to become a paid trainee librarian who might make art his spare-time hobby, and advised me to apply for that. I would have preferred a rich friend to pay me a steady wage

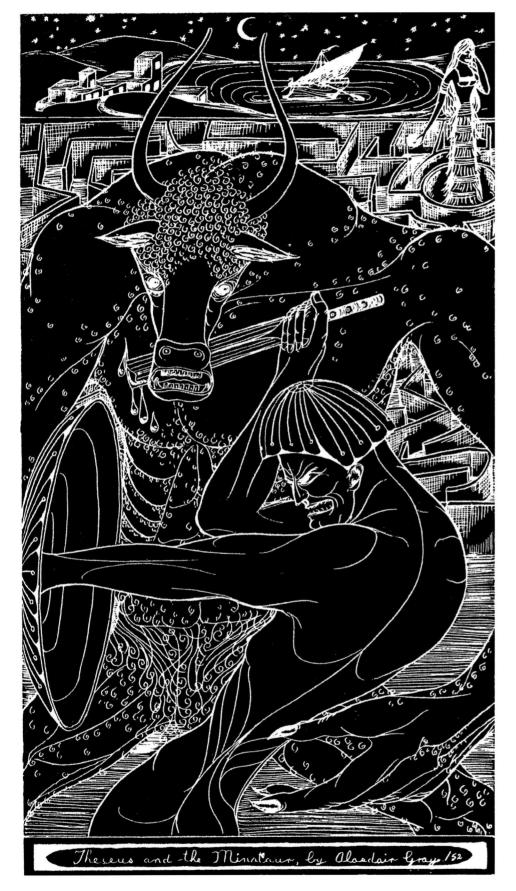

Theseus and the Minotaur, by Alasdair Gray. '52

Theseus and the Minotaur, 1952, scraperboard, 42 x 30 cm

Cartoons from Whitehill Secondary School Magazine, 1950–52

"And now Mrs Claveridge, I will delve into your subconscious mind."

"It's all very well for you!"

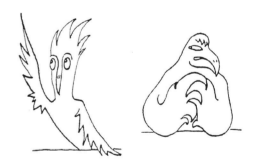

The Swot (or Beastly Swat) with his mortal foe, the common pupil.

"Don't be selfish, Geraldine!"

to paint anything I liked, and found one fifty years later. In 1952 Glasgow Public Library Department said I could start work with them in the autumn. Meanwhile I went to join a night school class in life drawing, because drawing naked men and women (preferably women) would teach me to paint people who looked less like caricatures. But this training would stop when I became a librarian who would have to work in the evenings.

The night school was in Glasgow School of Art, and applicants had to show the Registrar a portfolio of work, so he could reject those who only wanted to look at people without clothes. The Registrar, Mr Barnes, saw pictures shown in this and the last chapter – suggested I enrol as a full-time art student – told my dad that a government bursary could be got to support me. Dad asked what future would the Art School train me for. Mr Barnes hesitated, said most graduates became teachers of art, which was not possible for me as I had not a school certificate in Latin; however, very talented students were sometimes asked to remain in the Art School as teachers, and though he could not yet promise I would be one of those, it was a possibility. So I became a full-time art student. This was the luckiest event of my life, though I became the kind of student none of the Art School staff, including Mr Barnes, could have accepted as a fellow employee.

My wish to be a writer began at primary school, and at Whitehill a teacher of English, Arthur Meikle, encouraged this by making me his assistant as editor of Whitehill School Magazine.

My drawings on the previous page appeared in it, with some equally immature writings. I had also decided to write *A Portrait of the Artist as a Young Scot* and (to differentiate it from Joyce's first novel) would not have it ending with my hero leaving the city of his birth to become an artist, he would stay there until, maddened by a sense of failure, he took his life. I entered Art School determined, in my spare time, to make notes that would help me with that novel, though I had no intention of ending tragically myself. Memorable writers have never done so.

A View of Glasgow Cathedral from the Necropolis, 1952, ink drawing tinted with watercolour on paper, 30 x 21 cm

Five: Early Art School, 1952–55

A FOUR-YEAR art school training began with a two-year general course which included mornings of steady drawing and at other times, basic instruction in architecture, illustration, lettering, sculpture (mainly modeling in clay) and a craft (etching or woodcut or lithography or puppetry or ceramics or textile design) that we could change quarterly. There were also lectures on historic costume and, at much greater length, the history of art from the early Renaissance to early Impressionism. In the 1950s our teachers of painting thought Post-Impressionism was *modern* art and barbarous. Their own kind of painting could be seen for a month each year in the Royal Glasgow Institute exhibition at the McLellan Galleries, Sauchiehall Street: mostly portraits and landscapes Monet might have painted had he been timid and Scottish, with an inferior grasp of colour and design. Each month they gave a subject for a monthly painting to be made in the evenings or at weekends in the medium of our choice – watercolour, gouache or oil on paper, card or canvas. (Acrylic paint was not yet marketed.) At the end of each month our pictures were hung on screens in the Art School assembly hall for everyone to see and for a teacher to criticize.

In my last year at Whitehill School I had been allowed to study and work at what I liked without restraint, so my first year in Glasgow Art School often depressed me. The training was based upon the precepts of Ruskin. He said students should start to learn drawing by making outlines of simple things in pencil, then shading them with careful hatching and crosshatching until they looked solid. When our hands had learned skill by sketching boxes, bulbs and carrots we might draw plaster casts of architectural ornaments, a portrait bust, a figurine before we drew from life – a year of dull obedience would prepare us for free activity. I believed that the right training to draw something well was to draw it badly, then improve it. I stayed away from these dull lessons by pretending that my bad health kept me at home, where I concentrated on the monthly paintings. I wanted them to astonish and interest teachers and other students who would see them in the Art School assembly hall.

The given subjects often annoyed by their banality. The first (shown here) was "*An episode from your summer holiday*" – the same subject as essays given once a year by teachers from primary school onward. The boy in the pinstriped suit is a caricature of me, helping to serve tea to fellow guests at the Holiday Fellowship guest house in Lamlash on the Isle of Arran. This again shows how much I needed to closely study human proportions. When hung in the assembly hall nobody spoke of it, but my first-year art teacher, Miss Dick, a truly gentle lady, told me the picture was a coloured pattern, not a real painting. A real painting showed bodies in a light that made them brighter on one side, darker on the other, and had them casting shadows.

Nor did my picture suggest depth through lines of perspective – lines that would be parallel if seen from above, as in a map, but which, from nearer ground level, would appear converging to a point on a horizon level with the painter's eyes, even if a horizon were not shown. Miss Dick, like most of her colleagues, shared the conventions believed in by the friend who had persuaded Jean Irwin to spoil the composition of my *Two Hills* picture. In 2010 I now think painting might be revived by some of these conventions.

Afternoon Tea, Lamlash Guest House, 1952, gouache on paper, 58.5 x 46 cm

*The Beast in the
Pit*, 1952, ink
and watercolour
on grey paper,
55 x 30 cm

The given subject of this picture was "*Washing day with a minimum of three figures*" which I found depressingly banal until, near the Art School, in a lane overshadowed by the backs of tenements with fronts on Sauchiehall Street and Bath Street, I saw a court with washing line two floors above the lane. Nearby at ground level was a half-withered-looking hawthorn tree with a bough that looked overgrown through reaching for sunlight. I recalled Blake's etching of a lone figure about to climb a tall thin ladder whose top rests on the crescent moon. Behind him a lovingly entwined couple and the words beneath are "I want! I want!". The women with headscarves and aprons like surgical gowns are like a home help who attended to our house in my mother's last illness. The three figures, three cats, three washing tubs, three close entries are arranged to lead the eye round about the nearly symmetrical view. They cast no shadows, but the buildings are so shadowy nobody spoke of that. The main lines of the scene give an illusion of traditional geometrical perspective, though anyone using a ruler to discover the vanishing point on an invisible horizon would find the picture has two or three. I called this *The Beast in the Pit*.

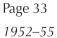

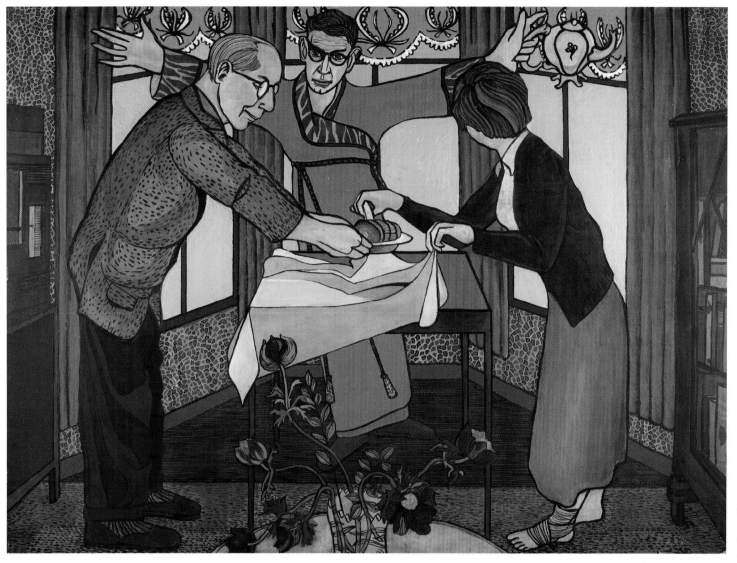

Three People Setting a Table, 1953, gouache on paper, 56 x 76 cm

The Pointillist carpet, gaudy peonies and wallpaper here are colourful inventions to compensate for so much brown, otherwise the picture is true to the clothes of the Gray family and our living-room furniture. We ate at this card table, setting it up before the fire – I moved it to the bay window to give the composition a symmetrical frame. My sister had a bandaged foot when I sketched her. My chin and Dad's profile were stronger than shown here. He would never place roast meat on a table while Mora spread the cloth and I presided wielding the ornamental teapot we never put to use. Despite elements of light and shade, notably in the tablecloth, the picture is united by the very flat dressing gown my mother had made from an army blanket. It was thick, comfortable, stately. Alas, my first wife chucked it out.

This is Malcolm Hood, the life-long friend I made in my first year at Art School and liked for the sense of humour we shared, and for qualities I lacked. His calm, firm, gentle manner suggested life was interesting, and often funny, but never surprising, horrid or overwhelming. He was handsome and well-dressed. This profile makes him look like an impassive Assyrian autocrat. Nearly 30 years later I used another drawing of him in the title page of *Lanark, Book 4*. This, adapted from the title page of Hobbes' *Leviathan*,

Malcolm Hood, circa 1954, ballpoint pen on paper, 30 x 21 cm

gives Malcolm's monarchic head to the man-shaped crowd dominating Scotland.

In January 1953 the given subject was any scene from *Tam O'Shanter*. I chose the moment when Tam shouts, "*Weel done, Cutty Sark!*" The mass of naked witches are not "*withered beldams, old and droll*" as Burns describes them. I made them horribly plump, hoping their appearance would shock attractive girl students who had not noticed my existence. (This happened.) There is strained topographical truth in the road connecting Alloway's "auld haunted kirk" with the brig over the Doon, and also the Burns memorial mausoleum in the park beyond it. I tried framing the scene between lightning flashes on the left reflecting ivy stalks on the right, though alas, the owl does not balance the flight of geese. I think the scene had enough cast shadows to please Miss Dick.

My oldest friend is George Swan. Like many Glaswegians he lived before marriage with his parents. Theirs was a one-room-and-kitchen flat in a four-storey tenement with three flats on each floor, shared lavatories on the communal stair. George's dad, like mine, had fought in World War One. He had been a picture framer, then grew blind and worked on the production line of Singer's sewing machine factory, Clydebank. This gentle, patient man sat for me at home with his back to the kitchen sink. The moonlit tower contains the central staircase of Duke Street Hospital in Dennistoun, seen from behind and long since demolished. The portrait was drawn with Indian ink on plywood, then tinted with enamel and oil glazes. I left some woodwork in the kitchen sink unit almost untouched, and only slightly darkened Mr Swan's skin colour. I gave this portrait to the Swan family. It was returned to me with apologies because it made him look old and blind and his wife never thought of him like that. My home was a

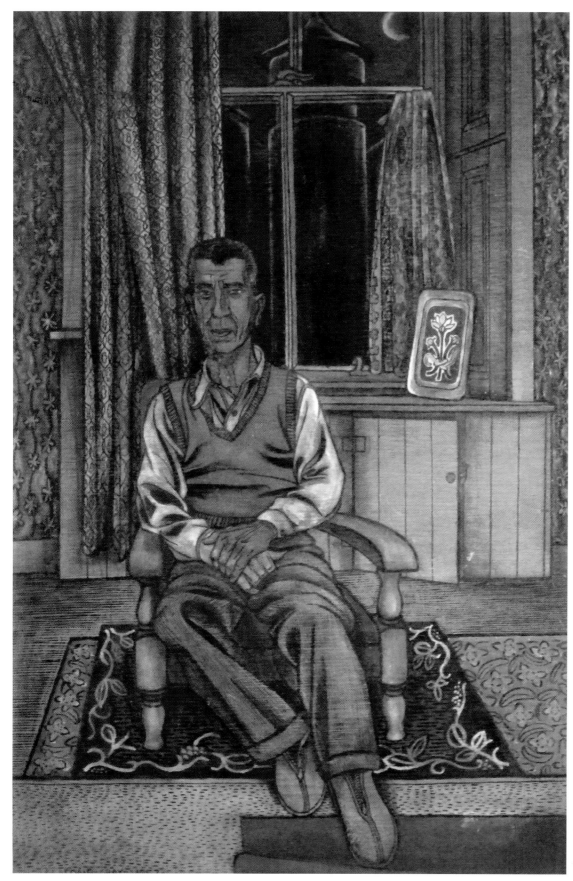

three-room-and-kitchen flat with a lavatory bathroom, but in my first Art School years I sometimes felt more at home in the Swans' Dennistoun kitchen than in the living room of the Grays' Riddrie home, perhaps because George's home still had a mother. After his wife died Mr Swan lived in Fife with George and his daughter-in-law Rose. George, after working as a Glasgow engineer, had become an editor with the D.C. Thomson Press and his house is a fine bungalow in a middle-class garden suburb. Mr Swan, missing the noises of neighbours in a crowded old working-class tenement, said, "Every day sounds like Sunday here."

I often made pictures with symmetrical frames

Page 35

1952–55

Opposite:
Tam O'Shanter, 1953, Indian ink and watercolour on paper

Left: Portrait of Mr George Swan at Home, 1952, ink, gouache, oil and varnish on wooden panel, 76 x 56 cm

Below: Young George Swan, 1972, ballpoint on paper, 23 x 14 cm

*Still life
with Green
Slippers
and Piano
Stool*, *1953,
gouache
on paper,
restored with
oil and acrylic
2006,
76 x 56 cm*

in them, most clearly in this still life. The ornaments on our piano stool, the slippers beneath it, belonged to my sister, whose photograph is in the tortoiseshell frame. The pattern of our living-room carpet was not as bright as I painted it. In my first two Art School years Mora still attended Whitehill School, so was painted more than anybody else, since I was painting at home. When the given subject was *musicians* I showed her sitting on the stool, playing our upright piano. I lacked patience to paint the black notes but the sheet music on the floor, brass-topped table with still life in front, small square panes in the upper sash windows were in our living room, also the sofa with wooden arms – a bed settee where my parents and (latterly) father slept so that Mora and I had a bedroom each. The music teacher, cat, barometer, sacred heart picture, patterned cushions, curtains, carpet and wallpaper are invented or remembered from elsewhere. This picture was later damaged but I restored it in 2007, with improvements to the porch and view outside.

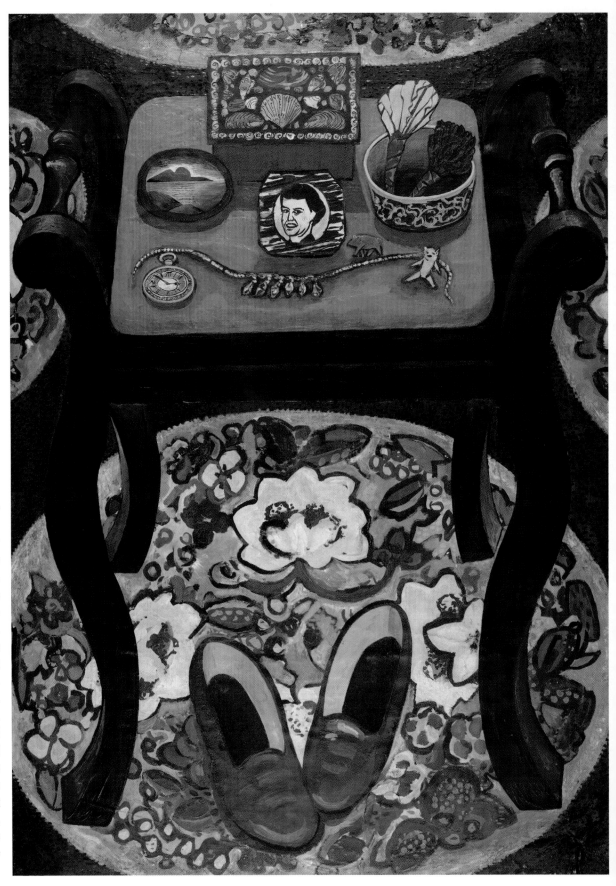

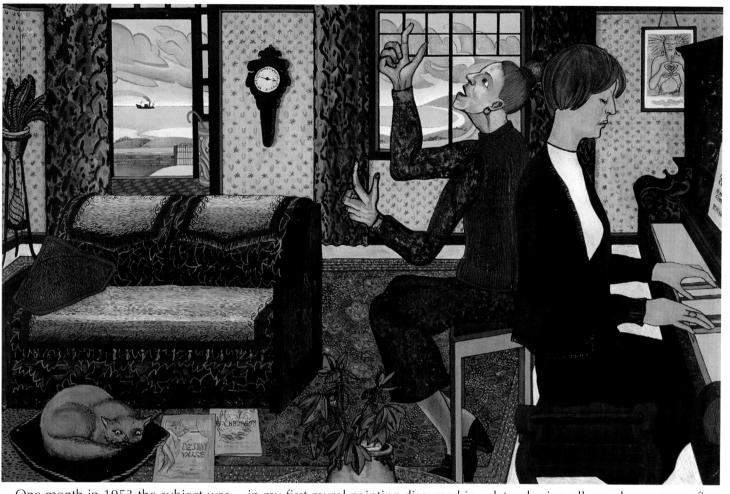

*The Musicians,
1953, gouache
and acrylic on
paper,
56.5 x 88 cm*

One month in 1953 the subject was the self portrait on the frontispiece of this book facing the title page. This certainly used cast shadows, dramatizing my loneliness against a tenement in the Drygate. To this ancient district under the shadow of the Necropolis (now covered by Tennent's Brewery) I added a section of the Monkland Canal that was nowhere near it. I envied cats for seeming at home anywhere and tried to join background to foreground with a line of them chasing each other. The original was in sheer black and white. In 2006 I added colours.

Of paintings lost from this time I most regret one on a biblical subject of our own choice. I painted a crucifixion with an emaciated Jesus being nailed by two modern British privates to a cross like a noticeboard. I mention it here because I used the same figure

in my first mural painting discussed in chapter 7.

I cannot imagine how my art would have developed had the Art School let me paint subjects of my own choice. The general course was meant to prepare painters who would use oil colour if allowed, in their third year, to specialize in easel painting. Before then we had no training in oils. To plaster, wooden and canvas surfaces oil paint can be applied in clear glazes, even layers or thick as mud – Rembrandt's *Flayed Ox* in Kelvingrove Museum was painted in all these ways – that only a very competent, confident teacher could demonstrate them. My own first attempts with oil paint kept giving me accidental colours I never intended, but so subtle and lovely that I spoiled my main idea by trying to include them. I gave oils up till years

later, basing all my shapes upon firm drawing, chiefly using the mediums of Miss Irwin's class and Whitehill School – opaque, fast-drying poster colour, mainly used in flat or patterned areas with distinct edges, sometimes drawn with a brush, or a detailed line drawing tinted with watercolour or inks. I never painted vague or indistinct things, and luckily in my second year I was at last allowed to draw what I had most wanted from Art School, living human bodies. I produced a large portfolio of life drawings of which all but six were later lost or stolen, but these six show the love of clear outline, and distrust of shadow that was too great to win our teachers' approval.

Miss Dick regretted that my pencil drawings of naked or near naked people firmly outlined subcutaneous muscles and bones which she thought should be

**Art School
Life Drawings**, *1953, pencil
on paper, 42 x
30 cm*

suggested by delicate shading which I never attempted, being incapable of it. Trevor Mackeson, a teacher I became friendly with, asked if I *needed* to make the people I drew look ugly and tortured. I said they didn't look that way to me. Davie Donaldson was the best painter of the Art School's staff. On overlooking me drawing from life one day he asked exactly what I was trying to do. I said I was trying to explain to myself the shape of the figure in front of me. "Really?" he asked. "Yes." I answered. In a resigned way he said, "Ach well son, carry on, carry on." At our monthly shows in the assembly hall a teacher would single out pictures as good or bad examples. Mine were never mentioned. Maybe my peculiar reputation was responsible.

The Art School shop was run by a pair of friendly widows, Mrs Mitchel and Mrs Cochrane. When I was their only customer one day one of them

said, "Miss Dick says you're a genius." I felt bothered and unhappy. Both were

watching me closely, then one asked, "What do you think of that?" I said, "Miss

*Life Class
Interior:
Student Model,
circa 1955,
gouache and
ink on paper,
30 x 42 cm*

Dick does not know me well enough to judge." If genius is known by work that others dare not call good or bad, then it is a damnable label to have attached. Most people, fellow students included, would make only two remarks about any picture of mine: "Very interesting", then, after a thoughtful pause, "You certainly put a lot of work into it."

In the summer holidays most art students, especially those from working-class homes, enlarged their grants by taking a temporary job, but in 1953 Dad allowed me to stay at home to write my *Portrait of the Artist as a Young Scot*. With the plot complete in my head there was now enough material (I thought) to write the book quickly, but the first few sentences on paper proved that I lacked a decent prose style. Hitherto diaries and school essays had been filled by writing as I talked, pouring out thoughts as they sprang to mind, but a narrative in that gushing voice was not convincing. I struggled to make my words calm and unemotional,

Life Class Interior: Woman with Red Shawl, circa 1955, gouache and ink on paper, 30 x 42 cm

especially when describing emotional disturbance. I learned to use as few adjectives and adverbs as possible, and to not describe what people feel when their actions and words convey it. After two months I returned to Art School

having managed to write only what finally became chapter 12, and the mad visions in 29. The book was growing and mingling with ideas for a modern *Pilgrim's Progress* inspired by Kafka, as Edwin and Willa Muir interpreted him.

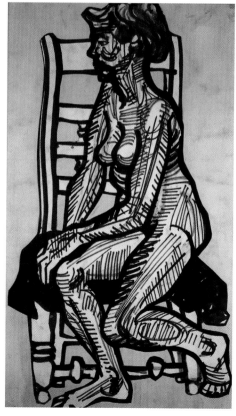

Nude at Red Table, 1954, ink and coloured papercollage, 61 x 32 cm

Reclining Nude, 1955, ink on paper, 61 x 32 cm

Nude on Chair, 1954, felt-tip pen and paper collage, 70 x 48 cm

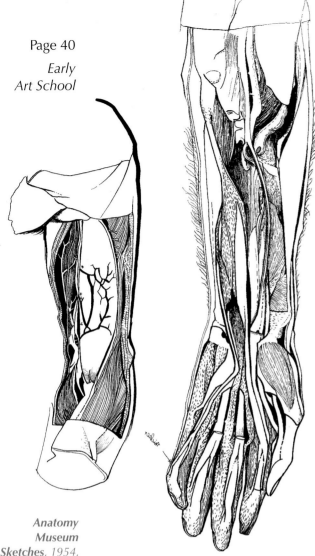

*Anatomy
Museum
Sketches, 1954,
ink on paper, 30
x 21 cm*

Mum's death, and my alternating asthma and eczema bouts, left me fascinated and horrified by the structure of bones, nerves, veins, glands, muscular and connective tissues that amount to a human being. I felt the horror could best be overcome by understanding them as Leonardo and Michelangelo had done, by studying morbid anatomy. I asked Mr Barnes to help me apply to Glasgow University Medical department, for permission to sketch in their dissecting room, but I was only allowed to sketch pickled and bottled specimens in the department's museum. I soon stopped doing so. Drawings like these gave too small an idea of how the living limb would work. The specimens that

*The Artist in
Wartime, 1954,
poster,
76.5 x 51 cm*

*Student Poetry
Reading 1,
1955, poster,
51 x 76.5 cm*

*Student Poetry
Reading 2,
1955, poster,
76.5 x 51 cm*

disturbed me were monstrous births like the cyclops and two-headed baby which may have been exhibits originally acquired by John or William Hunter, the 18th-century instigators of modern surgery who founded the university's Hunterian Collections. They proved that *the nature of things* – which for me was how God worked – could give dreadful undeserved pain to innocent folk, pains that nuclear radiation and warfare would multiply.

But I neared the end of my second Art School year on a friendly footing with most students and teachers I knew. Several girls enjoyed my company, despite my total failure to start a sexual romance with ones who attracted me. The Art School had no literary and debating society of the kind I had enjoyed at Whitehill, so I and Malcolm Hood started one. I sang in a choir run by a friend – performed in School concerts – had become a Recognized Character whose reputation (I heard later) was enhanced by many who thought I would die young. The State Bar in Holland Street, off Sauchiehall Street, was the School's favourite pub when Glasgow pubs closed at 9 p.m., even at Hogmanay, supposed to be Scotland's happiest festival and certainly the most drunken. Both my parents had celebrated it cheerfully but soberly. Around closing time on 31st December 1954 I left the State Bar and leant over the bonnet of a parked car feeling very sick and drunk. I was hailed by a small group leaving after me. They took me with them to parties in houses near the university I had never visited before or since. This was the best Hogmanay of my life; all later ones have been anticlimaxes. Bob Kitts was in the group, a London art student who had been invited north for the new year by Glasgow students he had met when on holiday in France. By talking and talking and talking with Bob I grew steadily sober.

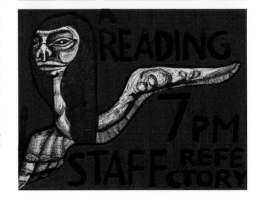

Drawing of Robert Kitts, 1955, ink on paper, 30 x 21 cm

Hilary Leeming, 1959, ink on paper, 30 x 21 cm

Portrait of Bob, 1958, ballpoint pen on paper, 30 x 21 cm

His father had been a merchant seaman who, unlike mine, had suffered unemployment during the Depression, but later worked as a driver for the GPO. World War Two had changed life for the Kitts as much as the Grays. The parents stayed in London while Bob, his two brothers and sister were evacuated to Cornwall, separated and billeted with strangers. As often happened, young Bob was with people who treated him badly until his strong-minded mother found out. She took him away and placed him with a kindly family he remembered fondly. During the London Blitz the father and mother were *bombed out*, so after the war the family were reunited in a completely different home, but resumed the Cockney tradition of summer holidays in the farms of Kent, earning money by hop-picking and sleeping in tents after sing-songs round a camp fire. Until 1960 every fit young British male had to serve two years in the armed forces. I (luckily) was unfit, but Bob had served two years in Henlow RAF base. This allowed him to attend night school classes and make a portfolio of work that had got the Slade Art School

to accept him as a student. His fees and living expenses were, like mine, paid by the new Welfare State so we were both Socialists – Bob said his family never had anything to Conserve. We were both fascinated by the visual arts, loved the writings of Dylan Thomas and Scott Fitzgerald, and were writing a semi-autobiographical novel inspired by Joyce's *Portrait of the Artist as a Young Man*. While discussing time and space in image and word one of us said, "The only logical outcome of our interest in word and image is filming," and the other agreed. We arranged to meet again as soon as possible and correspond with each other in future. On the night we met, Bob also met a Glasgow girl, Hilary Leeming, then a domestic science student. I came to enjoy a relaxed, platonic friendship with her that I later enjoyed more than once with the lovers of friends.

In the 1954 summer holiday I took part in an Art School visit by bus, ferry and train to Florence, Rome and Venice. Dad was then a site clerk at Arden, south Glasgow, where one of the new housing schemes that came to surround the city was being built. To pay for the trip he

got me work as a joiner's labourer and, during the Glasgow Fair Fortnight, as a day watchman. I made several sketches to help me make one of those large, complex, realistic compositions I have hardly ever had time to complete. I was also planning a picture for an Art School competition with a small money prize for the winner. The given subject was *The Marriage Feast at Cana* where Christ did his first miracle before his mother and disciples – six fishermen, a doctor, lawyer, tax collector, artist, handsome young lad and the accountant, Judas. In Italy I looked for faces illustrating this social and psychological range and found some among sculpture in Italian museums, where the pictures I mostly enjoyed were small early tempera paintings in clear bright colours and labelled *Primitive*. Beside them the wild dramatic gestures and swirling drapery of big high Renaissance oil paintings seemed very dull, though I now know they were seen through brown layers of varnish that restorers would soon start to remove. But these richly dressed folk had obviously been painted to satisfy equally rich patrons, which was why Blake had detested such art, and why Ruskin had

*Early
Art School*

**Sketches
from a
Workman's
Hut and
Building
Site**, *1954,
ballpoint
pen on
notepaper*

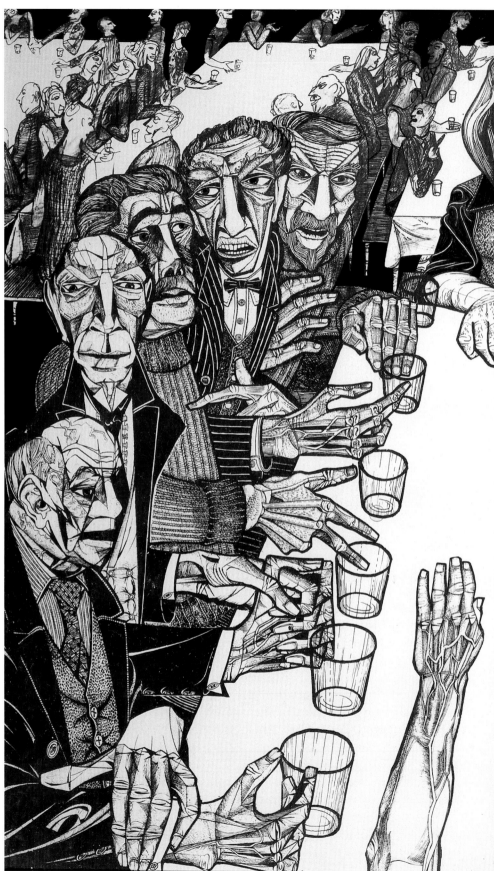

Marriage Feast at Cana, 1953

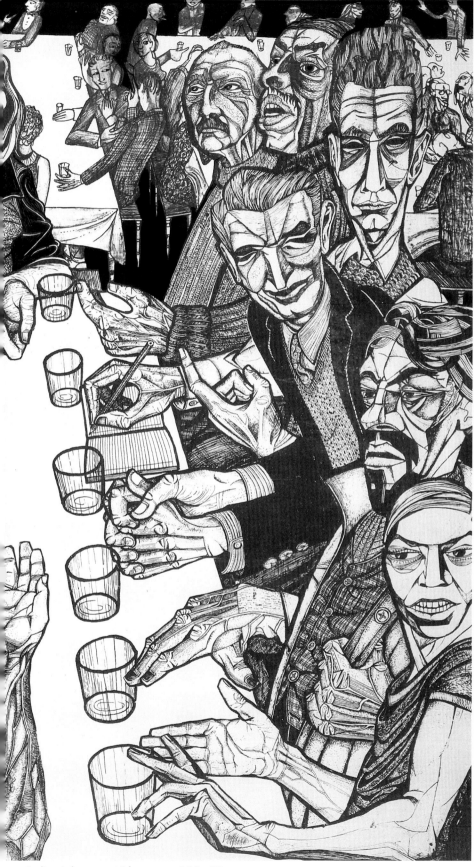

Indian ink on cartridge paper, 104 x 95 cm

1952–55

Sketches from a Workman's Hut and Building Site, *1954, ballpoint pen on notepaper*

Hut A (2)
Stove detail

Hut A (2)

Stove detail

thought art from before Raphael's time set better examples. St Peter's, Rome, perplexed my working-class soul with its preposterously expensive efforts to impress. I thought the holy water stoups unintentionally comic. The water lay in folds of sculptured drapery held up by cherubs happily kicking their legs – marble or bronze winged babies who would have been eight or nine feet high and weighed several tons had they stood on the floor. To what was visible within the great buildings I preferred the sight of them and the people and streets outside. I saw why Matthew Arnold said that the British should learn to build beautiful cities from Italy. Yet in Venice I enjoyed much of the labyrinthine mystery of Old Town Edinburgh.

Meanwhile I found several faces for my *Marriage Feast* picture among my fellow students, and the grief-stricken face of Mary at the head of the table came while doodling in a notebook. I thought it appropriate for the mother of many sorrows, though on this occasion she need not have looked so unhappy. She was a Jewish mother urging her son to

perform his first miracle – turn water into wine. He did, after complaining that she should let *him* decide when it was time to start out on his miraculous career. (Years later an Orthodox couple I met liked this picture because they said it described a typical Jewish mother–son situation.) I meant to make this picture something I had not before attempted – a big oil painting on a hardboard panel. Back in Glasgow I had no time to do that. Mary and the disciples were drawn separately with Indian ink on cartridge paper, then cut out and pasted together on a larger sheet of paper backed by hardboard. Unable to imagine the face of Jesus I depicted the scene from his viewpoint at the foot of the table. Only his naked arms appear, one hand making a gesture of refusal, the other of acceptance. I drew them from my father's arms and now see that I too have small, sturdy hands like his. They are the only successful part of the picture. A disciple's head at the end of the left row peeled off and has never been replaced. Five years later I gave the picture as a wedding present to Malcolm Hood and his wife Joy, borrowed it back

to have it photocopied, and left the original too long with the photocopying firm. When I went to collect it the firm no longer existed so the original was probably destroyed.

This picture ended my first two Art School years of the General Introductory Course, after which the students chose the department in which they wished to specialize, with a second choice in case that department would not take them. I wished to specialize in painting pictures to be hung in rooms and galleries, but the teachers in the Painting Department did not want me. They liked pleasant pictures and none I had made were very beautiful. I might have been accepted if Hugh Adam Crawford had still been head of painting, a great painter under whom Colquhoun, McBride and Joan Eardley studied. Crawford had annoyed the Glasgow Art School governors by mingling with his students as their social equal. They so curbed him that in 1945 he left for Aberdeen School of Art. More will be said on this subject, but the Art School department that accepted me was my second choice – Mural Painting.

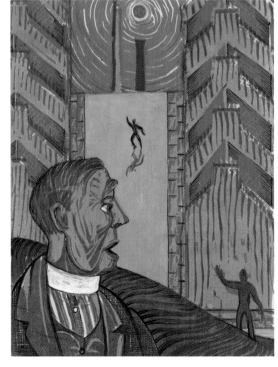

*Minister with
Ominous Street
Scene, 1952,
linocut with
addition of pen
and acrylic in
2006,
30.8 x 26.2 cm*

*Book of Jonah,
1954, lithograph,
15 x 25 cm*

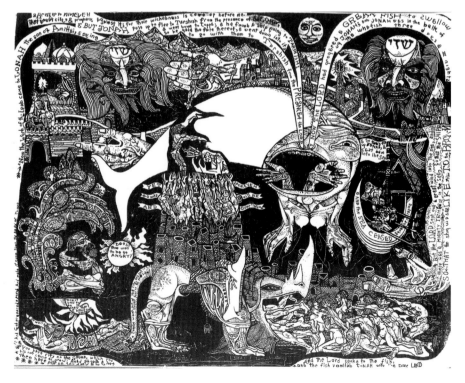

Six: Alan Fletcher, 1954–58

IN THE 19TH century Glasgow's population grew so fast that near the end it had the largest outside London. It had Scotland's filthiest slums, but its export of ships, steam trains, wrought iron, carpets and textiles had made it Britain's wealthiest industrial city. The local government had made it a city-state whose public water and electrical supply, transport, libraries and telephone system were examples emulated in England and America. A rich and expanding industrial city needs good architects, designers and artists. Glasgow had many already, and to train more Charles Rennie Mackintosh was commissioned to draw plans for a modern art school. In the McLellan Galleries, Sauchiehall Street, the Royal Glasgow Art Institute exhibited work by several Scottish painters who had more in common with contemporary French painting than with the London Royal Academy. That is why the dying Whistler, annoyed with London's art establishment, willed his unsold work to the Hunterian Museum. The *Glasgow School of Painting*, as journalists called it, was partly due to French influences that most English painters rejected, but was partly an independent parallel development. These works were seen, discussed and sometimes purchased locally before being exported by Glasgow art dealers with international contacts, but Mackintosh had the greatest foreign reputation, especially in Vienna and Munich.

If I stay mentally healthy and live long enough I will write a book explaining why most Scots in the first half of the 20th century stopped noticing they could govern themselves locally and make fine works of modern art. The one public figure who loudly objected to these connected failures was Hugh MacDiarmid (born 1892, died 1978) though their effect was a catastrophic neglect of our finest local culture. In Glasgow School of Art, lecturers in architecture said nothing about Scottish buildings and never mentioned Rennie Mackintosh. Students knew the School building accommodated us in unusually convenient, imaginative ways and some saw it was beautiful, yet occasional foreign visitors were often surprised to meet students who had never heard the designer's name. Our lecturers on art history spoke of nobody later than the French Impressionists and ignored *all* Scottish painting. Luckily the Art School library had books where we could study reproductions of Post-Impressionist art, and such modern English painters as Paul Nash and Graham Sutherland, who the London art establishments recognized, but we took years to discover that Scotland also had a tradition of modern painting that included the Impressionist landscapes of McTaggart, some daring work by George Henry (especially his *Galloway Landscape*), Rennie Mackintosh's late watercolours, John Quentin Pringle and the group called the Scottish Colourists. The last of these, J.D. Fergusson, lived mainly in France between the two World Wars but painted in Glasgow throughout the 1950s. The Art School's teachers of painting did *not* invite him to address the students, or refer to him. Like them he painted recognizable landscapes, figure paintings, portraits, but the forms and colours were strong enough – *modern* enough – to make theirs seem old fashioned and feeble. Lively students who noticed that our teachers preferred feeble painting felt they must invent a strong new art for themselves, and only later discovered the Scottish predecessors whose examples would have taught and encouraged us. In Glasgow School of Art I learned most from a fellow student, Alan Fletcher.

There is no single artistic type. Great painters have been Don Juans, henpecked husbands, cautious bachelors and reckless homosexuals. They have been an orthodox diplomat working for a Catholic monarch (Rubens), a fanatical agent of a revolutionary republic (David), a comfortable bourgeois Hedonist (Renoir). Since the early 1800s a Bohemian lifestyle was forced on many artists because, though talented, they could not earn secure incomes. Alan Fletcher is the only artist I know who looked like the Bohemian artist of legend. He was the free-est and most intelligent man I ever met, so a diminished version of him later appeared in three of my fictions. Had I not diminished him he would have stolen attention from my main characters, versions of me. His home

Head of Alan Fletcher, 1954, ink on paper, 24 x 22 cm

*Mr Fletcher
in the Kitchen
Bed Recess,
by his son
Alan Fletcher,
circa 1956,
ink on paper*

was a top floor flat of 144 West Graham Street in the Cowcaddens, a few blocks downhill from the Art School. His mother, Mary Giles, was of a Cornish gypsy family and, I suspect, illiterate. She was the most observant woman I have ever met and a successful restaurant manager who worked at hotels, often in English coastal resorts. Her visits home had the character of eruptions for she hated Alan's girlfriends and disliked how he rearranged the house in her absence. His father, son of a long-dead Highland schoolmaster, had trained as an engineer but now worked as a boilerman, maintaining the heating of the Grand Hotel at Charing Cross. Mr Fletcher's ironical, detached view of life resembled that of a Zen Buddhist. When at home he would lie reading a library book in the bed recess of the

*Self Portrait,
Alan
Fletcher,
1955, ink on
paper*

kitchen which his son used as a studio, because the fire range and gas cooker made it the flat's only dependable warm room. Here Alan painted and conversed with friends, usually late into the night. His sketch of Mr Fletcher has the alarm clock in the foreground that worked best when left face down. The female on the wall behind is part of a mural I painted there.

Born in 1930, Alan was maturer than the rest of us, having come to Art School after his two years of compulsory Military Service. I had seen his paintings in the monthly assembly hall exhibitions where one was singled out as a bad example, perhaps by the same teacher who told us Cézanne might have painted successfully if he had been given the right spectacles. Alan had his mother's observant capacities, which trained him as an artist. From the appearance of a building, an article of furniture or clothing or any human construct he could see how well or how badly it had been designed, could discuss how it might or might not be improved. He

had visited the Hunterian Museum and, by looking hard at Whistler's portraits, including the unfinished ones, had seen how to build up a painting with strong immediate strokes. Alan made sure the surface of every painting he completed was covered by brush strokes applied in the same spell of rapid work. If the picture did not finally satisfy he might destroy it, but generally used it as an underpainting and sketch for an improved version he painted on top, so that only his fresh new strokes were visible. From reproductions in books and magazines he learned from contemporary artists most of us had never heard of – De Staël, Dubuffet, Giacometti. He could talk easily to anyone, look with interest on everything, but ignored all that was useless to his own vision, his own active soul or self. He enjoyed companionship which many were willing to offer, because being with him felt like an adventure.

On leaving the first two years' General Course Alan, like me, had made the Painting Department his first

choice and like me was rejected, so he specialized in his second choice, which was sculpture. This did not stop him painting, usually at night, so he sometimes arrived hours late at the Art School, without my useful excuse of ill health. The sculpture teachers must have accepted this because they knew he worked hard at his art and foresaw posterity would ridicule them if they expelled him for poor timekeeping. The rest of this chapter shows some of his work since very few people now know it. This terracotta head, portraying an art school model, shows his mastery of both portraiture and the material he used. The hair was rendered by grooving the soft clay curls with a table fork. He shaped the pedestal by turning it on a potter's wheel, making its substance continuous with the neck before baking the whole to hardness. Only a master of sculpture *and* the potter's art could have achieved this. Viewed straight from behind, this head also proves the mastery of his eye and hand. The only flesh visible is a hint of earlobe and nape of the neck, so the mass of natural-looking curls hide the shape of the skull yet still indicate it, so what inferior sculptors would make a featureless mass is still a lively portrait.

If more than a few inches high, clay heads and figures are supported from within by a wooden or metal skeleton called the armature. Two of Alan's figurative sculptures were inspired by the sight of bodies in Grove Street Municipal Swimming Baths near his home in the Cowcaddens, which he had visited from his school days onward. He welded the armature of these figures himself, leaving it visible as the underwater hunter's spear, and as the diving board's support frame, which is also the sculpture's pedestal. This open use of something essential but normally kept hidden is a sign of unusual creative intelligence. Alan's was recognized by the head of the sculpture department, Benno Schotz, who came to employ

Mary, Alan Fletcher, 1956, terracotta head with pedestal

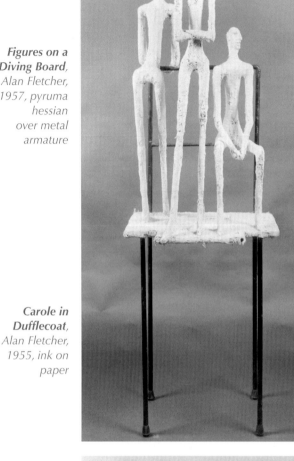

Figures on a Diving Board, *Alan Fletcher, 1957, pyruma hessian over metal armature*

Carole in Dufflecoat, *Alan Fletcher, 1955, ink on paper*

him as an assistant when carrying out his private commissions. Benno's early sculptures, and usually his best, were portraits in bronze. It was late in life he came to work with welded iron, and his speech at the opening of Alan's Retrospective Exhibition told how crucial Alan's help had been with the Crucifixion commissioned for a Catholic church in Glenrothes. Working in the studio attached to Benno's home in Kirklee, Alan suggested the instruments of the Passion – nails, hammer, pincers, spear, crown of thorns etc – should be made of welded iron, persuaded Benno to buy welding equipment, and helped him use it. "Visiting our home, as he did," said Benno, "Alan endeared himself to my wife and my son, and became like one of the family. I remember saying to him, 'Alan, I feel that you are like a son to me,' and he replied, 'Yes Mr Schotz, and I feel I am like a father to you.'" This story proves both Alan's sharp wit and Benno's unusual honesty.

Alan's intelligence could master any visual art form. Grove Street Municipal Swimming Baths gave him ideas for a film that, shortly before his death, he was discussing with Louise Annand of the Scottish Educational Film Association. In the Textiles Department he made silkscreen prints or *serographs*, as the Americans call them, one of which was shown at an international serograph show in New York. On finding that the Textile Department was throwing out nearly full tins of printers' ink because they had grown too dry, he cheerfully retrieved them. Still a dedicated painter, he could seldom afford the good quality oil paints he would have preferred, and by moistening the inks with oil managed to paint with them on whatever panels he found when unable to buy canvas. His still life *Oil Lamp with Cup and Saucer* on a wooden table top, *Screaming Man* on the vertically cracked back of a plywood breadboard, made the surface RIGHT for the subject painted there.

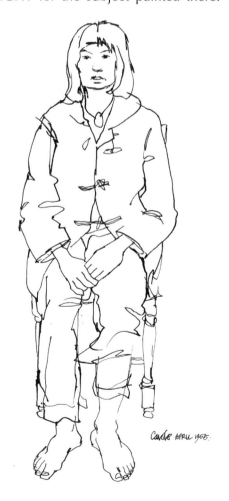

Underwater Hunter, *Alan Fletcher, circa 1957, metal and plaster*

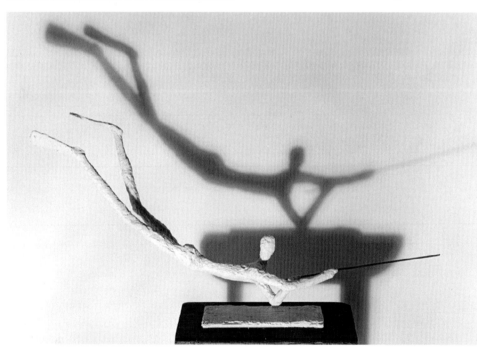

What follows here are a few memories of him.

I sat in his kitchen once when Alan was painting and pigeons on the windowsill croodle-crooing. Mr Fletcher, in bed as usual when not at work, remarked that someone had written that pigeons sang to aid their digestions. I said that opinion was typical of folk who thought it was scientific to give a simple, almost mechanical explanation of something alive and complex; I believed birds sang for the same reasons people did. At this Alan murmured, "You mean, for money?" I had meant that birds sang to know themselves by making themselves known to others, but Alan's short question showed even this idea was too simple. In those days old working-class districts of Glasgow like

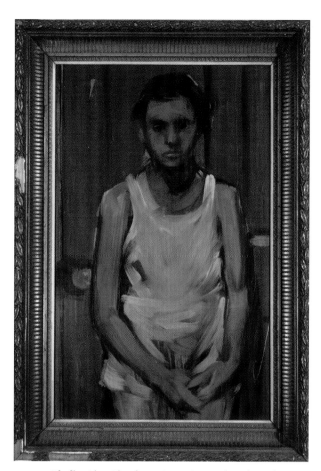

Phylis, Alan Fletcher, circa 1956, oil on board

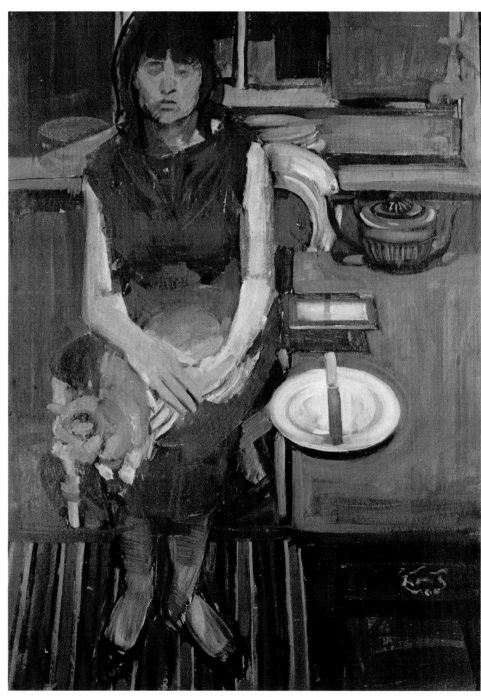

Carole and Ginger in Alan's Kitchen,
Alan Fletcher, circa 1956, oil on board

Carole Gibbons, *Alan Fletcher, circa 1956,
silkscreen print*

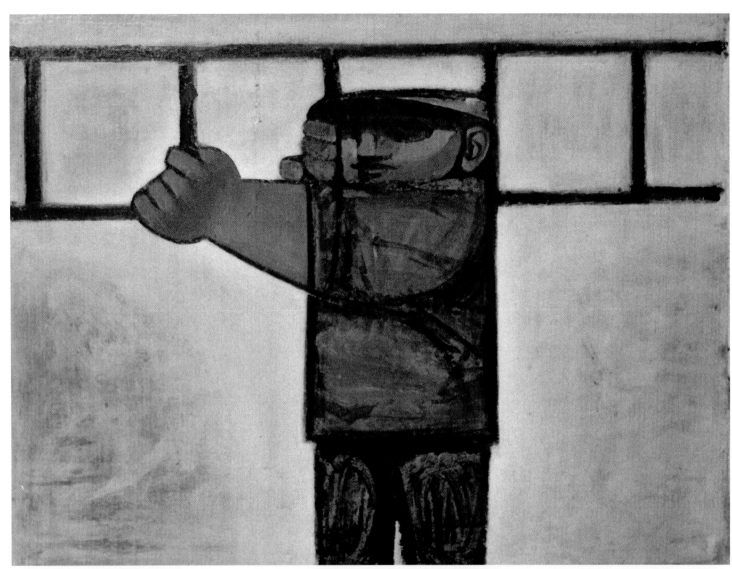

Man with Ladder, *Alan Fletcher, oil on board*

Sheep's Head, *Alan Fletcher, oil on board*

the Cowcaddens had small cheap shops that could legally stay open after 5.30 in the afternoon because only the owners worked in them. (This was under a law passed around 1900 to prevent shop assistants being exploited by employers, a law abolished by a Tory government in the 1970s.) Alan knew many small shops over Glasgow that sold second-hand goods and liked collecting old oil lamps because their shapes pleased him, and they appeared in several of his still lives. After dark one warm summer evening, two hurricane lamps gave him an idea for an expedition. He led Carole Gibbons, Douglas Abercrombie and me to a shop where we bought paraffin for the lamps, then left the Cowcaddens by climbing a steep street (which no longer exists) to Port Dundas. After crossing the canal by an old wooden bridge we lit the lamps and entered a great wasteland between a railway marshalling yard and Sighthill cemetery. It was a terrible, wonderful place. A range of steep high slag bings left by extinct industries surrounded a large pond filled with effluent from a nearby Imperial Chemical factory, formerly owned by Tennent's. Local children called the steepest, highest bing Jack's Mountain; the pond had a greenish-yellow scum on top, stank of sulphur and they called it the Stinky Ocean. The

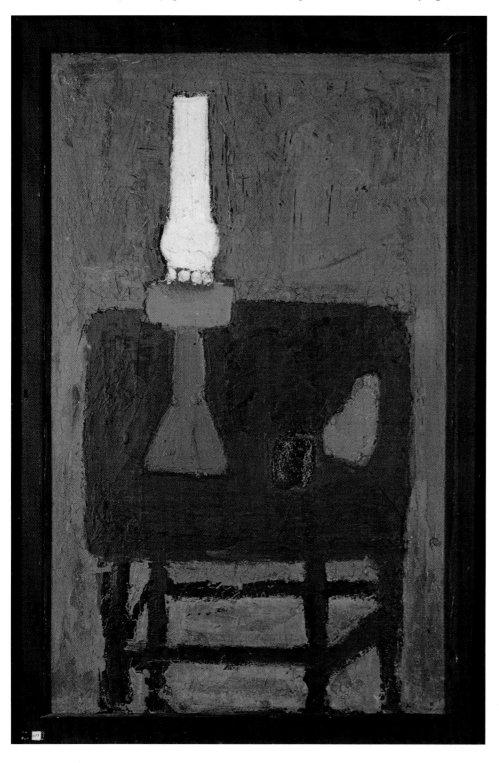

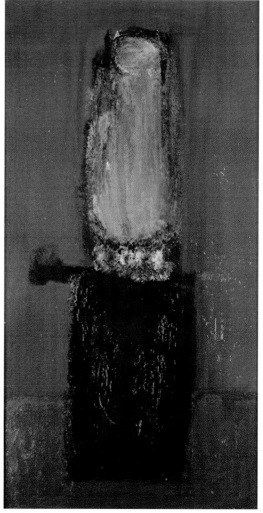

Lamp on Table,
Alan Fletcher,
mixed media on
board

Oil Lamp
with Red
Background,
Alan Fletcher,
oil on board

railway line to Edinburgh skirted the south side of it. A steep-sided bing on the north had a flattened summit broad enough to have the goals of a football field at each end. Down the side into the Stinky Ocean was a static avalanche of concrete rubble where a forgotten contractor had dumped the remains of Second World War air-raid shelters. I had never seen such a huge, majestically ugly landscape, even by daylight. By lamplight it intoxicated us. We chased each other childishly around it, laughing and hooting like owls. It became, like the canal, part of my biggest later paintings. When Bob Kitts next visited Glasgow I took him round it. He was now studying film-making at the Slade, and to graduate made a documentary about city life from dawn to dusk, and to make it of more widespread interest, blended shots of public places in both London and Glasgow. Jack's Mountain was in a wasteland part of it, and near the end Alan, Carole Gibbons and other friends are shown leaving the tenement where he lived after dark to take part in a cheerful night life.

Despite Alan's highly strong character, none of his close friends became disciples, trying to act or work like him. His example helped us grow more like *our* selves. He would discuss artistic ideas with anyone, but those who knew him best, Douglas Abercrombie, Carole Gibbons, the cartoonist John Glashan, went on to become very different artists. He thought I overworked my pictures, sketching them quickly and competently, but spending hours changing colours and readjusting details. When the picture seemed near completion I would sometimes stop and begin it again. I

Seated Nude,
Alan Fletcher,
circa 1956,
red and black
conte pastel

Alasdair Gray,
Alan Fletcher,
circa 1956, oil
on board

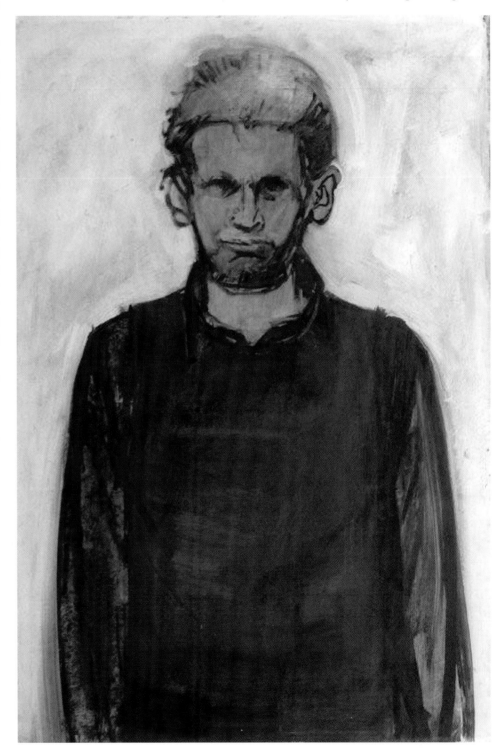

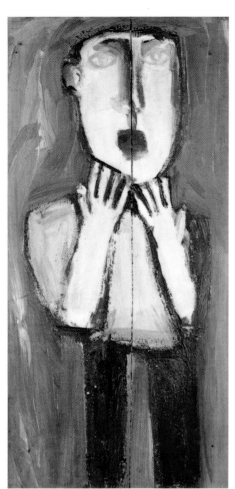

could not paint as fast and freely as Alan, though some of my best work and several of my happiest moments have been when doing so. Had I been accepted by the Art School Painting Department I might have more readily achieved this freedom, but working on large mural areas required more complex ideas, if the painting was to be more than a pleasantly coloured pattern. And maybe my working-class inheritance inclined me to think a painting should use all the new ideas and improvements that occurred to me as I worked on it. Picasso's picture *Les Demoiselles d'Avignon* is famous because, having painted three out of five nude women in a Neo-Egyptian style, he

was so impressed by Sub-Saharan African sculptures that the last two pictures are in his newly discovered and deliberately crude early Cubist style. In the last four or five years of Alan's short, mature working life he also evolved new ideas and ensured the transitions happened between one work and the next, which after *Les Demoiselles d'Avignon* was also Picasso's practice. Within the rectangle of a composition I often struggled for days to make new ideas harmonize with the earliest. I have since taken years or decades to finish some pictures, having time to do so because nobody wanted them.

Page 53
1954–58

Screaming Man, *Alan Fletcher, oil on bread board*

Nude on a Chair, *Alan Fletcher, circa 1956, silkscreen print*

Oil Lamp with Cup and Saucer, *Alan Fletcher, circa 1955, oil on wooden tabletop*

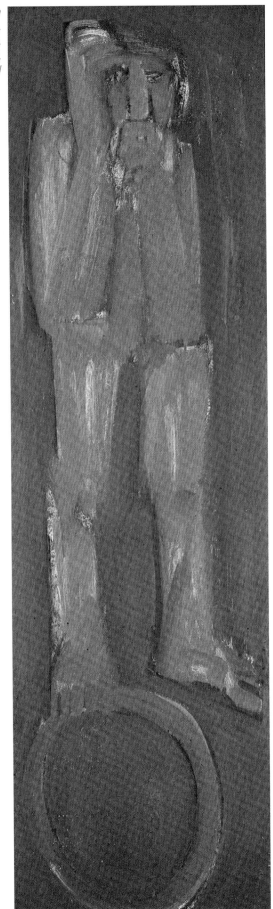

Man with Wheel series, Alan Fletcher, circa 1957, oil on board

grooved paint on a breadboard

silkscreen on paper

blue and white paint on cardboard

Seven: Later Art School, 1954–57

THE MURAL DEPARTMENT studio was lit by the huge north-facing windows Mackintosh had designed for us, and entered from the long corridor we called *the hen run* with southern windows overlooking the roof of the Regal Cinema and Sauchiehall Street. My asthma got me the privilege of reaching the School's topmost floor by a lift normally reserved for the staff. The mural teacher was Walter Pritchard, thin, pleasant and not despotic. He began by telling new students that mural painting was mainly a matter of painting bigger than was usual nowadays, but wall painting was the most ancient pictorial art, for it started when Europeans lived in caves. Pictorial decorations on Greek and Roman walls led to Christian artists adapting mosaic mural schemes to cover the walls and ceilings of churches in Byzantium and Ravenna. From about 1200BC such great artists as Cimabue, Duccio, Giotto had painted equally big schemes for north Italian churches in tempera on plaster. They and their successors also made smaller religious paintings on moveable panels for private houses and chapels, but the great mural tradition was continued by Michelangelo, Tintoretto and Tiepolo into the 17th century, and its last great representative was Delacroix, who painted the history of western civilization on the ceiling of the Bibliothèque du Palais Bourbon in Paris. By then the discovery of painting in oil colour had allowed pictures on canvas to be made which were not commissioned as parts of great public buildings, but sold and bought as private properties.

Mr Pritchard did not go on to say how a class of professional dealers had arisen who worked as middle men between professional artists and wealthy purchasers, and how geniuses like Rembrandt and Cézanne seldom found them helpful. He said enough to show the dignity of mural pictures, asked us to choose a reproduction of one we liked and copy it, or a detail of it, on the same size as the original though not necessarily in the same medium. I chose a medieval panel painting of Saint George on horseback spearing a dragon, all in flat colours clearly outlined against a red background. With great pleasure I painted it in gouache on paper. Then Mr Pritchard told me I could now paint, on any size of panel I wanted, whatever I liked. On a panel six feet high by three broad I began painting Adam and Eve with the Tree of Knowledge of Good and Evil between them, a subject I probably chose because 1) it was highly ambitious; 2) It contained nude figures; 3) Many artists had tackled it; 4) I loved Durer's version so wanted to make my own; 5) I was obsessed with the bond between man, woman and knowledge, being unable to gain carnal knowledge of women who attracted me, and unwilling to try with prostitutes. My novelty was to make the Tree and its branches the body and arms of Lilith, Adam's first wife who did something so bad that God gave him Eve instead. This Hebrew tradition is not in the Authorized Bible, but some Christians accepted enough of it to identify Lilith with Satan, which is why Michelangelo painted the Serpent on the Sistine ceiling as a thick python below the waist and a woman above it, handing the fruit from the Tree to Eve. I revized and revized this panel for weeks, unable to make it come right until Mr Pritchard, in a quiet but determined voice, told me to finish it in a week and start something new. I said (morosely) that I would try to do so, then a cheerful inspiration made me happily add, "If a new idea for finishing it arrives, sir, I won't be able to reject

Design for Stained Glass Panel, 1954, Indian ink and gouache on cardboard, 42 x 30 cm

it because if I did God might not send me more." Mr Pritchard was a Catholic convert who maybe knew I was not a churchgoer and thought I mocked him, but I was sincere, having learned from William Blake that God in men is the creative imagination. But Mr Pritchard was right to try getting me away from that panel, which I never completed. He was right because the theme of carnal knowledge between man and woman was too ambitious for a nineteen-year-old sexually frustrated adolescent to resolve. If Mr Pritchard had begun by asking me to paint a panel for a café, workers' canteen or doctor's waiting room I would have likely and swiftly produced a colourful, decorative panel that would have pleased both of us, but he had given no limiting context for the panel, and my apparent refusal of his advice made him unwilling to have me in his class. On learning that I now shared an attic studio in a tenement not far from the School, he got permission for me to work there during the day from the registrar, Mr Barnes, so I need only visit the School for classes in drawing and craft work, and to meet friends socially. So the only painting I finished in the mural department studio was a design for a stained glass panel.

Sadie McLellan, Mr Pritchard's wife, taught stained glass there as a subsidiary subject. She was then probably the best Scottish professional artist working in that medium.

The attic flat was in Royal Terrace overlooking Kelvingrove Park, and was rented by Nicky Gill, a painting department student, and his brother Mike who was studying jewellery. One room was large enough for a studio where four people could work together without intruding on each other, so they allowed Malcolm Hood and me to share it for a few shillings a week. To a blank wall I tacked a sheet of cartridge

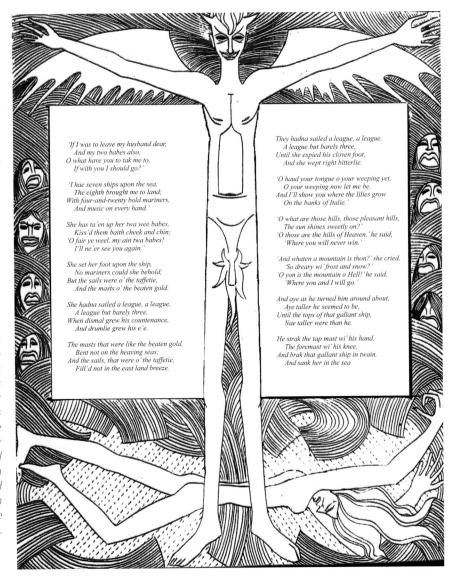

The Demon Lover (Border Ballad Illustrations), 1953, scraperboard, 30 x 21 cm

The Lyke-Wake Dirge (Border Ballad Illustrations), 1953, scraperboard, 30 x 21 cm

Drawn white on black scraperboard, with verses cut out from a book & stuck on top. The lost originals survive as photographic negatives which are most clearly reproduced in white on black, instead of black on white as in the originals.

'If I was to leave my husband dear,
And my two babes also,
O what have you to tak me to,
If with you I should go?'

'I hae seven ships upon the sea,
The eighth brought me to land;
With four-and-twenty bold mariners,
And music on every hand.'

She has ta'en up her twa wee babes,
Kiss'd them baith cheek and chin;
'O fair ye weel, my ain twa babes!
I'll ne'er see you again.'

She set her foot upon the ship,
No mariners could she behold;
But the sails were o' the taffetie,
And the masts o' the beaten gold.

She hadna sailed a league, a league,
A league but barely three,
When dismal grew his countenance,
And drumlie grew his e'e.

The masts that were like the beaten gold,
Bent not on the heaving seas;
And the sails, that were o' the taffetie,
Fill'd not in the east land breeze.

They hadna sailed a league, a league,
A league but barely three,
Until she espied his cloven foot,
And she wept right bitterlie.

'O haud your tongue o your weeping yet,
O your weeping now let me be,
And I'll show you where the lilies grow
On the banks of Italie.'

'O what are those hills, those pleasant hills,
The sun shines sweetly on?'
'O those are the hills of Heaven,' he said,
'Where you will never win.'

'And whaten a mountain is thon?' she cried,
'So dreary wi' frost and snow?'
'O yon is the mountain o Hell!' he said,
'Where you and I will go.'

And aye as he turned him around about,
Aye taller he seemed to be,
Until the tops of that gallant ship,
Nae taller were than he.

He strak the tap mast wi' his hand,
The foremast wi' his knee,
And brak that gallant ship in twain,
And sank her in the sea

paper four feet high and the length of the wall, about twenty feet, and started sketching on it a frieze of the Monkland Canal, which was both the largest, most exciting and the most neglected work of architecture I knew. The section I dealt with stayed level by winding round the hillsides between Pinkston Power Station (which supplied Glasgow trams and underground railway) and the aqueduct over the River Kelvin. It linked tenements, bonded warehouses, old factories, timber yards with basins where squared-off sections of tree floated, a school, a 1930s council estate with allotments, an iron foundry and Firhill football park. My task was to combine forms of these taken from sketches into a pattern, using a map of the district as a guide, so that looking along the frieze from one end to the other would suggest the adventure of travelling along the towpath. I was trying to do on a big scale what Picasso and Braque had done in their Cubist phase, when they combined many views of a still life, portrait head or landscape into single canvases. To do the same thing on a much bigger scale I needed an exact web of construction lines before starting to apply colour. This web was so hard to achieve that my revisions turned into an impossible, tiresome tangle. By this time Alan Fletcher had introduced me to Jack's Mountain and the Stinky Ocean. I tore the frieze down, tacked to the wall a canvas roughly seven feet high by twelve broad and sketched the Ocean and Mountain in the centre with Sighthill Cemetery and Pinkston Power Station behind, and in the foreground the heads and upper bodies of friends, Mike Gill and his fiancée Maureen Howden. This also became too difficult. Before the third year ended the only work I had finished was mainly scraperboard illustrations to various legends.

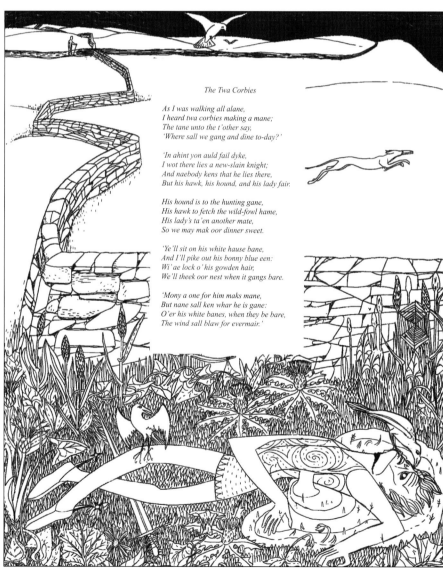

The Twa Corbies

As I was walking all alane,
I heard twa corbies making a mane;
The tane unto the t'other say,
'Where sall we gang and dine to-day?'

'In ahint yon auld fail dyke,
I wot there lies a new-slain knight;
And naebody kens that he lies there,
But his hawk, his hound, and his lady fair.

His hound is to the hunting gane,
His hawk to fetch the wild-fowl hame,
His lady's ta'en another mate,
So we may mak oor dinner sweet.

'Ye'll sit on his white hause bane,
And I'll pike out his bonny blue een:
Wi' ae lock o' his gowden hair,
We'll theek oor nest when it gangs bare.

'Mony a one for him maks mane,
But nane sall ken whar he is gane:
O'er his white banes, when they be bare,
The wind sall blaw for evermair.'

Fine Flowers in the Valley (Border Ballad Illustrations), *1953, scraperboard, 30 x 21 cm*

Twa Corbies (Border Ballad Illustrations), *1953, scraperboard, 30 x 21 cm*

Page 58

*Later
Art School*

**I Think This
Life Must Be A
Cancer of the
Clay (Hospital
Version)**, 1955,
*ballpoint pen
and coloured
ink on paper,
30 x 21 cm*

As an organizer of the literary society I was still part of the Art School's social life, and for a party given by Henry Hellier's Interior Design Department, where I had several friends, wrote an allegorical play called *To Hell with Everything*, which may have avoided being terribly dreary because it was also very short. The actors representing Everyman, War, Peace, Art and Science were student friends who wore their usual clothes, but as a background I

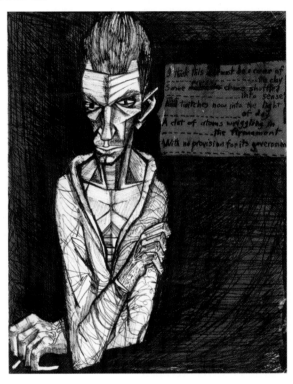

sketched them nearly six feet high and symbolically, with a brush dipped in black ink on big sheets of rough paper. War is the only figure I remember now, a murderous-looking ape-man clutching a stone in his fist. When the play ended I was tearing these down when Walter Pritchard came to me saying, "Keep them! Keep them! They're something you can show to the examiners at your Diploma Show!" He did not see why I could not take seriously things I made casually, without thought or effort, yet for some reason still respected me as an artist. So did Mr Barnes and the Art School director Percy Bliss. They proved it by offering me a real mural commission.

Glasgow had a Scottish–USSR Friendship Society financed by the Scottish Communist Party and (no doubt) Moscow gold, with a staff of three and offices in a fine terrace house in Belmont Crescent, Hillhead. George McAlister, the Society's secretary, contacted Mr Bliss saying they would like a mural decoration in their public meeting room, could pay for paints and other necessary materials, but could not afford to pay for an artist's work. Did the School have a student able and willing to undertake the job? It was offered to me. Perhaps a contributing reason was that most students in the small mural

department were Catholics who would have disliked serving a Society friendly to Soviet Russia.

The house in Belmont Crescent had been a usual pattern of Victorian family residence with servants' quarters in the basement, and on the ground floor a front and back room, once a sitting and dining room with a double door in the wall between. Both had been turned into one meeting room by piercing that partition with a big rectangular arch. I decided to decorate the smaller back area with horrors of war mural designs, and the front with designs showing the satisfactions of peace. The idea was accepted. After the Art School's summer holidays I would start my fourth year by working on the war areas.

My failure to paint anything worthwhile in my third Art School year was partly caused by failure to get as close as I wanted to a woman I liked. This book is not an autobiography despite personal details given to explain how and why, at different times, I came to make certain pictures in a certain way. Sexual frustration and ill health that seemed part of it was much of my life in those days. They must have coloured my view of life and also my art. I was no longer a very lonely soul with hardly any social life. As in any large institution, Art School

*Hospital
Sketch I &
II*, 1956,
*watercolour
and ballpoint
pen on paper,
21 x 30 cm*

folk naturally divided themselves into cliques, and I was accepted by several who had hardly anything to do with each other. I was welcomed when visiting the Departments of Industrial Design, Interior Design and Sculpture, was friendly with teachers and students elsewhere while belonging to Alan Fletcher's social group, but attractive and friendly girls started avoiding me when they saw I wanted more than conversation with them. Sexual dalliance should start as a friendly game. I could not help taking it very seriously. I expected to marry the first satisfying sexual partner I found, while at the same time doubting my ability to satisfy anyone. When not drawing or painting I was also physically clumsy. Intellectual self-confidence stopped me ever thinking my appearance was important, and though I regularly washed and bathed, my appearance may have been shabby. Since my mother's death nobody had spoken to me about it and I never bought clothes. When women friends of my Aunt Annie became widows she acquired for me their husbands' suits and coats, which seemed to fit and were certainly conventional. On asking Douglas Abercrombie's opinion of a pale grey pinstriped suit in which I felt unusually smart he said (fingering the lapel) "Very

good! The cloth alone must have cost two shillings a half mile." Of course anything I wore for long acquired paint stains, which is inevitable among art students, despite which many I admired looked neat and fashionable. And the realization that one special girl would never be more than my interested friend provoked an enraged horror culminating in what the Gray family doctor called *stasis asthmaticus* when summoning an ambulance that took me to Stobhill Hospital, where I spent most of my summer holidays.

While there I wrote and illustrated verses about the indifference of the universe to the minds it contained, selfishly ignoring it had taken the trouble to produce me, the nurses, doctors and hospital which, through the British Welfare State, were doing their best to care for and cure me. The illustrations led to my ward's consultant referring me to a psychiatrist with whom I had many unhelpful conversations, and the poems (which I called *Statements by the Unceilinged Blood*) were illustrated more successfully fifteen years later. This was the first and longest of four spells in hospital with asthma during which I sketched nurses and patients with a view to making a large painting of a ward interior. Not many of these survive. I was discharged by Stobhill

Hospital in a state much the same as when I entered. Greatly fearing that the illness might prevent work on the war mural, I made my wheezy way to the Art School and registered for my fourth year before the term started, met Alan Fletcher and other friends who were also registering and accompanied them to a pub, then to a party, during which my breathing difficulties disappeared until the following summer.

I decided to outline my designs in

Corruption is the Roman Whore (Hospital Version), 1955, ballpoint pen and coloured ink on paper, 30 x 21 cm

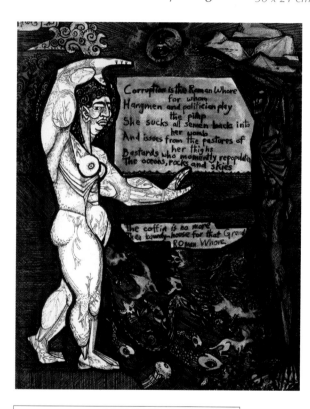

Nurse's Head, 1956, ballpoint on paper, 19.5 x 25.5 cm

Hospital Patient, 1956, ballpoint on paper, 19.5 x 25.5 cm

Young Nurse's Head, 1956, ballpoint on paper, 19.5 x 25.5 cm

black ink, using a newly invented steel fountain pen with a felt tip called a *Flowmaster*, though some lines were painted with a fine brush dipped in Indian ink. I intended to fill the shapes in with tinted emulsion paint and thin washes of oil colour, and on the east wall with the square arch that is what I mainly did. Here the small design for it frames a photograph of the wall as it was finally painted. The grotesques at the top showed my dread of how nuclear war would distort humanity, and were partly

suggested by malformed embryos in the university medical museum, partly by Francis Bacon's paintings, seen the year before at the Venice Biennale. I remembered them as lumps of raw meat with screaming mouths and legs like chickens, and hated them, though they were the only part of that international show I remembered. The figures on each side with folded arms represented soldiers blinded and crippled by defensive armour. When working on the wall I used only three of the grotesques

and, having painted in the military figures, found them too oppressive, and disgusted Mr Pritchard by painting them out and replaced them with imitation brickwork. I now agree with him in thinking I should have left them.

On the long north wall with the fireplace I drew a Glasgow landscape with (yes!) the Stinky Ocean, Jack's Mountain, the Sighthill Cemetery, Pinkston Power Station, various factories and tenements in the area tied together by railway lines at the foot and the canal

Horrors of War (for Scotland–USSR Friendship Society), East Wall, 1955–7, photograph of mural with preliminary sketch done in 1954 in gouache and pen on board (sketch), 39.5 x 48 cm

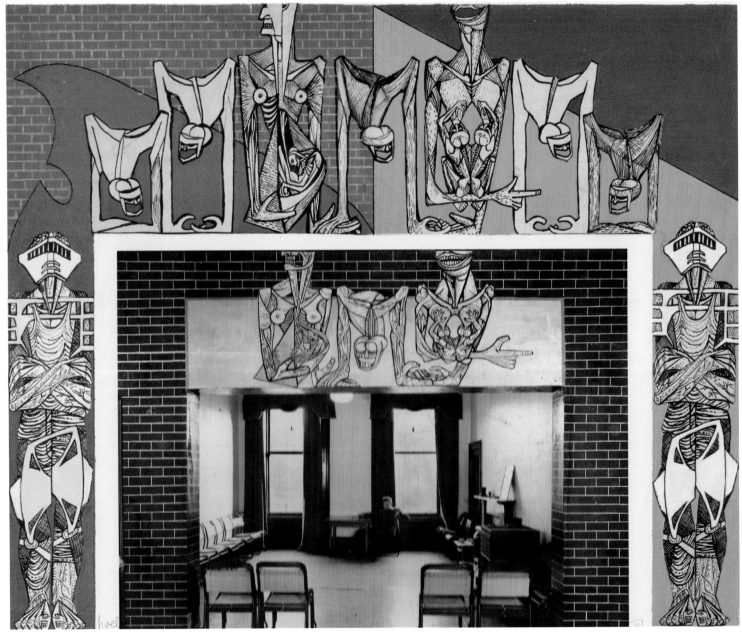

at the top. I meant this to be my version of Brueghel's *Triumph of Death* landscape and Dürer's *Apocalypse* woodcuts, but without showing physical horrors I had never personally seen. The Bible's last book, the apocalyptic *Revelations*, has a star called Wormwood flung into the sea that poisons the world's waters. This struck me as a prophecy of nuclear warfare, so I had a flaming body falling into the Stinky Ocean and crowds of people around it fleeing into underground shelters. In the foreground

I had various folk from the waist up in a state of dread, but showing protective feeling for each other. Above the door of a cupboard to the right of the wall I drew an eyeless spike-brained mutant threatening those below him. I wish I had finally coloured this wall as I had planned, as a two-dimensional design with hardly any feeling of depth. But as weeks passed this flat tapestry of places I had walked through started oppressing me, so I began work on the wall facing, putting a modern crucifixion in the

centre with a deeper landscape and much lower horizon in the distance.

Grünewald's treatment of this in his grand Colmar poliptych still seems to me the truest, most disturbing picture of the horrible way Romans used to execute folk. Most other Christian painters have made the cross an excellent piece of smooth carpentry, the horizontal bar neatly dovetailed into the vertical, but not the Colmar crucifixion. When the Art School's General Course asked for a religious subject of our own choice I had

Horrors of War (for Scotland–USSR Friendship Society), South Wall, 1955–57, mural on south wall

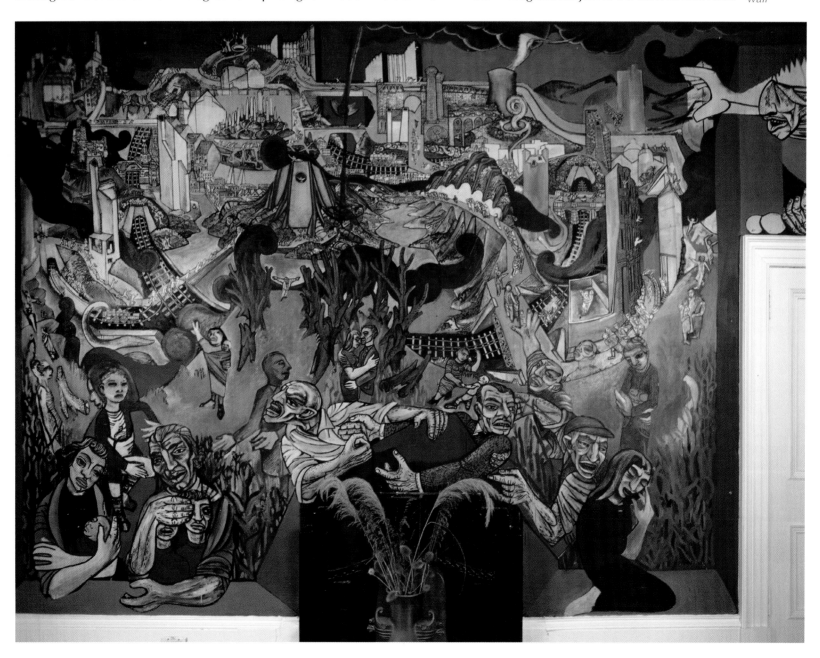

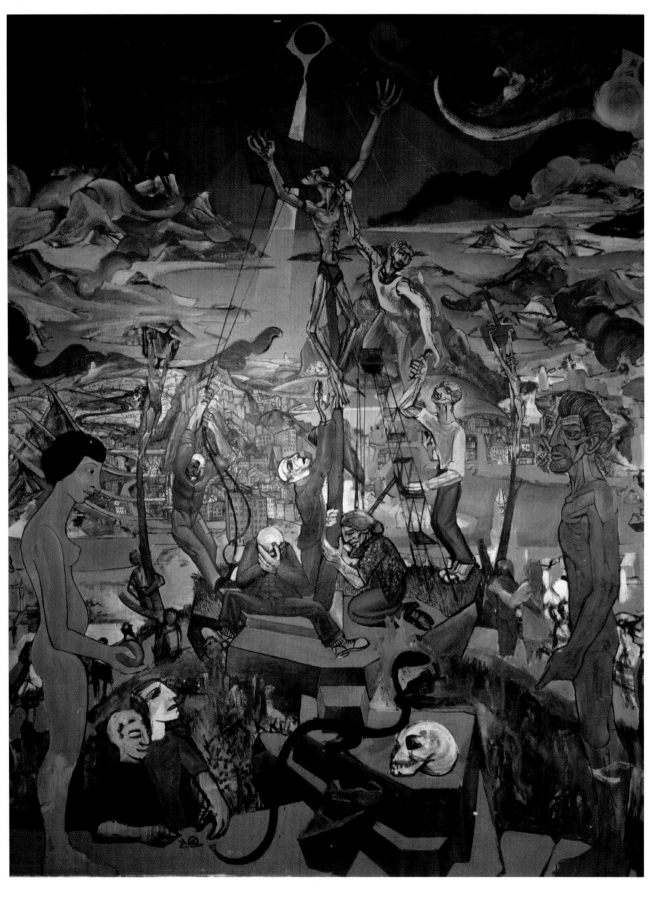

***Horrors of War (for
Scotland–USSR Friendship
Society), North Wall****, 1955–7,
mural on north wall*

painted a crucifixion
in modern dress with
Grünewald's in mind.
He shows the strong
vertical upright timber
with the cross-piece a
more slender tree trunk,
circular in section except
where parts had been
planed flat to let the
cross-piece be fixed to
the upright and Christ's
hands be nailed there,
so the weight of Christ's
terribly dead body drags
the cross-piece slightly
down at each end.
My cross-piece was
two short planks like a
noticeboard, fixed to an
upright like a telegraph
pole, but thin enough to
be bent slightly by the
weight of the planks and
the body being nailed
to them. People were
nailed to crosses flat
on the ground before
being raised upright. My
Jesus, held up by ropes
suspending him from
the noticeboard, had
a private soldier on a
kitchen stepladder who
had nailed on one hand
and was about to tackle
the other. This unlikely
crucifixion method was
dramatic enough to look
pictorially convincing. I
redrew this composition

in the middle of the wall much larger than the original painting in gouache (which was eventually lost) with a skull in the foreground, since the site of execution was called Golgotha, meaning *the place of the skull*. With silver and gold enamel I painted Eve and Adam on each side, wanting to show the beginnings and end of as much as I could. I knew of Mantegna's *Story of the Cross* paintings which indicate that the wood of the crucifix had once been the Tree of Life and/or Tree of Knowledge in the Garden of Eden. I showed the serpent between them had legs and hands, having not yet been cursed to travel on his belly.

While working to blend all these elements with a deep view of towns, mountains and a sea beyond them, seen by light still radiating from an eclipsed sun overhead, it became clear that I would never finish this part of my mural by the end of my fourth year. So giving my poor health as the main reason, Mr Bliss and Barnes and Pritchard allowed me a fifth year.

Alas, the war mural never was satisfactorily completed, though near the end of my fifth year it had an official opening ceremony. Mr Bliss tried to draw public attention to the mural by asking his friend Alex Cairncross, economic adviser of the British Treasury, to make a speech on the occasion. In the photograph of me between the two a cavity can be seen in brickwork at the foot of the cross, with the upper part of the Golgotha skull in it. The skull is open at the side showing the head of a foetus. Leonardo's drawing of a sectioned womb and skull had suggested that the foetus in the first would fit neatly into the cavity of the second, uniting our end and origin in an image I have often used. The opening was not reported by radio, TV or newspaper. The early morning edition of the *Glasgow Herald* mentioned the mural but eliminated it from later editions. Nor did governors of the Art

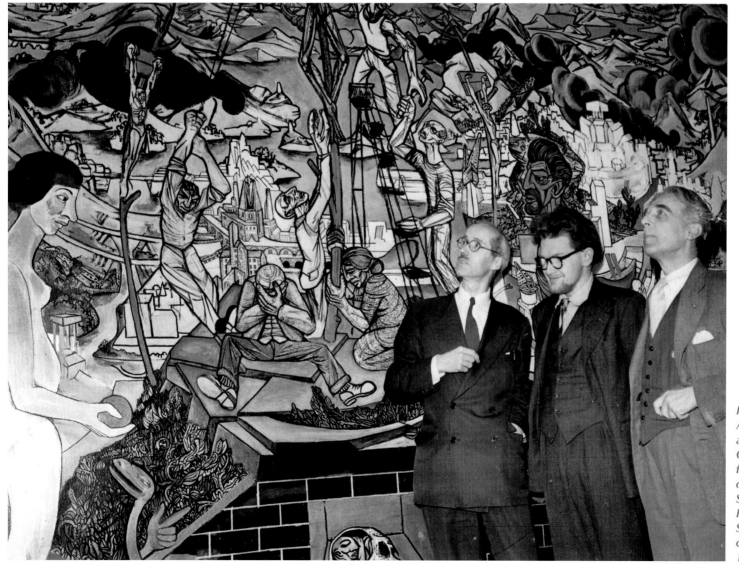

Percy Bliss, Alasdair Gray and Professor Cairncross in front of Horrors of War (for Scotland–USSR Friendship Society), crucifixion wall, 12 June 1957

*Ygorra, Alan
Fletcher, 1956,
magazine cover,
30 x 21 cm*

*Ygorra, (Spread
of Ian Nicol),
1956, pen and
ink, 30 x 21 cm*

A few words
to explain the Spread
of
IAN NICOL

ONE DAY IAN NICOL, A RIVETER BY TRADE, began to split in two, down the middle. The process started as a small bald patch on the back of his head. For a week he kept smearing this with hair restorer, but the surface became curiously puckered and so unpleasant to look upon that, at last, he went to a doctor.

" What is it? " he asked.

The doctor looked closely.

" I don't know," he said, " but it looks like a face, ha-ha! Eating well? "

" Enough for two men, doctor."

" H-mm . . . Any pains? . . . Headaches? "

" I actually do wake up at night, doctor, with splitting headaches."

The doctor tapped Ian all over with a stethoscope and said, " I'm going to have you X-rayed, and I may have to call in a specialist."

Ian visited the doctor two days later and found the specialist examining X-ray plates.

" No doubt about it, Nicol," said the specialist, " you are splitting in two down the middle."

Ian thought about this.

" Does it often happen? " he asked.

" It happens more than you might suppose. Among viruses and bacteria it is very common, but this is the first authentic case of it happening to a riveter. I'm afraid you'll have to go into hospital."

In hospital Ian was put to bed in a special ward. For three weeks he did nothing but eat furiously until he had absorbed (it was calculated) 47 times his normal bulk. Then he sank into a sort of coma which lasted until the division was complete. The bald patch on his head was now a definite face. The lobes of his brain separated and a shutter of bone formed between them. His spine twinned itself convulsively.

26

*Daft Friday
Decoration,
1956,
photograph*

School attend the meeting, though they were invited. What newspapers called *The Cold War* was at its height. A few months earlier the Soviet Union had invaded Hungary and crushed its independent government while Britain, France and Israel were invading Egypt without declaring war in order to seize the Suez Canal. Several years later Professor Cairncross was found to be one of the Soviet spies recruited in 1930s Cambridge along with Philby, McLean and the queen's cousin Anthony Blunt. My friend Elspeth King believes my association with him, the Scottish–USSR Society and (later) the Campaign for Nuclear Disarmament badly affected my later career as an artist. I disagree. Scottish businessmen and local government officials had no interest in commissioning mural paintings from artists, Scottish or otherwise.

My last two Art School years were made happier by Alan Fletcher's friendship. Our diploma shows at the end of our fourth years were judged by external assessors, mostly examiners from English art schools. In 1956 the examiner of sculptures, confronted by a room of Alan's sculptures, had refused to assess or judge it, declaring that he could neither praise it as good nor condemn it as bad, so he too was allowed a fourth year over again. In social demand by many people, he was asked by a medical student to help with the production of *Ygorra*, a Glasgow University student magazine edited and printed once a year and sold on Charities Day. This was an autumn festival when students from most colleges of education dressed up weirdly and paraded the city centre on the open backs of lorries, before spreading through the streets with collecting cans and copies of *Ygorra*, always a facetious production. For two years Alan became acting editor and, by getting cartoons

*An Explanation
of Recent
Changes*, 1957,
pen and ink,
30 x 21 cm

Ygorra, Alan
Fletcher, 1957,
magazine cover,
30 x 21 cm

and articles from people close to him, produced two elegant, more than usually humorous, almost completely Art School editions. Two of my earliest short stories appeared in these, giving me a chance to join illustration with typography, a useful lesson that helped me design the *Unlikely Stories, Mostly* book in 1983.

As a result of the *Ygorra* work the board of the Men's Union got me to decorate the assembly room for their end of term Daft Friday celebration, then the board of the Women's Queen Margaret Union invited me to decorate the ballroom of what is now called the McIntyre Building for their annual dance. I enjoyed painting these decorations fast with brush on canvas, inventing shapes as I did so and never

revising. My improvizations usually had nude women in them. For the Queen Margaret ball I and two others from Art School (Anne Rodgers and Malcolm Hood) had been given sheets of cardboard about four feet by three. Laying a line of them flat on the floor I joined them in a strip a yard wide and slightly higher than the ceiling, outlined a naked giant woman on it, then cut discs and triangles out of silver paper and stuck them on for nipples and pubic hair. After throwing ropes over a beam holding up the coved ceiling I pulled the figure up to it and fixed the base to the wall behind the platform where the band would play. Probably the tallest nude in Britain, it would overhang the dancers. I thought this great fun, and had no intention of shocking anyone.

Though 21 years old I was unusually naïve, so astonished when a member of the board told me she and others wanted my decoration taken down. I threatened to tell the story to newspapers

**Monster
Rally,
Glasgow
Art School
Christmas
Ball
decorations**, *1956,
emulsion
paint on
plaster*

*Left and
centre:
emulsion on
cardboard.
Right:
emulsion on
canvas.*

 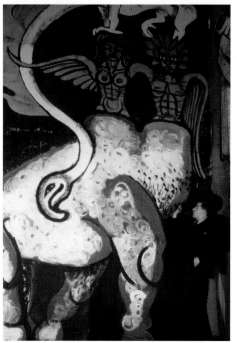

if that happened, but two other board members told me they didn't know what the fuss was about so my big woman stayed for the ball. I forget the names of the objectors, but marriage made my supporters Joanne Semple and Greta Hodgins, who became my life-long

friends. Through them I also became a friend of Andrew Sykes, then a student, who was Strathclyde University's first Professor of Sociology and my only dependable patron. But the biggest decorative scheme was painted in 1956 for the Art School Christmas fancy dress

ball, when Malcolm and I suggested *Monster Rally* for a theme and carried it out in the assembly hall. Afterwards I selfishly had only my own decorations photographed.

Most students spent the last few months of their final Art School year

preparing an exhibition of their work to show the visiting assessors how good they were. Mr Pritchard had asked his students, as a subject for this show, to paint a mural decoration for the dining room of a luxury liner, a kind of ship Glasgow was still famous for building. Since the assessor would be taken to see my war mural in Belmont Crescent I

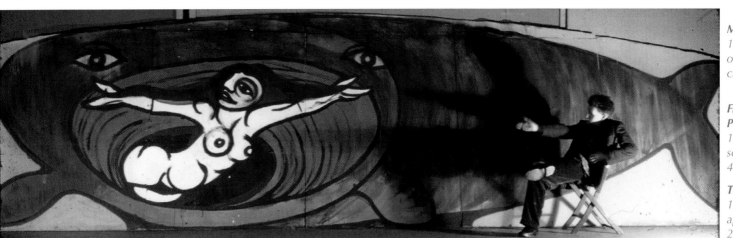

Monster Rally,
*1956, emulsion
on plaster and
canvas*

*From the Soul's
Proper Loneliness*,
*1955, verse on
scraperboard,
42 x 30 cm*

That Man is a Fool,
*1956, lithograph,
approx.
20 x 20 cm*

From the soul's proper loneliness love and affection seem
Part substance and part dream
Held in the mouth in that some way the snake carries its eggs
If gripped too hard they break
Leaving a few small grains of bitter dust
And a heart crippled by its weight of lust

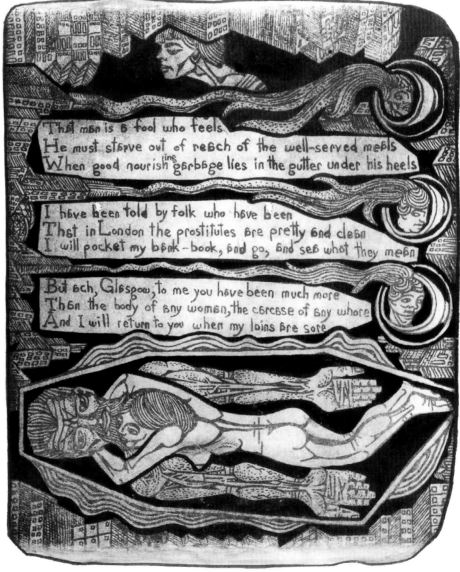

That man is a fool who feels
He must starve out of reach of the well-served meals
When good nourishing garbage lies in the gutter under his heels

I have been told by folk who have been
That in London the prostitutes are pretty and clean
I will pocket my bank-book, and go, and see what they mean

But och, Glasgow, to me you have been much more
Than the body of any woman, the carcase of any whore
And I will return to you when my loins are sore

*Glasgow
School of
Art Diploma
Show, 1957,
gouache
and oil on
hardboard*

thought it more important to work upon that and did so, leaving Mr Pritchard free to think ill health kept me from work in his department. When he discovered what I was doing through a phone call to the Scottish–USSR Friendship Society, he sternly commanded me to return to the Art School on pain of expulsion. On arriving there he and the Registrar, in a private interview in Mr Barnes' office, said I would be expelled at once if I did not paint the luxury liner panel for the diploma show. I at once acquired a panel and in less than a day painted a spritely male bather attacking the fishy end of a mermaid with a knife and fork, against a background of repeat-patterned fishes. That with a few other quick decorations and a number

*Self Pity,
1956, lost oil
painting*

of framed paintings went into the show. The assessor also viewed my still-incomplete war mural. As a result I was awarded a Scottish Education Department Diploma in Design and Mural Painting and the Bellahouston Travelling Scholarship, a grant of money that would enable me to study art overseas. Malcolm Hood, Alan Fletcher

and Douglas Abercrombie also won travelling scholarships.

It is obvious that the Glasgow Art School authorities dealt very kindly with me, and also obvious why they never wanted to employ me as a teacher or colleague. Thus ended five vital years of artistic education, the gift of a Welfare State that had freed me and other students from money worries without putting us in debt. Most graduates left at once for Jordanhill Teachers' Training College. An ambitious minority left for London. I lacked the Certificate in a foreign language that would have let me train as a teacher of children. Anyway I did not want that. Like Mr Micawber I now hoped "something would turn up" that would let me continue as an artist.

Eight: Death & Creation, 1957–61

IN 1957 MY sister Mora was in Aberdeen, studying to be a teacher of physical education at the Dunfermline College there. On deciding his children were now independent a year or two before, Dad had stopped work as a building site clerk and become a hill guide with the Holiday Fellowship, a part-time job that paid him very little money but which he thoroughly enjoyed. It often took him away from Glasgow, but he still paid the 11 Findhorn Street rent so I was not homeless. He had also paid Riddrie Co-op to deliver a pint of milk there daily, and our kitchen cupboards had tins and jars of treacle, macaroni, flour, icing sugar and condiments untouched since Mum had died five years earlier. I steadily consumed them while earning money by gardening once a week for the mother of a friend, and visited my Aunt Annie for occasional meals, though not so often that she suspected I was sometimes hungry. I sold books I did not need, and once pawned our wireless set, hoping to reclaim it before Dad returned. I failed, which depressed him. But I missed almost as much as money the company I had enjoyed at Art School, especially the company of women I had fraternized with over coffees and meals in the refectory, and at entertainments shared with them. There were only two houses where I could depend on finding friendly company: Alan Fletcher's, when he was not working as Benno Schotz's assistant, and Katy Gardiner's, who then lived a few blocks from Findhorn Street, near Riddrie Public Library. I will say more of her later, but she was at home to me almost anytime I called for a talk with coffee and biscuits in her book-lined living room. And she did not mind me drawing her and her daughter Susan.

Photocopying was then so expensive that architects drew their plans on tracing cloth or paper and reproduced them by the dyeline process, which was cheap. I fixed a tracing cloth to the square top of the table on which the Grays dined together. It was the size and shape of the table top, and in Indian ink I drew on it a picture of Faust in his study. On BBC Radio in 1949 I heard a translation by Louis MacNeice of Goethe's *Faust*, and the subject appealed to my imagination as much as the story of Jonah. I chose the moment when Faust contemplates the sign of the Macrocosm, and tried to fill the area with so much fascinating detail that a dyeline print from it would easily sell for a pound or two, though I had paid the printer in shillings. My Macrocosm or big world image was a cranky piece of clockwork powered by

Mother and Daughter: Kate Gardiner and Susan Boyd, 1960, acrylic, pen, ink and wash on paper, 48 x 76 cm

Susan Boyd, Television and Cat, 1960, pencil and watercolour on paper, 18 x 28 cm

*Faust in his
Study, 1958,
dyeline print
from lost original
on tracing cloth,
84 x 82 cm*

the earliest form of James Watt steam engine, whose beam-balance is held up by Jehovah, its boiler heated by a furnace whose front I saw in the boiler room of the Grand Hotel at Charing Cross, when visiting Alan's father there. Faust is an idealized version of me, busily introspecting. A few years later I learned that if dyeline prints are exposed for long to ordinary light, the blacks fade to brown as the white paper darkens. By then the drawing on tracing cloth was lost, and I preserved the design by getting the best surviving dyeline photocopied. Not surprisingly, I had sold only three of them. In those years there was no Scottish art market for the young.

The west of Scotland had no private dealers interested in contemporary local art, and no public gallery curators who

exhibited it. The Royal Glasgow Institute held a big yearly show in the McLellan Galleries on Sauchiehall Street to which any artist could submit work, but the Institute's selection committee refused anything that struck them as *modern* – not *traditional* – so only painters working in the style of their Art School teachers had a chance of exhibiting. And hardly any were rich enough to rent a gallery where their work could be seen. To bring public attention to their work, in 1957 Alan Fletcher and five other painters hung their paintings on the railings of the Botanic Gardens on Queen Margaret Drive at weekends when rain did not fall. Then three recent graduates of Glasgow Art School (James Spence, Anda Patterson, Jimmy Morrison), having earned enough by teaching, decided to rent for their work part of the McLellan Galleries. News of their decision spread. They welcomed other young artists who wished to join them, and held meetings that led to the creation of an artists' co-operative with seven other members worth naming in alphabetical order: Douglas Abercrombie, Alan Fletcher, Carole Gibbons, Alasdair Gray, Jack Knox, Ewen McAslan, Ian McCulloch. We called ourselves *The Young Glasgow Group*, dropping the adjective *Young* a few years later, but holding annual shows that came to occupy the whole of the McLellan Galleries as members of the co-operative increased. The Group's annual shows ran from 1958 until 1990, the year when Glasgow became Capital of European Culture. That year the McLellan Galleries were commandeered by the Glasgow Museums Service under arts administrators brought in from England who had no interest in local art. The Glasgow Group never fully recovered from that deprivation.

If this were an autobiography I would here print a report I wrote for the Trustees of the Bellahouston Travelling Scholarship, explaining why I had partly

Alan Fletcher working at the kitchen sink at 144 West Graham Street, 1957, dyeline print, 42 x 30 cm

Kitchen at 144 West Graham Street, 1957, dyeline print, 42 x 30 cm

"Bearded City Artist Plunges to Death", from the Glasgow edition of the Daily Express, Saturday, 2 August 1958, when British beards were only common among artists, naval commanders and destitute folk, so journalists thought them newsworthy

BEARDED CITY ARTIST PLUNGES TO DEATH

Express Staff Reporter

BEARDED, 28-year-old artist Alan Fletcher, whose paintings were seen by thousands in open-air exhibitions outside Glasgow's Botanic Gardens, died in Milan yesterday after a fall from a 22ft.-high wall.

Fletcher, dark-haired and 6ft. tall, was found by a janitor at the foot of the wall round an Italian students' hostel.

The top edge of the wall passes a few feet from the window of the room which he shared with fellow student Douglas Abercrombie (24), of Ledard-road, Battlefield, Glasgow.

On a tour

Fletcher attempted to climb down the wall during the night when the hostel entrance door was locked, police said.

He and Abercrombie—they had both received art awards—were on a three-week tour to further their studies. Together they had held many exhibitions in Glasgow.

They were due home early next week.

Fletcher studied at the Glasgow School of Art for six years. He helped to produce Charities' Day magazines. He prepared the magazine cover for a number of years and did much of the layout.

'So happy'

He did his National Service as a sergeant in the Intelligence Corps.

Fletcher's father, 66-year-old boilerman Mr. Archibald Fletcher, of West Graham-street, Glasgow, learned of the tragedy in a telegram at his home last night.

Mrs. Fletcher is on holiday in Bournemouth.

Said Mr. Fletcher, "It is unbelievable. Alan and Douglas were so terribly happy when they set off. They had waited a long time to go on this tour and they were looking forward to it."

LATEST

Cinema audience trapped

KLAGENFURT, Friday.— Several hundred people trapped by floods in a cinema at Bodendorf, Carinthia. It was several hours before they could be rescued.—B.U.P.

Telephone: Bell 3550

On holiday— his lock-up blazes

A TAXI was destroyed and four motor cycles were damaged in a mystery 2 a.m. blaze in a lock-up in Ark-lane, Dennistoun, Glasgow.

Firemen smashed open the door of the lock-up with axes and pushed the motor cycles out into a yard.

The owner of the lock-up, Mr. Gordon McKenzie, Dunchattan-street, Dennistoun, set out for a holiday in Devon last night.

Forty-year-old taxi driver James McCrimmon, Fisher-street, Dennistoun, said "I put the taxi in at 1 a.m. There was no sign of a fire then. I was at home when I heard the fire bells. Then I saw the roof of the lock-up blazing. There was no hope of saving my taxi."

'Test-tube' inquiry

The Earl of Eversham is to be chairman of an inquiry into human artificial insemination.

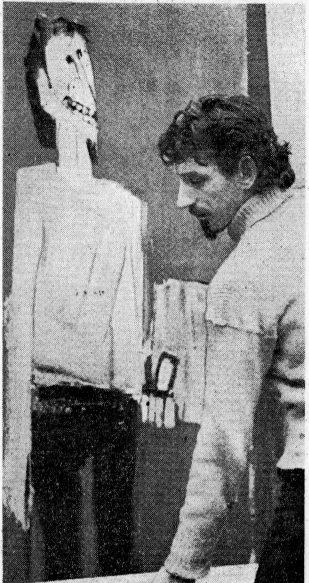

ALAN FLETCHER—BY HIMSELF

The 28-year-old artist who died in Milan yesterday is shown here with the "Self Portrait" he exhibited outside Glasgow Botanic Gardens last year. "Really," he said, "it's not a joke. This is one of my more serious efforts."

Girl saves chum from car on pavement

Express Staff Reporter

A 14-YEAR-OLD Glasgow schoolgirl pulled her chum

lost, partly spent their money. I omit it because the experience added nothing to my visual art that can be shown. I had left 11 Findhorn Street in November 1957 suffering from asthma, and returned to bed there, not much better, early in February 1958. On the morning after my return Dad posted a card mentioning it to Alan. In those days there were two postal collections and two deliveries before 12pm, and Alan delighted me by arriving to see me with Douglas Abercrombie at noon. To get out of difficulties abroad I had borrowed money from Dad, so meaning to repay it I now found work as an unqualified art teacher in Lanarkshire factory towns, where schools were so short of staff that the local authority was employing graduates who had not trained as teachers.

A few months after my return Alan and Douglas left Glasgow together with their own travelling scholarships. Alan sent me a postcard from Brussels, then from Berne in Switzerland before leaving for Milan, where he was found dead the morning after his arrival at the foot of a very high wall around a youth hostel, a wall which was only a few feet high on the hostel side. For years after his death Douglas and Carole and I still met each other and his parents in 144 West Graham Street, or visited the Grand Hotel boiler room and sat on comfortably dilapidated basket chairs, gossiping with Mr Fletcher before the furnace door he occasionally opened to shovel in coke. On the coldest winter nights it was a warm place and, being friendly with the kitchen staff, he

Douglas Abercrombie, 1958, ink on brown paper, 30 x 21 cm

A Game of Patience: Douglas Abercrombie, Carole and her mother, Mrs. Gibbons, 1958, ballpoint pen on lining paper, 30 x 42 cm

sometimes served us with sandwiches or biscuits.

I started revisiting Brown's Tea Room, Sauchiehall Street, with two other art teachers in a school where I taught. Before Mrs Thatcher's government made it legal for pubs to be open all day, many social meetings in Glasgow were in tea-rooms with a smoke room for men because many polite women hated the reek of tobacco. The smoke room of Brown's was a big basement with thickly upholstered sofas around the walls. Art School and ex-Art School students used it because we could linger here as long as we wanted over a single cup of tea or coffee, and it was there I had met Katy Gardiner, who was a heavy smoker. She spoke to me because she had gone to Whitehill School ten years before me, then to Glasgow Art School, but had kept in touch with Whitehill staff I had known – Bob Stuart and Arthur Meikle – who had told her of me. I asked if Mr Stuart the art teacher had liked my work. She said, "Yes. He told me you were a genius." I was surprised because he had never hinted that to me. She said, "Did you not notice that in his classroom he let you do anything you wanted?" and asked to see my recent paintings. She then bought *The Beast in the Pit*, otherwise called *Washing Day with a Minimum of Three People*. It was wonderful to be recognized as an artist by a glamorous, mature, intelligent,

*Lullaby, Eddie
Boyd*, **Scottish
Field Magazine**,
*December 1959,
30 x 21 cm*

Lullaby

Ballalow an' ballaloo,
There's a croon o' thorns on ma bairnie's broo.

An naebody's seen it there bit me,
An naebody else had een tae see.

As ye lay, ma lamb, on yer clean strae bed,
The skaith o' the nails an' the Roman ged.

Wheesht! ma hinnie, an' cuddle doon,
The nicht's on fire abune the toon.

Wheesht! ma doo, an' fear nae ill,
The fire-flaught's loupin' on Calvary Hill.

Wheesht yer greetin' an' dry yer ee,
Ye'll need a' yer tears for Gethsemane.

EDWARD BOYD

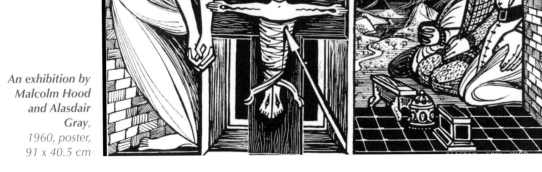

*An exhibition by
Malcolm Hood
and Alasdair
Gray,
1960, poster,
91 x 40.5 cm*

an exhibition
of drawings
paintings
prints
by
malcolm
HOOD
alasdair
GRAY

Saturday
14 MAY
to
21 MAY
BLYTHSWOOD
SQUARE
GALLERY

well-read woman with whom I could chat or enjoy companionable silences. During these I often drew her and Susie, her daughter by the playwright Eddie Boyd. They were divorced, but a Christmas carol he wrote would be printed in *The Scottish Field* December edition, so she persuaded him and the magazine's editor to let me supply a full page illustration round it. The editor then suggested I illustrate a poem in that way every month, which nearly became a nice little source of income. For January 1960 I illustrated a Burns poem, and for February was given Edwin Muir's *The Brothers*, a dream of the Orkney childhood he recalled as a golden age of innocence long after leaving it for Glasgow, then London. His recumbent profile appears on the

horizon. I forget who wrote the poem I illustrated for the March edition. It never appeared because, said the editor, the printers had lost it. He promised to pay me for any future work of mine that his employees lost, but if I insisted on payment for the lost March picture he would commission no more of them.

This was blackmail, so I insisted on payment.

In 1958 I met Mr Young, elder of Greenhead Kirk of Scotland in Bridgeton. The congregation was to be combined with that of another nearby, and were renovating the interior, hoping that Glasgow Synod would put folk from

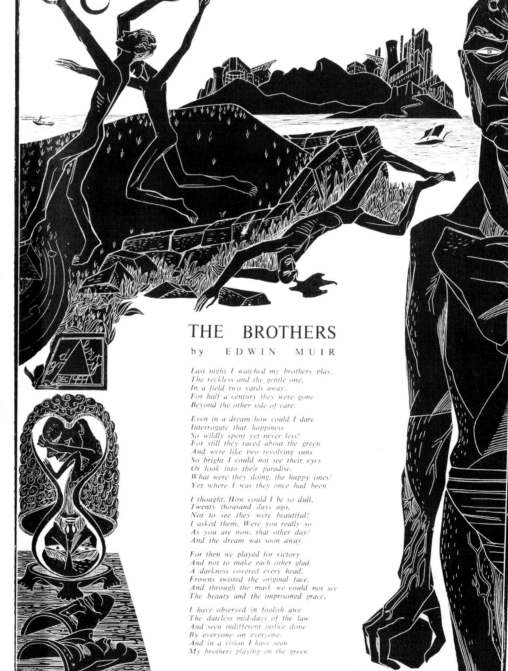

ANDERSON
ANDERSON
FLEMING
METHVEN
NOBLE
AULD
GRAY
HOOD

**paisley
art gallery**

**friday 28th april
–sat. 13th may.**

**KOK
GROUP**

THE BROTHERS

by EDWIN MUIR

Last night I watched my brothers play,
The reckless and the gentle one,
In a field two yards away.
For half a century they were gone
Beyond the other side of care.

Even in a dream how could I dare
Interrogate that happiness
So wildly spent yet never less?
For still they raced about the green
And were like two revolving suns
So bright I could not see their eyes
Or look into their paradise.
What were they doing, the happy ones?
Yet where I was they once had been.

I thought, How could I be so dull,
Twenty thousand days ago,
Not to see they were beautiful?
I asked them, Were you really so
As you are now, that other day?
And the dream was soon away.

For then we played for victory
And not to make each other glad.
A darkness covered every head,
Frowns twisted the original face,
And through the mask we could not see
The beauty and the imprisoned grace.

I have observed in foolish awe
The dateless mid-days of the law
And seen indifferent justice done
By everyone on everyone.
And in a vision I have seen
My brothers playing on the green.

*Death &
Creation*

**Greenhead Church of
Scotland Mural: The Six
Days of Creation**, *1959,
photographed around
1970, emulsion and oil
on plaster*

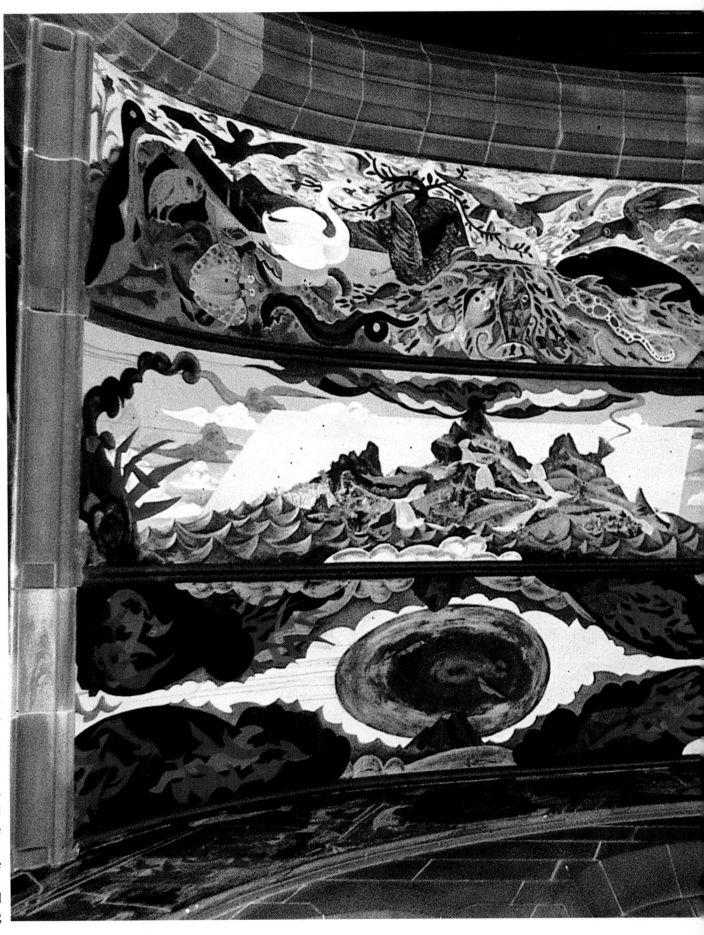

the other kirk in their building, not vice versa. If I painted a mural for this poor church in a working-class district, it could afford to pay for the materials and scaffolding, but nothing else. My part-time teaching made this possible, so in less than four years I brought a large mural to completion. The arched chancel ceiling seen here was divided by mouldings into six panels, reminding me of the six days in which the Genesis God made our universe, and the Creation mural Gulley Jimson died before completing. Here the bottom left panel shows the creation of light in the midst of chaotic waters, light being originally a smooth blue egg with a golden yolk. On the wall around the stained glass windows at the back of the chancel I painted (dimly visible here) a chaos of flame, dark clouds, rocks and water, also surrounding

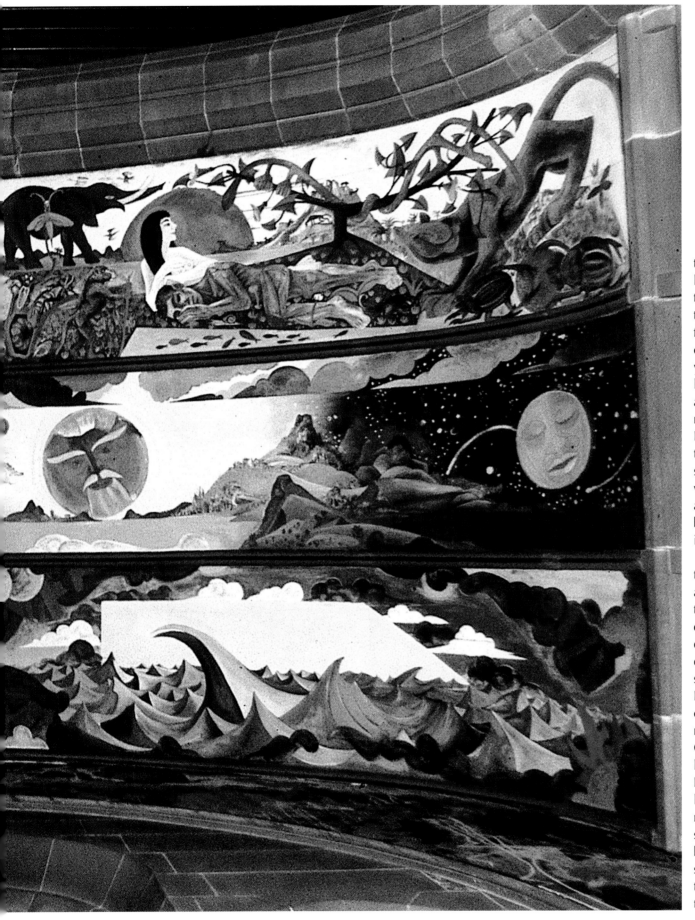

the new-laid egg of light and, on day two, the firmament dividing the waters beneath from those above. The chaos on the wall had yellow lightning flashes leading up to a space above the point of the middle window where I showed God, as the third sentence of Genesis says, moving over the waters, not like a dove as sometimes depicted, but more like Superman in silhouette.

This photograph of the ceiling was taken around 1970, when the colours were more or less tarnished by damp. The kirk was then derelict and demolished soon after so that London Road, where it stood, could be widened to a motorway. (A plan that Glasgow city planners later abandoned.) Before demolition, a letter to the council from my friend Mary Bliss suggested the building be kept for the mural's sake. A reply regretted this was not possible, though the council knew

I had painted it *as a form of therapy.*

The ceiling was done in 1959. I had wished to show God on it as Michelangelo did, at work through weekdays, making all things, from light to men and women, but the kirk elders forbade that. The minister, a kind man, said my God would frighten the children. But on the chancel's right-hand wall was a big arched panel facing the organ on the left. I painted here the seventh or Sabbath day, and what came after. On the extreme left this had God wearing a black coat down to his feet, seen mostly from behind, what was visible of His

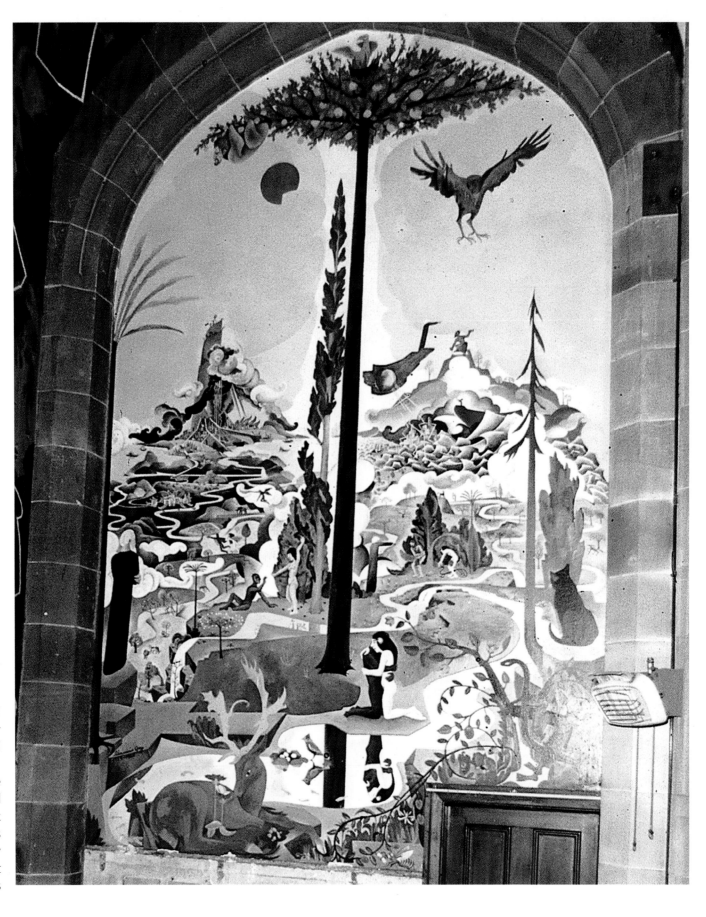

face indicating He had a white beard like my dad's. He did not look dreadful, though foreseeing the first couple eat His forbidden fruit before being forced out into a world where war, deluge, the tower of Babel, Moses hammering out His moral laws and the crucifixion are bound to happen.

One of the congregation had a firm that was painting the interior of a newly built synagogue in Cathcart, and had contracted to paint the large ceiling with a blue sky and clouds. He asked me to take some days off my kirk job to design and supervise this painting. He would pay me for my work and his employees would assist it. We mixed three big cans of white, pale grey and silver paint for the clouds, and a strong blue for the sky in between. On a mobile scaffolding I chalked outlines with the initial letter of each colour inside, then the painters brushed in these areas while I came behind them refining the edges. My blue suggested a night sky to the rabbi, who asked for Stars of David to be added, which I gladly did. Later the painters' boss told me that the synagogue's committee, having expected a pale blue sky with soft white cotton-wool clouds, were horrified by the result until the chief rabbi, opening the synagogue for worship, said he liked it. I think this photograph shows my fierce pattern blends with the Hebrew script on the marble tablet behind the Decalogue.

In the kirk one evening I was painting my dark, turbulent chaos laced by ribbons of lightning when an art teacher friend visited me with a stranger, Archie Hind, who said my chaos affected him like Forster's account of the Marabar caves in *Passage to India*. It was wonderful that someone saw the point of my work without explanation. Archie, his wife Eleanor, four (and shortly after, five) of their children became life-long friends. On Friday or Saturday nights they pleased like-minded folk

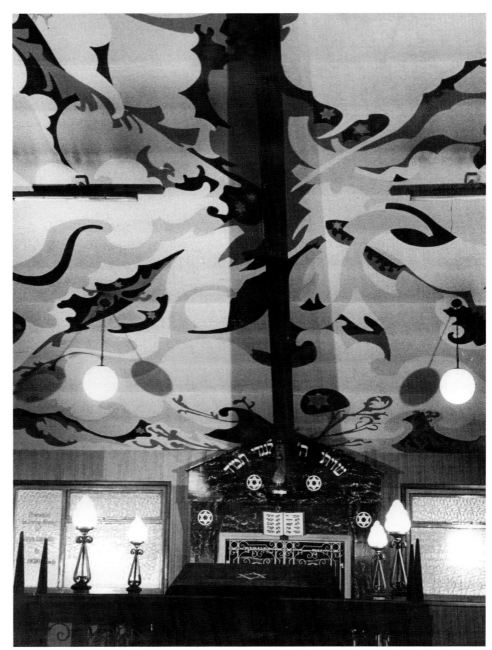

Belisle Street Synagogue Ceiling, *1959–60*, *mural*

with coffee and conversation in the kitchen of their two-room flat in Govan, another home where I felt welcome. Archie, six years my elder, came from Bridgeton, my parents birthplace. He had widened his thoughts in Glasgow's excellent public libraries, and was reading Schopenhauer when, like most working class children of fourteen, he left school to become a wage-earner. (The British school leaving age was raised to 16 years in 1972.) First a clerk in Beardmore's engineering works, then a grocer's warehouseman, the British army took him to Singapore and Ceylon for his National Service before, through the Workers Educational Association, he took a course in literature at Newbattle Abbey. The warden and his wife, Edwin and Willa Muir, were the first translators of Kafka into English. They became encouraging friends. After marriage he supported his growing family by being a social security clerk, trolleybus conductor, labourer in municipal slaughter house, between working at

Woodland Behind Milngavie Reservoir, 1959, oil on wooden panel, 30 x 42 cm

his novel about trying to be an artist in Glasgow. At first this embarrassed us - I was sometimes writing a novel on the same theme. Published in 1966, his *Dear Green Place* is now an accepted modern classic of Scottish literature.

The Holy Loch was about to become Europe's biggest nuclear arsenal, for the London government had leased to the USA this part of the Clyde waters for use as an atomic submarine base, and suddenly many popular groups united to oppose this. I painted a banner for Eleanor Hind's Govan branch *Women Against the Bomb*. I joined protest marches through Glasgow and round the Holy Loch, and came to know the lawyer Keith Bovey and the advertizing agent Brian Smith, both CND secretaries. I painted adverts and decorations for meetings and rallies they organized. The biggest public

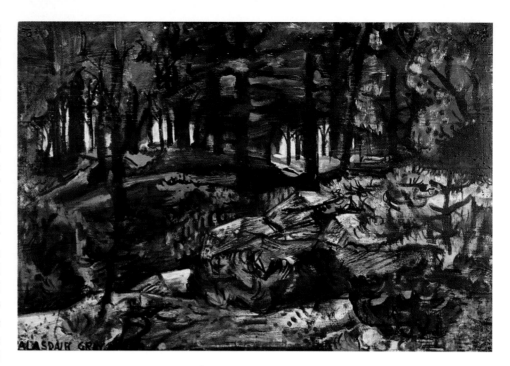

demonstration was a huge procession from the pier at Dunoon to the Holy Loch pier serving the newly arrived submarine base. Folk from nearly every good part of Scottish society were there – trade unionists, Church of Scotland clergy, folk singers, working- and middle-class husbands and wives with their children and babies in prams. I wanted to paint a huge long frieze showing this big march, a modern democratic version of Mantegna's

Triumph of Caesar in Hampton Court, where the banners were held aloft by soldiers above the heads of conquered folk who had been enslaved. I collected newspaper photographs of the event, though most appeared in newspapers who thought the demonstration less interesting than the sight of USA sailors fraternizing with Dunoon lassies. On a later weekend I returned to sketch the scenery through which the march would pass, but schoolteaching and

Holy Loch Sketches: USA Supply Ship with Nuclear Submarine; Dunoon Pier; Dunoon Town; War Memorial at Sandbank; Head of the Holy Loch, 1961, pencil on paper, 15 x 21 cm

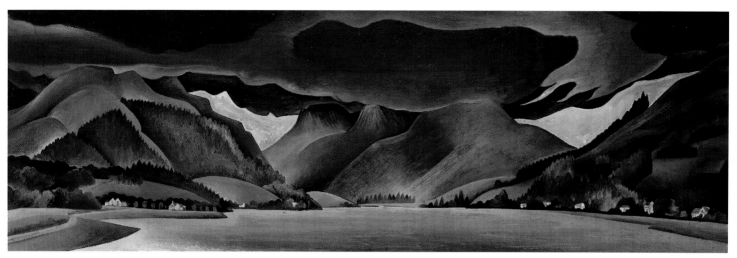

Holy Loch Landscape, 1961, oil on hardboard, 30.5 x 91.5 cm

painting in the kirk left me no time to do more. A few years later someone asked me to paint them a Highland landscape, so from the sketches I made a view of the Holy Loch. The intended purchaser refused it unless I replaced the dark clouds with a sunny sky, which I would not do. The picture lacks the American warship and submarine I sketched beside it, but I now think I unconsciously put into it my horror of an impending nuclear war.

But that was certainly my subject when a group of CND Scottish clergymen asked me to join artists I knew in painting for an exhibition called *Artists Against the Bomb*, to open in the Glasgow McLellan Galleries before being moved to the gallery of the Gateway Theatre, Edinburgh. The other artists were Carole Gibbons, Douglas Abercrombie, Ian McCulloch, Jack Knox and Johnny Taylor, who gave several pictures. I gave one. On a canvas six feet by eleven, the biggest I could afford, I painted a modern *Triumph of Death*, once again using central features from my Scottish–USSR society mural, with an Intercontinental Ballistic Missile about to hit the reflection of a red sun in the Stinky Ocean. To the right are mutants that were for me the equivalent of the skeletons taking the world over in Brueghel's *Triumph of Death*, and devils in Hieronymus Bosch's hells.

Decorated Door: Keith Bovey's Byres Road flat, 1959, drawing tinted with oils

Decorated Door: safe door from Brian Smith's West Regent Street office, 1961, Indian ink on painted metal

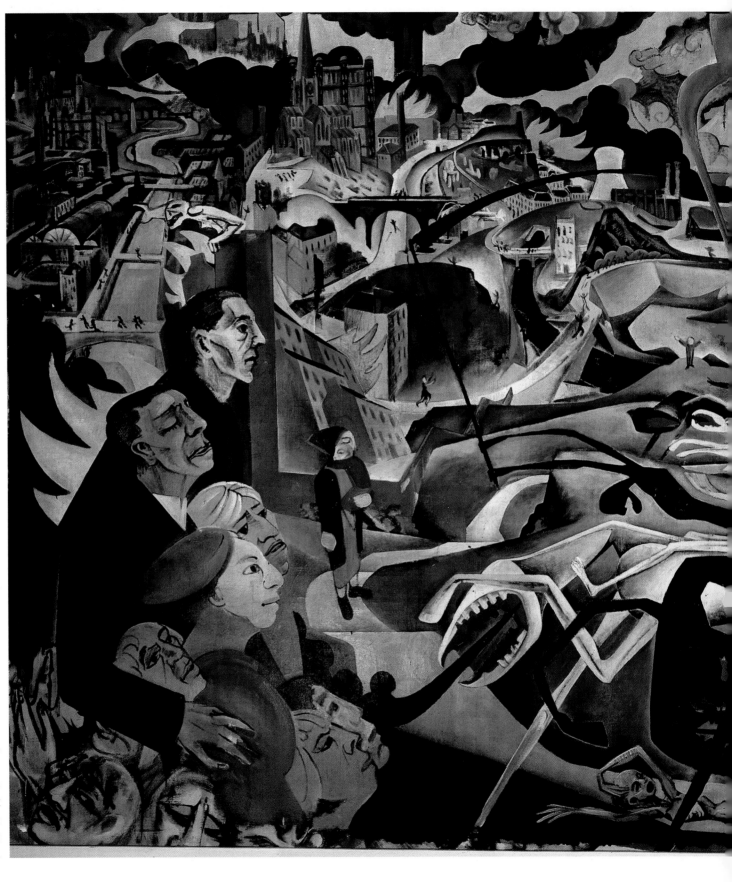

Death & Creation

Glasgow Triumph of Death, *1961, oil on canvas, 178.5 x 336 cm*

To the left, facing them, is a heap of folk with the top man Archie Hind in profile. The other folk are mere types, one with a badly drawn arm and hand. The bony riders on the blind beasts between are the four horsemen of the apocalypse, the only bits of the picture that look properly finished. One of them wields a paper with type from a Letraset sheet, a fast method of neat lettering now replaced by word processors. In the background are the Necropolis, Royal Infirmary, Cathedral, Clyde, St Enoch's station, George Square and Municipal Buildings, bits of Glasgow that should have been as distinct as in Lowry's pictures.

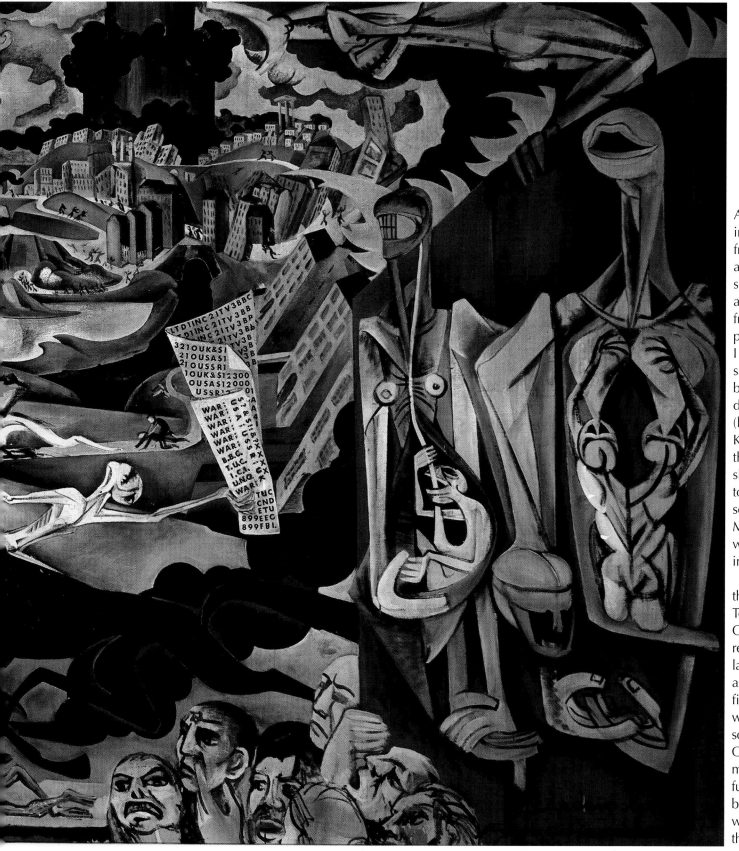

1957–61

And the starving infant under the front horsemen is a cheap vulgarity I should never have added. Copied from a newspaper photograph, which I never directly saw it (like the bits of Glasgow), or directly imagined it (like the mutants). Keith Bovey acquired this picture after the show until he moved to Edinburgh, and sold it to Angela Mullane, a friend who will not let me improve it.

In 1959 I learned that Jordanhill Teacher Training College no longer required a foreign language certificate as an entrance qualification from those with art diplomas, so I enrolled there. Once again this made me a state-funded student, and being taught to teach was much easier than actual teaching.

Submarine Battle: Whale and Squid, 1960, silkscreen print, 33 x 47 cm

The Painter and his Muse, 1960, silkscreen print, 30 x 22 cm

Portrait of George Singleton, 1962, ink and wash on paper, 30 x 21 cm

Portrait of Rosemary Singleton, 1962, ink and wash on paper, 30 x 21 cm

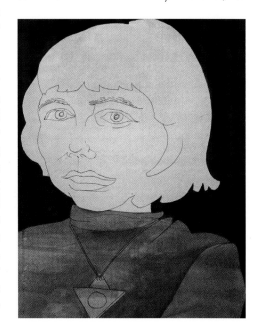

Jordanhill also gave trainee art teachers time to practise their art, so for the first time in my life I made what I thought adequate prints using silk-screen with wax stencils, cut with a scalpel from a thin wax sheet backed by paper, called Profilm. But the college inevitably led to teaching again, though in Glasgow. The Education Authority then had splendid offices in Bath Street, since leased to commercial offices, as did many fine public properties before the Thatcher government's privatizing policy was kept going by later governments. I met there the head of the city art department, told him I wanted to teach only three days a week in order to paint in the Bridgeton Kirk, and so started at Riverside Secondary School as the first (and perhaps last) part-time day-school teacher in Glasgow. The school, long since demolished, was on the banks of the upper Clyde between Parkhead and Dumbarton. There I saw what seemed an unusually attractive, neat, well-dressed girl student who I learned was Rosemary, a new teacher of English, and English herself. In those days men and women teachers had separate staff rooms. I met Rosemary at a bus stop when we were going home, and asked if she would come with me to a performance of *Hamlet* at the Citizens Theatre. She kindly refused me, explaining that she was engaged to be married. This led to friendship with her and her husband George Singleton, whose father had started the Cosmo, for many years the only Glasgow cinema to show foreign language films, and now owned a chain of Glasgow cinemas that, with the spread of television, would become bingo halls. Rosemary had met George at Oxford, where both were students. To stay outside his dad's business he had become an accountant, while she taught English. This friendship later led to a pair of domestic mural paintings.

In the 1960 summer holiday I travelled to Milan with Mrs Mary Fletcher, to

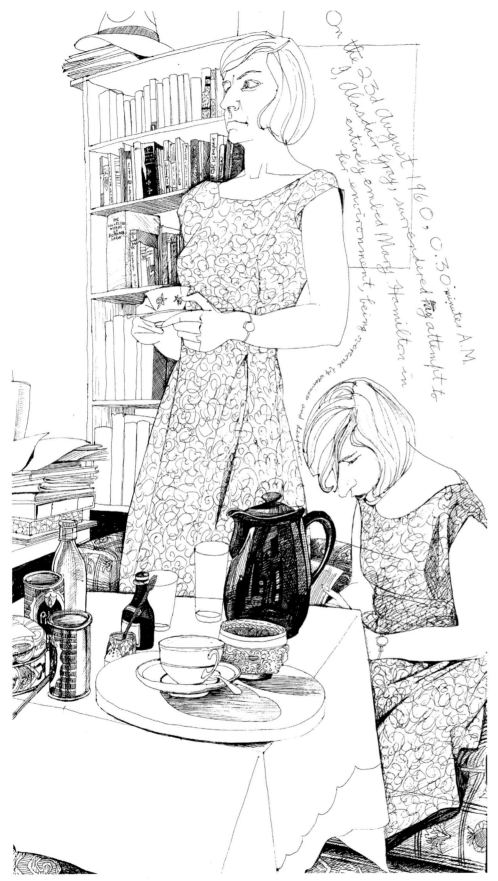

On the 23rd August 1960, 0.30 minutes A.M. I, Alasdair Gray, surrendered my attempt to 3, entirely embed Mary Hamilton in her environment, being version by welcome and background

Crucifixion, Alan Fletcher, 1957, sketch on paper, 30 x 21 cm

arrange for the placing of a stone over her son's grave, a slab incised with a design Douglas Abercrombie had adapted from a crucifixion sketch by Alan. On the way home through London I stopped to meet friends of Bob Kitts who had become my friends, especially Mary Hamilton, now a qualified medical practitioner, who liked my early writing perhaps more than my painting. She came from a New Zealand family with a highly literate independent culture, so enjoyed our talks together, though disagreeing about many things, especially politics. I proposed marriage at the end of one such talk, during which I had sketched her. She sensibly refused, which did not damage our friendship. What fascinates me about this sketch in cheap ballpoint pen is the detailed still life on the tabletop, with cast shadows and reflections in the glossy coffee pot that would have pleased Miss Dick. It is a clear case of what Freud called *sublimation*. When working on it I had missed the last train home that day. Between 2 and 3 a.m. next morning I caught what must have been a night mail train that brought me to Glasgow in time to teach on the first day of Riverside's autumn term.

Two Views of Mary Bliss, 1960, ballpoint pen on paper, 42 x 30 cm

Brian Smith, owner of a small advertizing firm and active CND organizer, had good ideas that needed the help of many others to be practical. Glasgow CND members gave him that help. In West Germany there was now the kind of political cabaret that had flourished in Paris and Berlin before being banned by Fascism. It had also become fashionable in London. In those days the laws forced British pubs to close early: 9 p.m. in Glasgow, 9.30 p.m. in Edinburgh. On Saturday evenings Brian rented a big room in a little lane near the Mitchell Library, installed coffee-making equipment, bought a licence for folk to bring in their own alcohol and drink it there, asked performers he knew to provide a cabaret and advertized it as *THE SATURDAY LATE NIGHT CLUB*. Young folk singers and comedians gladly performed without pay (I was one) but there was a membership fee. Almost at once the club became a popular and financial success, which gave Brian the idea of starting a much bigger seven-nights-a-week CND nightclub in Edinburgh during the festival to be called *FESTIVAL LATE*. For this he rented an ancient property between the High Street and West Bow, the former Edinburgh Rock candy factory soon to be demolished and replaced by Midlothian Police Headquarters. Electricians in the Gorbals Young Communist Party (who disagreed with their Stalinist elders) wired this warren of old rooms for light, heat and catering. All who helped him make and run the club were from Glasgow so he filled a big room with rented mattresses for use as a dormitory. We whitewashed the bare stone walls, and on those of what would be the dancehall I painted black silhouettes of nymphs and monsters with linear details in silver enamel. This took place during my summer holiday, which ended in the week that the 1961 Edinburgh Festival started. At the last moment I gave up my teaching job to continue as a cabaret performer and part of the Festival Late adventure. For three weeks this opened each day at 6 p.m. and closed at 4 or 5 a.m. when the staff went to their sleeping-bag beds. This led to much social mixing, several love affairs and some marriages, one of them mine. It was here I met Inge Sörensen, a Danish nurse in Edinburgh City Hospital, one of those who liked lingering with people running the club long after most members had left.

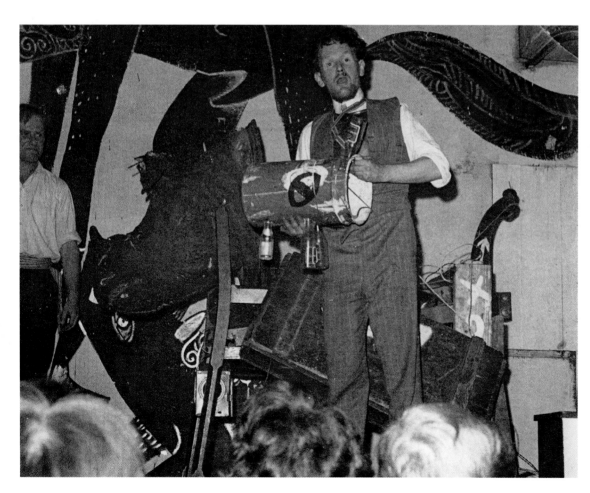

Nine: Portraits, 1961–2009

WHEN AN INFANT I made pictures in order to see imaginary worlds that seemed more exciting than familiar reality. This motive lasted almost until I went to art school, when I was enjoying novels by Dickens, Hardy, Joyce, Kafka, and planning to write one of my own, and had accepted that the best and worst and most exciting things in life would be found through people I knew. It was therefore clear that the world about them, social and natural, was a context that ambitious pictures should also represent. Legends, poems and other fictions, Bosch, Blake and Beardsley had shown that exotic, even nightmare fantasies were also great ways of showing truths that I did not mean to lose, but I was also pleased to imagine and represent the world before my eyes. In Alan Fletcher's home I began sketching him and his friends, a habit I carried into any place where I could relax and feel at home. Because my dad, sister and Aunt Annie were so familiar to me I felt (wrongly) that there was nothing new for me to see in them. Later I often drew my wife Inge and son Andrew because they were always new to me. At the Festival Late nightclub a scribbling fury in quiet moments made me draw in ballpoint everyone I sat with, in a tall book of white pages that stationers called, I think, a navigation notebook. I gave the book to Brian Smith as a memento, and when he died at the end of the 20th century it was not found among his papers. This may be the only surviving sketch from that time.

It has been said that every portrait is the artist's self-portrait more or less disguised because no one can see more of another's character than they recognize in themselves. Some great artists have tended towards a type; thus Leonardo's young faces, male or female, smile out of an inward mystery, and Renoir's women are usually chubby with snub noses and pouting lips. But I believe my less lovely portraits show faces and expressions very different from my own and from each other.

Hugh McBain, Glum Satirist at Festival Late Nightclub, 1961, ballpoint pen on paper, 42 x 30 cm

A Minister's Wife in Buccleuch Street, 1966, oil on board, 30 x 42 cm

Netta with Fur Collar, 1965, pen and wash on paper, 44.5 x 57 cm

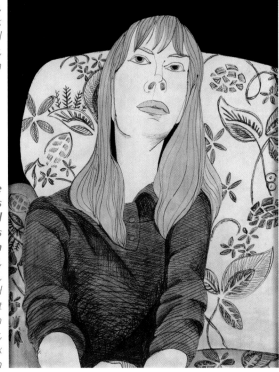

Portrait of Susan, 1960, ink and pencil on paper, 30 x 21 cm

Carole Gibbons and Flowers Between Still Lives, 1964, framed ballpoint pen on paper, 109.9 x 78 cm

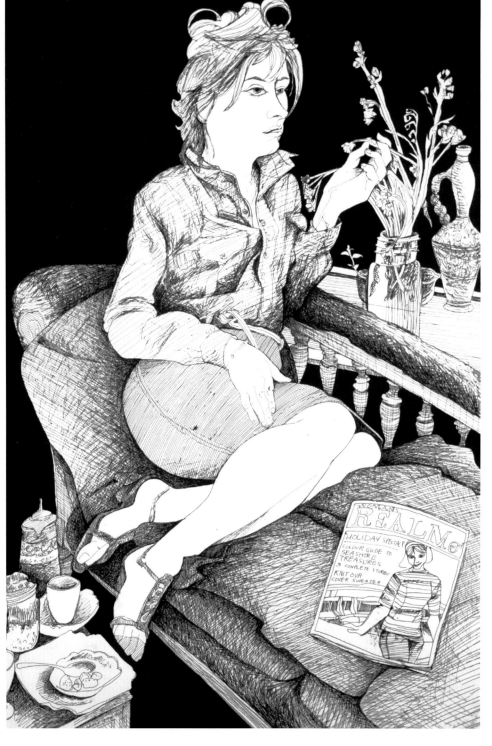

My sketches only became pictures when each was in a rectangle giving shape to the surrounding spaces, spaces that might contain other people and furniture. The main lines were usually drawn in one go on cheap newsprint, wrapping paper, the plain side of spare wallpaper rolls. These could always be found nearby, and even nowadays, when I can afford good quality cartridge paper, it still makes me uneasy and self-conscious because too expensive to risk

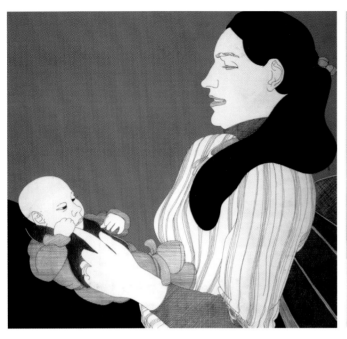

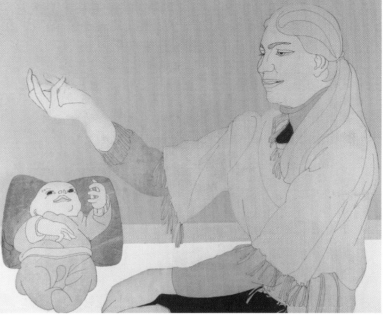

Mother and Baby, Monochrome, *1964, ink and Indian ink on paper, 30 x 30 cm*

Mother and Baby, Lightly Coloured, *1964, ink drawing with watercolour on paper, 30 x 40 cm*

spoiling. On completing the essential outlines I might make them weightier with shading in ink or pencil. If portraits were ambitious I took the drawings home and, on a pane of glass with a light beneath, traced them on new paper with improvements, sometimes combining what was best in more than one sketch, and sometimes making more than one version. The best was then pasted onto a rigid board and had as few tones and colours added as the picture needed to appear complete. My earliest portraits often had black or grey backgrounds with subdued tones and colours because I then felt the bright heraldic colours I most enjoyed would distract from my fine lines. The colour of the paper was usually left as the colour of my people's skins, made to look natural by tinting lips, eyes, hair and surrounding areas. To get a combination of contrast yet harmony I mingled pencil and crayon shading,

Conversation 1964: Sheila Tees, Ann and Bob Johnson, *1964, pen, watercolour, wash, enamel and newsprint on board, 30 x 55 cm*

Marion and David Donaldson at Home, *1966, ink on paper, 30 x 55 cm*

Mary and Tony Bliss in Bearsted, *1960, ink on paper, 30 x 55 cm*

watercolour washes, acrylic, felt-tipped colour pens and oil paint. Often a clear oil glaze was used to slightly darken an area of paper without other addition.

When in France between 1900 and 1935 the Scots artist J.D. Fergusson (a friend of Picasso) was strongly influenced by Matisse and became one of the original Fauves. He used and advocated what he called "living paint" – colour applied boldly and creamily with brush strokes that made their own contours, instead of filling outlines drawn earlier, like tints on a map. The glory of oil paint (said Bernard Berenson) is in modelling that lets painted figures look as if you could grasp their arms and walk behind them. Some of my portraits in oils attempted that, but most show me an illustrative decorator whose technique owes most to great Japanese print makers, Hokusai and Hiroshige, and Europeans who learned from them – Beardsley, Toulouse Lautrec, Van Gogh, Gauguin. The triumph of Japanese art is its visions of people looking convincing and beautiful in urban and rural settings which often

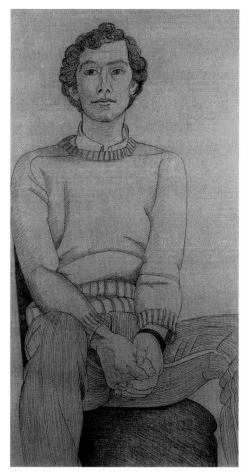

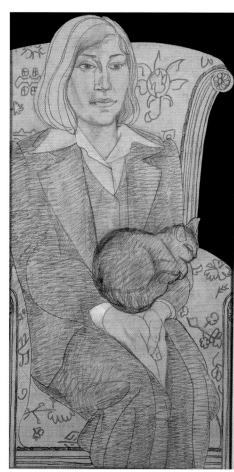

Bookseller Reinhold Dowes, *1974, pencil on brown paper, 43 x 32 cm*

Agnes Samuel with Pussycat, *1974, pencil on brown paper, 43 x 32 cm*

Lorna Casey, *1972, pencil on paper, 47.5 x 32.5 cm*

Doreen Winning, *1971, pencil on paper, 43 x 32 cm*

Bill Hamilton Reading, *1970, ballpoint pen with wash on paper, 43 x 32 cm*

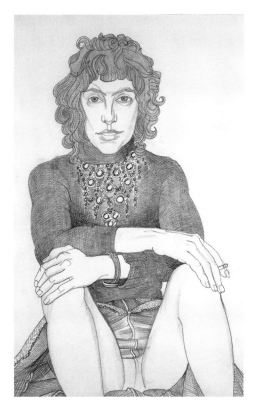

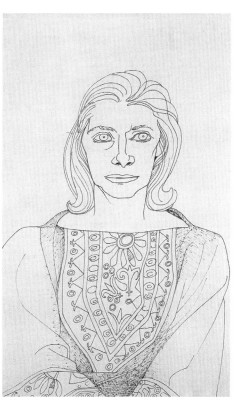

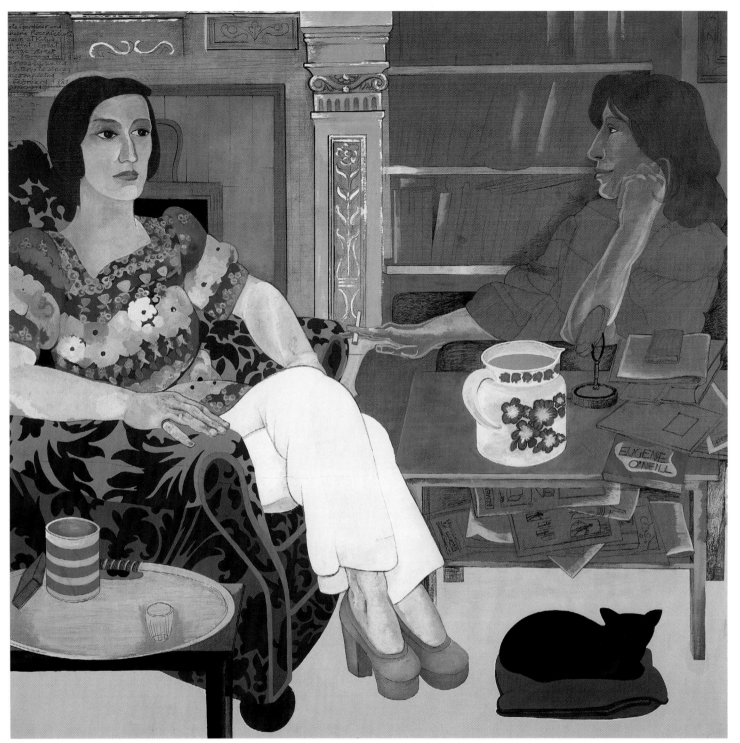

*Kate Gardiner
and Sheena
Rocchiccioli,
1969, pencil,
watercolour and
oil on brown
paper,
84 x 118 cm*

suggest distances, though lacking what Berensen called *tactile values*. My own work also often lacks that.

In 1969 I visited Katy in her Great George Street flat, found her friend Sheena there, sketched both in pencil on a very large sheet of paper and took it away, meaning to build up colours in every medium that came handy, but finishing with a layer of subtly-tinted oil paint making a surface as smooth and richly coloured as a Van Eyck interior. With time and care I was sure this could be achieved, though perhaps Katy's lightly sketched profile would have lost something if over-worked. The acrylic painting of Sheena's face has made it too mask-like, which the final layer of oil would have mended. In 1989 she offered to buy the picture as it stood and, needing money, I sold it.

Being natural is simply a pose.

Executed in Indian Ink, subsequently tinted with watercolour, tempera and a little oil.

Alistair Leigh at Table, 1980, Indian ink, watercolour and oil on paper, 41 x 44 cm

In 1980 my friend Angela Mullane commissioned a portrait of Alistair Leigh, a recent drama student. He decided to be drawn after a meal he had prepared for us in her home, as his own home was too untidy. He deliberately chose this pose, arranged the still life in front of him, and asked me to inscribe that quotation from Oscar Wilde. I made a pure black and white line drawing of this picture which Ms Mullane preferred, and the above colour version, which I liked better and gave to Alistair, who died of cancer in February 2010. His portrait is the less than a quarter the size of Katy and Sheena's portrait.

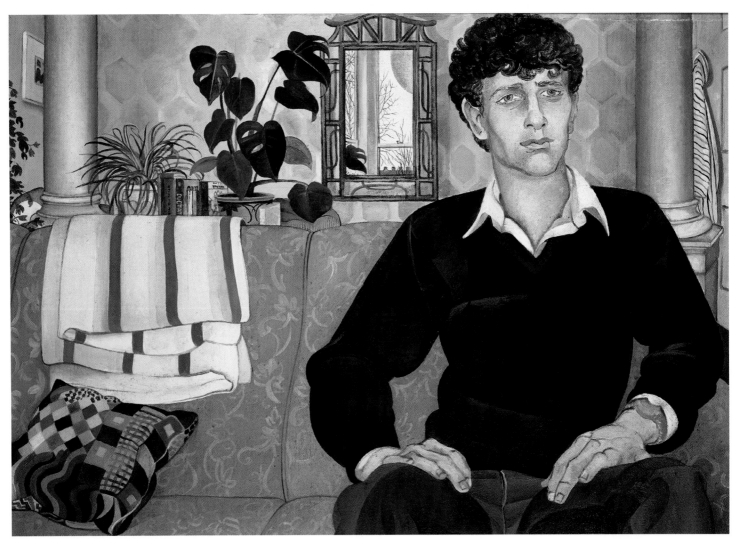

Stephen Dando:
Student in
Kingsborough
Gardens, 1983,
oil on paper on
wood,
43 x 61 cm

Douglas Dando was an energetic businessman who started two or three businesses and failed in them. His imagination led him to diversify beyond his powers, yet he always picked himself up and started again. He attempted art dealing in the early 1980s, when he commissioned this portrait of his son Stephen, then a student at Glasgow University.

I drew Stephen in his lodging at Kingsborough Gardens, a district of 19th-century terrace houses, intended for rich families, as the two elegant pillars in the single room Stephen rented shows. I pasted the drawing onto a wooden board and, working fast, lost the pencil lines beneath an oil painting in which the colour and

Katherine Fraser,
later Mrs Dando,
1983, pencil and
wash on paper,
51 x 59 cm

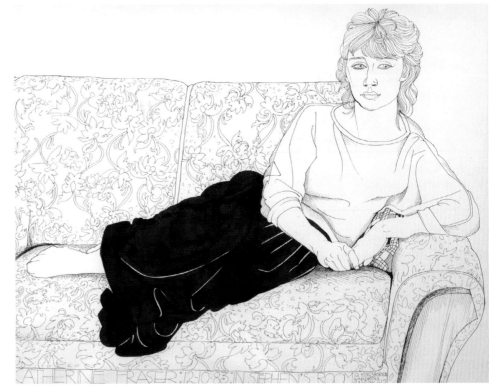

background detail have the masterly finish I wanted all my paintings to have, but often had no time to achieve. When turning a drawing into a painting in my studio, I sometimes ensure harmony by departing from the colours of the objects drawn, though harmony and truth to the original colours *can* be had when an artist concentrates on getting it, as I did here. The two background pillars with the mirror centred between them – a mirror reflecting branches of winter trees outside the window *facing* Stephen – give the picture a symmetry pleasantly contradicted by the sitter on the right of the mirror and the still lives on the left.

On receiving this portrait Stephen commissioned a sketch of his girlfriend Katherine, also a Glasgow University student. She is drawn on the sofa in the painting. They married, moved to London, and eighteen years later commissioned this portrait of their son, drawn in the Glasgow home of his mother's parents. He is drawn in ink, his skin left the colour of the paper, and the tone made convincing by the adjacent areas of watercolour and acrylic paint.

Seven years after that I drew their daughter, again in the home of her grandparents. Katie is drawn in pencil, her hair tinted with wax crayon pencil. The other colours are acrylic, excepting her skin which is painted in oil which I applied with great care, fearing to lose her delicacy.

Many children cannot stay still for a portrait unless I sit by a TV set and draw them watching a programme. All the Dandos were patient sitters and I completed their portraits quickly, even the oil painting of Stephen, though I usually take a long time to finish pure oil paintings. That medium is so versatile that there are too many ways of getting it wrong.

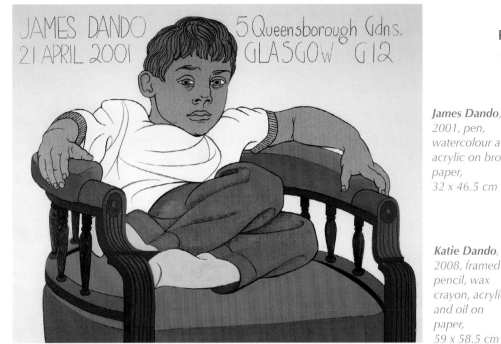

James Dando, 2001, pen, watercolour and acrylic on brown paper, 32 x 46.5 cm

Katie Dando, 2008, framed pencil, wax crayon, acrylic and oil on paper, 59 x 58.5 cm

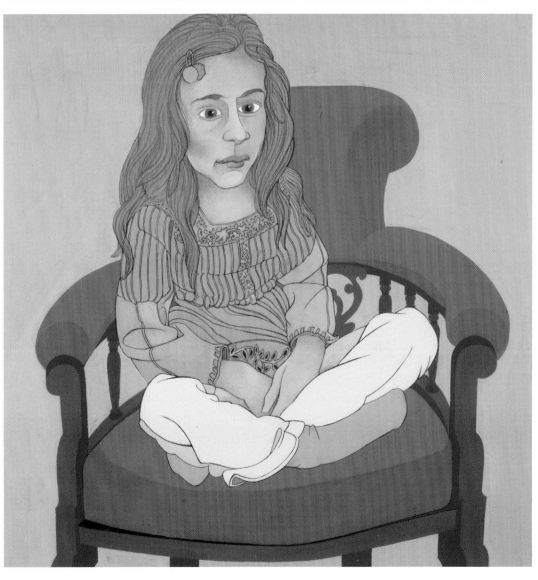

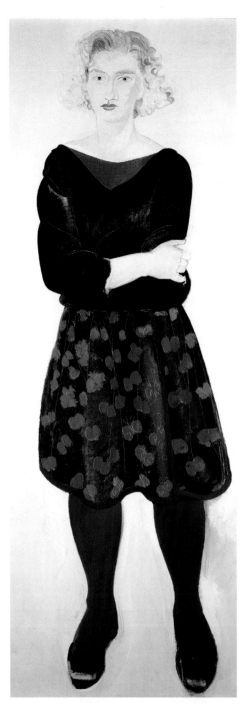
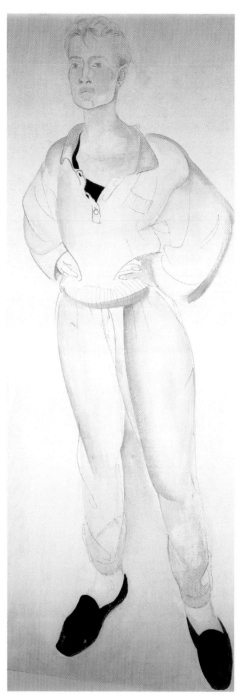
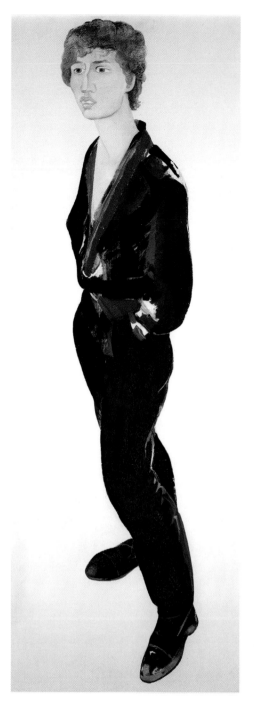

***Three Sisters: Andrea, Karen & Rhiannon Williams**, 1985, oil on board, each board 112 x 45 cm*

When Mr and Mrs Williams commissioned portraits of their three daughters on three separate panels, I decided to work in oils from the very start, painting boldly with the brush after scribbling very few guiding pencil lines. The result was three colour sketches painted on three separate days, which I meant to *work up* into three solid portraits. The care I would need to do so without destroying the liveliness of these first few strokes kept frightening me into doing other jobs instead. After a few years the parents of the girls insisted upon buying the portraits as they were.

From start to finish I took five years completing this picture of the Stansfield family, which shows I *can* finish an ambitious oil portrait of more than one sitter. Here also the colours were observed, not invented. The most difficult part was painting my own hand at work sketching the face of Pat Stansfield, and the top of the easel holding the drawing board. Pat was an art teacher who drew my face as I drew hers.

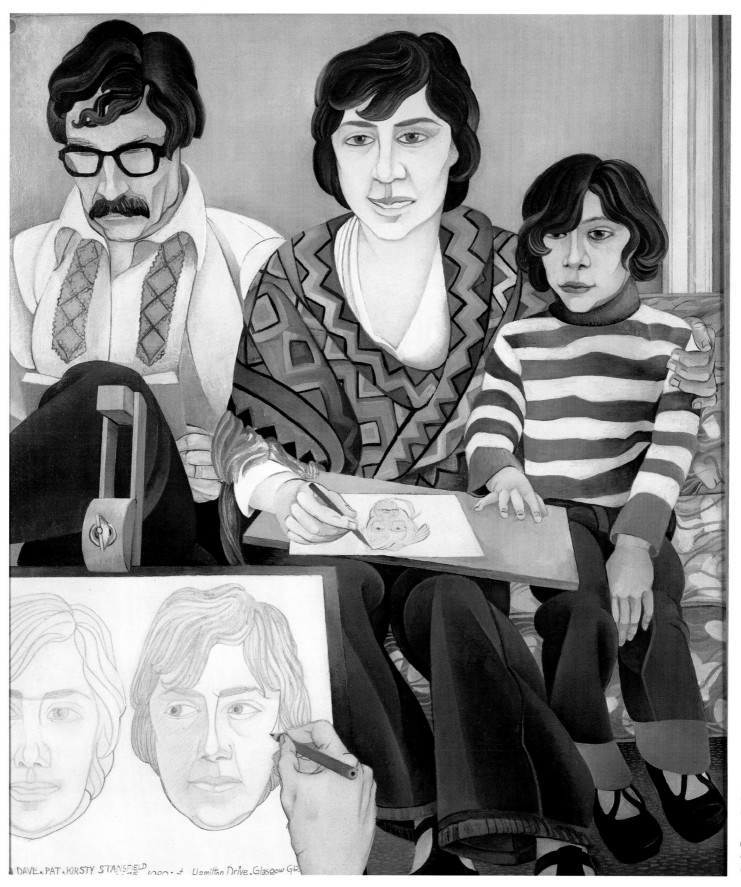

Dave, Pat and Kirsty Stansfield, 1980, oil and pencil on wood and paper, 67.5 x 58 cm

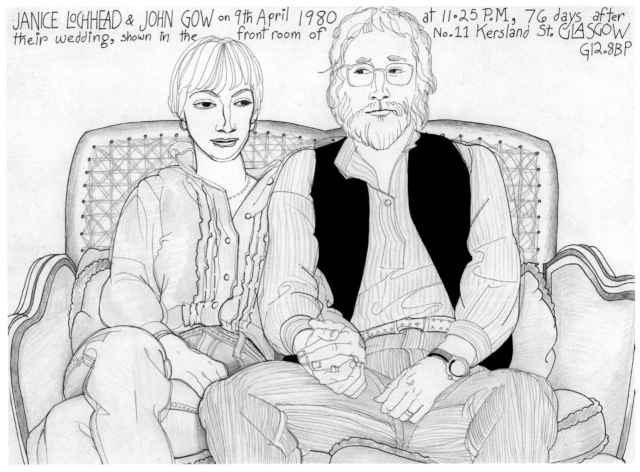

JANICE LOCHHEAD & JOHN GOW on 9th April 1980 at 11·25 P.M, 76 days after their wedding, shown in the front room of No.11 Kersland St. GLASGOW G12.8BP

Janice Lochhead and John Gow, 1980, pencil, ink and crayon on paper

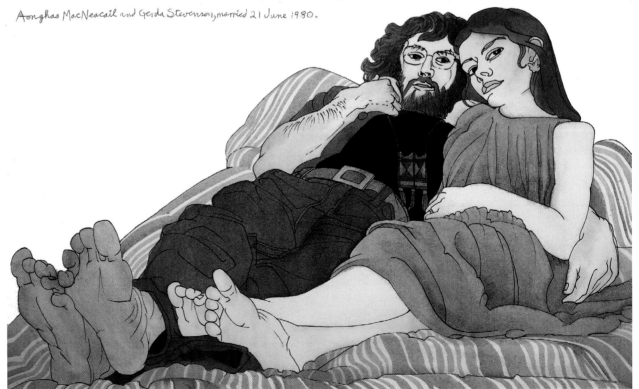

Aonghas MacNeacail and Gerda Stevenson, married 21 June 1980.

Aonghas MacNeacail and Gerda Stevenson, 1980, ink and watercolour on paper, 37 x 61 cm

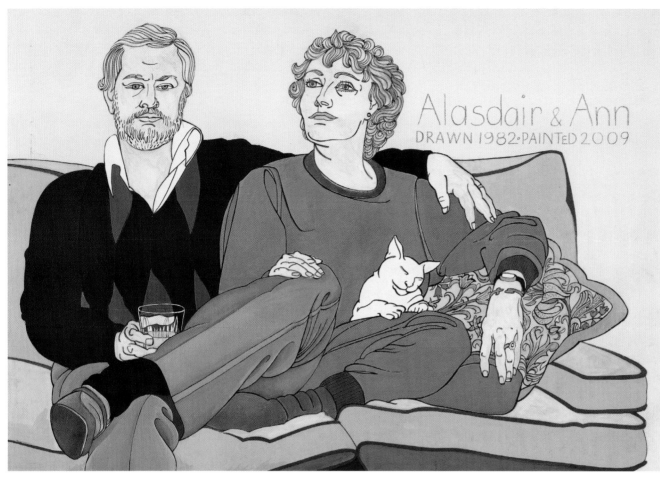

*Alasdair and
Ann Hopkins*,
*1982–2009,
ink, acrylic
and oil on
paper,
48.2 x 69.8 cm*

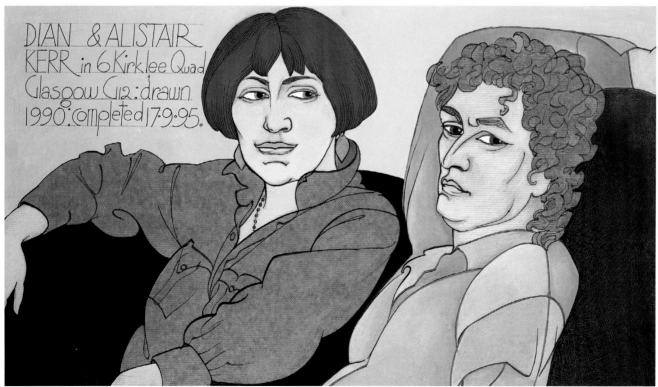

*Diane and
Alistair Kerr*,
*1990–95, pen,
acrylic and oil
on paper,
37 x 66 cm
(With
apologies
for omitting
Diane's final
E.)*

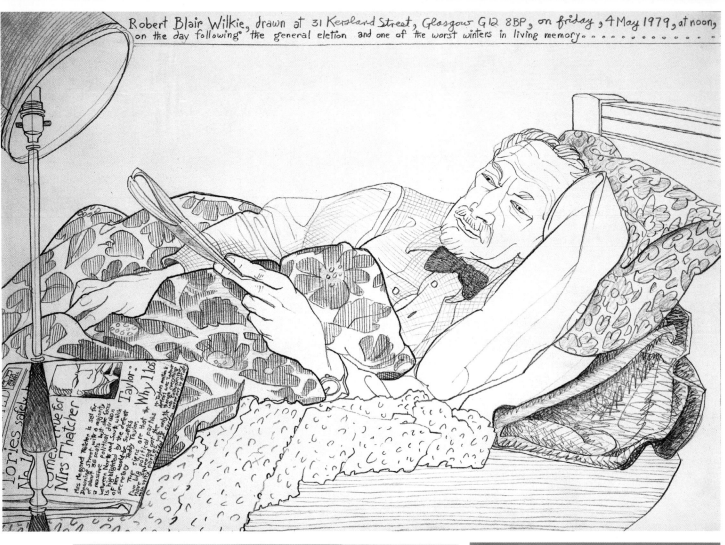

*Robert Blair
Wilkie*, 1979,
pencil on brown
paper,
41 x 63.5 cm

Professor Ross Roy,
1994, hand-tinted
photoprint,
28.5 x 28 cm

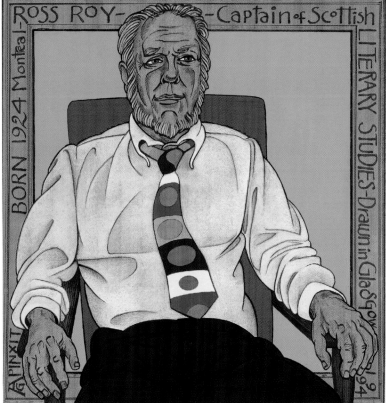
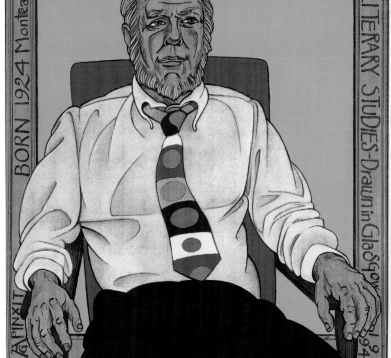

Portrait of Walter Cairns,
1995, acrylic and pencil
on paper,
40 x 30 cm

robert copstick 23d.jan.2000

DANIEL LYNCH FROM HIS CHILDREN

Portrait of Robert Copstick, 2000, acrylic, crayon, oil and pencil on board

Dan Lynch: Seventieth Birthday, 1993, acrylic, ink, pencil and watercolour on brown paper, 46 x 21.5 cm

TEACHER, HISTORIAN, POET, ANGUS CALDER, 1942–2009, in an Edinbourg care home where he died. & is here murmuring recollections of Nairobi University.

Teacher, Historian, Poet: Angus Calder, 2009, ink drawing tinted with acrylic, crayon and oil on board, 41.5 x 64.5 cm

Portraits

Small Boy Sleeping (Stuart MacLean), 1970, ink drawing with watercolour and acrylic on board

Jonathan with Lego in Kitchen, 1973, pencil, watercolour and acrylic on brown paper, 50.5 x 38 cm

Michael Leonard Drawing a Portrait of Stephen Leonard by Candlelight, 1981, pencil on brown paper

Lily Scarlett Wheatley, 2010, pen, acrylic and varnish tint on brown paper, 32.5 x 25 cm

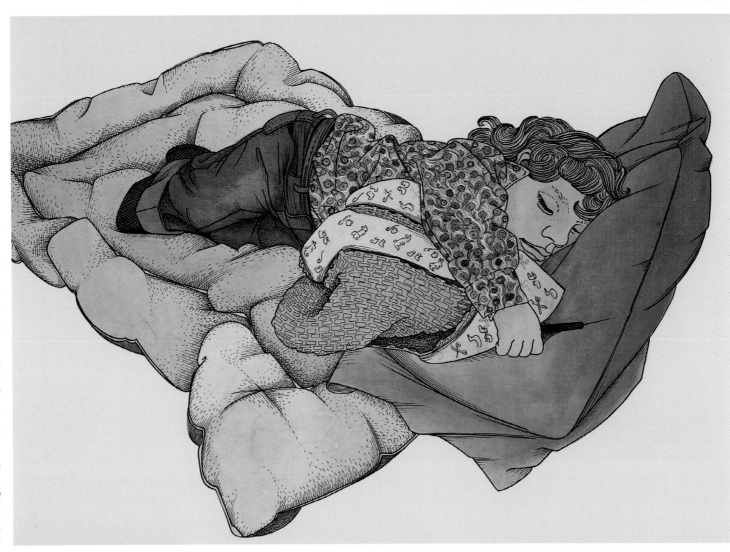

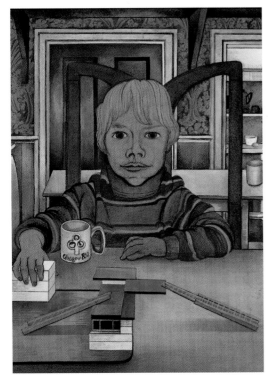

The McGurn Children: Mercedes, Karen & Damian, 1973, pencil on brown paper, each 35.5 x 40 cm

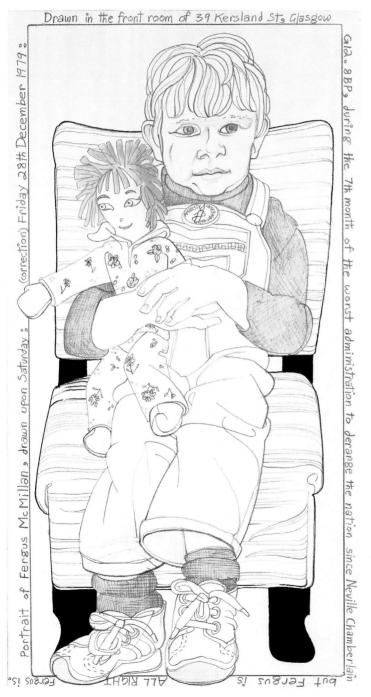

Drawn in the front room of 39 Kersland St, Glasgow

G12. 8BP, during the 7th month of the worst administration to derange the nation since Neville Chamberlain

(correction) Friday 28th December 1979.

Portrait of Fergus McMillan, drawn upon Saturday.

Fergus is. but Fergus is ALL RIGHT

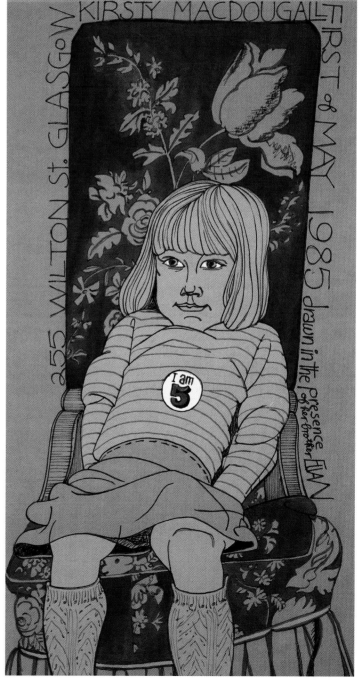

KIRSTY MACDOUGALL FIRST of MAY 1985 drawn in the presence of her brother EWAN

355 WILTON ST. GLASGOW

I am 5

Young Fergus with Doll, 1979, pen, pencil and watercolour on paper, 38 x 21.5 cm

Kirsty MacDougall, 1985, ink, watercolour, acrylic on card, 38 x 21.5 cm

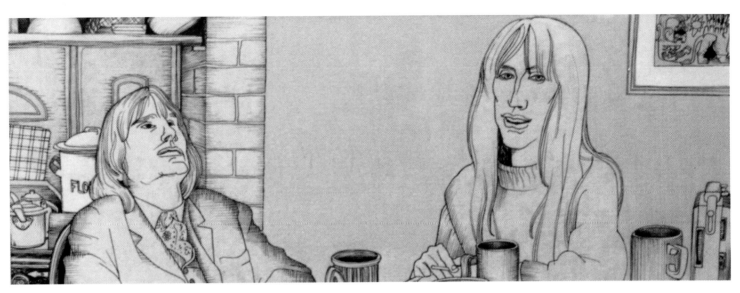

Susan Boyd and Dougie Carmichael, circa 1970, pen, crayon, watercolour and oil on brown paper, 35 x 80 cm

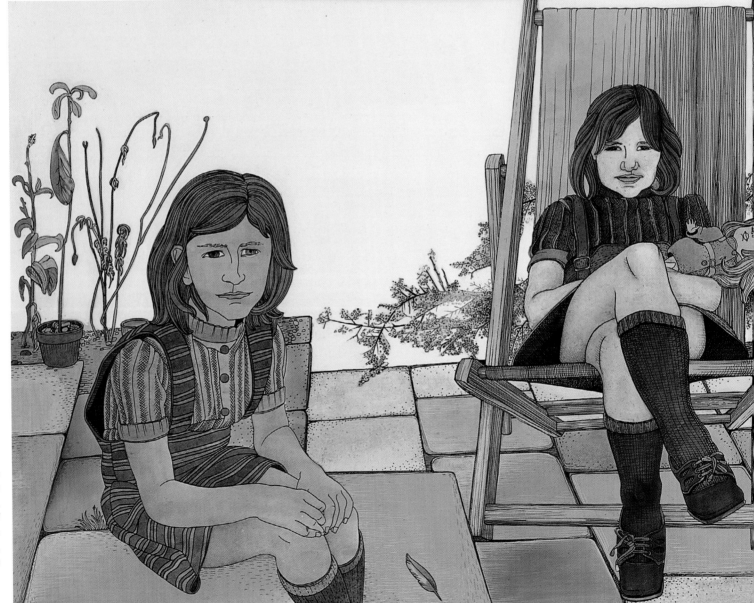

Alan Singleton and his Daughters, 1970, oil, pen and watercolour on paper, 40 x 80 cm

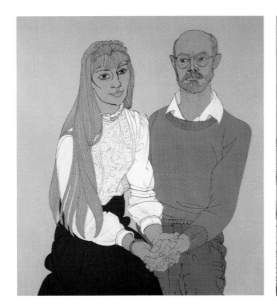

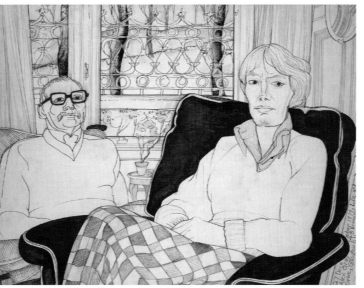

Portrait of Scott Pearson and Angela, 1995, ink with acrylic on brown paper, 59 x 60 cm

Alex and Liz Gray in Broomhill Drive, 1979, ink, pencil and watercolour on paper, 40 x 60 cm

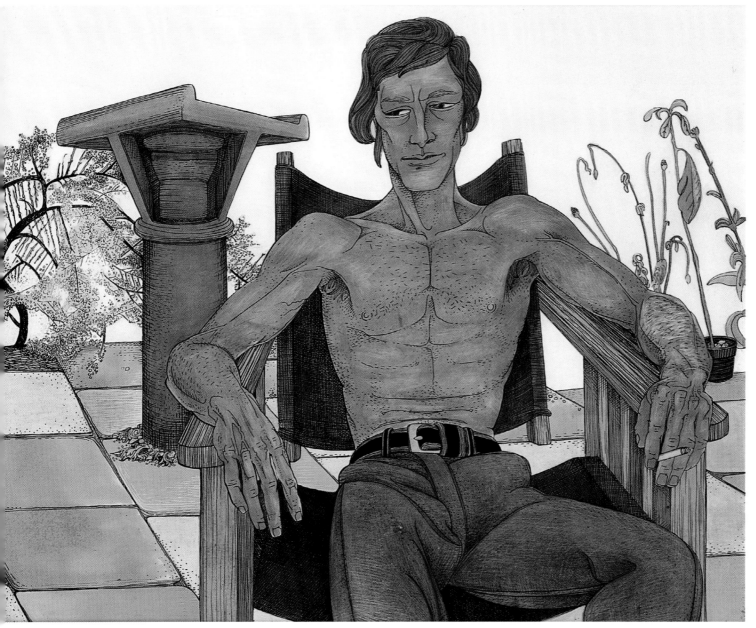

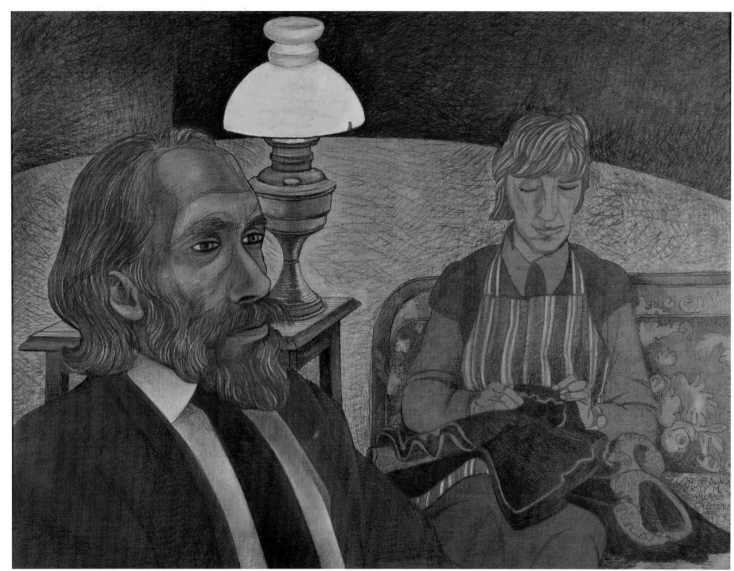

*Leslie Duncan
& Kirsty
McFarlane in
their Carluke
Cottage*, 1974,
*pencil, crayon
pencil, pen and
watercolour on
brown paper*

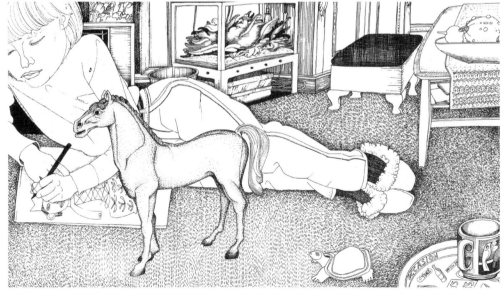

*Tracy Rolley
on the Living
Room Floor
on Boxing Day
in Stevenage*,
*1971, pen on
paper,
25 x 40 cm*

Many of my portraits have no obvious
atmosphere or hint of a time of day,
being painted in my studio without the
cast shadows loved by Miss Dick. The
above picture has all these things, being
drawn on one evening and coloured on
a second visit soon after. Leslie (called
Dan by friends) was an artist, Kirsty an
art teacher, also a fellow student in Miss
Dick's class. Though lacking tones I think
the line drawing of my niece Tracy does
suggest a quiet atmosphere. Through my
own fault, this picture vanished with
four others after a 1970s Glasgow Group
show. I hope it was not destroyed, and
that someone owns it.

Ten: My Second Family, 1961–64

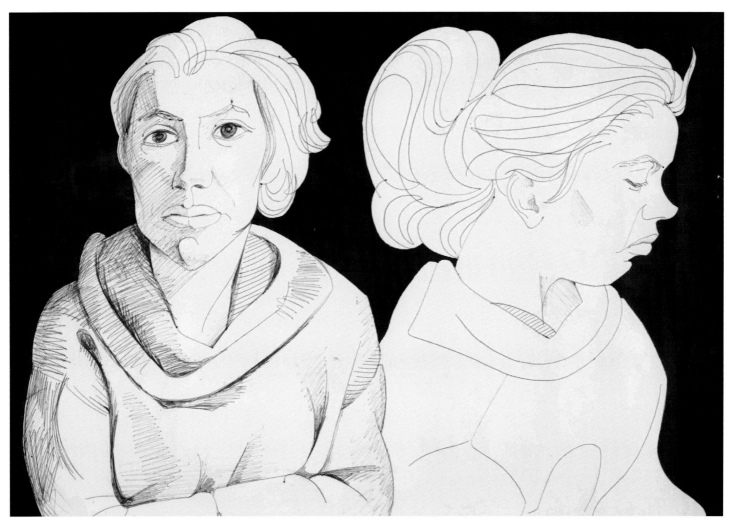

Two Views of Inge, 1961, ballpoint pen on paper, 60 x 75 cm

A RECENT BIOGRAPHY suggests that a headstrong Danish teenager decided to marry me after a short love affair because, unlike Scottish and English women friends who had rejected my proposals, she saw me as "a rising man" at the start of a prosperous career. Some of my Festival Late cabaret turns (not all) had amused audiences containing Albert Finney, then playing Luther in John Osborne's play, and members of a famous Oxford revue. Also William Gray, lawyer and Glasgow Labour Councillor, had spoken of giving me a mural commission. He abandoned that idea when I returned to Glasgow and my career as entertainer ended. I was no longer a teacher, Inge no longer a nurse, so we were penniless almost at once. After filling in our marriage licence Inge had at least a fortnight to change her mind about the wedding and return to her very tolerant parents in Denmark. On the day of the marriage in Martha Street Registry Office we bought (if I remember right) the wedding ring from a jewellery shop on George Square, using money Inge had received from her parents that morning. The money may also have paid for our honeymoon in Arran, where we stayed in Michael Gill's cottage on a hillside above Whiting Bay. In late December I took a portfolio of my best life drawings to friendly teachers at Glasgow Art School, begging them to buy one for whatever money they could afford. Two or three were bought by folk in the Interior Design Department, who kept the portfolio so that other possible purchasers could see them. When I returned it was not in the cupboard where it had been stored, so Inge and I passed a miserably poor Christmas and New Year together. I believe she married me because, being Danish, she was more socially adventurous

than most British girls, found me more interesting than men with steady jobs and more money, and knew I would never coerce her. We quarrelled, often for reasons I hardly remember now, but she never tried to make me work for money at jobs I disliked. However, thinking it my duty to support my wife at home (for in those days most married men did that) I became a full-time art teacher in the Sir John Maxwell School, Pollokshaws. Inge at first believed she could live happily with me in the house my father rented and shared with us when not guiding hill-walkers, but on taking a holiday with her Danish parents in the summer of 1962, said she would not return to Scotland if it was not to a home of our own. This was the only time she ever threatened to leave me, and I was able to provide us with a new home. I suddenly remembered that, legally, I already had one.

A year earlier two artistic friends had found a four-room-and-kitchen flat they wished to rent in central Glasgow, but the factor insisted that the main occupier must prove he had a steady job. Neither could do this so they asked me – then a qualified schoolteacher with letters that proved it – to undertake the lease in return for the use of a room I could use as a studio whenever I liked, without paying rent myself. This came to pass, though I never used the room nominally mine until finally shifting my

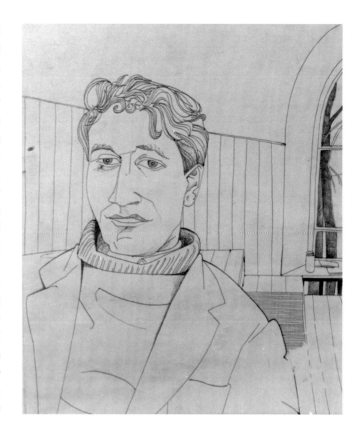

Steve Gill: St Columba's Workshop, Whiting Bay, 1960, pen on blue paper, 30 x 21 cm

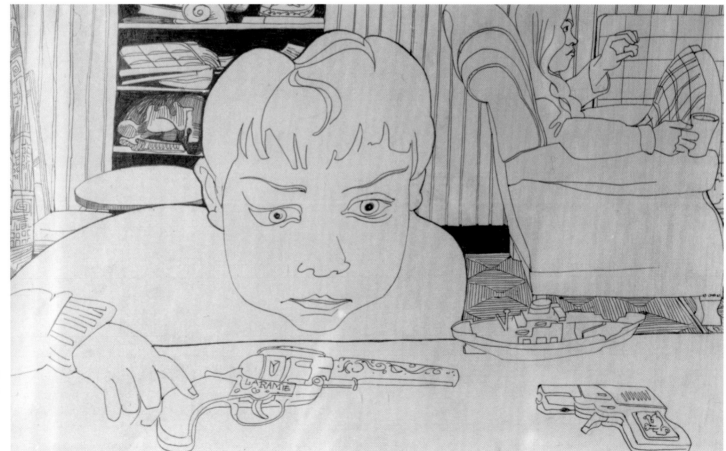

Ominous Child with Gun: Whiting Bay, 1961, pen on blue paper, 21 x 30 cm

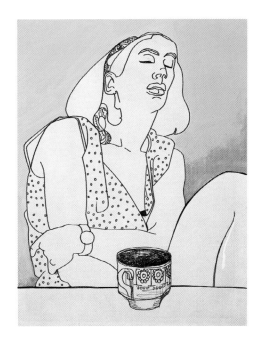

books and other possessions into it on leaving 11 Findhorn Street. Dad also left it with no sign of regret, moving his own favourite possessions to Carbeth, in one of those comfortable huts between the Stockiemuir and Craigallion Loch. Others used their hut as a weekend home, he as a residence between part-time work for the Holiday Fellowship and Scottish Youth Hostels Association. My sister, now a married schoolteacher with a home in Aberdeen, also took loved articles from our birthplace. She and I felt slightly sad in leaving it for ever, but only I was sure that from now on intense nostalgia for Riddrie would overwhelm me whenever I read that name on the front of a tram or trolleybus.

I was wrong. On my first night in the top flat that would be our new home on the hill between Charing Cross and the Cowcaddens, I felt a freedom that had been missing from my life, probably since Mum's death had cast a kind of shadow over 11 Findhorn Street. Bringing me out of that shadow was the first great thing Inge did for me.

Inge's fierce look in the portrait below may not have been directed at my friend, the artist John Connelly, though I drew them together in the same twenty or thirty minutes. It may have been caused by words I said just before I drew her.

Before flitting to Hill Street I had painted one new mural.

Inge with Teacup and Yellow Background, 1963, pen, acrylic and watercolour on paper, 34.5 x 26.5 cm

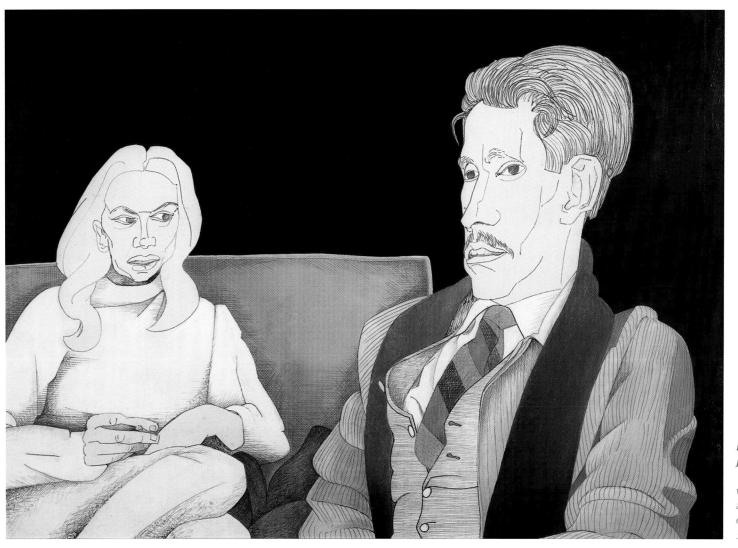

Inge Gray and John Connelly, 1963, pen, watercolour, acrylic and oil on newsprint, 52.5 x 74.5 cm

***Story of Jonah:
280 West Princes
St, Glasgow***, *1961,
restored with added
detail 2002, mural*

There had been a housewarming party in the new home of George and Rosemary Singleton. There I had cut my hand on a broken wine glass, staining with blood their pure white bedroom wall. I offered to hide it under a design which became my wedding gift to them, painted on the wall without first sketches or drawing. The big fish was made first in the middle and I easily composed the rest starting at the top left hand corner with a God who looked a bit like my dad, then going on right round until I had told the whole story in numbered quotes from the Bible, ending with Jonah fainting beside the withered

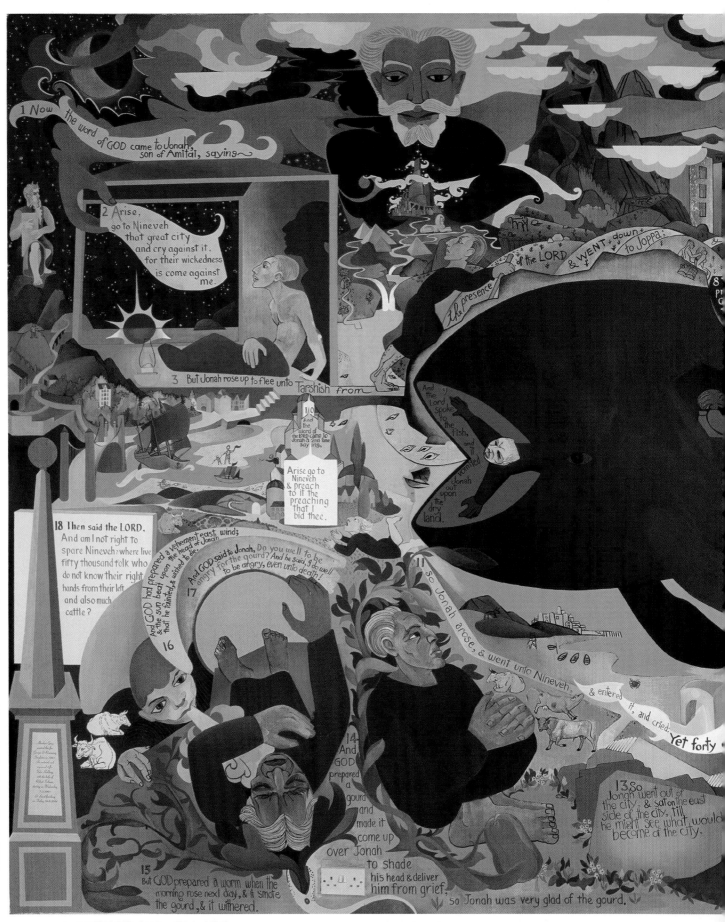

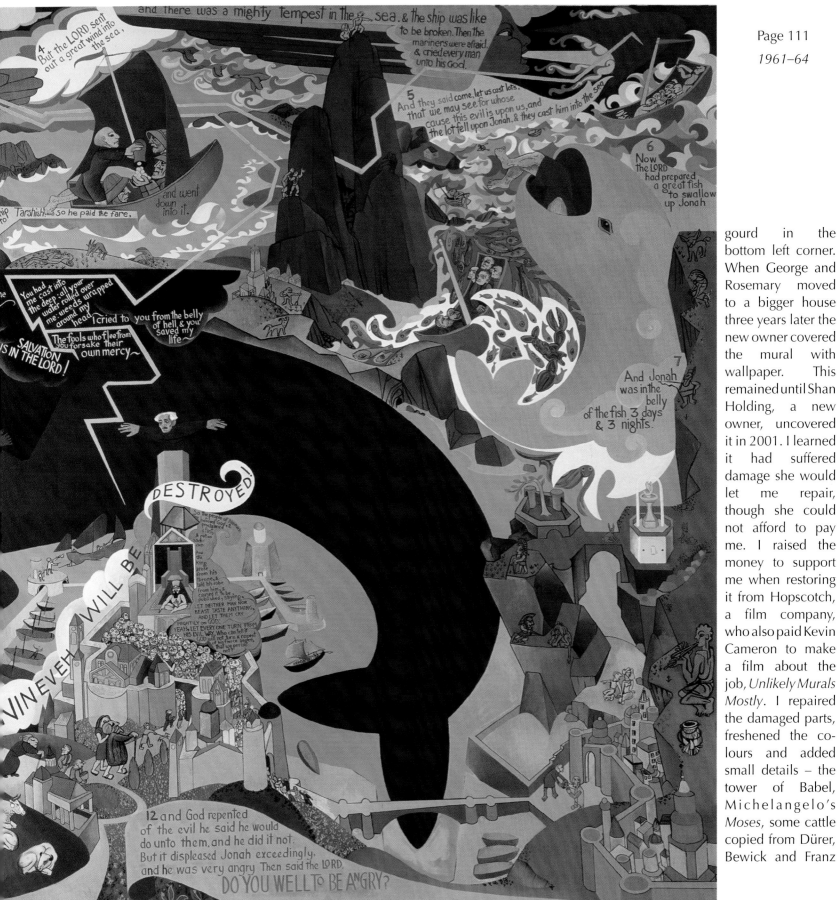

gourd in the bottom left corner. When George and Rosemary moved to a bigger house three years later the new owner covered the mural with wallpaper. This remained until Shan Holding, a new owner, uncovered it in 2001. I learned it had suffered damage she would let me repair, though she could not afford to pay me. I raised the money to support me when restoring it from Hopscotch, a film company, who also paid Kevin Cameron to make a film about the job, *Unlikely Murals Mostly*. I repaired the damaged parts, freshened the colours and added small details – the tower of Babel, Michelangelo's *Moses*, some cattle copied from Dürer, Bewick and Franz

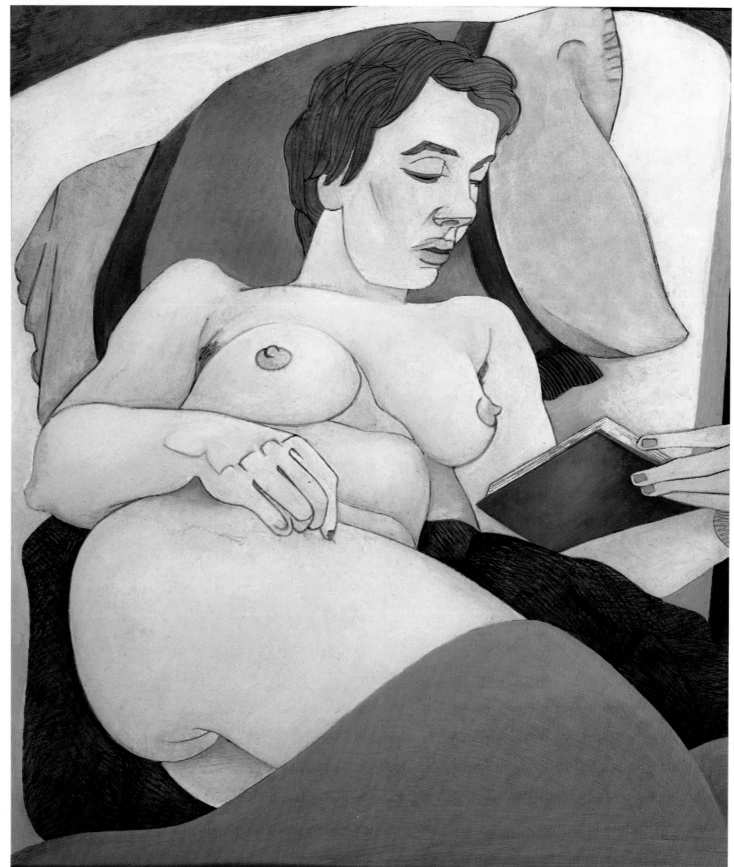

**Inge,
Pregnant,
Reading Saul
Bellow's
Herzog**,
*1963, oil and
pencil on
paper,
43 x 36.5 cm*

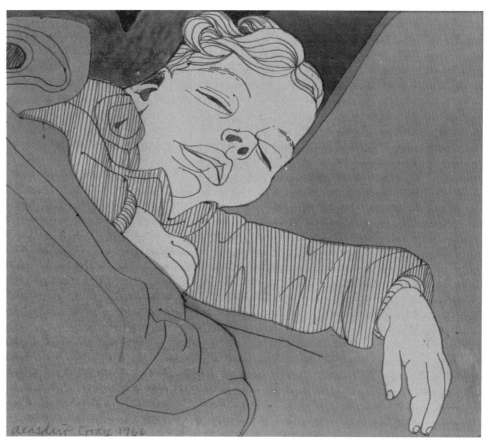

and paint big areas of canvas flats and backcloths, even though they would be painted over by later artists. Inge never complained about the lower wage I now earned, or about the even more hand-to-mouth way we survived when the scene-painting stopped. Most Scots or English wives would have kept me steadily and unhappily supporting them by forcing me back to teaching. Inge never quarrelled with me about the smallness and irregularity of our money. I became an unemployed scene painter in 1963 because the Pavilion began ordering new scenery from an English firm. After working a few months for the Citizens Theatre I was sacked in the week my son Andrew was born. His birth was the second great result of marrying Inge. I registered as an unemployed scene painter at our Sauchiehall Street Labour Exchange where my teaching qualifications were unknown. There were now no vacancies for scene painters in Scottish theatres so for a year

Andrew Sleeping, *1966, pencil and ink on paper, 41.3 x 38 cm*

The Seventh Day after Creation, *1959–62, oil on cardboard, 65 x 34.5 cm*

Marc. I was now happy to have a home with Inge in central Glasgow, but also miserable because full-time teaching stopped me working much as an artist. I think most of my pupils found me a good teacher, but many classes had one or two disruptive pupils who forced me to bully them, which I loathed. Our Hill Street flat was shared with Graham Noble, a former electrician whose hobbies were painting and mountaineering. He had the gift of finding more interesting jobs for which he sometimes needed the help of friends. Later he became a hill guide, manager of a playground for deprived youths, a house restorer, ceramic salesman, photographer, publicist for a dance company and more. In 1962 he was employed by the Glasgow Pavilion Theatre to paint scenery and, needing an assistant to design and paint cloths for the pantomime *Dick Whittington*, got the stage manager to employ me too. I was glad to stop disciplining kids

Greenhead Church of Scotland Mural: Six Days of Creation, 1959, emulsion and oil on plaster, photographed circa 1972

Greenhead Church of Scotland Mural: Tree of Life (detail of a sloth with the artist's head), 1961–3, mural detail

we lived on dole money, family benefit and the rare sale of a painting. Inge never complained because we lacked luxuries thought essential by richer folk. She liked having me at home where I could baby-sit, help with shopping, and had plenty of time to paint and write. My married life became as creative as any time before or after.

In 1963 I at last completed the Greenhead Church mural. At the service of dedication Tom Honeyman, former curator of Glasgow Art Galleries and Museum and certainly its best, spoke highly of the work, but no art critic reported it. One newspaper mentioned it because the tall Garden of Eden panel depicts Adam with a darker skin than Eve, also because I had said I was Agnostic, which produced a small **ATHEIST PAINTS GOD** headline. This monochrome photo gives a clearer view of the interior than the colour plate of the *Seventh Day of Creation* wall in chapter 8, though it was taken when the church was derelict, shortly before the demolition. Opposite and on the previous page are two later pictures derived from this mural wall with my black-coated God, the serpent with legs, creatures copied from *The Miracle of Life* and cigarette cards Dad gave me. Neither has the church's central Tree of Life with Phoenix and the sloth with my face – an apology to the church folk for me not finishing the job sooner.

Brian Smith suggested I might sell work faster if I painted decorative fantasies on small chipboard panels. I

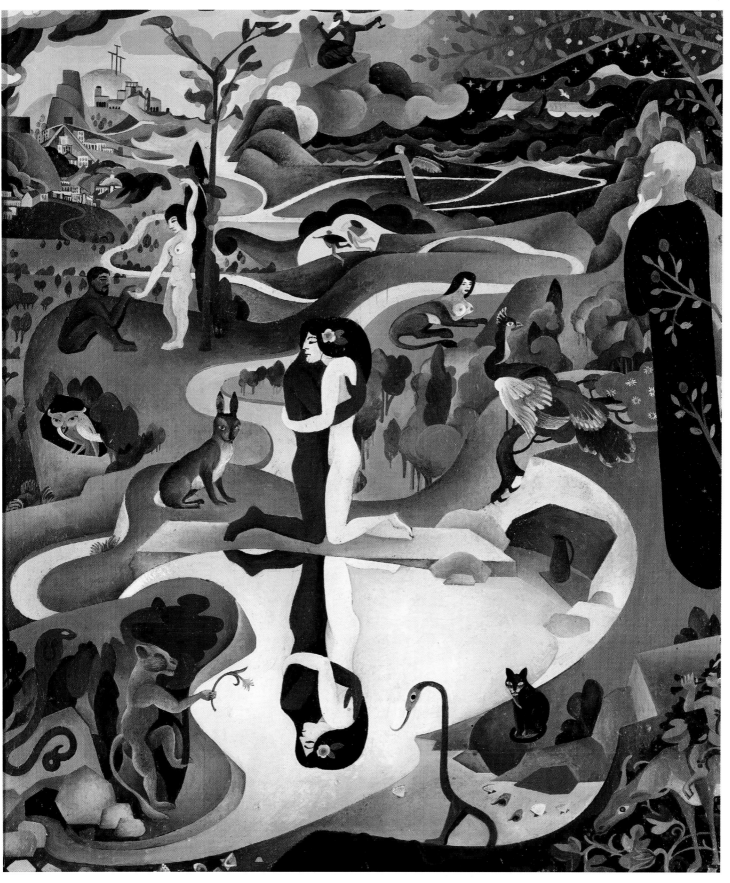

Eden and After, *1966, oil on board, 38 x 28 cm*

Page 116
My Second Family

Small Dragon, 1964, oil on chipboard, 30 x 55 cm

Round the Square: an Architectural Fantasy, 1963, restored in 2010, acrylic and enamel paint on chipboard, 61 x 61 cm

Astrological Fantasy with Zodiac, 1963, oil on wood, 122 cm in diameter

A Charm Against Serpents, 1962, oil and acrylic wash on chipboard, in nine parts, 61 x 30 x 1.5 cm/ 30 x 30 x 1.5 cm/ 91.5 x 30 x 2 cm/ 61.5 x 61 x 1.5 cm/ 30 x 61 x 1.5 cm/ 91.5 x 30 x 2 cm/ 61 x 61 x 1.5 cm/ 30.5 x 61 x 1.5 cm/ 91.5 x 30 x 2 cm

painted some without success. *Small Dragon* is typical of them, *Round the Square* less so, but I enjoyed using heraldic colours so much that I painted bigger fantasies, mostly in oil mixed with lacquer on bigger panels. People bought these. *A Charm Against Serpents* is a collage of chipboard panels screwed onto batons at the back. These pictures were all improvized for fun and contain no profound symbols. Three serious works were begun in 1962 and '63: *Satan in Chaos*, *Northern Birth of Venus* and *Cowcaddens Streetscape in the 1950s*. Only the last was completed. It was based on sketches and ideas for the Monkland Canal picture I had given up trying to paint as a third-year art student in 1955. Almost 4 feet by 8 it is still my best big oil painting. The buildings are shown accurately in relation to each other, though the road up

The Temptation of St Anthony, 1963, Indian ink and oil on wood, 43 x 149 cm

Border Ballads: Circular Panel, 1964, oil and acrylic on wood, 80 cm in diameter

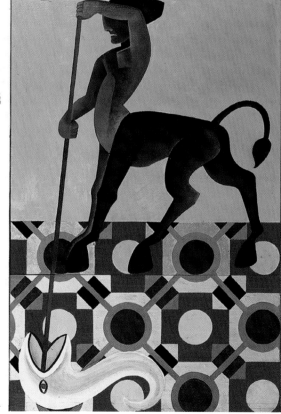

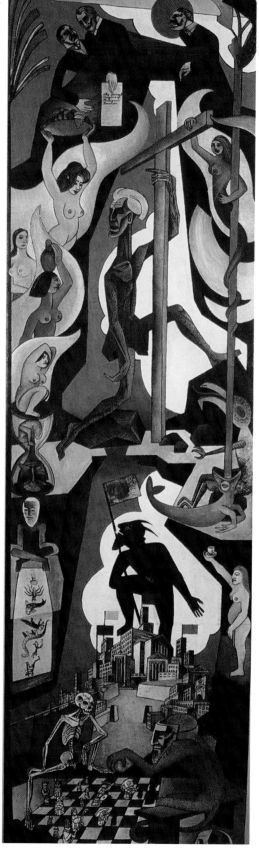

to the canal on the right and downhill on the left was actually straight, with the central road (leading to the city's destructor plant) at right angles to it, so a sliding viewpoint shows the place from Port Dundas in the north to St Aloysius Church in the south round an angle of 180 degrees. This bent perspective means that the distant gas lantern on the right and the near one on the left are different views of the same. The near electric street lamp with old man on the right are both distantly viewed on the left. (In 1955 street lighting still had a few gas lamps in proximity to electric

*Cowcaddens
Streetscape in
the Fifties, 1964,
oil on hardboard,
121.5 x 224 cm*

ones.) The picture also has a time shift. The foreground faces belong to the couple whose figures are downhill left.

Andrew Sykes, the University of Strathclyde's first sociology professor from 1967 to '89, had served his National Service as a sergeant in Britain's Indian Army before being becoming a mature student at Glasgow University, which estimated his undergraduate work so highly that it awarded him a doctorate. Sometimes pugnacious to others, to me for over 20 years he was a friend and most generous patron. He bought *A Charm Against Serpents* and the *Cowcaddens*

Streetscape on sight. Behind him as shown here in his Strathclyde office, the foot of the latter painting appears on a filing cabinet with the lower part of the terracotta head by Alan Fletcher, fully shown in chapter 6. Andrew bought the head from Alan's parents on my advice. During my marriage and long after I would go to Andrew when in financial trouble and offer a picture at a price he always accepted, paying me at once. Finally he owned at least 20 of my best pictures, most of them stacked hard against each other on the

filing cabinet behind the streetscape. His office in the Livingstone Tower was beside the Collins Gallery, Strathclyde's exhibition centre. In 1974 Andrew arranged for my first retrospective show there. It was opened by Glasgow's Lord Provost, William Gray, later knighted by Margaret Thatcher, and like most Glasgow art shows its only public notice was a small article in the *Scotsman*, a slightly bigger one in the *Herald* where Emilio Coia spoke kindly of it, but was surprised to see so young an artist having a retrospective show. (I

was only 39.)

In 1963 I was employed to teach art appreciation by Martin Baillie, head of Glasgow University Extra-Mural Department. Twice weekly for 20 weeks I travelled to west of Scotland towns and gave lantern-slide lectures on painting to classes of housewives and retired people. Those in the Paisley Liberal Club and Uddingston Public Library were near home, those in Dumfries and Moffat were more luxurious, with long railway journeys, meals and nights in pleasant family-owned hotels. All

Professor Sykes in his Office, 1970, watercolour and oil on paper, 38 x 50 cm

Homage to Pierre Lavalle, 1971, ink and watercolour on paper, 30 x 42 cm

this and a salary came from the British Welfare State, which was boosting public education with generous grants. Other painters whose art Martin Baillie helped by employing part time were Tom MacDonald, Alasdair Taylor, John Connelly and Pierre Lavalle, whose individual techniques were also rejected by more official establishments. Each deserves an illustrated chapter to themselves but there is no room.

Pierre is shown above in his room-and-kitchen flat on the Maryhill Road, part of a now long-demolished tenement. He said he was born in 1918, son of a Belgian mechanic and Scots mother, but had grown up in France. Coming to London in 1938, in the Wheatsheaf pub, Soho, he had mingled with anarchist writers and painters: Emma Goldman,

Herbert Reid (with whom he quarrelled), and the novelist Ethel Mannin, who nicknamed him Pierre Lavalle. I think nobody in Glasgow knew his real name after his arrival here in the mid 1940s, apparently living by small civil service or part-time jobs while spending a lot of time in cafés and tearooms, talking with painters and art students about art and ideas. His eloquent love of these was as rare in Glasgow as the beret he wore. For over a century every creative artist has had to forge their own unique style or imitate someone else. In those days informed Scottish art criticism hardly existed, so from Pierre several students were introduced to modern ideas from abroad that their teachers rejected. For a year or two in the early 1960s he had a page in the monthly *Scottish Field*,

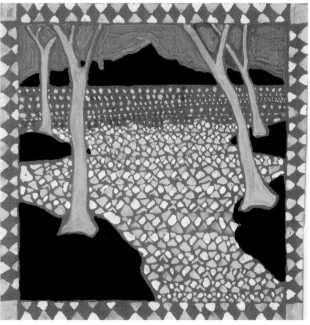

Solitude over Loch Caron, Pierre Lavalle, 1975, gouache on paper, 18 x 18 cm

where he discussed the works of young innovative artists with colour plates of them. He showed my Glasgow *Triumph of Death* and, before they left for London, abstractions by Douglas Abercrombie and Fred Pollock. His own modest semi-Pointillist paintings are sometimes seen in Glasgow living rooms, though he seldom sold one. He had a supportive wife and daughter, both unable to live with him because, though completely harmless, he was often infuriating.

I had no telephone in 1963 when I received a telegram from Bob Kitts with a London number where I should phone him, reversing charges. Bob had now a job in BBC Arts broadcasting after graduating from London University Film School. The BBC had only two television channels, no producers there thought commercial TV worth competing with, so the quality of its productions was best in the world. Huw Wheldon, head of documentary and music, was largely responsible. Like Lord Reith, the BBC's founding governor, he thought broadcasting should provide more than popular entertainment. Wheldon thought it should also cater for "the small majority" who enjoyed fine art

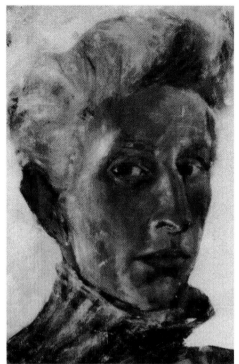

from the past and innovative art now. His support of new ideas started the careers of Ken Russell, David Jones, Melvin Bragg and others now less well known including Bob Kitts and (indirectly) me. Russell made great documentary drama about Elgar, Isadora Duncan, Delius and other great artists. Bob had interested Wheldon

in a series of films about unknown artists who, Bob thought, deserved to be known. If Wheldon approved of me, I could be one of those. For a while, at BBC expense, I enjoyed the company of Bob in air flights, taxis, meals in posh restaurants and talking as an equal to Huw Wheldon. The film was made despite me not letting my private life be a part. I refused to be shown eating with Inge and my infant son as if a large crew of BBC technicians were not in the room. Inge agreed, saying she would act Lady Macbeth anytime, but not like an artist's nice wee wife. Nor could I pretend to paint honestly while being filmed. I wanted the film to show nothing but my pictures, with nothing on the soundtrack but my words. So Bob made my physical absence from the film interesting after the start by implying (without directly saying so) that I was dead, since artists who die young and unappreciated are popular, legendary folk. At the very end of the film this confidence trick was revealed, to the annoyance of several critics and some folk who knew me. It did not make me famous. None of the paintings I showed in a Sauchiehall Street shop during the broadcast were sold, unless Andrew

***Lights, Gravel
and Buildings,***
*Robert Kitts,
circa 1953,
gouache,
crayon, pastel*

Life Drawing,
*Robert Kitts,
circa 1955,
charcoal and
red conte on
paper*

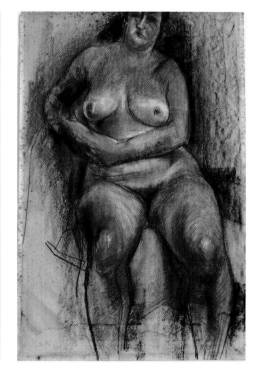

Sykes bought one, but Bob got me BBC payments that let us live for over a year without social security money (for which I was no longer eligible). The experience gave me ideas for a TV play. It was accepted and led me to a new income from part-time writing that also left me time to paint until the mid 1970s. I will make the rest of this chapter a tribute to Bob Kitts.

If he had not liked obscure people so much he would have been as well known a film director as Ken Russell. His first wife was an actress only he would employ, and when the BBC told him not to do so again he made a dramatic documentary about the life of Colette with his wife in the main part. It was never broadcast, got him sacked from the BBC, ended both his marriage and career as a British film maker. Thereafter he lived by teaching in film schools and making commercial documentaries. In 1979, in the month when Margaret Thatcher was elected and folk with large investments were holding parties to celebrate, he left for Singapore with Marlene Abrams, his second wife. British establishments usually allow able people from the right public schools at least one bad mistake, sometimes several, but Bob's accent and interests were working class.

After he went abroad we only conversed by telephone, but he always sounded lively, hopeful and full of plans, and his widow says he kept his enthusiasm until the stroke that killed him in 2002. He leaves a son, Sian, who is doing well in Australia, and more documentary films than I know of, though I admired the five I have seen, including the banned Colette film. An institution that acquired an archive of these would find their historic and aesthetic value increasing with the years. He began his career as an artist in the Swindon airbase where he was stationed as a National Serviceman. Four of his paintings from that time now belong to the Imperial War Museum. They show neglected spaces between the typical brick and concrete buildings hastily thrown up during the Second World War. Nothing dramatic is happening, but each has an air of something crucial about to happen. His figure studies and portraits give the same robust sense of a place with people. Later he set out like Seurat to combine his vision of mundane life with classical geometry. His masterpiece is a triptych painted on a six foot high folding screen showing three phases of womanhood. The orange background is sectioned into rectangular units with silver outlines. These contain first, the figure of an Edwardian mother holding a baby daughter, who secondly becomes a 1920s bride, and lastly a 1940s widow. These figures, derived from old family photographs, have the calm authority of Byzantine mosaics, yet are 20th-century English women. Bob would have become a good painter had he made that his main job. We lived well for a whole year on what I was paid by Bob's production in that golden epoch of BBC television. *Under the Helmet* (as he called the film) did not boost my sale of pictures, but enabled me to buy enough paint and brushes to last me several years, and a canvas 7 by 11 feet which I stretched on my studio wall and began covering with an ambitious view of north Glasgow which I have never since had time to complete. He used his talent in attempts to make me and other obscure artists better known, and eventually succeeded with me, a few years after his death.

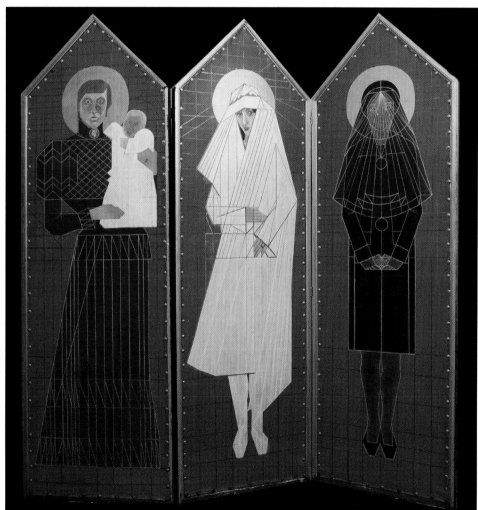

Screen Triptych, Robert Kitts, circa 1973, acrylic and enamel paint

Andrew Sleeping: 21 December 1965, 1965, ballpoint pen on paper, 20.5 x 19 cm

Inge with Flageolet (top right), 1964, pencil on paper, 42 x 30 cm

Inge with False Fingernails and Hilary with Coffee Cup (bottom right), 1965, radiograph on paper, 41.5 x 57 cm

Hilary, Andrew and Inge (right), 1964, tinted with wash

Kitchen 158 Hill Street: Hilary with Alasdair Taylor and Andrew Gray (below), 1964, pencil, watercolour, acrylic and oil on board, 52.2 x 63.5 cm

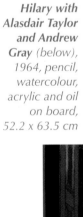

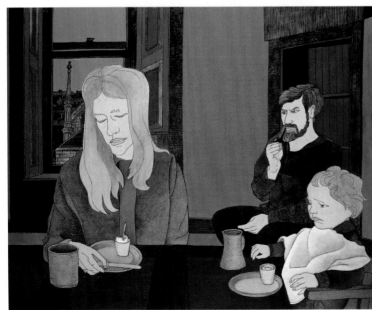

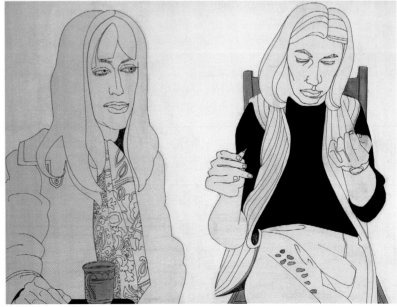

Eleven: My Second Family, 1965–70

OUR TOP FLOOR flat in 158 Hill Street had a ground floor flat beneath it, number 160, for the front door was on the street. Our landlord owned 160, renting it to a likeable lady, Mrs Peterson, who sub-let rooms to lodgers. In 1965 one went mad, murdered her, tried to burn the flat then gave himself to the police. Soon after, Inge, Andrew and I flitted to 160 as it had twice as many rooms. We were not superstitious, loved this more spacious home, also got money by sub-letting to lodgers.

The kitchen where I drew this picture was in a basement at the back of the house, but the steep hill behind let us see across the roof of the nearest building, a church on Buccleuch Street – on clear days we could see the top of Ben Lomond as well as from the

Andrew and Inge at the Kitchen Table: 160 Hill Street, 1966, ink on paper, 52.2 x 63.5 cm

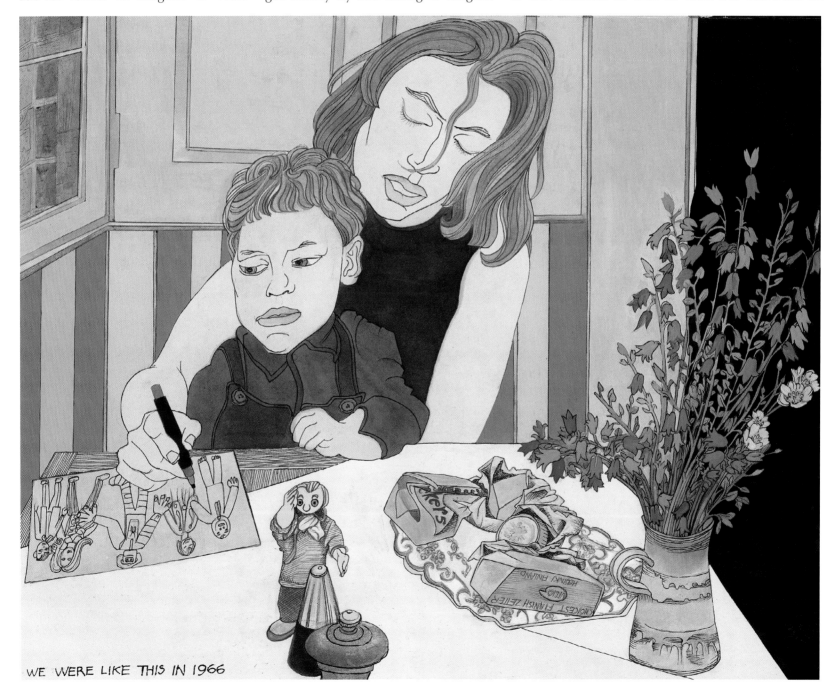

WE WERE LIKE THIS IN 1966

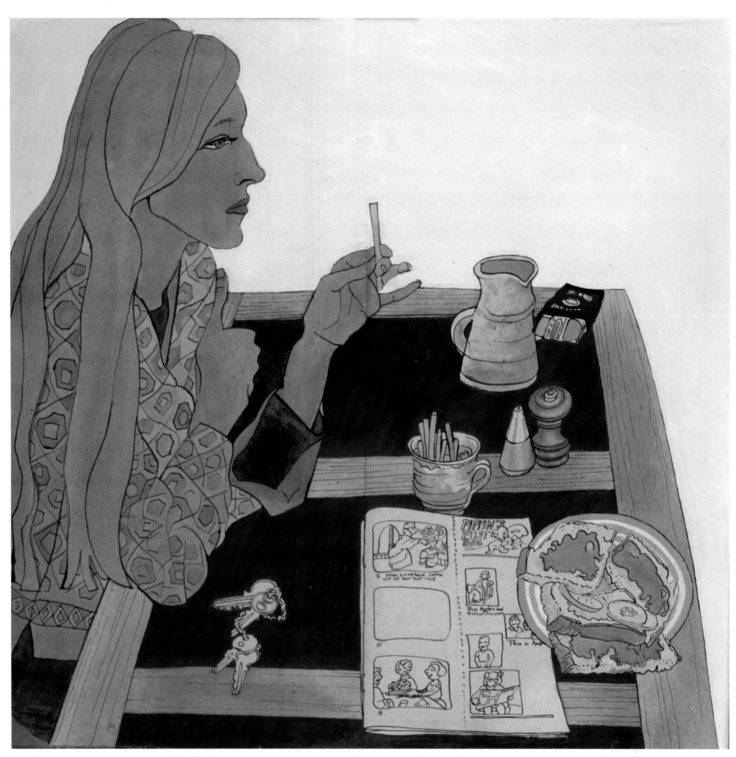

Spring Onions,
*1967, ink, acrylic
and watercolour
on paper,
40 x 40 cm*

top flat in 158. Our flitting happened when prosperity seemed dawning. London BBC Television had bought my 50-minute play *The Fall of Kelvin Walker*, after which Stewart Conn began commissioning half-hour radio plays for Scottish BBC. We enjoyed our spacious new home for nearly three years before it was demolished. *Kelvin Walker* was broadcast in 1968 and at a party afterwards I met Marion Oag and fell in love with her. She was used to having this effect on men, did not greatly value it, but liked both me and posing for me. Inge was not jealous of women I painted so my love of this tall, blonde, beautiful woman did not make my marriage stormier. Before Marion moved to London in the mid 1970s I often drew her. She seemed to be the heroine of a great

Marion Oag with Lucy Ashton, *1968, ballpoint, watercolour and acrylic on brown card, 26.5 x 37.5 cm*

Marion Oag with Bra and Mug, *1968, pencil on paper, 30 x 21 cm*

Susan Boyd on Nursing Chair in Basement Kitchen of 160 Hill Street, *1966, Indian ink, acrylic, oil colour and enamel on board, 80 x 55 cm*

drama that had somehow missed her. Like many of us she certainly felt that way. She became Inge's friend, sometimes lodged with her, and in 2000 returned from London to Glasgow and nursed Inge through her last months. In 2008 cancer killed Marion too.

Here is Susie Boyd, Katy's daughter, then a schoolgirl in her teens, drawn as she appeared when casually visiting us, reflecting wryly upon life while sitting on a small nursing chair in the 160 Hill Street kitchen. She looks older and harsher than she appears in both my earlier and later pictures of her. The black areas are all Indian ink, the jeans are painted in oil colour, the rug under her feet is an invention needed to give the painting a colourful foundation. Notice the roof of the Buccleuch Street church in the Cowcaddens through a corner of the bay window. The kitchen walls were grey. I had laid the floor with a pattern of white, grey and black linoleum squares, and made it black to balance the black of Susan's sweater.

Moved by Bob's TV film, George Singleton commissioned a stairwell

Page 128

My Second Family

Stairwell:10 Kelvin Drive *(view of entire mural plus two details), 1964, mural, ink on cartridge paper*

decoration for his second family home, commissioned it in black and white because he had liked the drawing of my Jonah mural but not the colours. He left me free to choose the subject, which became a brooding earth goddess drawn in Hollywood cartoon style, and uniting ideas from two Dürer engravings – *Melancholia* and *The Great Fortune*, sometimes called *Nemesis*. Around her swarm invented planets and creatures, while two armour-mutilated male figures erased from my Scottish–USSR mural, are standing with their backs to her.

Oriental Pastiche Murals, Nithsdale Road (Lobby; Living Room; Living Room with Sage and Monsters; Living Room with Moon over Landscape), 1967, mural

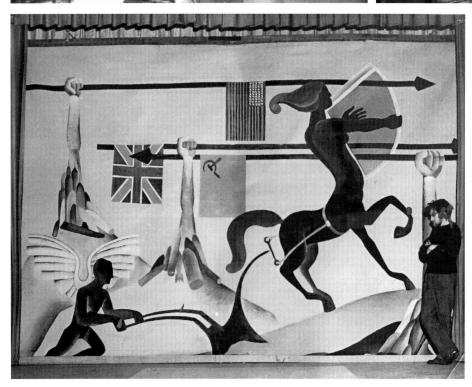

Maurice Cochrane of Rotary Tools Ltd was a businessman with a liking for Chinese images, and commissioned me to decorate these rooms for his wife around 1967, when I also painted backdrops for a big CND demonstration in one of the former Broomielaw Clydeport warehouses, and a Swords into Ploughshares conference in Dumbarton. Then one day I came home and found Pete the Poet chatting to Inge in our kitchen. I first met Pete Brown when he, Horowitz and other London poets came north to read in the 1959 Edinburgh Festival Fringe. Pete also gave a reading in the Glasgow home of a friend, and became one of mine. In 1967 he explained that he was writing songs for a popular band called Cream and had a band of his own, also a flat near one owned by The Beatles in Montague Square. Would I paint a mural in it? Since friends

CND Conference Backdrop Dumbarton: Swords into Ploughshares, circa 1969, mural

Pete Brown: Poet and Musician, 1969, pen and ink on paper, 30 x 21 cm

The Cuilt Brae Road from the Campsie Foothills, 1965, oil on canvas, 34.5 x 60 cm

Upland Road, 1966, oil on canvas, 40 x 58 cm

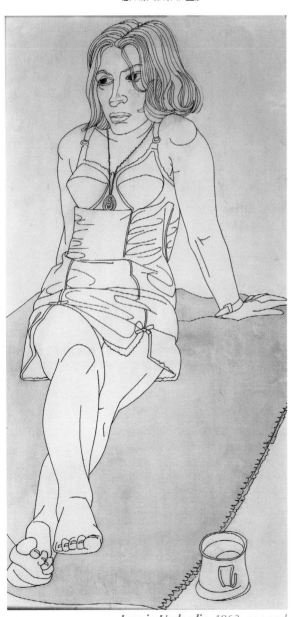

Inge in Underslip, 1963, pen and acrylic on paper, 61 x 31 cm

hardly ever paid me for my work I told him I would soon be visiting London to discuss a BBC commission, so might spend a day or two painting a panel for him. He rejected the idea, explained that he was now rich ("I'm into the really heavy bread, man") and for a mural would pay *** hundred pounds at least – I forget how many hundred but in 1967 it was a lot. He would also pay for the materials and a good sum per week for my living expenses in London, whether I slept in his flat or not, and would also provide me with an assistant.

Pete Brown's money made life easy while I painted for three or four weeks in his attic flat near Hyde Park Corner. The main room had a low ceiling. The only furniture was floor cushions and a record player, so I made it like a clearing in a magic forest, painting the walls with dryad caryatids supporting a frieze of foliage, and between them droll, slightly sinister but unthreatening things and people. At that time *The Yellow Submarine*

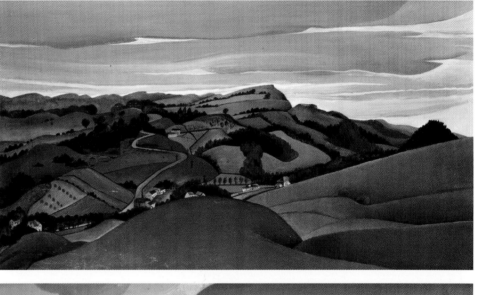

Couple: July 1967: 160 Hill St, Glasgow

In this decade I tried to make my painting known by one exhibition a year, at first by renting the Kelly Gallery, a small private one near Sauchiehall Street. Later I became friendly with Sheila Ross, adviser to the Talbot Rice Gallery in Edinburgh, who also arranged exhibitions on the walls of the Traverse Theatre Restaurant, in those middle years when the Traverse was at the foot of the West Bow. These shows never paid for themselves as I seldom sold more than one picture at each, but I annually got new pictures finished and framed for them, and some lines of mention in the *Herald* or *Scotsman* newspaper.

At the end of the 1960s many old Glasgow communities were destroyed by the building of a motorway around the city centre. The west end of Hill Street including 160 (our loveliest home) was demolished to dig a cutting for the road down to the Kingston Bridge. After Christmas 1968 we were rehoused in 39 Kersland Street, a spacious top-storey five-room-and-kitchen flat in Hillhead, between Glasgow University and the Botanic Gardens.

Couple, 1967, pen, acrylic and oil on newspaper, 42 x 30 cm

Christmas Greeting Card, 1968, ink on paper, 15 x 10 cm

was being shown so I painted one on the ceiling with a porthole in the underside through which God (resembling Thomas Carlyle) looked sternly down. (I was reading *Paradise Lost* with its farcical war in Heaven at the time.) I regret having no photograph of that mural, which must now have been papered over or painted out. Though sorry to be apart from Inge and Andrew I also felt, for a while, that London was a place where I might become rich and free.

*The Firth of
Clyde from
Arran, 1970,
oil on plywood,
17.5 x 61 cm*

Every marriage between a couple with strong, different minds involves strain, as *Couple* in the Hill Street kitchen shows. We were nearly two years in Kersland Street before the strain at last separated us. First we hired baby-sitters to let Inge return to the nursing she had left on marrying me. Meanwhile I drew, painted and finished some landscapes. On seeing the *Firth of Clyde Skyline* Inge, as if sending a friendly signal from a great distance, said it was strange that such a calm, pleasant picture was painted by someone as miserable as me. The sketches for it were made when drawing this rock on the Arran shore near Sannox. Leslie McKiggan, my distant cousin, commissioned the painting of it because her husband as a child had played there with his brother. *Firth with Flag and Obelisk* was

*The Rock
(Arran),
1967, oil on
canvas,
30 x 42 cm*

*Firth with
Flag and
Obelisk,
1968,
emulsion and
oil on board,
28.5 x 59 cm*

painted from a memory of a picnic on the coast near Largs. The foreshore and monument to the Battle of Largs are local features. The tumulus with flagpole is in Ruchill Park, north Glasgow. It flies the Saltire because Winnie Ewing (who owned my *Border Ballads* roundel) had just won Hamilton for the Scottish National Party, and I hoped she would buy this (she didn't). Years before I had sketched Brodick Bay when on a Holiday Fellowship outing, and made a painting from it when invited to donate one to a London sale in aid of South Africa's apartheid victims. The detailed land across the bay was helped by a photograph in the USA *National Geographic* magazine, taken from near the place where I had sketched. The head in the foreground did not then strike me as grotesque. The *Coast Near Kinghorn* was begun while sitting on the foreground wall sketching, on an outing with Malcolm Hood. In the 1960s the Scottish east coast still had crumbling gun emplacements built for the Second World War.

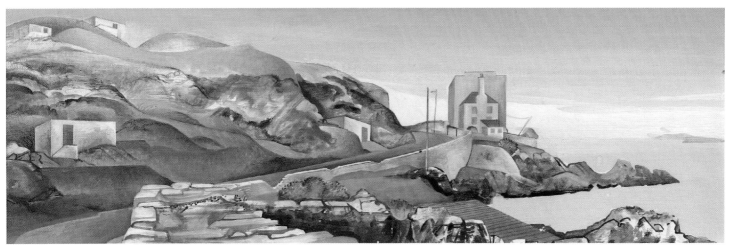

Brodick Bay from the Slopes of Goat Fell, 1965, oil on board

The Coast Near Kinghorn, 1970, oil and acrylic on plywood, 24 x 74.5 cm

*Keith, Jenny,
Mungo
and Helen
Bovey in
Westbourne
Gardens,
1966, pencil,
crayon,
watercolour
and oil on
brown paper,
100 x 120 cm*

My dad outlived my mother by twenty-one years, dying in March 1973, and I took him so much for granted that this is almost my only portrait of him. When my sister and I no longer depended on him he lived by work that paid him little but which he thoroughly enjoyed, living in Holiday Fellowship guesthouses and working as a hill guide in summer, in winter lecturing to schoolchildren for the Scottish Youth Hostels Association. He usually lived in a country hut on the Carbeth Estate and sometimes lodged in Kersland Street. My mother's sister, Annie Miller, was a kind woman with a sharp, dry wit and a genius for friendship – the sort who is called "a good neighbour". She was also a good aunt who served me a meal whenever I called on her, so she also I thought perpetual, and took for granted, and only drew once.

*Alexander Gray, 1970, ink on paper,
30 x 21 cm*

Bill Skinner in Otago Street Living Room, 1968, pencil, pen, oil, emulsion, watercolour, crayon, coloured ink on brown paper, 30 x 42 cm

Bill Skinner, Scottish Nationalist and Socialist, retired shipyard worker and laboratory assistant, still lived in the Otago Street home he had shared with his mother. It was surely the last Glasgow flat with interior gas lighting and had hardly been dusted or cleaned since his mother's death. This portrait in his living room shows three of his pictures on the wall, his pamphlet about the origins of life in the table, and through the window an obsolete railway station with beyond it Caledonia Mansions on Great Western Road. A fire destroyed the station soon after I began the portrait so I added it from imagination. Bill was cheerful company, though arthritis and psoriasis made him an invalid. He feared to call a doctor who, seeing the state of his home, might have summoned an ambulance to put him in hospital. Inge gave him a clean bed and bedroom in our flat where a doctor treated him till he was at least well enough to go home, though he did not live long after.

Aunt Annie, 1970, ink on paper, **23 x 22.5 cm**

Fashion Drawing: Dresses designed by Marion Donaldson, front and side views, 1969, ink on paper, 49 x 34 cm

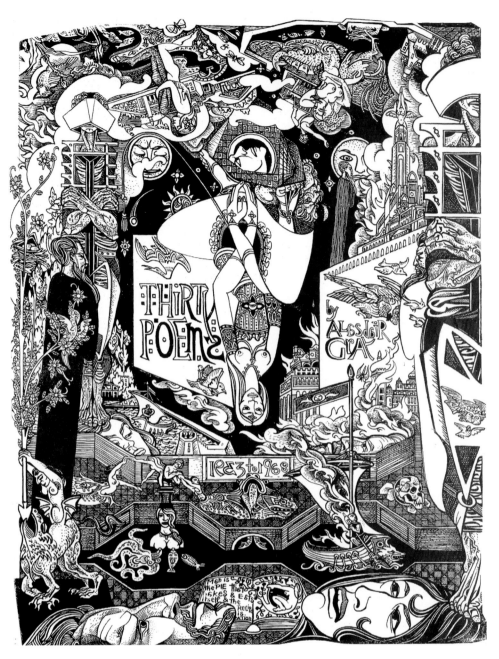

In 1969 Gordon McPherson, a former Minister of the Kirk, paid me for cartoons satirizing its pretensions, and the Scottish Arts Council paid me to make prints illustrating my verses. Seventeen designs were the result. Gordon's cartoons only became public property when, working with Glasgow Print Studio, I turned them into silkscreen prints in 2008–09. The verse illustrations also waited four decades to become prints because I used up the Arts Council grant while working on them. The original drawings were bought by Glasgow University's Hunterian Gallery, six of which are on the right. One specimen title page was reproduced by photolithography. See it above – a confused design crammed with bits from earlier drawings and murals, and partly meant to be viewed upside down. It shows how badly I work when rushing because short of money.

Thirty Poems (Title Page for an unpublished book), 1968, lithograph, 42 x 30 cm

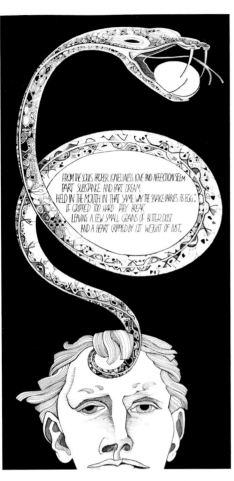

FROM THE SOUL'S PROPER LONELINESS LOVE AND AFFECTION SEEM
PART SUBSTANCE AND PART DREAM,
HELD IN THE MOUTH IN THAT SAME WAY THE SNAKE CARRIES ITS EGG;
IF GRIPPED TOO HARD THEY BREAK
LEAVING A FEW SMALL GRAINS OF BITTER DUST
AND A HEART CRIPPLED BY ITS WEIGHT OF LUST.

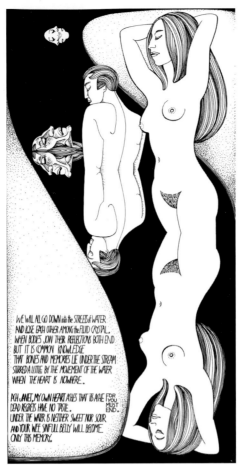

WE WILL ALL GO DOWN into the STREETS of WATER
AND LOSE EACH OTHER AMONG the FLUID CRYSTAL.
WHEN BODIES JOIN THEIR REFLECTIONS BOTH END
BUT IT IS COMMON KNOWLEDGE
THAT BONES AND MEMORIES LIE UNDER THE STREAM
STIRRED A LITTLE BY THE MOVEMENT OF THE WATER
WHEN THE HEART IS NOWHERE.

ACH JANET, MY OWN HEART ACHES THAT IS ACHE FOR YOU MUST END.
DEAD REGRETS HAVE NO TASTE.
UNDER THE WATER IS NEITHER SWEET NOR SOUR
AND YOUR WEE SINFULL BELLY WILL BECOME
ONLY THIS MEMORY.

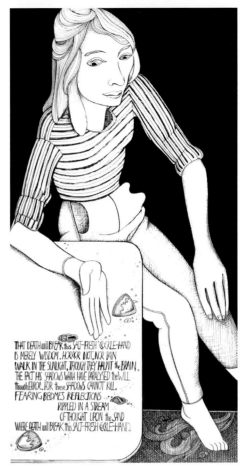

THAT DEATH will BREAK this SALT-FRESH COCKLE-HAND
IS MERELY WISDOM. HORROR NOT, NOR PAIN
WALK IN THE SUNLIGHT, THOUGH THEY HAUNT THE BRAIN.
THE FACT HAS SHADOWS WHICH HAVE PARALYSED the WILL
through ERROR. FOR these SHADOWS CANNOT KILL.
FEARING BECOMES REFLECTIONS
RIPPLED IN A STREAM
OF THOUGHT UPON the SAND
WHERE DEATH will BREAK this SALT-FRESH COCKLE-HAND.

From the Soul's Proper Loneliness, 1965, collage, black ink and pencil on paper stuck to cardboard, 63 x 45 cm

We Will All Go Down Into the Streets of Water, 1975, collage, black ink and pencil on cardboard, 57.7 x 29.2 cm

That Death Will Break the Salt-Fresh Cockle-Hand, 1970, ink on scraperboard, 58.3 x 29.8 cm

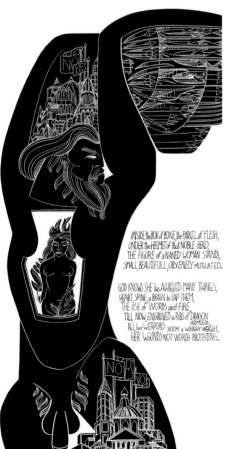

INSIDE the BOX of BONE, the PARCEL of FLESH,
UNDER the HELMET of that NOBLE HEAD,
THE FIGURE of a NAKED WOMAN STANDS,
SMALL, BEAUTIFULL, OBSCENELY MUTILATED.

GOD KNOWS SHE has ACHIEVED MANY THINGS,
HEART, SPINE, a BRAIN to CAP THEM,
THE USE of WORDS and FIRE,
TILL NOW, ENSHRINED in RIBS of DRAGON ARMOUR
ALL her WEAPONS SEEM a WEARY WEIGHT,
HER WOUNDS NOT WORTH PROTECTING.

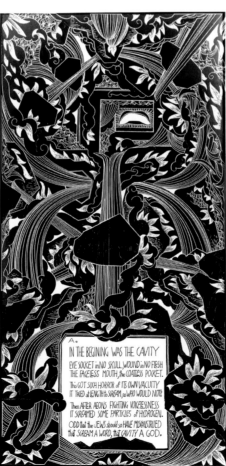

IN THE BEGINING WAS THE CAVITY
EYE SOCKET in NO SKULL, WOUND in NO FLESH,
THE FACELESS MOUTH, the COATLESS POCKET.
This GOT SUCH HORROR of ITS OWN VACUITY
IT TRIED at LENGTH to SCREAM, as WHO WOULD NOT?

Then AFTER AEONS FIGHTING VOICELESSNESS
IT SCREAMED SOME PARTICLES of HYDROGEN.
ODD that the JEWS should so HAVE MISCONSTRUED
that SCREAM a WORD, that CAVITY A GOD.

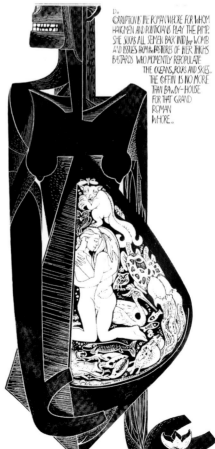

CORRUPTION IS THE ROMAN WHORE FOR WHOM
HANGMEN and POLITICIANS PLAY THE PIMP.
SHE SUCKS ALL SEMEN BACK INTO her WOMB
AND ISSUES FROM the PASTURES OF HER THIGHS
BASTARDS WHO MOMENTLY REPOPULATE
THE OCEANS, ROCKS AND SKIES.
THE COFFIN IS NO MORE
THAN BAWDY-HOUSE
FOR THAT GRAND
ROMAN
WHORE.

Inside the Box of Bone, 1965, ink on scraperboard, 63.6 x 44.6 cm

In The Beginning was the Cavity, 1965, collage, black ink, pencil and white paint on cardboard, 63.6 x 52.1 cm

Corruption is the Roman Whore, 1965, collage, pencil, black Indian ink and white paint on plastic and cardboard, 64 x 44.5 cm

*Look Before
You Leap,
Andrew Gray*,
1970, pencil,
crayon and ink
on plywood,
17 x 6 cm

*Andrew as
Red Indian*,
1969, pencil
and acrylic
on paper,
51.5 x 16 cm

*Andrew with
Stick and
inscription to
Jean Irwin, the
picture's first
owner*, 1970
(restored 2006),
pen, ink and
acrylic,
42 x 29 cm

*Viking,
Andrew Gray*,
1970, felt-tip
pen drawing,
30 x 21 cm

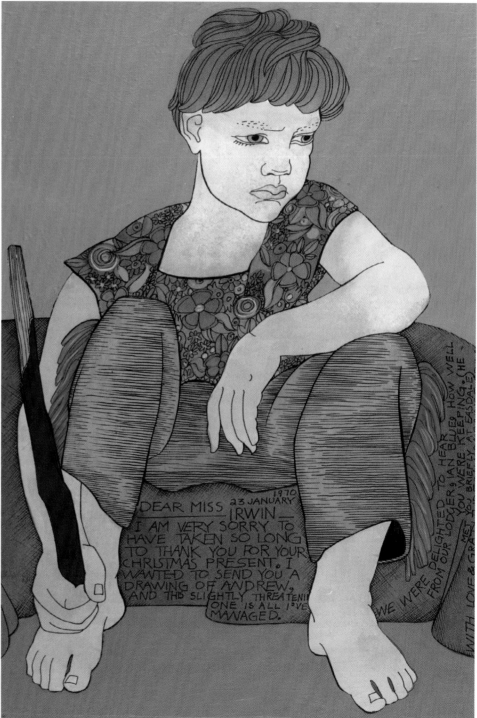

DEAR MISS 23 JANUARY 1970
IRWIN —
I AM VERY SORRY TO
HAVE TAKEN SO LONG
TO THANK YOU FOR YOUR
CHRISTMAS PRESENT. I
WANTED TO SEND YOU A
DRAWING OF ANDREW,
AND THIS SLIGHTLY THREATENING
ONE IS ALL I'VE
MANAGED.

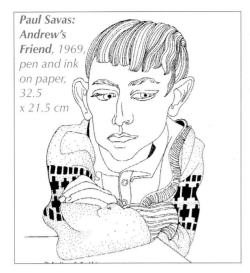

Paul Savas: *Andrew's Friend*, 1969, pen and ink on paper, 32.5 x 21.5 cm

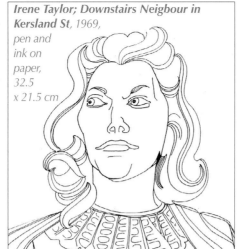

Irene Taylor; Downstairs Neigbour in Kersland St, 1969, pen and ink on paper, 32.5 x 21.5 cm

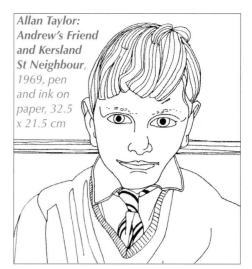

Allan Taylor: *Andrew's Friend and Kersland St Neighbour*, 1969, pen and ink on paper, 32.5 x 21.5 cm

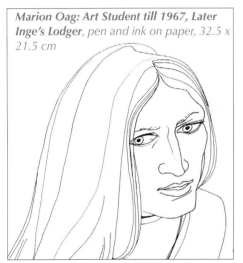

Marion Oag: Art Student till 1967, Later Inge's Lodger, pen and ink on paper, 32.5 x 21.5 cm

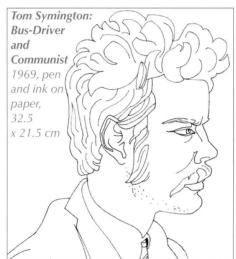

Tom Symington: Bus-Driver and Communist 1969, pen and ink on paper, 32.5 x 21.5 cm

Judy McRae: *Australian Friend and Teacher*, 1969, pen and ink on paper, 31.5 x 23.5 cm

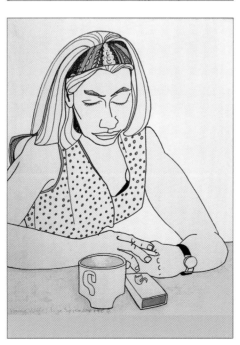

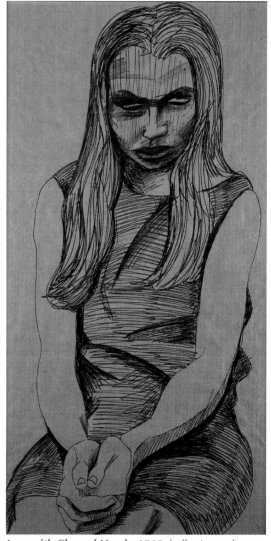

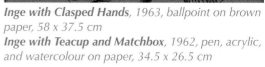

Inge with Clasped Hands, 1963, ballpoint on brown paper, 58 x 37.5 cm
Inge with Teacup and Matchbox, 1962, pen, acrylic, and watercolour on paper, 34.5 x 26.5 cm

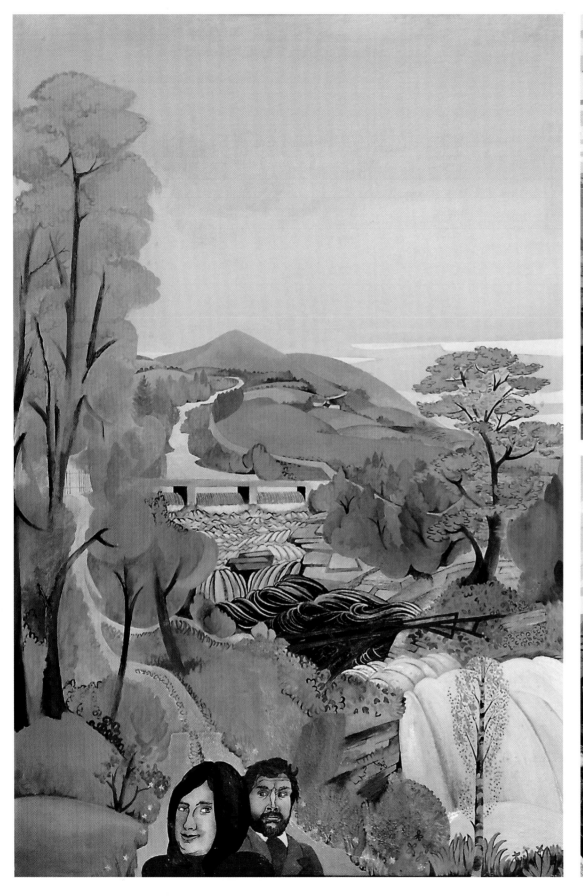

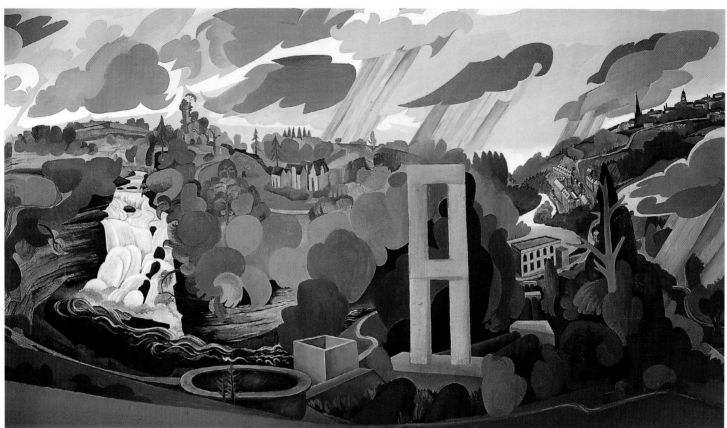

Kirkfieldbank Mural, 1969 (restored 2010), acrylic and oil on plaster, 766 x 142 cm

Opposite page: Three details of left end

This page: Detail of right end

In 1969 James Campbell, a Lanarkshire builder, was renovating an old pub in Kirkfieldbank. This long, single-street village would be a suburb of Lanark were it not cut off from the town by the Clyde and a steep hillside. He wanted a mural decoration for the pub lounge, so a former fellow-pupil of Whitehill School (whose name I forget) told him of me. A few weeks before, I had visited the Clyde Falls upstream from Kirkfieldbank on one of the rare weekends when the dam serving Bonnington power station is raised. This lets the whole river plunge over Bonnington Linn and, after pouring for a mile along a very deep gorge,

plunge over Cora Linn. Thus I had seen these as they had been when famous in history before the power station came in the 1920s. William Wallace had used the gorge as a hiding place after starting the war for Scottish independence. David Dale and Robert Owen, humane factory owner and founder of Co-operative Socialism, had used the falls to drive the machines in their model industrial village of New Lanark. I had seen them as Coleridge, the Wordsworths, Turner and most Scottish landscape painters saw them. I wanted to put all this good scenery into my mural, and told Mr Campbell that any preliminary sketch I

drew for him would give no idea of its final appearance. I asked for money to buy paint and live upon while doing the job, and to be finally paid more if he liked the result; if he did not, he should discharge me and have my work painted out. For three or four weeks when not sketching on the banks of the Clyde and painting the big wall I slept on a platform above the lounge bar's gantry. This was the happiest long painting spell I ever enjoyed. It alternated with spells of misery at the separation from my family, which was soon to be permanent. Mr Campbell finally liked the mural and paid for it.

Kirkfieldbank Mural, 1969 (restored 2010), acrylic and oil on plaster, 766 x 142 cm, photograph mid restoration in 2009

*Andrew Gray
and Allan Taylor*,
*1971, pen,
watercolour,
acrylic and oil on
white paper,
40 x 38 cm*

*Andrew, Cat and
Television*, *1972,
ink, ballpoint
pen, Indian ink
and acrylic on
paper,
30 x 42 cm*

*Sad Flowers
and Inge*,
*1970, ink,
oil and
watercolour
on paper,
40 x 35 cm*

In 1970 Inge returned to nursing in the hospital attached to Glasgow University, the Western Infirmary nearby. We found it was easier for us to remain friends if we did not share the same house and I moved to lodgings nearby so that Andrew had no sense of losing me. These pictures were made after that separation. Inge's pathetic expression beside the flowers is not typical. She never lost her energy, courage and readiness to try a new way of life. From nursing she became a cinema manageress, then passed a civil service exam, was a customs and excise officer in Glasgow then in Newcastle-on-Tyne. Becoming interested in homeopathy she married a homeopathic doctor, became one herself, shared an alternative therapy clinic in Manchester with friends, then returned to Denmark to work with her father's market garden. At the end of her vigorous life she often visited Andrew in the USA where, a married man, he worked as a physical therapist. There she enjoyed the friendship of Andrew's wife Libby and Alexandra, our small granddaughter. When threatened with incurable cancer she returned to the Manchester clinic, then to Glasgow where she died in 2000, having then more friends here than elsewhere. She still thought of me as one.

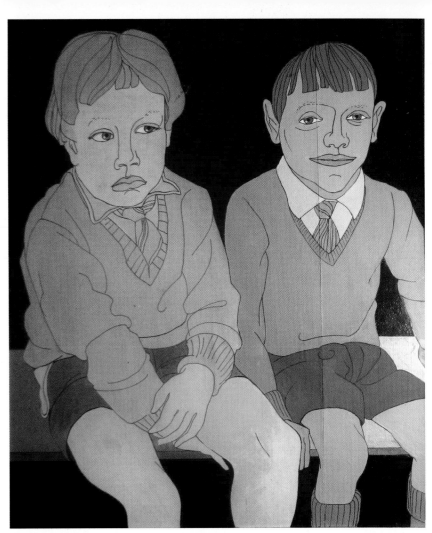

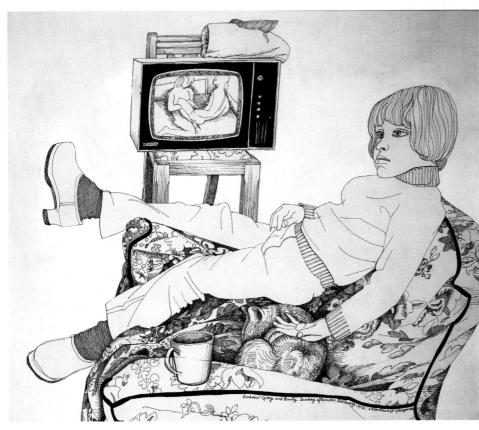

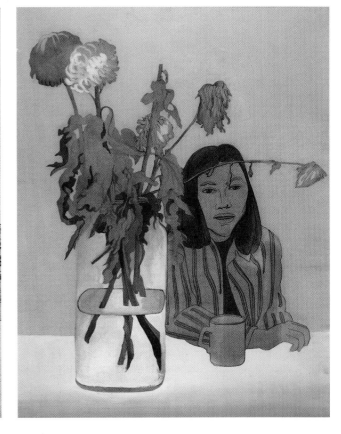

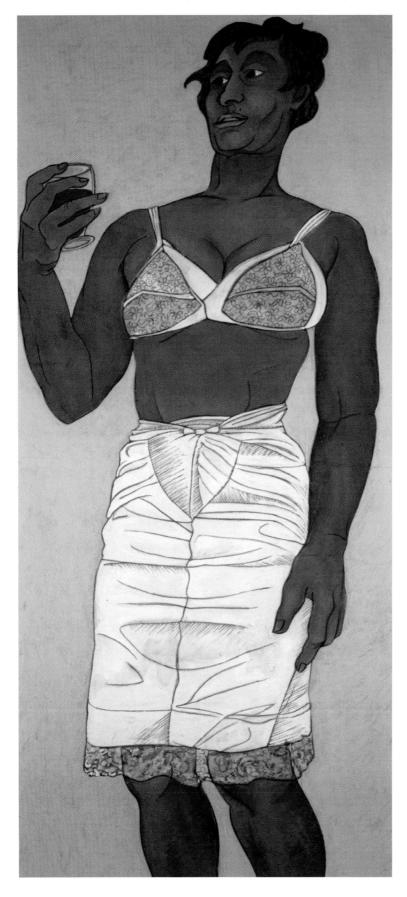

Twelve: Bared Bodies, 1964– 2010

OUR HILL STREET home was three blocks from Glasgow Art School. In the 1960s I paid models with time off from there to pose in my studio. Mrs Nanni was one. Wholly naked women's bodies filled me with admiring wonder. My best drawings of them at this time were taken by folk I have forgotten. More pictures of partly bared bodies remain. Drawing these was more tantalising but roused no emotions that stopped the work of drawing what I saw.

Mrs Nanni in White Slip, Bra and a Glass of Wine, 1964, oil, gouache and pencil on paper, 62 x 28 cm

Mrs Nanni in Black Stockings, 1967, tinted drawing, 51 x 14.5 cm

Beth McCulloch was a housewife and mother without time to develop her own artistic ability, so was glad to help me make pictures she could not make herself. This one was drawn on a big sheet of tough red paper from the Sauchiehall Street studio of a friendly fashion photographer who had used it as a background. Beth's faith in my art greatly helped me as my marriage became difficult. The others in this chapter were depicted after it stopped.

The drawing of Juliet was completed on paper at the first sitting. I cut the figure out and pasted it onto a wooden board, and set out to make it an oil painting in the manner of Cézanne. The skin of young humans is hard to paint convincingly, being semi-transparent over a pink and pale purple micro-vascular network of varied thickness, depending on its depth above muscles and bones beneath. This needed one or two sittings over several weeks, in the course of which the painting of her suspended foot changed its outline

Red Beth, 1968, pencil drawing on red paper, 70 x 46 cm

from the drawing beneath. Painting the trousers and hair was easier. The chair was a present from my friend Winnie Wilson, born in the year Queen Victoria died, and I was glad to think its pattern emphasized the body without swamping it. When the sittings ended my main trouble was with the carpet. Working like Cézanne needed (I thought) no departure from what I saw. My carpet had a strong Persian pattern which I could not make cohere with the rest. After years of occasionally repainting I settled for what you see.

Page 145

1964–2010

***Juliet in Red Trousers**, 1976, oil on paper mounted on wood, 99 x 49.5 cm*

***Jean Anne, American Opera Singer**, 1980, acrylic, ink, oil and pencil on card, 90 x 57 cm*

Kate Copstick,
1977–2000,
oil on plastic-
mounted
composite
board,
53.5 x 47.5 cm

*Danielle:
Black, Red,
Silver, Wan*,
*1972, ink,
pencil and
acrylic on
paper,
47 x 58 cm*

When the first publisher to accept *Lanark*, my first novel, finally rejected it, I grew depressed. Kate Gardiner decided the best cure would be to paint another nude, and found her friend Kate Copstick (also an actress) was willing to sit for me. Kate sat very patiently through more sittings than I recall while I carefully painted as well as I could, like Cézanne making each brushstroke correspond to a glance at a small area of skin: a colour that differs, however slightly, is mixed before the next stroke is applied. The surface I worked upon was a composition board with smooth white plastic veneer, once a

panel in prefabricated kitchen furniture whose remains are still often seen on our pavements, waiting for the cleansing department to remove them. (I still find useful surfaces among such discards.) Ms Copstick's work at last took her from Glasgow, leaving me with the best figure painting I never finished. Outlines round the nose, edges of her hair, some areas of leg show this. Were she to pose again in similar lighting I could still not now finish it because the Opal oil medium I used, my favourite oil medium because it dried matt, stopped being manufactured ten years or more later. I

therefore left it alone until 2010, when the roughly sketched bedclothes and background were smoothly finished by my helper Richard Todd, using Liquin oil medium.

Danielle was French. She came to Glasgow University and studied Scottish Literature under Professor Alexander Scott (on page 185). She was introduced to me by the playwright Joan Ure, another friend who (I suspect) thought more female company would be good for me. I always ask my sitters to choose poses they like. Danielle mostly liked poses in which she lay upside down.

Janet on Red Felt, 1980, oil on wood, 37.5 x 120.5 cm

Mary Nesbit in Red Trousers, 1975, pen, pencil, watercolour on craft paper, 35.5 x 89 cm

Annelise Taylor: North Bank Cottage, Portencross, Ayrshire, circa 1980, pencil and charcoal on brown paper, 25 x 55 cm

*Marion Oag and
Blue Scarf*, 1969,
ink, watercolour
wash and acrylic
on brown paper,
48.5 x 20.7 cm

*Two Views of
Katy Mitchell*,
1980, ink and
watercolour on
paper,
92 x 72 cm

May Hooper,
1984, Indian ink
on brown paper,
48.5 x 20.7 cm

To paint steadily like Cézanne requires an unearned income. I mostly represent figures by swiftly putting a line round them, then try to make the ground I draw on look like skin with my surrounding colours and tones. The two views of young Katy Mitchell commissioned by her mother are also her portrait. The flat black leotards are painted on white card with the Indian ink used in the outlines, a technique learned from Aubrey Beardsley. Katy and Marion Oag are drawn with a Rotring pen; architects use it because the nib gives lines of unvaried thickness. I implied the volumes of Marion's body by adding the least shading (draftsmen call it hatching), lightly tinted scarf and hair, then painted an opaque background. My backgrounds

May in Black Dress on Armchair, *1984–2010, ink on brown paper, acrylic background, 79.5 x 49.4 cm*

May in White Bodice, *1984–2010, ink on brown paper, acrylic background, 86.5 x 50.5 cm*

May on Nursing Chair, *1984–2010, ink on brown paper, acrylic background, 81 x 45.7 cm*

May on Striped Coverlet, *1984–2010, ink on brown paper, acrylic background, 45.5 x 99 cm*

are usually flat and often overpainted before I get it right. The last coat of paint on Marion's background does not wholly hide the one beneath, so it has depth. I drew May Hooper in the middle 80s when I felt free enough to use a thick-nibbed script fountain pen whose outline varied with the angle of the stroke, which was enough to suggest the volume of bare limbs et cetera without any of the hatching I kept for her garments. I liked the contrast between these and meant to fill a small book of May pictures. With the support of my recently acquired art dealer I finished those you see here in 2010.

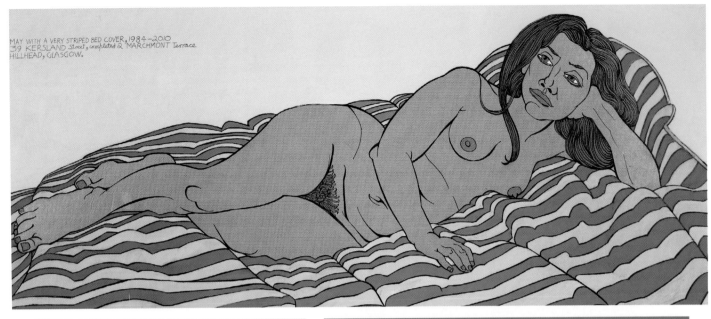

MAY WITH A VERY STRIPED BED COVER, 1984–2010
39 KERSLAND Street, completed 2 MARCHMONT Terrace
HILLHEAD, GLASGOW.

May on Very Striped Coverlet, *1984–2010, ink on brown paper, acrylic background, 45 x 99 cm*

May on Sofa, *1984–2010, ink on brown paper, acrylic background, 90 x 49.8 cm*

May on Invisible Armchair, *1984–2010, ink on brown paper, acrylic background, 68.7 x 46.1 cm*

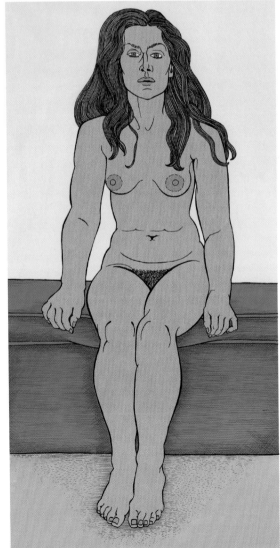

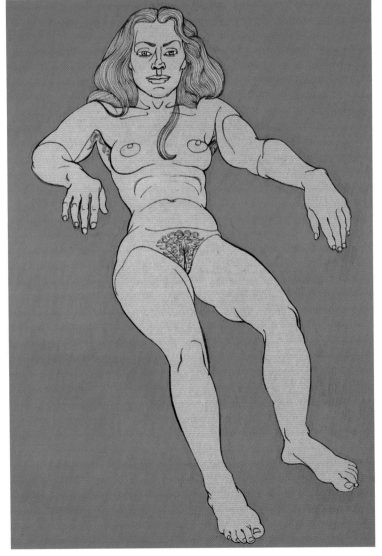

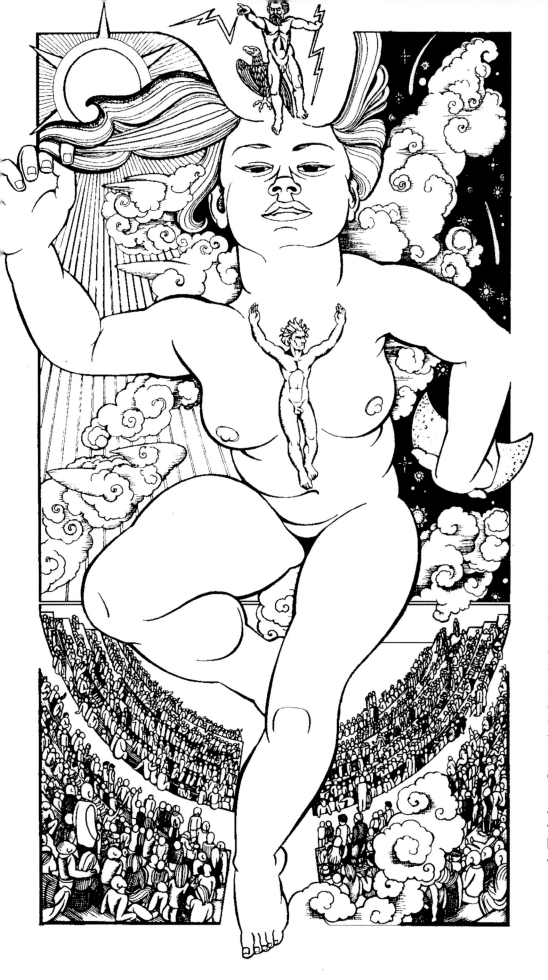

This picture was made from another drawing of Danielle (see page 147) who posed with head and shoulders on the floor, one leg on the seat of a chair, the other leaning against its back. Turned upside down she appeared (though a small person) like a mighty goddess springing forward, and as such she appeared also on a USA jacket of *Lanark* and the poster of a dramatized version that toured Scotland before the end of the last century.

For 20 years I drew no bare bodies, then in 2007 I started attending an evening class run by Nichol Wheatley in one of the McLellan Galleries. Glasgow School of Art (an adjacent building) was paying him to teach life drawing, a subject no longer a necessary part of the School's curriculum. That, painting and other subjects which once had their own departments, were now taught under the general heading of Visual Art. I was too old for Nichol to teach me much, but in Nichol's class I sketched two nudes of a man and began two pictures of a woman model reproduced on the following page.

The drawings of the man were made with crayon, pencil, felt-tipped pen and silver paint pen, completed on the spot. The drawings of the woman were turned into pictures at home. The coverlet in the top picture is watercolour tinted over white crayon shading, the background is acrylic. The lower picture has a coverlet densely coloured with wax crayon, and the skin and background painted in oils, so was only completed in 2009.

Page 153
1964–2010

Unlikely Stories, Mostly (*illustration*), *1983, ink on paper, 67.7 x 43 cm*

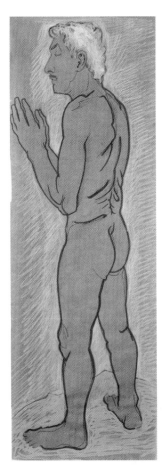

Nichol Wheatley's Life Class Drawings: Silver and Pink Man, 2007, lead & white crayon pencils, paint & felt-tipped pens on brown paper, 75 x 25 cm
Woman on Peach Coverlet, 2007, watercolour and acrylic on board, 39 x 58 cm
Nichol Wheatley's Life Class Drawings: Silver and Blue Man, 2007, lead & white crayon pencils, paint & felt-tipped pens on brown paper, 69 x 32 cm
Woman on Green Coverlet, 2010, ink, wax crayon and oil on paper, 40 x 60.2 cm

Thirteen: Starting Again, 1970–77

THIS PICTURE WAS made in the home of Gordon and Pat Lennox, he an engineer, she a social security clerk, who had met and married on discovering they both preferred art. They had married and were now students at Glasgow School of Art and friends of Archie Hind. He told them I needed lodgings close to Andrew and Inge. The Lennox flat in Turnbury Road was near Andrew's primary school, so he easily came to lunch with me. It was not far from the BBC on Queen Margaret Drive which was paying me to write plays for Schools TV broadcasts, and where a secretary, Flo Allan, was typing chapters of my *Lanark* novel. Hillhead also contained Glasgow University, so in local pubs I made many new friends lodging in the district who were students of literature, lecturers, folk keen upon writing who also respected my art. Among these was the poet and mature student Tom Leonard, and the Gaelic poet Aonghas MacNeacail. They introduced me to their English lecturer Philip Hobsbaum and his then partner, the American poet Anne Stevenson. We all coincided one night in the Rubaiyat Pub, then went to a party where Philip lost his temper so badly that I hated him as I have never hated anyone. All Philip's friends (I later learned) had that experience. He could be as moody as a rhinoceros since he too had barely enough eyesight to walk about safely. A few days later in the old Pewter Pot bar, he said he heard I had written a good play – could he borrow a copy? Which led to me joining the writers' workshop he ran privately in his flat, and there I met James Kelman and folk you will see in later chapters. But before this I had become a friend of the poet Liz Lochhead.

We had met on a train to Edinburgh,

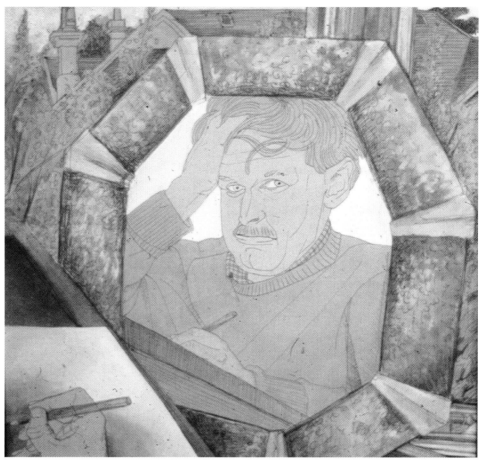

Self Portrait as Bankrupt Tobacconist, 1977, watercolour and ink on paper, 46.7 x 50.1 cm

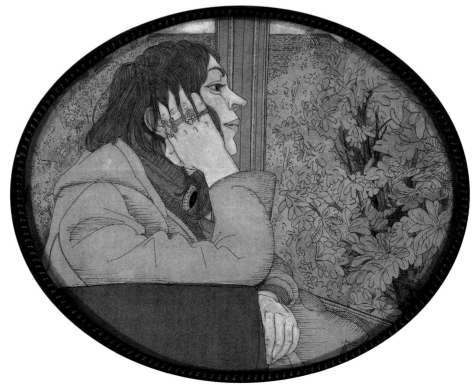

Poet and Tree: Liz Lochhead, 1971, ink and watercolour on brown paper

me going to arrange a show of my pictures in the Traverse Theatre (then in the West Bow), she to receive a BBC award for her poem *The Black Bull*. Judges had unanimously chosen it as by far the best entry in a competition open to all Scottish writers. Liz, a student at Glasgow Art School, knew me because one of my plays had been acted by an Art School drama society, and at once asked me to share a drink with her and the judges giving the award. I thus first met Norman McCaig and George Mackay Brown. Not all writers so gladly welcome others

of their kind. Her first book, *Memo for Spring*, was published in 1972, with a cover photograph she disliked as much as the title, since together they suggested she was romantically inclined. That book still established her reputation as a fine poet.

A year or two later Malcolm Hossick, a BBC producer, asked me to co-operate with him in making a film of his own that would combine shots of my drawings with shots of people they represented. Together we agreed on a story for it and a title, *Now and Then*. I would draw, he

would film a young art student in a room where she was remembering a love affair that had once flourished and ended there. Malcolm's filming would show her lonely activities in the present, my drawings show memories of times with the absent lover. The soundtrack would be a monologue giving the woman's thoughts, which neither Malcolm nor I were capable of writing. We asked Liz to do it. She responded by describing the course of the love affair in a series of sensitive, first-person lyrics. Her closest Art School friend, Doreen Tavendale,

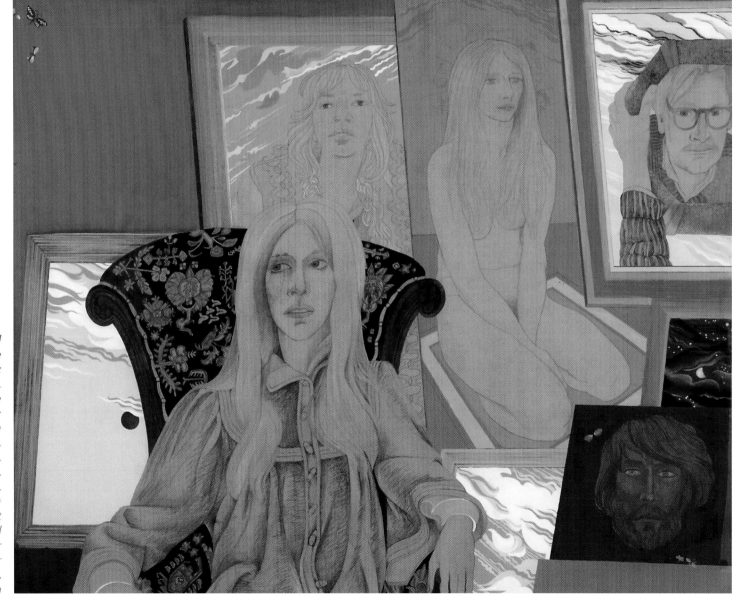

Credit Panel (film sequence with Liz Lochhead), 1972, (clockwise from chair: Doreen Tavendale, Liz Lochhead, Doreen again, Alasdair Gray, Russell Logan) acrylic, ballpoint pen, oil, pencil and watercolour on brown paper on board, 106 x 127 cm

agreed to pose for me and be filmed by Malcolm as the girl. Her lover (who would only appear in my pictures) was played by her fiancé Russell Logan. (In 2010 they had been happily married for nearly 40 years.) The room chosen was Malcolm's home in a Kirklee Terrace overlooking Great Western Road, a richer location than most student lodgings but spacious enough for our purpose, and made more convincing by adding cheaper items and artistic bric-a-brac. Over several days Malcolm filmed Doreen in the girl's melancholy present, I drew her and Russell in her usually brighter past. I drew quickly with a pencil I needed never stop to sharpen, for when the point wore down I flung it away, uncovering a new sharp one underneath – a kind of pencil manufactured for only a year or two. I worked on brown wrapping paper because big areas could be got cheaply and locally, and the rough side of that paper is easily coloured by most artistic mediums when the paper has the solid backing of the hardboard on which I pasted them. I have coloured small drawings fast with flat areas of colour, but pictures with many of these would look cheap when alternated and be compared with the girl and her surroundings in colour film. My drawings would therefore have to be

The New Room (film sequence with Liz Lochhead), 1972, acrylic, crayon, oil, pencil and watercolour on brown paper on board, 106 x 127 cm

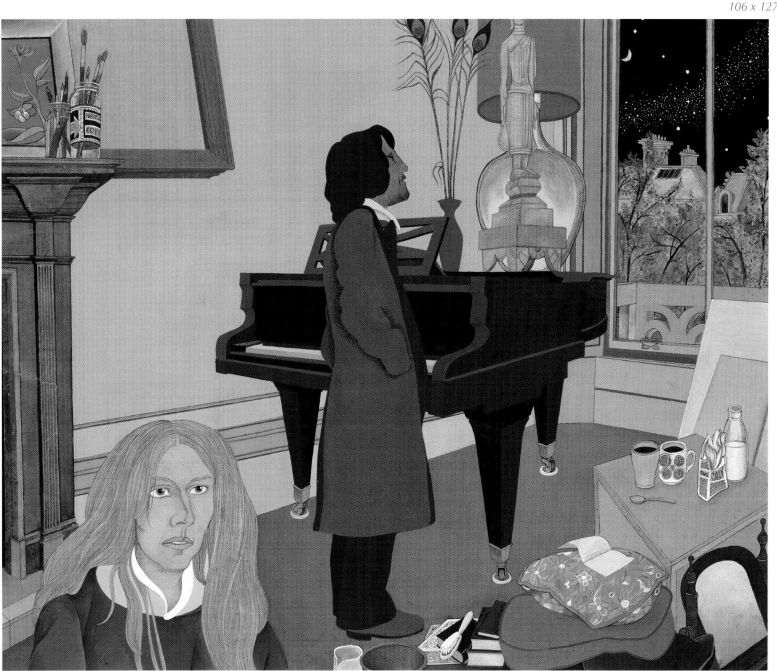

Starting Again

Sunday Morning,
1972, pencil,
acrylic and
crayon on brown
paper on board
(work missing)

Making Pictures
(film sequence
with Liz
Lochhead), 1972,
acrylic, ballpoint
pen, oil, pencil and
watercolour on
brown paper on
board,
120.5 x 91.5 cm.

richly coloured and subtly toned. The colour had to harmonize with the colour of the paper, which would be left as the colour of Doreen's skin.

No face or hand is a simple colour because complexions respond differently to light. Small blood vessels incline the skin of Caucasians to pinkness, especially over layers of fat, but being more or less transparent skin does not wholly hide fine blue arteries, producing subtleties that artists in every century have tackled differently. Successfully realistic portraits in a wax medium survive from Roman times. Nobody has made subtler, more realistic portraits than the Van Eycks and Holbein, who used an egg medium to model face and hands in greenish monochrome before laying pinkish

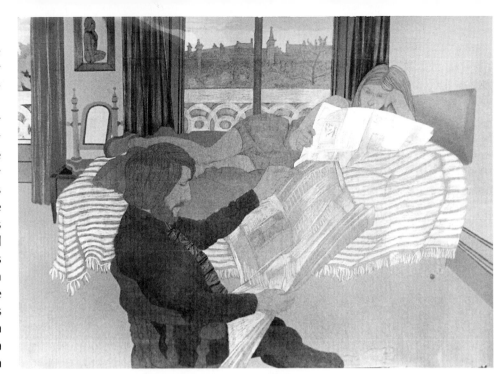

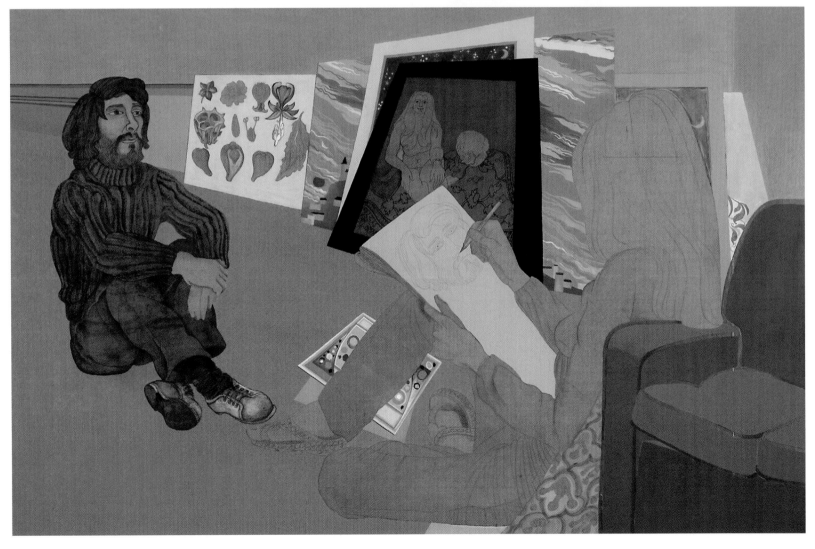

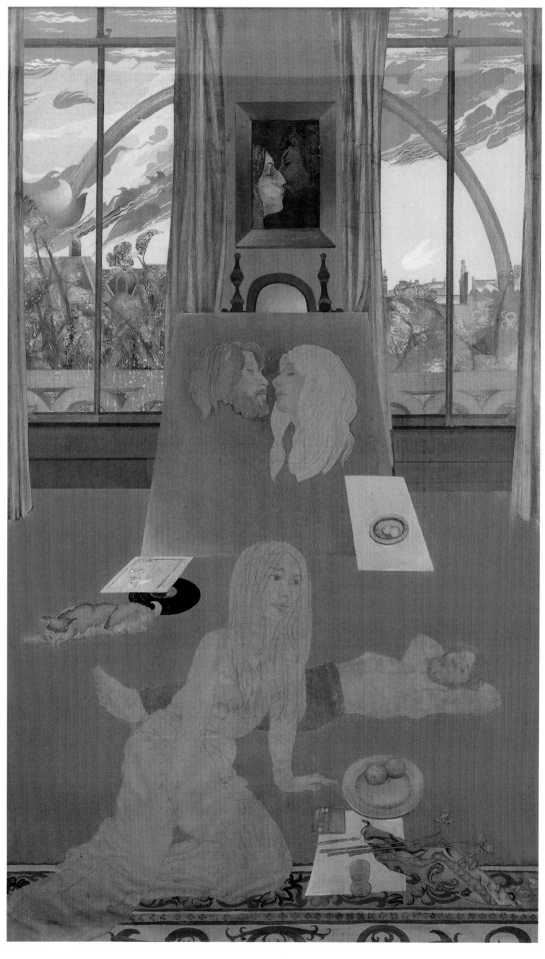

***The Rainbow
(film sequence
with Liz
Lochhead)**, 1972,
acrylic, oil, pencil
and watercolour
on paper on
board,
215 x 134.5 cm*

One poem has the girl playfully
mocking her architect lover, and
suggesting he is blind to the beauty of
the colour in oranges she is painting.
Outside the window rain stops falling,
sunlight breaks through the clouds
and a rainbow forms as they unite in
a kiss or more. I meant the camera
to travel up from the still life at the
bottom while the recorded voice of Liz
described these things. By combining
so many viewpoints in one frame the
picture's whole composition is very
poor, but may please if each part is
looked at one at a time.

Snakes and Ladders (film sequence with Liz Lochhead), *1972, acrylic, coloured ink, crayon, oil, pen, pencil, watercolour and tiddly-winks on brown paper on board, 141 x 135 cm*

The poem by Liz Lochhead has the same title as the picture, and describes the ups & downs of lovers' moods as a game of snakes and ladders they are playing. I owned that rug and the board game. The cat, named Freak, was drawn in the Eldon Street home of Ian Murray & Annie Good.

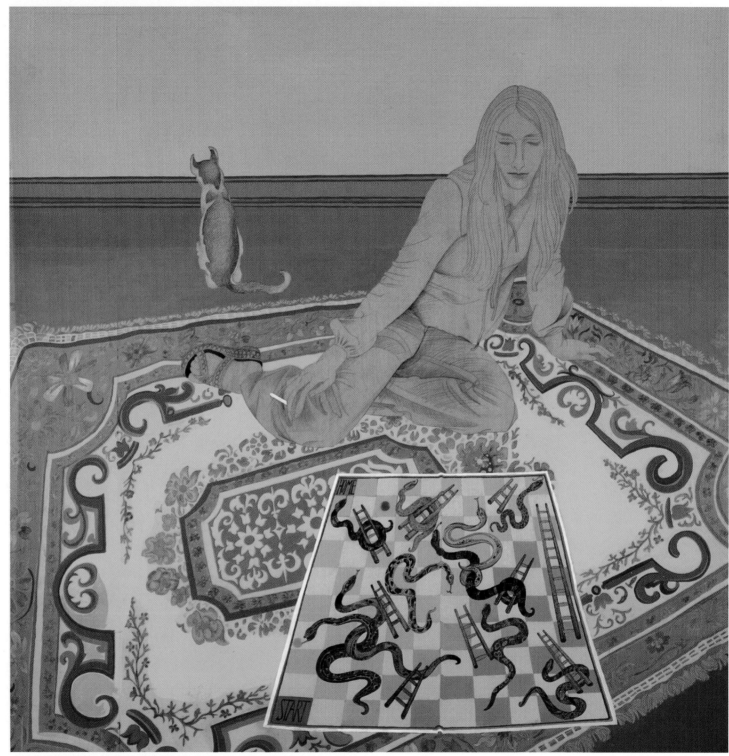

We played this childish game.
You need sheer freakish luck to win.
Snakes and ladders is its name.

Home and dry is everybody's aim.
Throw a double six, there's luck, begin.
We played this childish game.

Dice and pure chance, I cannot blame
 how they fell for the box I'm in.
Snakes and ladders is its name.

Eve was foolish , thought she'd tame
the serpent, keep Adam at her side with sin.
We played this childish game.

Unravel ups and downs, see how we came
 to end back at square one again.
Snakes and ladders is its name.

Fall foul? The serpent has a tongue of flame.
Land lucky? Ladder-rungs are thin . . .
We played this childish game.
Snakes and ladders is its name.

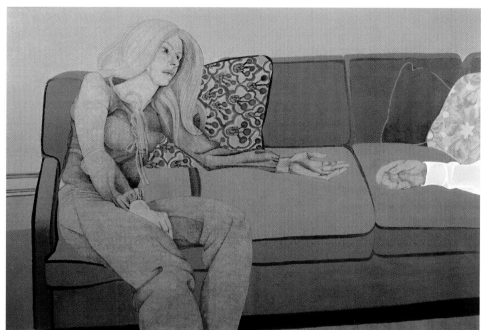

On Sofa Reaching (film sequence with Liz Lochhead), 1972, pencil, oil, watercolour, and acrylic on board, 120 x 91.5 cm (work missing)

These show moments when the man's infidelity starts a gap opening between the lovers.

Snakes and Ladders (film sequence with Liz Lochhead), two details, 1972, acrylic, coloured ink, crayon, oil, pen, pencil, watercolour and tiddly-winks on brown paper on board, 141 x 135 cm

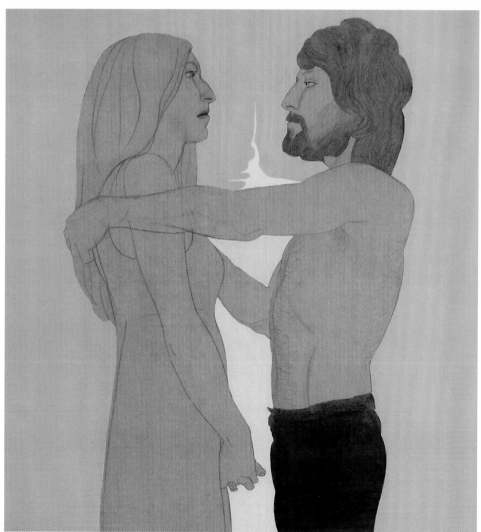

But I Dare You (film sequence with Liz Lochhead), 1972, acrylic, oil, pencil and watercolour on brown paper on board, 91 x 85 cm

Oh, But in the End, *1972, pencil, acrylic and crayon on brown paper on board (work missing)*

The woman, after love-making, sees she has failed to hold her lover as he cheerfully rises, dresses and leaves her for the last time. This picture, reproduced from a very old slide, has now been lost. I would welcome news of it.

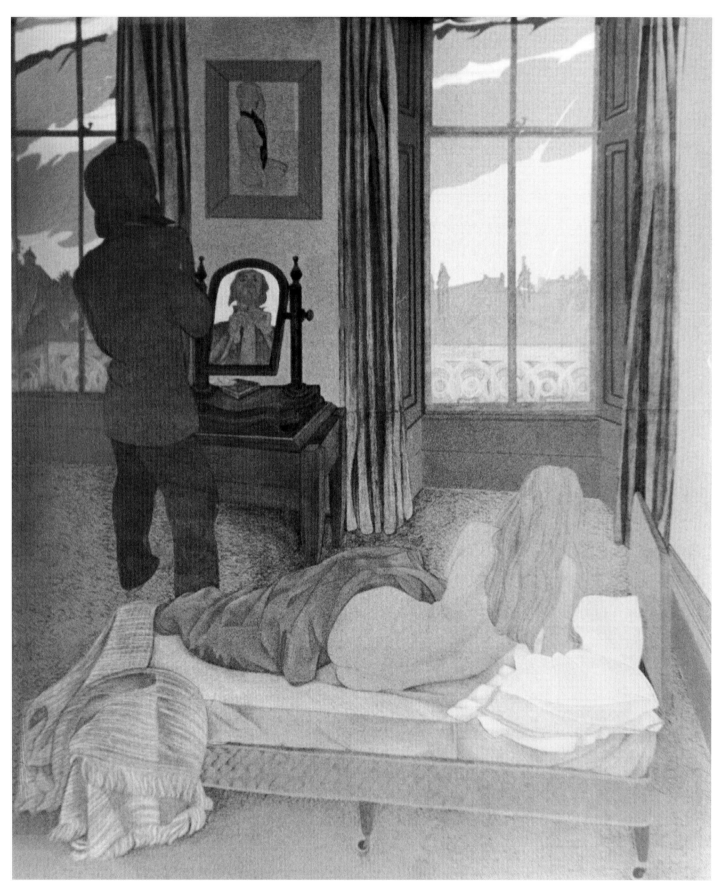

glazes on top – a very slow process. Da Vinci worked slowest of all. Rembrandt worked fast in oil only, applying many thin layers of glaze in shadowed areas to give them depth and richness, and using it thick in well-lit ones, with many layers of glaze. Impressionists and Post-Impressionists rejected glazed shadows, working in strokes, dabs or areas of pure colour, sometimes (like Van Gogh, Lautrec, Gauguin) asserting the shape of a face or body with a distinct outline. Cézanne in his prime kept the pure Impressionist palette of colours but modelled the forms of bodies as deeply as the Renaissance masters. This meant painting very slowly, always with the sitters before him, and so annoying him by their restlessness that he would curse them for not being more like apples and pears. I have only thrice managed to paint a figure in oils by the Cézanne method, and only twice nearly succeeded. (See the previous chapter, pages 145 and 146.)

Having no time to paint Doreen in Cézanne's way I drew her in pencil, with or without boyfriend, tinted lips, eyes, hair and clothing with watercolour, then added a few tones to her features, sometimes shading them with a very fine-pointed Rotring pen. To make this brown paper colour appear like skin I painted surroundings with many mediums – watercolour, inks, wax crayon, felt-tipped pens and (mainly on skirting boards) acrylic, and on flat areas of wall or plain floor, oil paint that harmonized with the matt surfaces of the rest, while its slight gloss contrasted with them. I produced 12 pictures whose average size was 3 by 4 feet, one roughly 4½ feet square, one 3½ by 7 feet.

Winnie Wilson, born on Christmas Day 1900, was a really gentle woman. We met when, hearing I needed money, she paid me to make a portrait of her friend Emmy Sachs, and became my friend for life. Her flat in Queen Margaret Drive was not far from me and by 1990 I was her only surviving friend. She gave me the Victorian armchair partly visible in the *Now and Then* credits picture, *Juliet in Red Trousers* and, with new green upholstery, elsewhere in this book.

Queenly Janet (now Mrs Crouch) was a friend of Liz and Doreen, who shared a flat in Garnethill Street, round the corner from my now demolished Hill

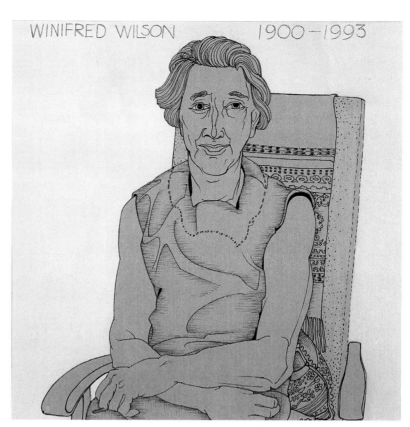

WINIFRED WILSON 1900–1993

Winnie Wilson, 1984, ballpoint pen on paper and mounted on card, 54 x 54 cm

Queenly Janet, 1971, ink on paper, 42 x 30 cm

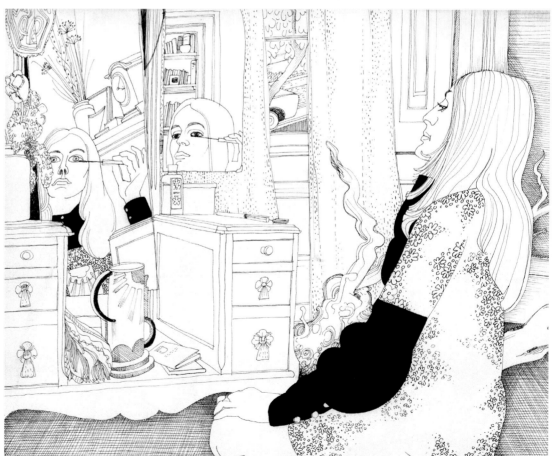

Street home. Janet did not live there, but visiting them one day I saw her preparing her face for a party and was allowed to make this picture, which I was keen to do because the mirrors allowed more than one view of her. The 1930s dressing table, given by a relative or bought second-hand, is typical of student furnishings in the '60s and '70s. So too is the piece of weathered tree that artistic folk called "found sculpture".

In the 1970s the demolition of Greenhead Church of Scotland, Bridgeton, was mentioned in a Glasgow newspaper, and the loss of my best and biggest mural painting was noticed by an elder of GREENBANK Church of Scotland in Clarkston, south of the Clyde, a church that had been willed a lot of money by wealthy parishioners. The congregation wished to commemorate the Reverend Mr Fulton, a popular minister recently deceased. The elder (alas, I forget his name) suggested I might paint the walls of what would be called The Fulton Memorial Transept, so I was

Greenbank Church of Scotland Mural: Design (rejected),
1972, pen, coloured pen and watercolour on board,
53.4 x 76.5 cm

Greenbank Church of Scotland Mural: Designs for the Book of Ruth (accepted),
1973, coloured pen, ink and watercolour on board,
51 x 30.5 cm

asked to submit a design. My friend and landlord, Gordon Lennox, drove me to Clarkston, where I found the church building less ancient but more spacious than Greenhead Church, with a splendid barrel-vaulted wooden ceiling. The transept's ceiling was lower, with three walls panelled to shoulder height, the middle wall pierced by three lancet windows. These spaces so pleased me that I almost wept with fear that I might not be allowed to paint them, and unlike my other murals except the Bellisle Street synagogue, be paid. My Jonah mural in the West Princes Street flat was now under wallpaper so I planned to paint the story again, bigger and better. I loved that story because, after the creation, it is the most miraculous and kindly of Old Testament tales, showing God at his most ecumenical and least

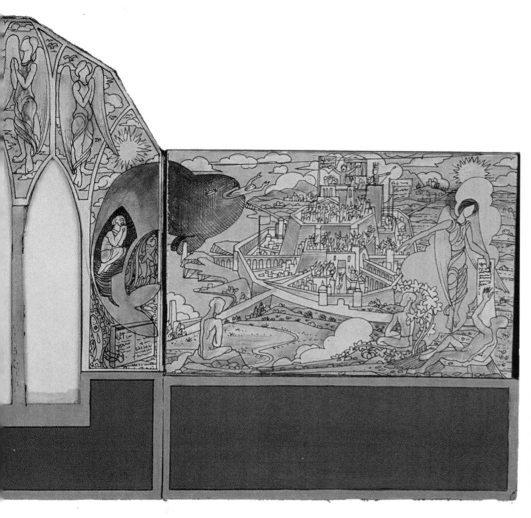

Then film had taught me how to do it. After the Greenbank elders and minister had accepted my Book of Ruth sketches for the transept I drew on brown paper friends acting out the story in modern dress, for it could happen in any century. I then cut the paper figures out, pasted them onto the transept walls in the order I had planned, gave them a coat of varnish and was then ready to paint their eyes, hair, clothes and surroundings.

I worked here for months, spending many nights in a sleeping bag on the floor of the minister's vestry until winter weather froze the vestry's lavatory cistern. To break the ice I had to lift off the earthenware lid which first stuck, then came off so suddenly that I dropped and broke it. I was henceforth shut out of the vestry and slept in the holiest part of the kirk under the communion table. This space was enclosed on three sides with its own floor, so almost as draught-proof as the pulpit where I had sometimes slept in Greenhead Church.

Greenbank Church of Scotland Mural: Designs for the Book of Ruth, coloured pen, ink and watercolour on board, 51 x 30.5 cm

genocidal, which is why Jews read it on their Days of Atonement. The design I submitted was too wildly dramatic for this Church of Scotland congregation. I was asked to illustrate instead the Book of Ruth, which has no miracles and says nothing about God. It tells of how all the men in a family of Jewish emigrants die, leaving the mother Naomi dependent on Orpah and Ruth, two foreign daughters-in-law. Ruth goes with Naomi back to Bethlehem and supports them both by the poorest kind of field work. On her mother-in-law's advice, Ruth seduces and weds a landowner there, thus becoming Jewish and bearing a child whom the Old Testament calls the ancestor of King David and also (says the New Testament) Jesus Christ. Such a story could only be painted realistically, and my pictures for the *Now and*

Mother and daughters-in-law are shown below. Ruth on the right has her hand on Naomi's shoulder and my art student landlady Pat Lennox posed for her, Pat's real mother posed as Naomi, an actress who was Pat's friend as Orpah. The monuments behind are reminiscent of some in Glasgow's necropolis. The broken tree with dead branches on the left with carrion crow suggest death, the new branch with budding spring leaves on the right is a symbol of hope, as is the rainbow of course.

For some years Dad had been living at Alderley Edge in Cheshire with his second wife. I returned one weekend to my digs in Turnberry Road and found a three-days-old letter from my sister. It said Dad was being treated for a heart attack in a Manchester hospital. I went there by train, arriving at the intensive care ward late that evening when other visitors were leaving. I was allowed to sit by his bedside with Lynn, my step-mother, and heard how he had gone to the annual Holiday Fellowship gathering in London's Festival Hall, had helped younger folk stack chairs after it then driven to Alderley Edge where, finding the garden path under snow, he had cleared it with a spade

before his stroke. From now on (said the doctors) he must "take things easy". Lynn swore she would ensure that and, since he was calm and cheerful, left us to talk. I gave him Tolstoy's *War and Peace* as he would have time to read it and, a World War One veteran, would like how it described military leadership. After more quiet chat I said goodbye and left as he composed himself for sleep. Next day he was supposed to leave intensive care for an ordinary ward, but in Glasgow next morning his widow phoned to say he had died in his sleep. Alexander Gray was quietly remarkable. For 20 years between two world wars he worked 5½ days a week on a cardboard cutting machine while still doing unpaid work with others improving peoples' chances of enjoying the open-air recreations he too enjoyed. This was work he continued to the end of his life. He had many friends, no enemies, and I believe the only bad thing he did was spank me and Mora when our mother ordered it. A wholly happy childhood is impossible. His books, ideas, example shaped my mind. I'm glad he died in his sleep after our pleasant chat when I was a broadcast playwright.

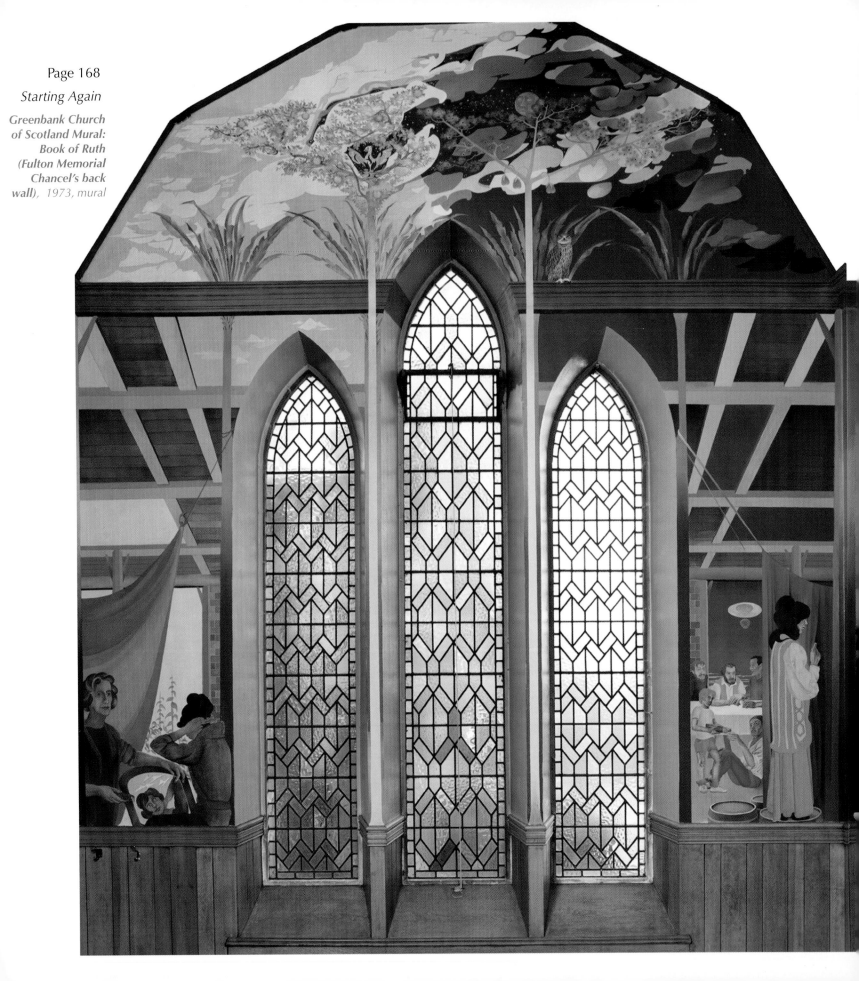

Starting Again

Greenbank Church of Scotland Mural: Book of Ruth (Fulton Memorial Chancel's back wall), 1973, mural

Ruth is shown here thanking Boaz, who I drew from Gordon Lennox, Pat's husband. I portrayed the elder who had got me the mural job as the servant beside Boaz who he employs to oversee the reapers and gleaners.

I exasperated the minister of the church and maybe others by the time I took to the job. On starting it I had accepted an agreed payment, another on completing the first wall and would be paid the final sum on completion. Since the many weeks spent making the work good did not earn me more money I felt no guilt about them, and first speeded the job by paying friends to help out of my own pocket. A large curtain hid the chancel's interior from the body of the kirk, so painting could go on during services. Four of us were on a high scaffolding, silently at work on the chancel's window wall when the opening hymn in a well attended marriage ceremony had been sung. The minister was saying some well-chosen words when a large paint pot was knocked over and clanged noisily down to the floor. He continued after the briefest pause as we stealthily climbed down, left the chancel by a side door, went to a local café and did not return until the church was empty of all other folk. This naturally upset people, as did increasingly frequent changes to the background, to make it fit the many foreground figures. In the bottom right corner of the window wall Philip Hobsbaum sits at the table with Tom Leonard on his right and the church officer on his left. The boy pouring wine

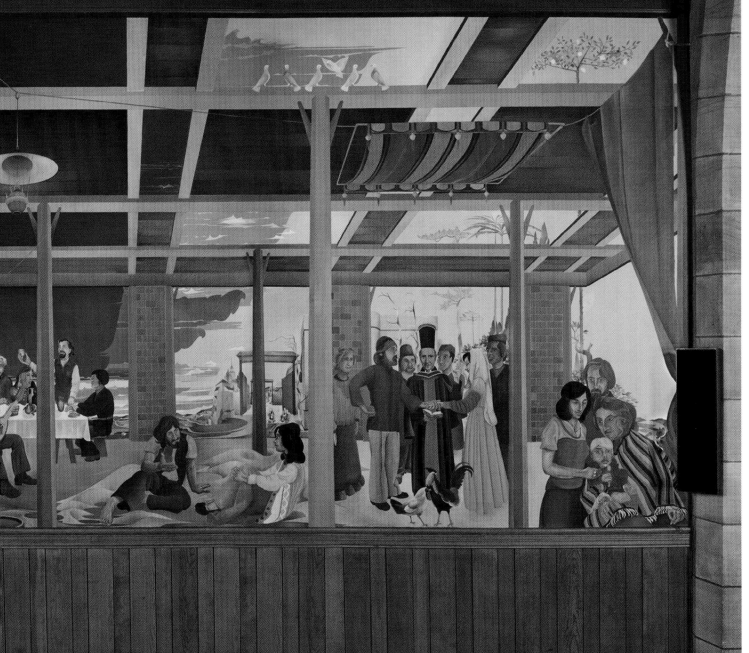

Greenbank Church of Scotland Mural: Book of Ruth (Fulton Memorial Chancel's right wall), 1973, mural

Scottish Wildlife Mural: Palacerigg Nature Reserve Exhibition Centre (details), 1974, oil on plaster

in front of them was Andrew, my son. On the chancel's right wall Boaz, Gordon Lennox, appears four times, Ruth, Pat Lennox, thrice. The party round the table on the left are Anne Stevenson in a red tunic, Archie Hind glass in hand, Liz Lochhead and my favourite elder. Beneath Boaz and his guitar the cat Freak sits on top of a barrel. Under the canopy on the left I painted the minister as a rabbi conducting the wedding ceremony. The hen and cock at his feet were painted by Gordon Lennox – I certainly could not have painted them better. The young child holding a spoon on Naomi's lap belonged to the wife of an Irish house painter I knew.

In 1974 I was asked to make a mural by David Stephen, naturalist, author and warden of Palacerigg Nature Reserve. In Greenbank Church only the skins of my people were still unpainted, my shyness when touching flesh had left that to the last. And I wanted a holiday from Greenbank Church, being now slightly unwelcome to the minister and his wife. I sketched for David Stephen a design he accepted, and began painting in Palacerigg's exhibition centre. The Reserve was several acres of wilderness on a Lanarkshire plateau and belonging to Cumbernauld, a small old town nearby that had recently turned into a big new one. Stephen was a man who understood and loved wild and domestic animals much more than people, so was

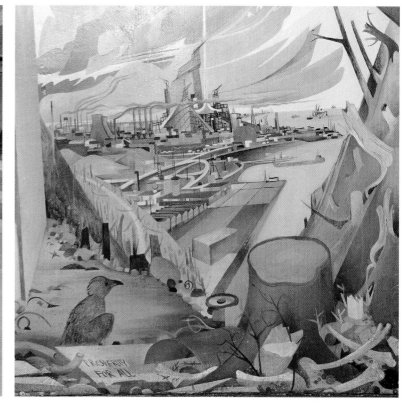

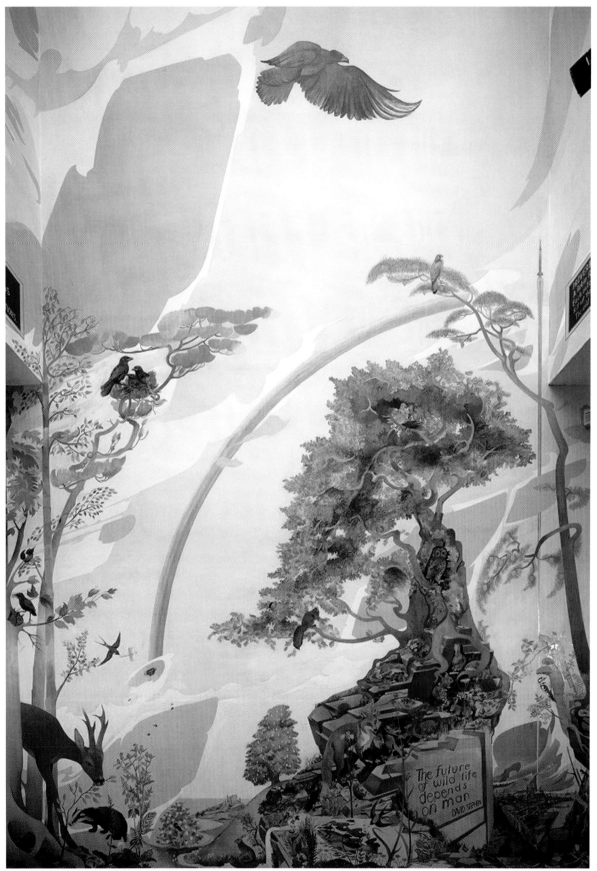

Scottish Wildlife Mural:
Palacerigg Nature
Reserve Exhibition Page 171
Centre (main wall), *1970–77*
1974, oil on plaster

an ardent conservationist. Outside many mining, steel industry and factory towns that were starting to fail, Scotland's midland belt was mostly farms under modern cultivation that destroyed rabbits, foxes, badgers, birds, rare plants and trees, while encroaching on wilderness where these could breed and grow. Other new towns had acquired parks or community farms for the use of the citizens. Employed to design a park by Cumbernauld, Stephen called it a Nature Reserve because he chiefly wanted it for the use of Scotland's wildlife, which human visitors would see, enjoy and learn to respect. So the Reserve had woodlands, heath, a bog with a reedy loch in it, a smaller loch that migratory geese visited to lay eggs and nurse their fledglings for flight. There was also the exhibition centre, a building with a café-restaurant, room for wildlife displays, and a foyer with a skylight and big wall facing the entrance. I decorated this with a painting on the theme of natural and human ecology.

The Garden of Eden in my first church mural was centred on the Tree of Life. David liked my decision to centre this one on an oak, as oaks often sheltered whole ecological cycles of insect, bird, animal and herb. I painted many creatures in the Reserve, some sketched from life, more from photographs in his books. The dead rat the fox has brought to its cubs was painted from a stiff one in a transparent plastic bag he produced from a freezer. In the warden's house near the exhibition centre I had a bedroom and both

Scottish Wildlife Mural: Palacerigg Nature Reserve Exhibition Centre (side wall), 1974, oil on plaster

breakfasted and dined with David, his wife, daughter and four animals who also ate with us in the kitchen – a large Alsatian, a Jack Russell terrier, a cat, a tiny gosling that had followed David into the house. On hatching it had seen him before anyone else and assumed he was its mother. At night the Alsatian slept in a wicker basket with terrier, cat and gosling snuggling against it. The gosling grew up very fast and returned to its goose community.

I finished this mural a few minutes before the Nature Reserve was officially opened and returned to Glasgow. In 1981 I encountered the Greenbank minister's wife. She said the money due me on finishing the mural had gone to an artist who had coloured my people's skins. "It now looks very good," she said, "A lot of people came to the official opening and liked it very much. It's a pity you weren't there." I said that I might have come if I had been invited.

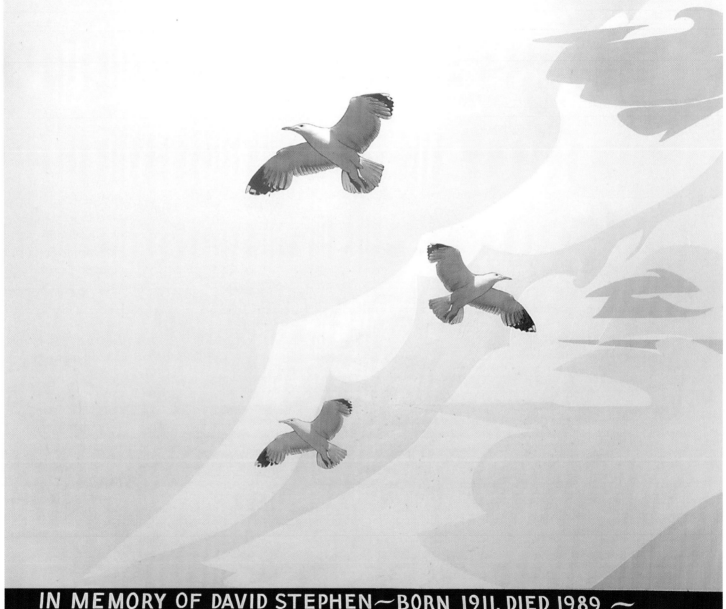

IN MEMORY OF DAVID STEPHEN~BORN 1911, DIED 1989 ~
A GOOD NATURALIST, WRITER & PUBLIC SERVANT
WHO PLANNED PALACERIGG NATURE RESERVE. HE WAS
THE FIRST WARDEN, & IN 1974 CHOSE THE ARTIST
FOR THIS PAINTING, & THE THEME, & AUTHORISED INSCRIPTIONS.

Fourteen: City Recorder, 1977–78

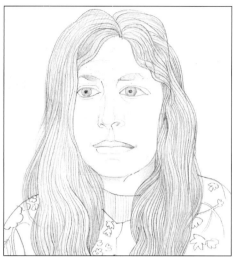

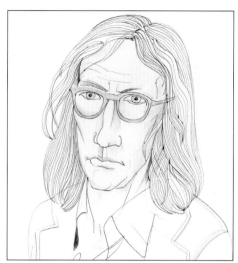

IN THE 1960s everybody dining out in Glasgow ate foreign fare. Expensive hotels specialized in French service. Good Italian, Indian and Chinese restaurants catered for those who paid less. The most popular outside meal was fish and chips sold mainly by Italian cafés. Ronnie Clydesdale, a friend of mine from early CND days, changed that in the early '70s by leasing a small place in a back alley off Byres Road and opening The Ubiquitous Chip restaurant. Here, working as his own chef, he served most kinds of traditional Scottish fare apart from chips (which were not on his menu) at very reasonable prices. At first it only opened in the evening, customers brought their own wine and were served by pleasant young women who had professional day jobs or were students. People were soon queuing to get in, so the queues were reduced by raising prices, getting licences to sell drink and training the waitresses to advise on the expensive vintages. Pressure of profits steadily turned The Chip into the expensive but still Scottish restaurant of today. In 1977 it crossed Byres Road to a former garage in Ashton Lane with an internal courtyard, which had once been a livery stable. The yard was roofed over, a goldfish pond and rockery built along one wall, and the rest turned into a dining space. When the rockery plants were putting out their first shoots I took the bare look off the wall (which was plastered and whitewashed) by painting over it a Douanier-Rousseau jungle with creatures in it.

I was back in the Kersland Street flat I had left in 1970, since Inge, now a civil servant, had left it for England. Seven years earlier a London literary agent had got Quartet Books to pay for an option on my unfinished novel. She died in 1977, ending my career as a playwright just before Quartet rejected *Lanark* because it was too long. To pay for my big flat's rates and electricity I let three rooms to lodgers, which did not pay for food and drink. Ronnie Clydesdale gave me these in return for my work of painting the mural, work that was good for both me and his restaurant. Moisture began destroying the plaster under the mural as soon as I finished it, and eventually I painted a more lasting mural elsewhere in the Chip.

One afternoon I was called to the restaurant's telephone where I heard the voice of someone I had never met: Elspeth King, curator of The People's Palace, Glasgow's local history museum. The Palace had been built on Glasgow Green in 1898 as a cultural centre in the city's east end to balance Kelvingrove Museum in the west, yet it had very few exhibits and no paintings of Glasgow streets or people later than the early 20th century. Could she employ me to work for the Palace as the city's modern Artist Recorder? My 1974 Collins Gallery retrospective show had made her think I would like the job. And indeed I did! There was one difficulty.

My salary must come from the Labour government's Jobs Creation Scheme. An institution or firm wanting an extra worker they could not afford to pay, could get them paid a basic salary by the government, but only if this took the worker off the unemployed register. I had been a self-employed artist since 1964. To let Elspeth get the Jobs Creation salary for me I visited my Maryhill Labour Exchange and explained my situation to a clerk who could not at first understand it. He feared that if registered as an unemployed artist I would become a social benefits scrounger, as I had certainly been in 1963. I promised that if registered unemployed I would at once work for the People's Palace without receiving unemployment benefit money. So began the pleasantest steady

North Arcadia Street, with Honda and Constable Adams, 1977, ink, watercolour, acrylic and oil on paper, 71.5 x 165.5 cm

This seems part of a city bombed by enemies, but was once a busy place where many local people worked in local factories and warehouses adjacent to tenements where they lived. In 1977 many still did, such as Gordon Adams on his Honda. At the end of this street, just right of the chimney stack, is the barred window of a cell in Tobago Street Police Station. My dad was jailed there in 1915 for being absent without leave.

job of my life, in a former warehouse on Arcadia Street, Bridgeton. It was rented by Glasgow Museums Service as a store, work space and studio for the People's Palace two blocks away.

Glasgow in the 1970s was changing in very striking ways. The old industries which had made the city famous were being closed and moved to England or abroad, while the Labour councillors who ruled the city (for reasons any economist can explain) were building multi-storey housing blocks and a constantly expanding motorway system. In Glasgow's local history museum Elspeth King, a coalminer's daughter, worked hard to acquire and preserve evidence of local culture that was being hustled into the past. Since the First World War the city had given the People's Palace no funds to buy anything new, but her assistant Michael Donnelly had permission to enter buildings scheduled for demolition, so was bringing to the store troves of ceramic tiles, stained glass windows, theatre posters, banners of disbanded trade unions, rent rolls and other artefacts. Elspeth sometimes gave Michael manual help with this work as the rest of her staff were not paid to retrieve objects from dirty, unsafe buildings. Neither, of course, were Elspeth and Michael, so the new and successful exhibitions they put on cost the city council little or nothing. As a colleague they now had me, who was equally keen to record what existed in

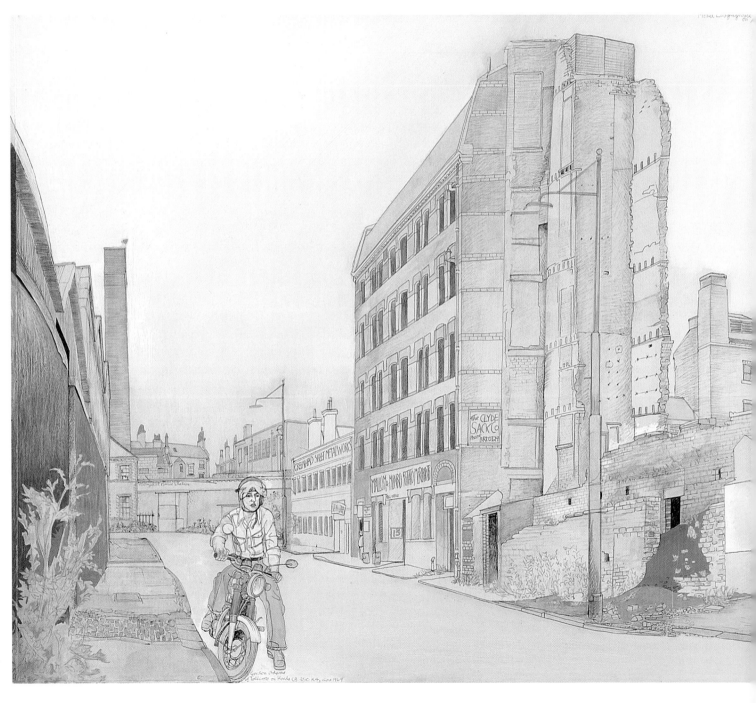

contemporary Glasgow. We agreed that I would paint the following:

1) Streets about to be changed or demolished.

2) Folk in politics and the arts.

3) Private members of the general public.

4) Interiors of work places with the workers.

These pictures would contain as much detail of furniture and setting as I could manage.

The store was in Bridgeton, which had suffered years of *planners' blight* – people knew changes were scheduled without knowing exactly what they were, so prosperous people and businesses moved elsewhere and owners stopped renewing their properties. The streets I pictured were therefore nearby. I had a special interest in them as my mother's and father's families had lived in Bridgeton, and I had visited it when painting my *Seven*

Days of Creation murals in Greenhead Church, which planners' blight had demolished. The summer of 1977 had many warm summer days so open air work was easy. I sat on a folding stool drawing the scenes in pencil and ink on paper, sketching whoever would stand still enough to pose for me. I then took the pictures to the People's Palace store, pasted them onto boards and coloured them as much as I thought necessary.

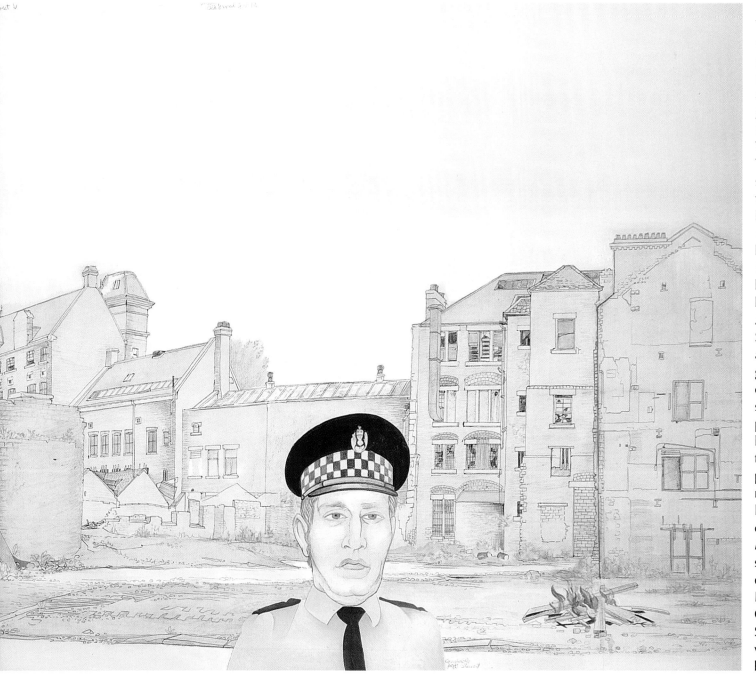

The building housing the potato merchant, and sack firm give on to the remains of a World War Two air-raid shelter. The waste land beside it was not caused by bombing. It allows back views of buildings on Abercromby Street. The tree above the roof grew in the old graveyard shown on page 178. The high building to the left was part of a cheap municipal lodging house, called a *Model Lodging*, soon to be demolished. Neither I nor Constable Jeff Stewart saw who lit the fire behind him.

*City
Recorder*

**London Road
between
Templeton's
Carpet Factory
and Monaco Bar
(End of Arcadia
Street III)**, *1977,
ink drawing tinted
with watercolour,
acrylic and oil on
paper,
70.7 x 132.7 cm*

The 1930s
building on
the left is
part of
Templeton's
carpet factory,
mostly a
building in
Venetian
polychromatic
brick, facing
Glasgow
Green.
Built in 1892,
its carpets
were in
Clyde-built
luxury liners
and British
colonial
parliaments.
The local
women,
young and
old on the
opposite
page, were
employees.
Templeton's
factory shut
down soon
after I
drew this.

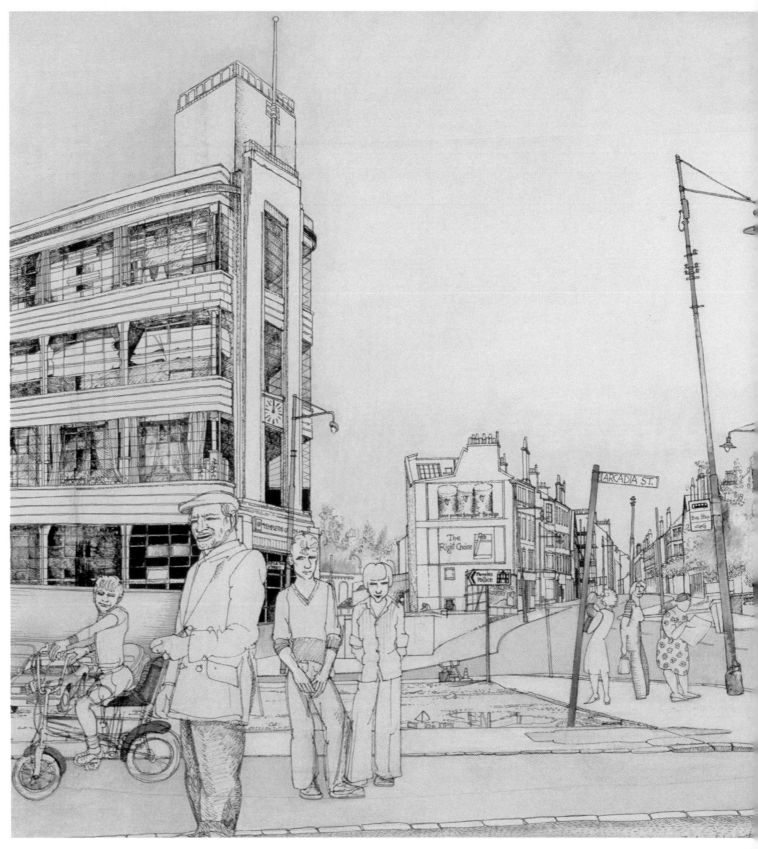

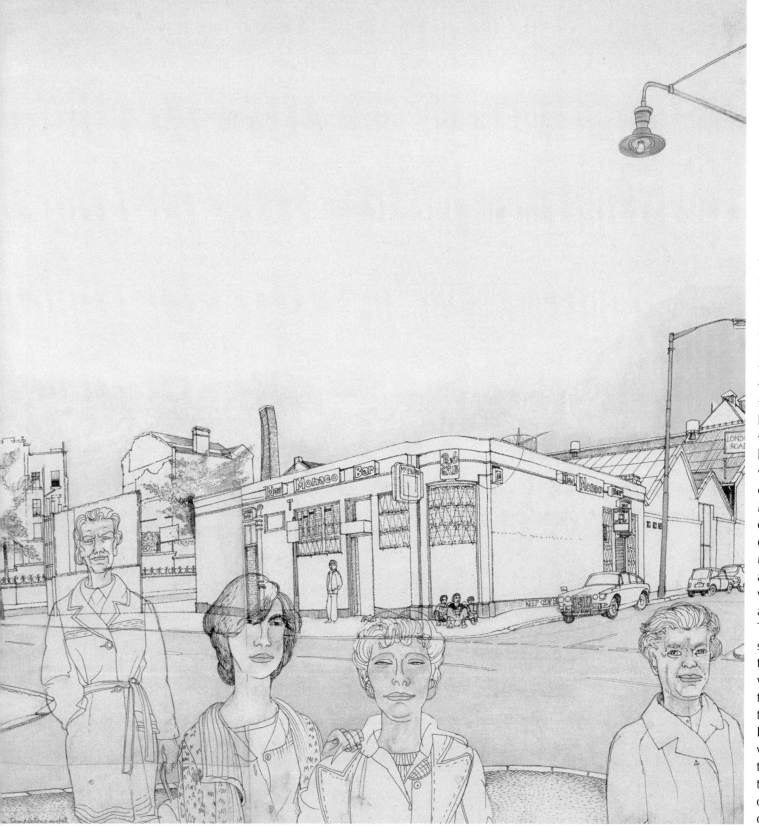

The Monaco Bar, like many corner pubs in Glasgow, remained for years when the tenement block of which it had been part was knocked down. Elspeth, Mike and I enjoyed a drink in the Monaco after work – it was raucous and friendly. The three boys sitting at the corner went there to get into this picture. I wish I had written on this picture the names of everyone drawn in it.

*Arcadia Street
with Jackson's
Garage and
Wee Harry of
the Monaco Bar
(joins onto The
North End of
Arcadia Street),
1977, pen and
acrylic on paper,
71.5 x 103.4 cm*

*Harry McShane
and the Weavers
Monument,
Abercromby
Street, Calton
1977, pen, ink
and acrylic on
paper, 29.8 x
43.4 cm*

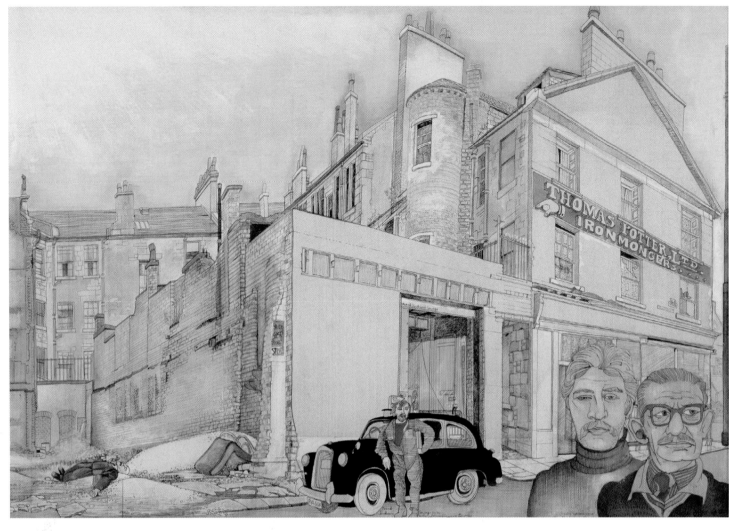

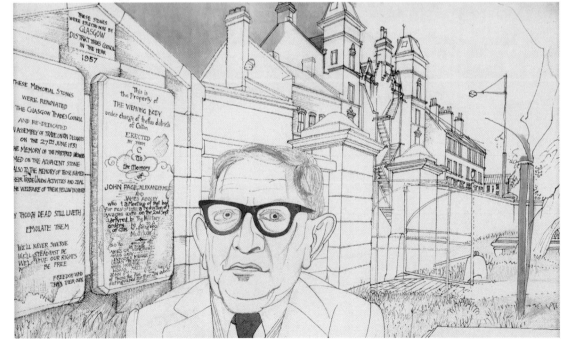

The above view is a continuation of the picture on p175 – the alcoholic is sleeping on the same piece of waste ground as the small bonfire.

The small graveyard at the foot of Abercrombie Street contains a stone commemorating six weavers killed by the military opening fire on a large gathering of weavers demonstrating against a wage cut. The stone, eroded by a century and a half of smoky air, needed frequent renovation by trade unionists and others who cared about working-class attempts at betterment. Harry McShane was a Communist and Red Clydesider born 1891, died 1988, an active trade unionist and defender of workers' rights for most of his life. The graveyard, also holding

the cast-iron tombs of local industrialists, was pleasantly maintained by the city parks department until the early 1970s, when the Wilson administration started reducing grants to local governments. Glasgow Council saved money by discharging park keepers, including the elderly watchman of this place. The iron tombs went to dealers in scrap metal along with bronze plaques and memorial busts from other public parks and graveyards including the Necropolis.

Glasgow's meat market, where animals for the whole city were slaughtered, covered a large acreage of ground between Duke Street in the north, Gallowgate in the south, and Bellfield Street in the east, and had fine neo-classical entrance gates like this one. In the 19th century the red-brick building to the left had been a power-loom factory, mentioned by the first government inspectors for its foul atmosphere, as its small square windows could not be opened. The man wearing a blue jacket with a folder under his arm was a modern inspector employed by the Jobs Creation Scheme, who had come to find if I was usefully employed.

Graham Square Cotton Mill and Entrance to the Meat Market, *1977, ink and acrylic on paper, 66 x 88.4 cm*

Carlton Waste Ground with Two Boys and Skip, Looking East, *1977, pencil, ink, watercolour and acrylic on paper, 66 x 88.4 cm*

*Provost McCann
and Family,
1977, ink,
watercolour,
acrylic and oil
on paper,
52.2 x 77 cm*

Peter McCann, lawyer and for some years Glasgow's Chief Magistrate, was Lord Provost of Glasgow 1975–77. Crippled by diphtheria when young, he needed metal braces to stand and walk, acquired a sharp tongue that ensured nobody pitied him, and had a special interest in provisions for the disabled. Being a Catholic in a city whose annual Orange Walks are second only to those in Belfast, he was keen on religious tolerance, supported the creation of a fine mosque in Glasgow, and on being presented with a ceremonial sword by an Arabian head of state, was widely criticised for keeping it instead of receiving it on behalf of Glasgow. I hoped to draw it on his living-room table, but instead he chose this candle holder, presented by Glasgow District Trades Council for

services to disabled people and the trade union movement. The map shows part of a new housing scheme of multi-storey blocks in Anderston he promoted when a councillor.

Teddy Taylor, former journalist and Conservative councillor, became a Tory MP in 1964. As a local politician he worked hard enough to be elected by mainly working-class folk in a very Labour-dominated city, and chose to be drawn in the living room of a constituent in the Castlemilk housing scheme. Had he not lost his seat to Labour in 1979 he would have been the Tory government's Secretary of State for Scotland. Instead it gave him a safe seat in England where, elected for Southend-on-Sea near London, his journalism, broadcasting and membership of the Monday Club

made him a spokesman for measures too right-wing for the then Conservative leadership. He was against Britain entering the European Economic Community, wrote an article entitled *How Tories are Subsidising the Soviet War Machine*, and proposed to restore both corporal and capital punishment. He retired from politics in 2005.

Jack House, born in 1906, attended Whitehill Secondary School, my own old school in Dennistoun, Glasgow, drawn behind him. He started work as an unhappy accountant, and by amateur acting, playwrighting and occasional journalism became a full-time reporter with the *Glasgow Evening Citizen*. He stood as a Liberal Party candidate (failed) in a 1963 election, but he represented the city of his birth so well in friendly

In the top corners of the drawing, handwritten: "Teddy Taylor, M.P. conferring with a constituent" and "Councillor Ian Gourlay at home in Holmbyres Rd Castlemilk"

Teddy Taylor MP and Councillor Ian Gourlay, 1977, pen and ink on paper, 53.3 x 78.7 cm

Jack House with former Whitehill Senior Secondary School, 1977, pen, pencil and ink on paper, 28.6 x 45.1 cm

journalism and broadcasting that many folk nicknamed him "Mr Glasgow". He thought it in many ways a city state like Venice or Florence. In many ways it was, before the 1950s and ´60s, when local government dispersed many of the citizens to peripheral housing estates and new Scottish towns where new local industries were starting. In the 1980s the Thatcher government began privatizing our social services with no noticable resistance by the Glasgow ruling Labour Party. Jack campaigned (unsuccessfully of course) against the building of motorways through central Glasgow that destroyed many of its communities, and the building of multi-storey flats to rehouse them. He wrote 54 books, mostly local histories, the best of which is *Glasgow's Square Mile*

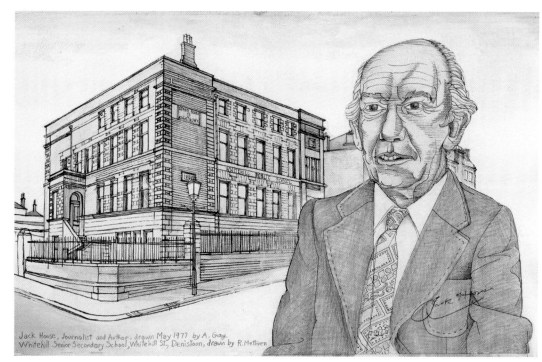

Jack House, Journalist and Author, drawn May 1977 by A. Gray. Whitehill Senior Secondary School, Whitehill St., Denistoun, drawn by R. Methven

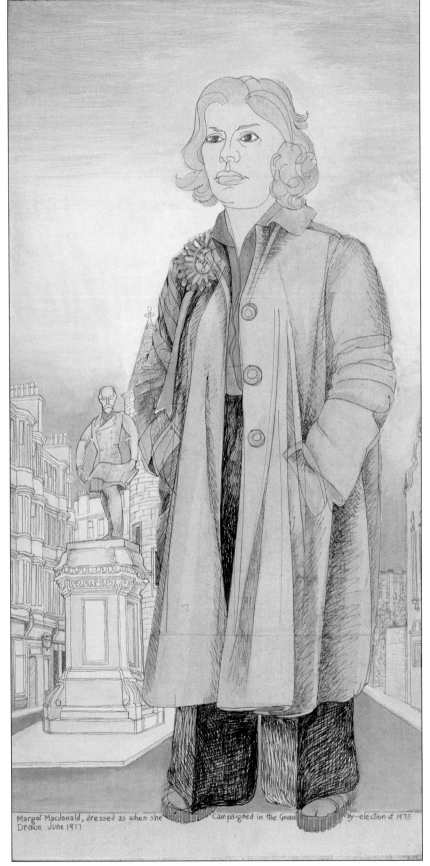

Margot Macdonald, dressed as when she
Drawn June 1977
Campaigned in the Govan
by-election of 1973

of Murder. By examining the trials of Madeleine Smith, James Fleming, Dr Pritchard and Oscar Slater, Jack shows that only Pritchard, by a narrow margin, was found guilty of murder, and Slater (a Jewish pimp) was wrongly framed for one, and that unjust verdicts were upheld to maintain the *respectability* of prosperous Glasgow citizens.

Margo MacDonald, former Physical Education teacher, was the first Scottish Nationalist Member of Parliament to win a Glasgow seat from the Labour Party – Govan, in a 1973 by-election – and though always a strong supporter of Scottish self-government, was too declared a Socialist to be popular with the Scottish parliamentary party leadership, and since 2003 has been elected as an Independent. Here she appears in the clothes she then wore, and chose to be standing at Govan Cross with The Black Man behind her – Govan children's nickname for the bronze statue, blackened by soot, of Sir William Pearce. Born 1833, died 1888, he was engineer and owner of what became Fairfields, the famous shipyard that for an era built Clydeside's biggest and fastest ships. As an employer he improved the conditions of his workforce, became a Liberal MP, and preserved more of Glasgow's architectural past than most local politicians.

Jimmy Reid (on page 183) was drawn with his wife and three daughters in his Clydebank council house. Born in 1932, he worked in the shipyards, became a trade union official, a Clydebank town councillor, then Glasgow's best-known member of the Communist Party. This came about through the Clydeside shipyard owners amalgamating their industries in 1967, preparatory to declaring them bankrupt in 1971 before asset-stripping and removing them from Scotland. Threatened with sudden wholesale unemployment, the workforce overwhelmingly voted through its trade unions to stage a Work-In, the last of Glasgow's major 20th-century industrial actions. Labour, Scottish Nationalist and widespread public support for the Work-In forced Edward Heath's Conservative government to hold back the closures for several years by helping to maintain Fairfield's, Yarrow's and John Brown's shipyards. Jimmy Reid became the unions' choice as spokesman when presenting the workers' case to reporters and broadcasters, who naturally presented him as the Work-In's main organizer, though he was one of several.

This is the biggest group portrait I made when

Glasgow's Artist Recorder, and hoped it would be shown beside an oil painting of a late 18th-century drawing room interior with a prosperous merchant's family. All the drawing was done on one day in the Reid family living room, but the figures and the background were drawn on different sheets of paper, then pasted onto a thick hardboard panel. I wanted to paint carefully over the whole with acrylic underpainting, then oil on top, until I achieved a finish like that of the 16th-century Flemish masters I admired. This would have meant working on this picture, and no other, for three or four weeks, and I had no time to do that. The Jobs Creation wage was too small for me to pay Andrew's fees at Kilquhanity School. John Aitkenhead the headmaster was kindly refusing to press

me for payments due, I suspect because he was accustomed to such difficulties with parents. But I hated being in debt, so applied for work with a bigger salary as Writer in Residence at Glasgow University, on the grounds of my experience as a professional playwright. Perhaps because Philip Hobsbaum was on the selection committee I was accepted for this job which started in September 1977, so all the pictures in this chapter were drawn and mostly coloured, in less than four months before then.

The writers on the next pages were mostly friends drawn in June, July and August. The portrait of Archie Hind on the next page was drawn in his home, and he chose for background a Clydeside footpath where he had played as a child. It is mentioned in his novel *The Dear Green Place*, which

tells how one of his schoolmates used to climb and run along the high wall to the left, which had a waterworks behind, and how that friend fell from it to his death. Dalmarnock power station behind him was demolished in the 1980s after Scottish nuclear power stations and North Sea gas fields mainly replaced coal as an energy source. Left of it appear two of the new high-rise flats. The right bank of the Clyde here is in the Royal Burgh of Rutherglen – not Glasgow – and was once the site of a small shipyard. In 1884 it started building Cluthas, *Clutha* being Gaelic for Clyde. These coal-fired boats could carry 360 passengers and were popularly called penny steamers because they worked as Clyde waterbuses between Dalmarnock and Clydebank, and some were bought for use in the rivers of foreign colonies.

Jimmy Reid and Family at Home, 1977, acrylic, pencil on board, (never completed), 81.6 x 132.2 cm

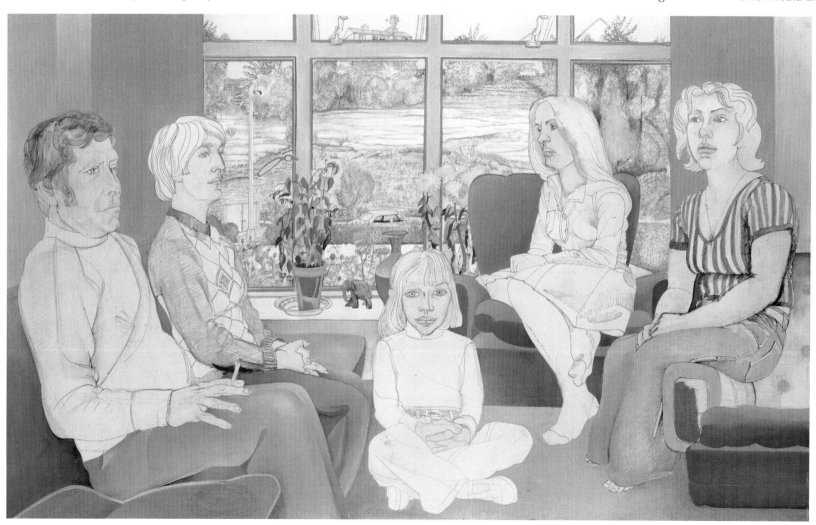

Page 184

City Recorder

Archie Hind on the Banks of the Clyde, Dalmarnock Power Station Behind, 1977, pencil, ink and watercolour on paper, 54.5 x 89 cm

Electric trams put them out of business in the 1910s. The boy sleeping beside the *Batman* comic and Striker Cola bottle is Andrew, then thirteen, spending the warm summer of 1977 on holiday with me.

Alex Scott taught Scottish literature at Glasgow University. Before his appointment Scottish literature was taught as part of English, like Irish and American literature. British universities lectured on Wilde, Joyce and Yeats, Hawthorne, Melville and T.S. Eliot, but in Scotland as well as England they disparaged or ignored Burns, Scott, Stevenson and MacDiarmid, and wholly ignored Scotland's Gaelic literature. MacDiarmid's polemics and the interest of academics in Europe and the USA led Glasgow University to create the world's only department of Scottish literature in 1971, with Alex Scott its first head. The Pewter Pot was a pub in the corner of a tenement near Kelvinbridge

on Great Western Road. With middle-class Hillhead on one side and working-class Maryhill on the other, its clients were an unusually pleasant mixture of ages and occupations, and for years it was where I met and made several good friends. It closed for refurbishment in the late 1980s when the tenement was demolished with many others, and the district between North Woodside and Maryhill Roads rebuilt with genteel little two-storey terrace houses. When the Pewter Pot reopened at least half of the former regular clients converged there in the first week, found all the snug interior subdivisions had been abolished, and departed never to return.

This portrait could also go with people in their workspaces. Born in 1940 Rutherglen, Tom McGrath was a jazz pianist who became prominent in the London 1960s "Underground

Culture", was founder-editor of London's *International Times*, and after returning to Scotland, a stager of Edinburgh Festival events and successful playwright. In 1974, with Scottish Arts Council backing, he opened the Third Eye Centre on Sauchiehall Street, an exhibition gallery, auditorium and café-restaurant where artists, writers and the general public could learn about each other and discover new work from elsewhere. Tom, a good administrator, had no time to practise his own arts. I think this caused strain visible in my portrait. After some exciting early years the Centre became wholly managed by southern British administrators with less and less interest in Glasgow and Scottish art. Nobody local was much interested or surprised when it went bankrupt in 1991. It was renovated and reopened as the Centre for Contemporary Arts, which appears to flourish.

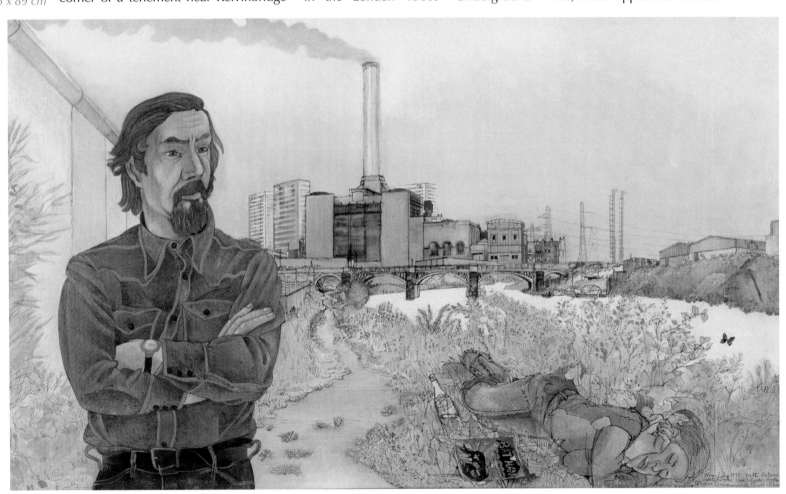

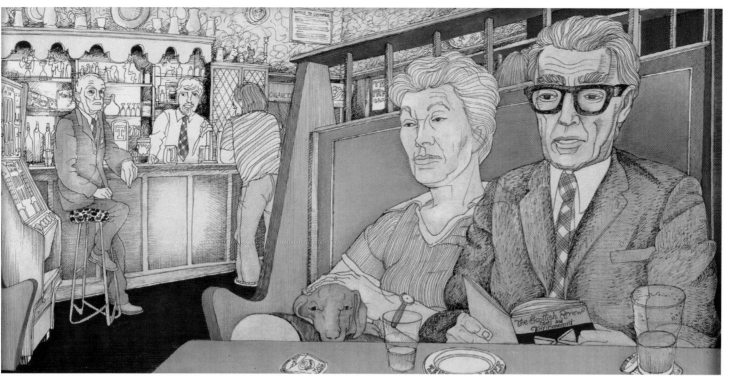

Alex Scott with his Wife Cathy in the old Pewter Pot, with Pat O'Shaughnessy at the Bar, 1977, ink, watercolour, acrylic and oil on paper, 31 x 61 cm

Tom McGrath in his Office at the Third Eye Centre with Secretary Linda Haase and View through the Window behind of Scott Street, 1977, pen, pencil, ink and watercolour on paper, 44 x 73.5 cm

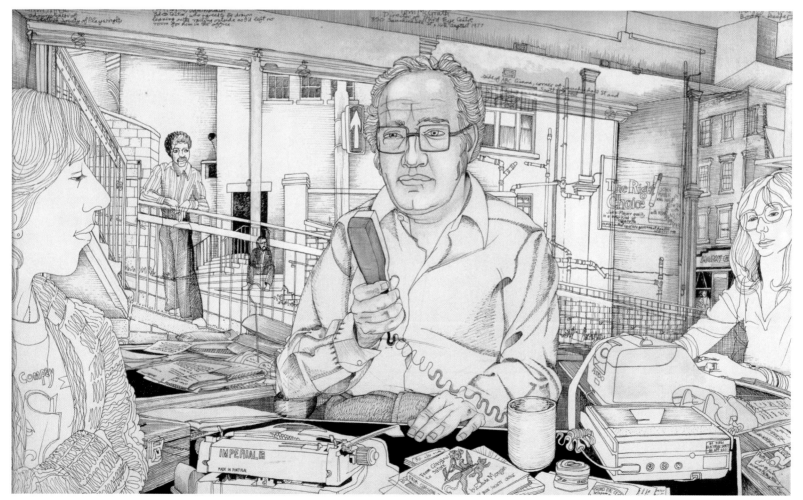

Page 186

*City
Recorder*

Liz Lochhead,
*1977, ink,
watercolour,
acrylic and
wax crayon on
paper,
60.9 x 31.7 cm*

***Jim Kelman
at Home***,
*1977, ink,
watercolour,
acrylic and oil
on paper,
30.5 x 55.9 cm*

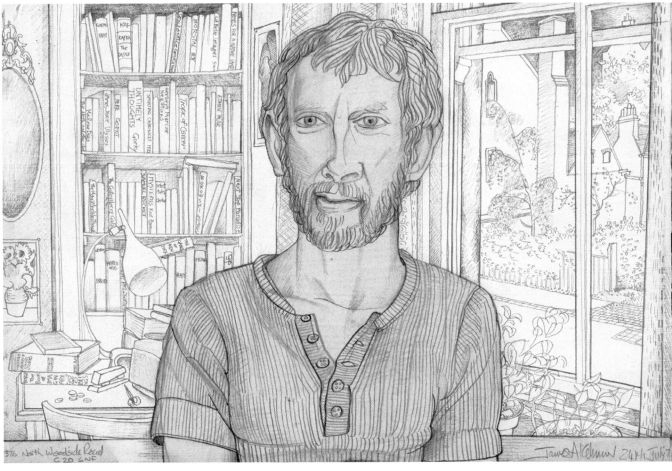

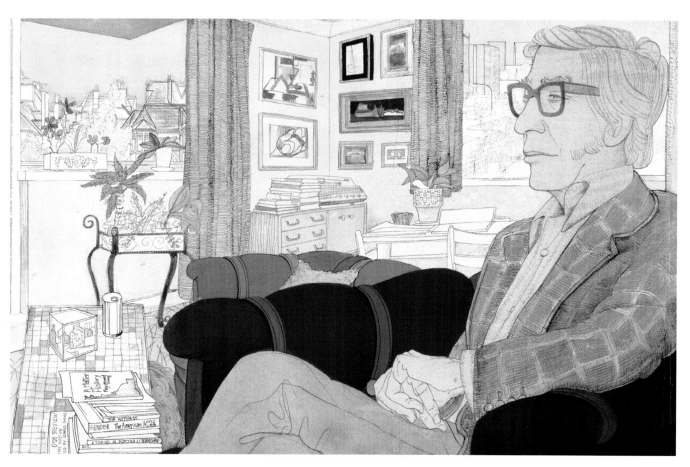

Page 187

1977–78

***Edwin Morgan at Home**, 1977, ink, watercolour, acrylic and wax crayon on paper, 33.3 x 61.6 cm*

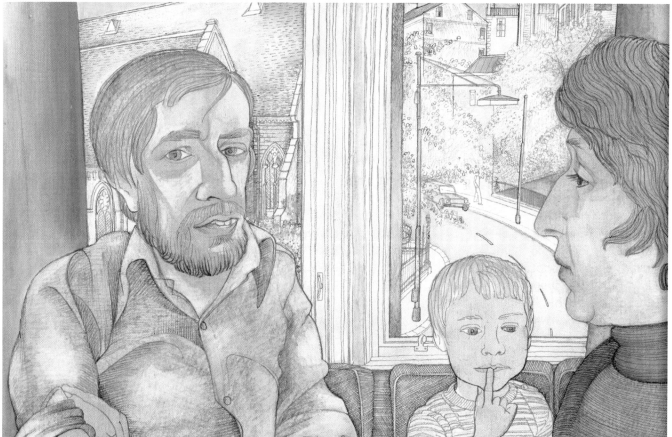

***Tom Leonard at Home**, 1977, ink, watercolour, acrylic and oil on paper, 30.5 x 43.1cm*

Reo Stakis: Hotelier, 1977, ink and collage on paper, 87 x 70 cm

This drawing was made in Mr Stakis' chief office in the Grosvenor Hotel a few weeks before a fire destroyed the whole building in 1978, when I painted flames on the brochure photograph. Mr Stakis had similar bad luck with earlier properties. Insurance and conservation grants let the former terrace of private houses be rebuilt with a truly modern hotel interior.

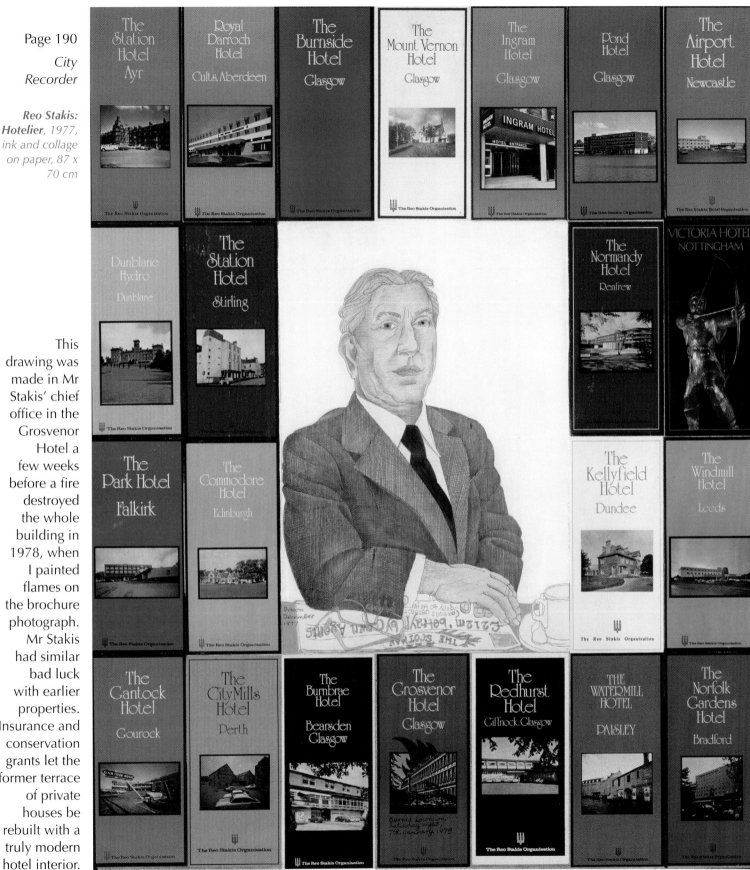

Many Britons could not have entered her overseas colonies without letting their natives come here, after many had fought for Britain's empire. In the 1930s Reo Stakis, a Greek Cypriot, came to Glasgow with a suitcase full of lace. At first a lowly potato merchant, he steadily banked his gains and became the biggest hotel owner in Scotland. His grandest property was the Grosvenor Hotel, Hillhead, built in 1858 as a terrace of private houses in a palatial Venetian style. During a strike of firefighters in 1978, a fire after midnight destroyed it, but insurance paid for the outside being exactly remade in glass-reinforced concrete, with inside a more efficient modern hotel. I commemorated the accident by adding flames to the hotel brochure's photograph.

By surrounding Inspector Derek O'Neil with photographs taken in Tobago Street Police Station, Bridgeton, I tried to convey the life inside it, but as an artistic and contemporary social document this is my least successful work, though the portrait is alright. The photographs were taken by Alan Singleton, a cousin of George.

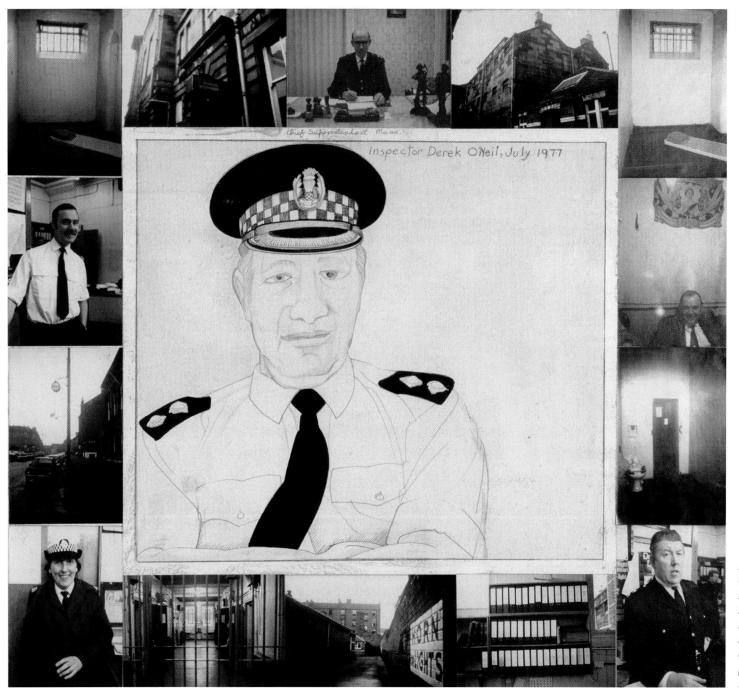

Inspector Derek O'Neil, Tobago Street Police Station, 1977, ink with acrylic and photo collage on paper, 52.3 x 77.1 cm

For many years Scots Protestant clergy, Episcopalian or (by Law Established) Presbyterian, have been mostly tolerant of other faiths. Born 1936, died 2004, Pastor Jack Glass hated Catholicism as much as Calvin and John Knox, which is why he asked to be shown, Bible in hand, between the Knox Monument in the Necropolis and Glasgow Cathedral spire. He left the Baptist Church when it too proved ecumenical and founded his own Zion Baptist sect in Glasgow. Jack Glass and the Reverend Ian Paisley objected to the Pope visiting Scotland in 1982, and when the Pontiff descended by helicopter in Glasgow's Bellahouston Park, led a crowd of followers who chanted "The Beast is Coming!" But even Paisley called his friend Glass "a bit of an extremist". Like everyone else I drew for the People's Palace I found him polite and friendly, though he discussed neither religion nor politics.

I asked Provost McCann to suggest a Catholic priest whose orthodox views

were strong enough to balance those of Glass. He suggested Canon Collins of Pollokshaws because Archbishop Winning (made Scotland's first cardinal in 1994) was "a nice enough man but has no fire in his belly. Canon Collins is your man." I found Canon Collins also polite and friendly. He only once mentioned politics, quoting with disapproval a lady who objected to the poverty of the peasants in Franco's Spain. She did not realize (he said) that Spanish poverty was caused by the Republican government (before Franco replaced it) sending Spain's financial assets to Moscow. I did not dispute this, though thought it unlikely.

I drew this picture of Bill Skinner before his death from heart illness in 1973, and donated it to the Palace surrounded by archive material – a portrait of the Scottish Episcopalian Archbishop Skinner who knew Burns, photographs of father, mother, himself as small boy, older schoolboy and adolescent body-builder in the living room of the family home, 60 Otago Street in 1926, where I portrayed him 42 years later. The bottom right photograph shows him with workmates in Fairfield's shipyard, where he was a marker-off, showing where rivet holes should be drilled through sheet metal. On the left side, under my obituary of him in Glasgow's short-lived *West End News*, is one of the small labels he attached surreptitiously to lampposts during World War Two and the Cold War that followed.

Bill Skinner, 1977, pen, ink and photographs on paper, 52.7 x 48.9 cm

Page 194

City Recorder

Cliff Hanley with Book Cover of First Edition of his Autobiography, *1977, ink on paper, 22 x 20 cm*

Malcolm Cooper and Fidelma Cook: Producer and Reporter in BBC News Gallery, *1977, ink, watercolour, acrylic and oil on paper, 52.5 x 77.4 cm*

Frank Worsdall between Front and Back Jacket of his Book, 1977, pen, pencil, ink and acrylic on paper, 21.8 x 21.5 cm

Sweeney Todd Hairdressing Salon, St Vincent Place, 1977, ink, watercolour and acrylic on paper on board, 52.3 x 76.5 cm

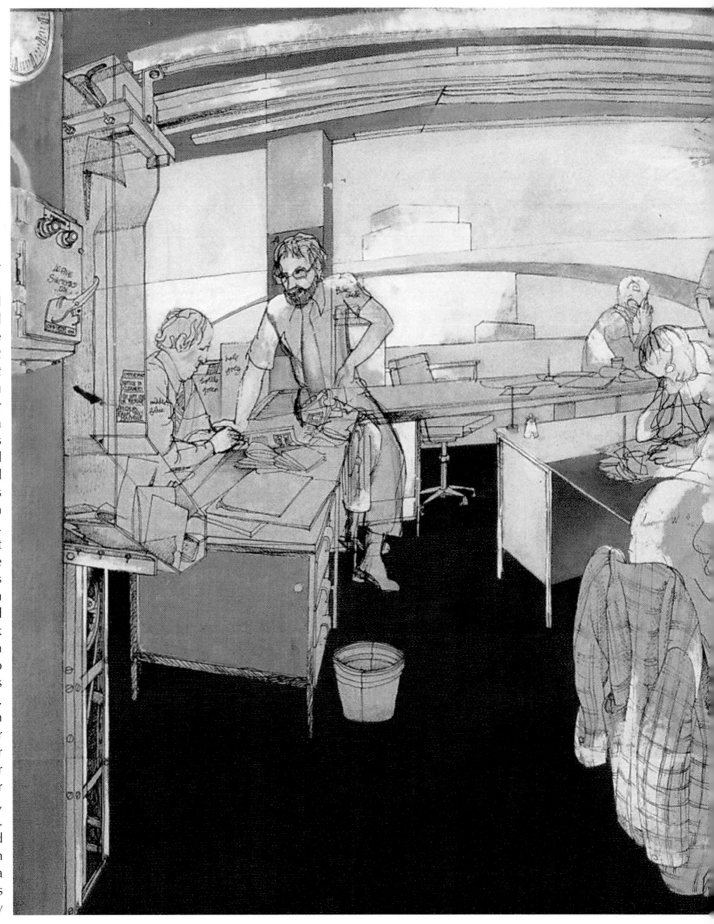

*City
Recorder*

**The Daily Record *Staff
in the Old Broomielaw
Newspaper Building, with
view of Kingston Bridge***, *1977, tinted pen drawing
on white paper,
66 x 88.4 cm*

Though drawn for
the People's Palace,
this unfinished
picture remained
with me. I gave
my *Self Portrait
as a Bankrupt
Tobacconist* in lieu
of it. This interior
records the era
before computers
were small and
commonplace, and
even in big offices
people wrote with
pens or typewriters.
In the transparent
box on the extreme
left, folded notes
flutter down from
an overhead
rail, sent by folk
somewhere else in
the building who
had received news
items by telephone.
The bald man with
spectacles under
the clock is either
the Record's editor
Bernie Vickers, or
the chief sub-editor,
Sandy Williamson.
Standing behind and
to the right of him
is Dave Foulis, a
sub-editor who was
given this picture by

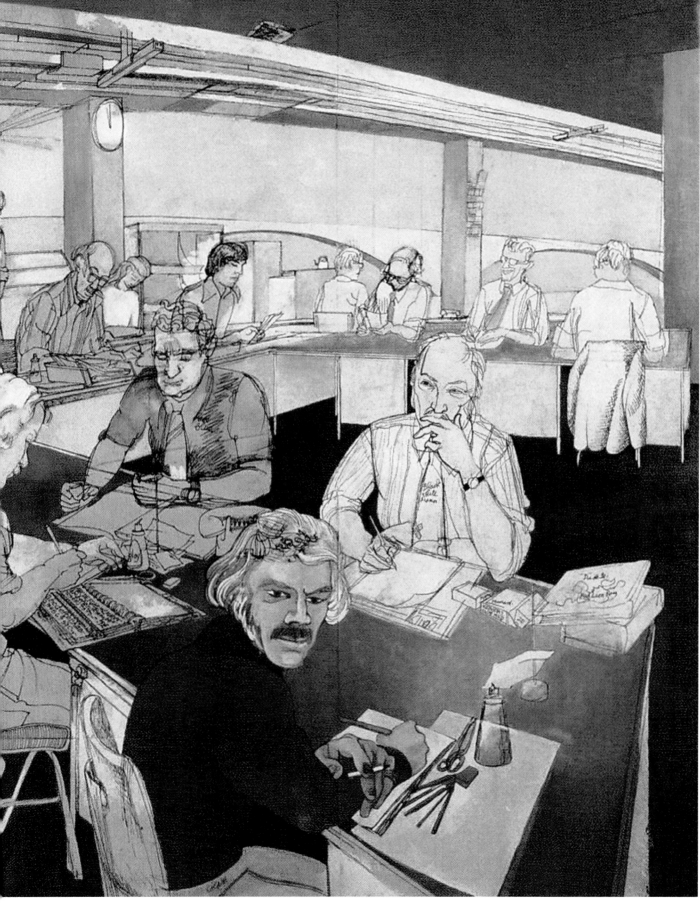

his friend and mine, Angela Mullane. (His heirs have inherited it.) The Kingston Bridge beyond the window was the Clyde's first bridge to carry a pedestrian-excluding motorway. Apart from two images on the next page, that is all the art I made when Glasgow's official recorder. Elspeth was hurt when, in September 1977, I left my City Recorder job to become Writer-in-Residence at Glasgow University. I would never have left it if the Jobs Creation wage had been enough for me to pay my half of Andrew's Kilquhanity School fees. For the first six months of 1978 all but the *Daily Record* interior were shown in *The Continuous Glasgow Show* with paintings the Palace owned of earlier people and places. The poster for it was displayed in the carriages of the subway, Glasgow's underground railway circle.

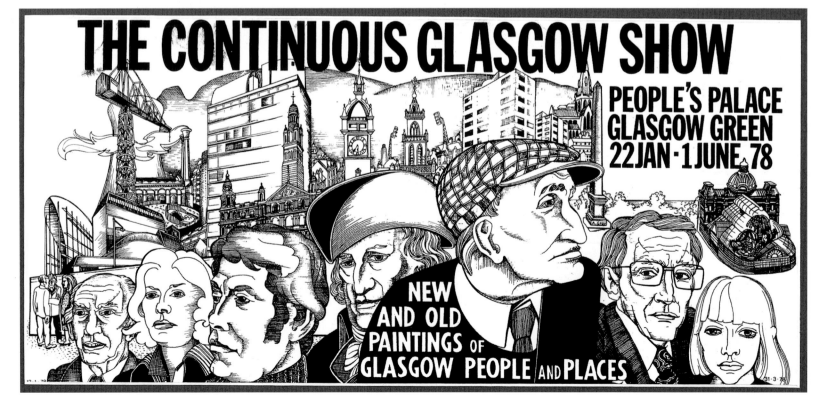

Norman Ross, Radio Clyde disk jockey, interviewing Flora, aged 12, whose back is in plaster, in the womans orthopaedic ward of the Southern General Hospital, Glasgow, in October 1977

Page 198

City Recorder

Norman Ross: Hospital Broadcaster, Radio Clyde, *1977, pencil and acrylic on paper, 40 x 60.7 cm*

The Continuous Glasgow Show: New and Old Paintings of Glasgow People and Places, 1978, poster, 19 x 41 cm

THE CONTINUOUS GLASGOW SHOW

PEOPLE'S PALACE GLASGOW GREEN 22 JAN - 1 JUNE, 78

NEW AND OLD PAINTINGS OF GLASGOW PEOPLE AND PLACES

Fifteen: Towards *Lanark*, 1970–81

THESE PORTRAITS show friends I met through Philip Hobsbaum's writers' workshop: two Glaswegians and two Gaels from the Island of Skye, all students of English from Glasgow University. With Tom Leonard they met Philip when he arrived there as a lecturer from Queens University, Belfast. Seamus Heaney, in his book *Preoccupations*, says that writers in Belfast had "stood or hung or sleepwalked between notions of writing that we had gleaned from English courses and writers from our own place whom we hardly knew, in person or in print … that state of affairs changed by the mid-sixties and one of the strongest agents of change was Philip Hobsbaum … He emanated energy, generosity, belief in the parochial, the inept, the unprinted … What Hobsbaum achieved was to give a generation a sense of themselves … to get to grips with one another, to move from critical comment to creative friendship at our own pace." In Glasgow he affected writers in the same way, taking it for granted that we

Aonghas MacNeacail, 1984, pen and watercolour on paper, 40 x 41.5 cm

James Kelman, author, 1974, ink on brown paper, 21 x 15 cm

Catriona Montgomery, Gaelic poet, 2000, ink on paper, 21 x 15 cm

Chris Boyce, 2005, acrylic, oil and pencil, 20 x 15.5 cm

Angela Mullane with Daffodils, 1975, pencil and watercolour on brown paper, 55 x 88 cm

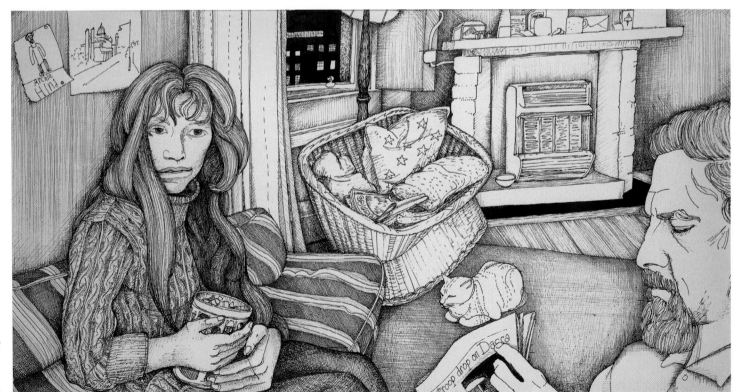

Nelliemeg, Serenus and Archie, 1972, ballpoint pen on newspaper

SCOTTISH SOCIETY OF PLAYWRIGHTS

ROBERT TROTTER
and HELEN MILNE
in two plays by
JOAN URE
'THE HARD CASE'
and'RICH AND FAMOUS'
8pm Friday 20th May
2.30pm and 8pm Saturday 21st May
TICKETS 80p Third Eye Centre
350 Sauchiehall Street,
Glasgow G2 3JD.
Telephone 041-332 7521

"Scottish Society of Playwrights Conference" (unfinished poster), 1975, acrylic and Indian ink on paper, 30 x 30 cm

"The Hard Case" and "Rich and Famous", 1977, poster, 49.2 x 21 cm

used the culture of our own place and time. So Aonghas MacNeacail stopped calling himself Angus Nicholson and from then on wrote poems in both Gaelic and English. Not all the friends I made through Philip became writers. One of my steadiest was and is Angela Mullane, who married Chris Boyce and became a lawyer.

The increasing number of writers in Scotland was not much noticed by official or commercial organisations here. I was one of very few who sold plays to Scottish BBC Radio and, like Peter McDougall, could only sell my television plays to broadcasters in England. From 1966 onward Cecil Taylor found it so much easier to get his plays acted in South Britain that he went to live in Newcastle-on-Tyne, but was still Scottish enough, and Socialist enough, to believe playwrights north of the border would have a better chance of recognition if they formed their own trade union. He and Tom Gallacher called a meeting, first in Glasgow, then Edinburgh, to get one going. I attended with Joan Ure, Liz Lochhead, Tom Wright and others who constituted themselves The Scottish Society of Playwrights, which made me the minutes secretary. I did not last long at that because my confused private life made it impossible to attend meetings steadily. I mention the matter here because the connection led to me designing several posters, as did my friendship with Joan Ure and an unsuccessful theatrical venture, the Stage Company of Scotland.

One evening in the Doublet, Park Road, I started talking to Carl MacDougall, then a journalist, which led to me illustrating his collection of stories for children, *A Scent of Water*. The publisher was Simon Berry who ran The Molendinar Press from his flat a few tenement blocks away. He allowed me total control of the layout, and the result

was a pleasant marriage of image and text in a pleasant wee book that I wish someone would reprint. The woman in the bottom right corner of the cover is Fiona, Carl's wife, who also appears in the family portrait below. It was begun in the year of the book in the MacDougalls' Glasgow flat, but finished over a year when they were living in Glenrothes New Town after the birth of their son, which explains a certain disconnection in the figures on each side, which I have tried to bridge with an imagined opening onto a Mediterranean balcony. A quotation from the novel on the table can be found under **MacDougall, Carl** in *Lanark's* Index of Plagiarisms.

'Live Theatre, Living Playwrights', 1988, poster, 39 x 32 cm

Head of Dan Healy, 2009, ink drawing on brown paper, 30 x 21 cm

Though drawn in 2008 this shows Dan Healy as he has appeared since I first met him in 1971. A builder privately employed by architects and town councillors who like to avoid publicity, he is excellent at difficult jobs to be carried out quickly for ready cash, but otherwise not dependable. He claims to be King of Scotland because nobody else wants the job. The resonance of his laughter once had him barred from every Glasgow pub, restaurant or meeting place he visited. I place him here out of friendship and because he introduced me to someone who gave me the greatest mural commission of my life, as will appear in a later chapter.

Carl MacDougall, Fiona and Euan, 1976, pencil, ballpoint, wax crayon, acrylic and oil on brown paper, 30 x 50 cm

THE BLUE LADY

HE DAY started well

THE WITCH'S PEARLS

HEN SEALS sing their sad song humans listen. It's the cry of a wounded animal, a cat's scream or a howling dog; a wild cry which fits the surroundings.

Some say seals are angels who fell from grace, but

A NEW KEEL

AIN MACRAE fished where the long finger of Kintyre reaches to touch Ireland; where Scotland's first fishermen reaped without sowing.

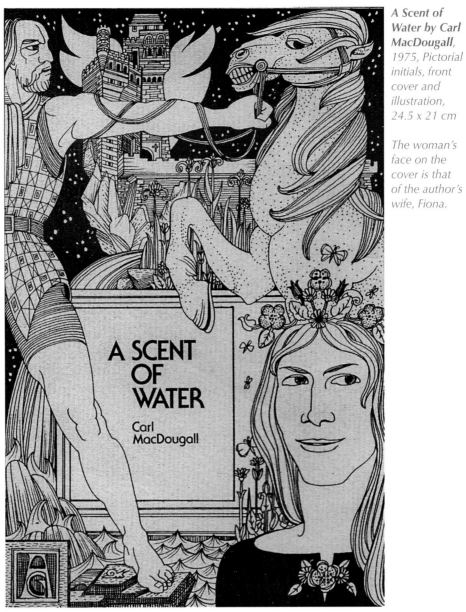

A SCENT OF WATER

Carl MacDougall

A Scent of Water by Carl MacDougall, 1975, Pictorial initials, front cover and illustration, 24.5 x 21 cm

The woman's face on the cover is that of the author's wife, Fiona.

THE SIX TRAVELLERS

for Nellimeg and Sheila Hind

OMEWHERE BEYOND the

THE GREEN SWEATER

OU KNOW what it's like at night with a radio's tinny rattle for company and the

Rosemary Singleton divorced her husband George, married Philip Hobsbaum and came with her two daughters to live with him in 1975. I drew the illustration to Peacock's novel *Nightmare Abbey* as a wedding present. Philip on the left is playing the host to Byron on one side, Edward Irving on the other; Rosemary faces him between Shelley and Coleridge. Her daughters are outside the window. I started colouring the picture when I knew Philip was seriously ill, and managed to finish it as a present for Rosemary after he died in 2005.

Writers-in-Residence were new to Britain when I applied to Glasgow University for the job, having had some plays broadcast, odd chapters of *Lanark* printed in *Scottish International* and Carl MacDougall's *Word* magazine. Philip was on the panel which interviewed me, and may have achieved my appointment. The two years of steady, well-paid, pleasant encouragement of willing writers were a wonderful relief, as the job allowed plenty of time for my own work. Aunt Annie was

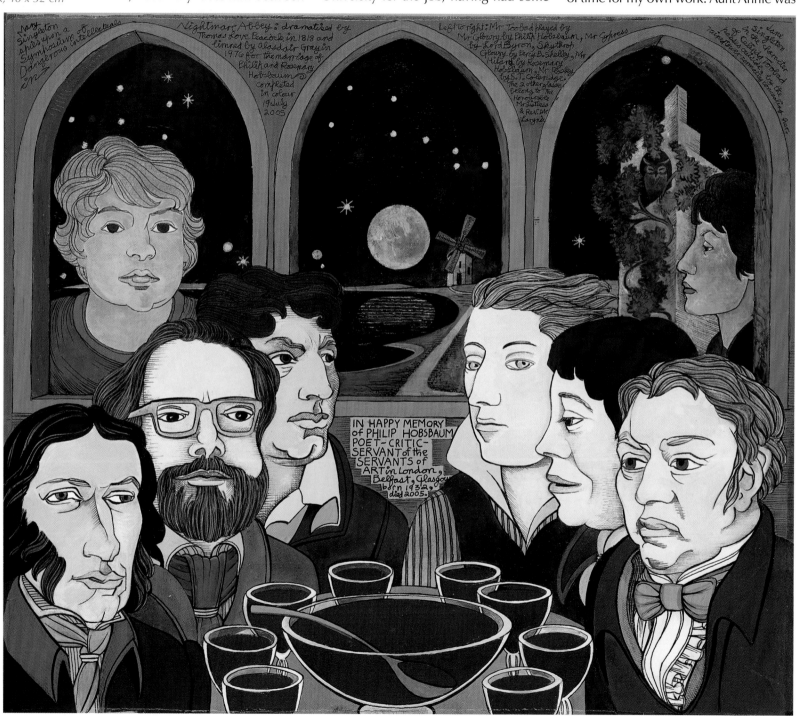

Dwelly's Illustrated Gaelic to English Dictionary, 1977, book jacket, 19 x 35 cm

The cover design by Alasdair Gray shows the eighteen Trees which represent the letters of the Gaelic Alphabet.

Glasgow University Creative Writing poster, 1977, 30 x 21 cm

Reading of "Crow" (Ted Hughes) by Marcella Evarristi and Mike Boyd, 1978, poster, 29.5 x 42 cm

especially delighted because she thought nobody more socially valuable than a university teacher, and I need never be short of money again. I told her the job would only be mine for two years but she said, "No no! As your Uncle Johnny used to say, once you're into one of those places you can take your bed in with you." She died in my first year of the job. Luckily I was with her in the evening when the first stroke disabled her, and on the morning of the last that killed her.

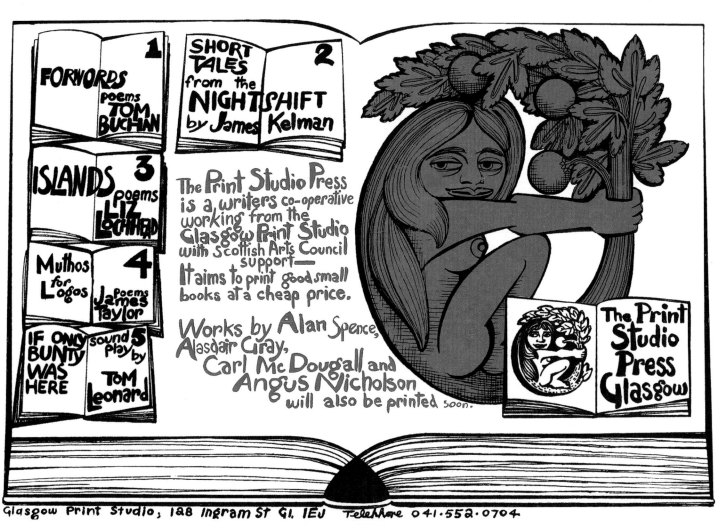

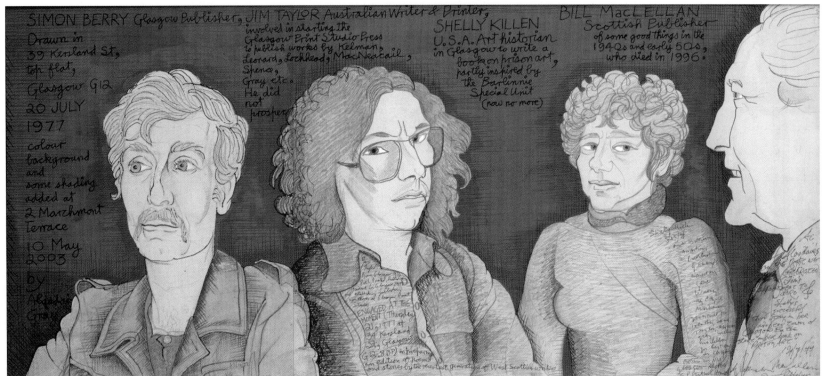

poems of a gaelic childhood

AONGHAS MACNEACAIL

IMAGINARY WOUNDS

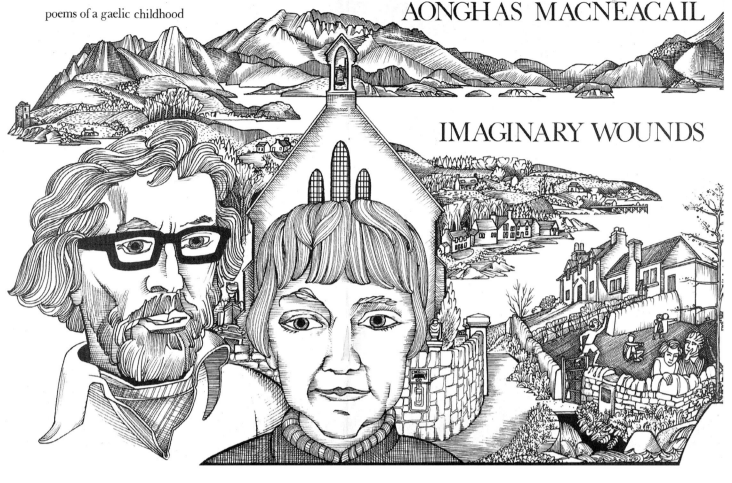

Imaginary Wounds by Aonghas MacNeacail, book jacket, 1980, 18 x 48 cm

In the 70s Glasgow Print Studio arranged readings by local writers in its Ingram Street premises. They contained an old cast-iron press with stands of type. They gave James Kelman, apprenticed to a printer in his teens, an idea he discussed with other writers and Calum McKenzie, the Studio boss. Together they formed the Glasgow Print Studio Press which would print (as my poster says) "good small books at a cheap price". Nine writers joined this co-operative. With Scottish Arts Council backing over several years each of us had a slim book published. I was (once more) the minutes secretary, and designed the logo, poster and cover of Aonghas MacNeacail's poems about his childhood in Skye. To draw his native shores for that cover I visited his workplace, then the Gaelic College at Ostaig by the Sound of Sleat, which also let me paint a saleable landscape. This small press did good by letting us meet, encourage each other and make others recognize our existence, but when distributing our books we found most shops saw no point in selling small cheap ones for which their commission on sales would be smaller, and those who did get shops to take a few usually failed to return for the cash. When the co-op disbanded we each took away a great pile of our unsold work. I dumped nearly all of mine (*The Comedy of the White Dog*) in my Kersland Street dustbin.

In 1975 I researched for a play in the old London Reading Room of the British

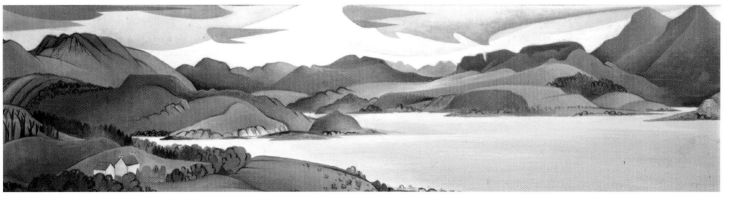

Sound of Sleat, Isle of Skye, 1970, oil and acrylic , 13 x 51 cm

Andrew Gray, 1980, pencil, ink and watercolour on brown wrapping paper, 104.4 x 44 cm

Arcadia Mural details, Ubiquitous Chip back stairs. Drawings of staff and some customers were pasted to the walls then painted in oils like their surroundings in 1980. Damage by water led to repainting of parts and additions 12 years later.

The grave colours of earth
brighten toward
an open book
of light unstained
by
word

Dave Byrne
Dennis Lee
Madeleine Valente
Jim Murray
Elaine Knox

Ubiquitous Chip Mural (stairway) 1979–82, additions and amendments made November 1999–July 2000. Left side of stairwell 4m (approx); right side 4.5m (approx). Top of stairs **"Linda Morrison and Kay Scott, 1980"** – 300 x 87 and **"Jodie Quadros 1980 and Lord Carmichael 2000"** – 87 x 180 cm, acrylic and oil colour on wall

Museum. The great circular chamber where Marx, Bernard Shaw and Lenin had educated themselves was entered through a shop selling souvenir postcards. Four reproduced richly symbolic title pages – Vesalius's *De Humani Corporis Fabrica*, Raleigh's *History of the World*, Bacon's *Novum Organum* and Hobbes' *Leviathan* – books that had advanced the arts of medicine, history, experimental science and politics. I saw they could be adapted to introduce the four quarters of my encyclopaedic novel, *Lanark*. I have mentioned finishing it in 1977 and posting it to Quartet Books after my agent, Francis Head, died of lung cancer. They had rejected it (like two other London publishers) because of its length. I feared that no good publisher would want it.

Novum organum scientiarum by Francis Bacon, 1620, title page, London (Franc. Baconis de Verulamio, Summi Angliae Cancellarij, Novum organum scientiarum)

Lanark: Book 1, title page, 1981

Angus Wolfe-Murray, founder of Canongate Books, had read two chapters of *Lanark* in the 1970 edition of *Scottish International*, then Scotland's liveliest literary magazine. He had phoned me, asking to publish it, and been sorry to hear Quartet Books had bought the

option. It seemed unlikely that a small Edinburgh press would take a book that three big London publishers thought might ruin them, and I would have felt more hopeless still had I known

Canongate now belonged to Stephanie Wolfe-Murray, the founder's separated wife (Stephanie kept it going through a series of financial crises that only ended in 1995). I was Writer-in-Residence in

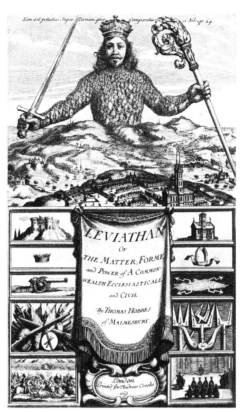

Lanark: First title page, 1981

Leviathan, by Thomas Hobbes of Malmesbury, *title page, London, 1651*

Lanark: Book 4 title page, *1981*

1978 when Stephanie's partner, Charles Wilde, sent me a letter accepting *Lanark* so enthusiastically that for a moment I doubted his sanity. The *Lanark* contract was signed when I had a comfortable office high up in the West Quadrangle of Glasgow University, with a splendid downward view of the Kelvingrove weir and Art Galleries beyond. The book was not published until three years later, which allowed time to get it printed exactly as I wished, while also gathering old stories and writing more for what would be my second book.

Big publishers have "a house style" to give their books an elegant, consistent appearance. It is maintained by art directors, and contracts deprive authors of any say in their books' design, typography and jacket. I wanted to design the whole of *Lanark*. Stephanie let me because her firm was small, and I would do it without payment. In most books the start of a new paragraph is shown by indenting the first line as you see it above, and in novels the start of a character's speech is indented in the same way, which splits a paragraph into as many smaller paragraphs as the speeches. I wanted all my paragraphs to be seen and read as separate units, so asked that no speeches start by being indented from the margin by more than their quotation marks, and for paragraphs to be separated by a line space before each indented first line. Stephanie feared this might look queer, asked her design director to print a specimen page, and saw it did not look

De Humani Corporis Fabrica by Andreas Vesalius, *title page, 1543, Basel*

Lanark: Book 2 title page, *1981*

queer. So she let me have text, margins, running heads, illustrations and cover design printed as I wanted. *Lanark*'s four main sections are numbered 3, 1, 2, 4. I compensated for that eccentric order by using the world's most conservative and common typeface, Times Roman. The most typographically intricate part is a chapter called Epilogue. It has a character who claims to be me – the author – who explains all his ambitions for the book. It has several playful devices: a running-head commentary in rhyming couplets got from Thackeray's *The Rose and the Ring*; long footnotes suggested by Flann O'Brien's *The Third Policeman*; a marginal index listing the book's influences and plagiarisms, some non-existent. It was a fair specimen of academic commentaries and a satire on them. On the jacket and interior title pages I drew images of

people, places and states of mind with images of many I liked or loved. Book One has Jim Kelman's face for my hero, Thaw, and Aunt Annie for his mother. The general title page has Marion Oag's face and parts of my 1958 *Faust in his Study* design. Malcolm Hood is the Leviathan of Book Four. The dust jacket has Andrew, me and Inge in 1970, with Alan Fletcher as the god Pan and Beth McCulloch as an earth goddess supporting the sun.

There had been so much advance warning for this book in Scotland that its success here was less surprising than in England, where it was also well and extensively reviewed. Sidney Workman has explained why in the Epilogue he attached to my previous novel, *Old Men in Love*, published by Bloomsbury in 2007.

Sixteen: Second New Start, 1981–89

EARLY FEARS THAT I was bad at giving and receiving sensual delight had not been changed by passionate but Platonic love affairs, my first marriage, and nearly ten following years of bachelorhood. A short love affair with an experienced woman before *Lanark* was published showed I could share sexual pleasure with other agreeable women if they first let me sleep with them for two or three nights without making me feel guilty. It was wonderful to discover I was sexually ordinary. I even welcomed the pain that followed the woman breaking off with me a few weeks later. It felt like heart-break, so proved I had a heart that could be broken – that I was not just kept going by an obsession with visual and verbal arts. Soon after *Lanark* I became good friends with other ladies, one of them Bethsy Gray, a Dane with her own one-woman silver jewellery business. Her second name came from marrying a Scot, as Inge had done. They were separated when we met. She and I became companions for nearly as long as my first marriage, during which time several of her friends became mine, most of them also divorced women. The home where she and her two children lived was three minutes' walk away from mine in Kersland Street. I usually slept there, and when she left in the morning to work in her shop, often remained behind to write, since I had long acquired the habit of writing in bed.

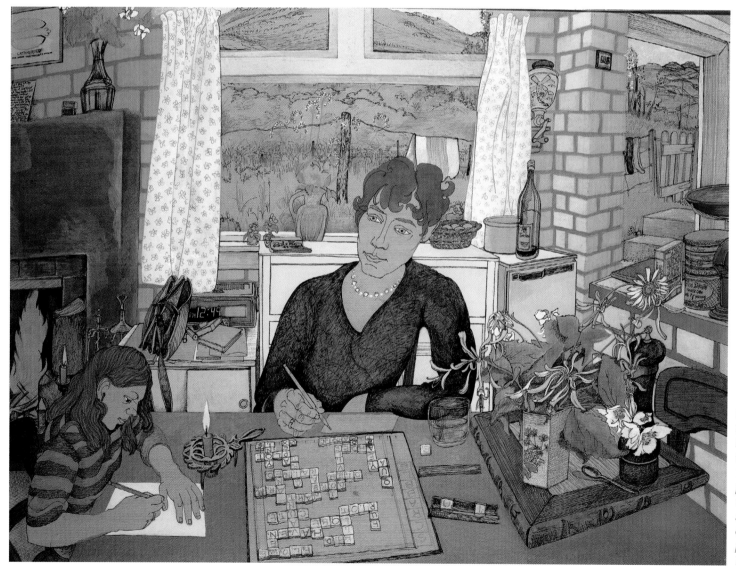

Bethsy and Sarah Purser in Janet's Cottage, 1982, pen, wash, watercolour and acrylic on brown paper, 73 x 103 cm

Bethsy Nude, *1986, ink and emulsion on paper, 79 x 33 cm*

Bethsy with Tea Things, Bower Street Interior, *1983, ink drawing, acrylic and oil colour on paper, 30 x 42 cm*

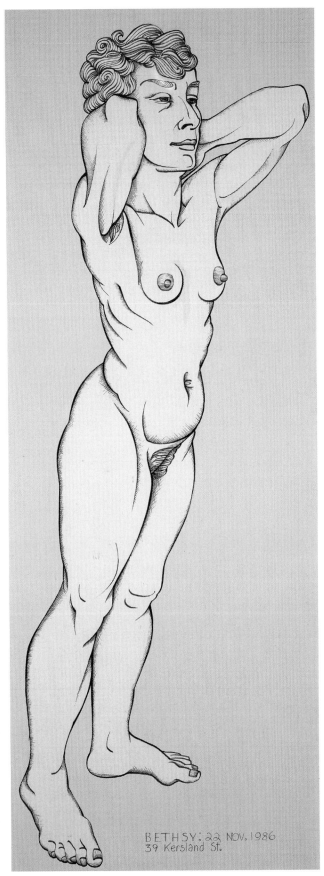

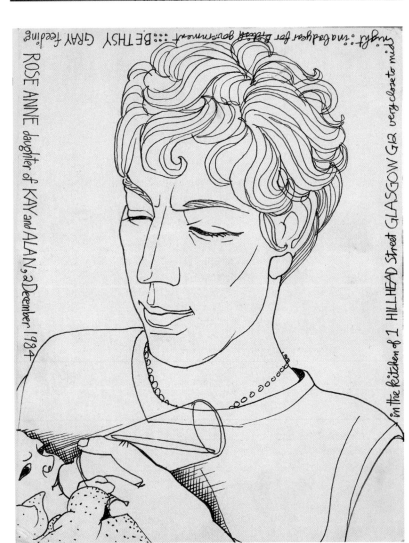

Bethsy Feeding Rose Anne, *1984, ink and pencil on paper, 30 x 21 cm*

Sewing Bee: Bethsy, Janet Antony, Barbara Currie, 1986, acrylic, crayon and pencil on paper, 73 x 103 cm

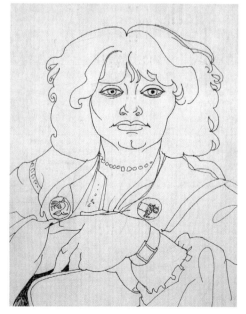

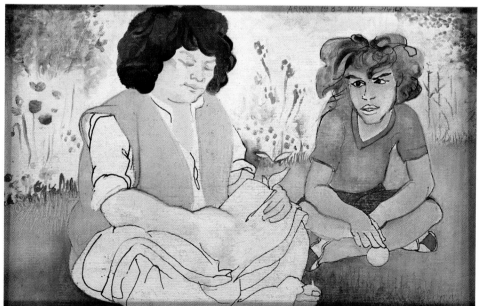

Mary Carsware Doyle, 1985, ink on paper, 30 x 21 cm

Mary Carsware Doyle and Saji Gill in the Yellow Land Garden, 1985, ink and oil on canvas, 20 x 30 cm

Page 216

*Second
New Start*

*Jackets of
Chapman, a
Scottish literary
magazine, 8
of 17 designed
between 1983
and 2000*, ink on
paper,
21 x 15.5 cm

The Kersland Street studio was where I painted and drew, especially for my second, not yet complete book, *Unlikely Stories, Mostly*. Twelve were fantasies and three realistic. I had scribbled an idea for a commercial traveller's monologue in 1963 when a traveller in south-west Scotland lecturing in art appreciation. While working to make it a two- or three-page story it swelled up – took in my masturbatory fantasies – anger with

what Thatcher's new Toryism was doing to Britain – and other interesting events that had not become parts of *Lanark*. This tale was becoming a novel when I left it half-finished and concentrated on my storybook.

The tales were in many voices and styles, the first having been printed in *Collins Magazine for Boys & Girls* when I was sixteen. Soon after came short ones from the 1956 and '57 *Ygorra* magazine (see chapter 7) for which I redrew the

illustrations. Near the end came four whoppers written when resident at Glasgow University. The illustrated title pages in *Lanark* had been amusing visual garnish the novel did not need. I felt the success of *Unlikely Stories, Mostly* would be helped by a playful appearance got by many illustrations mingled with the text. One story was told in the 16th-century diction Thomas Urquhart of Cromarty used in his pamphlets. Visual jokes were needed to

CANONGATE

Unlikely Stories, Mostly, 1983, jacket and metal boards, 19 x 13 cm

help bored readers skip over it with no sense of loss, so the book has a running gag starting on the front end paper where Urquhart, a man in his prime, sails east from Aberdeen with Bethsy's winged head blowing into the sail of his boat. Later pictorial vignettes show his adventures until the last end paper where, an old man who has gone round the globe he arrives back in the Firth of Clyde. Illustrations show others I have loved with Andrew's face as a boy after the first story, and pastiches of Paul Klee, two Christopher Robin pictures by Shepard, and an Urquhart title page. To combine these with the text I worked closely with Jim Hutcheson, the excellent Edinburgh book designer employed by Canongate. He was patient with my continual revisions, and revisions of revisions. I wanted the cloth boards of the book as richly decorated as the paper jacket, as many boards had been before publishers started using paper jackets in the early 20th century. Since then most cloth bindings have only had the title and author's name stamped on the spine in silver or gold – a process called *metalling*. I asked Stephanie to discover

Second New Start

Janet Sisson, re-drawn in 1993 to illustrate The Problem, pencil on paper, 30 x 30 cm

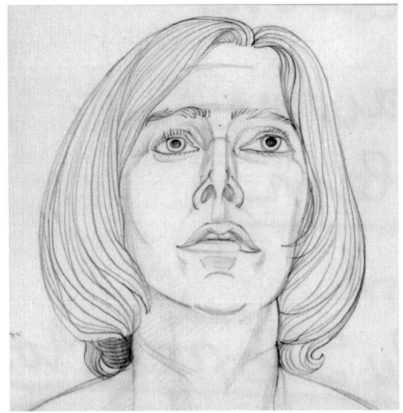

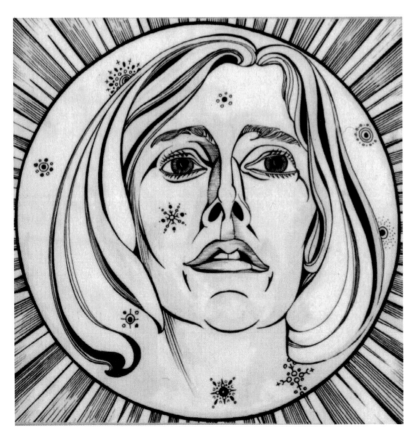

ALASDAIR GRAY

UNLIK

CANONGATE
19

STLY

Unlikely Stories, Mostly, 1983, title pages, 19 x 26 cm

ELY STORIES

EDINBURGH
3

MO ★

the cost of metalling the whole front and back too, and she discovered that it was very little. So my hardback first edition had golden thistles on the dark blue boards with words by the Canadian poet, Dennis Lee: *Work as if you live in the early days of a better nation* with *SCOTLAND 1983*. The Scottish Arts Council gave Canongate (not me!) a design award for this book, as they had also done for *Lanark*. Reviewers praised its good looks so highly that British publishers have since let all my hardback covers be metalled.

I was now halfway through the second novel, had run out of money, and Canongate could not afford to advance me the £1000 that would buy me time to finish it. Two years elapsed before I found a publisher who paid me that, Liz Calder of Jonathan Cape. *1982 Janine* was published in 1984 in London without internal illustrations. They would have distracted from the words of this, my best novel, especially in chapter 12, where unusual typography shows the narrator is breaking down mentally.

An Explanation of Recent Changes from Unlikely Stories, Mostly, *1963, ink and pencil on paper, 19 x 13 cm*

1982 JANINE
ALASDAIR GRAY

1982 Janine,
1984, book
jacket and
metalled board,
15 x 22 cm

The Fall of
Kelvin Walker,
1985, metalled
board, 14 x 20
cm

Lanark, page
from Epilogue,
1981,
19 x 13 cm;

Logopandocy,
an Unlikely
Story, 1983,
19 x 13 cm

1982 Janine,
1984,
chapter 12,
15 x 22 cm

The Epilogue of *Lanark* has three extra voices in the running heads, footnotes and marginal index. In one *Unlikely*

Story Thomas Urquhart uses double-entry book-keeping to put two columns of words on the same page, one

tapering downward like the mouse's tale from *Alice in Wonderland*, the other expanding downward to leave no blank

Column 1 (page 492):

492

trial slum and an upper-class girl who makes him aware of his inadequacies. Emotionally shattered, in a semi-delirious condition, he climbs a moorland, descends a cliff and drowns himself, in a chapter which recalls the conclusion of Book 2. He is then reborn with no memory of the past in a vaguely Darwinian purgatory with Buddhist undertones. At one point the hero, having stolen sweets, grows suspicious, sulky and prickly all over like a searchin! The connection with dragonhide is obvious. He is morally redeemed by another encounter with the upper-class girl, who has died of a bad cold, and then sets out on a pilgrimage through a grotesque region filled with the social villainies of Victorian Britain. (*See also* MACDONALD.)
KOESTLER, ARTHUR
See footnote 6.
LAWRENCE, D. H.
See footnote 12.
LEONARD, TOM
Chap. 50, para. 3. "In a wee while, dearie" is an Implag of the poem "The Voyeur".
Chap. 49. General Alexander's requiem for Rima is a Blockplag of the poem "Placenta."
LOCHHEAD, LIZ
Chap. 48, para. 25. The androjd's discovery by the Goddess is a Difplag of *The Hicke.*
I mouth
sorry in the mirror when I see
the mark I must have
made just now
loving you.
Easy to say it's alright
adultery
like blasphemy is for
believers but
even in our
situation simple etiquette
says
love should leave us
both unmarked.
You are on loan to me
like a library book
and we both know it.
Fine if you love both of us
but neither of us
must too much show it.
In my misted mirror
you trace two toothprints
on the skin of your
shoulder and sure
you're almost quick enough

Column 2 (The Conjuror Scratches, Reminisces):

The Conjuror Scratches, Reminisces

I don't know how Monboddo would propose to start this new system, but I could drown the practical details in storms of cheering. At any rate, bliss it is in this dawn to be alive, and massive sums of wealth and technical aid are voted to restore Unthank to healthy working order. You board your aircraft to return home, for you now think of Unthank as home. The sun also rises. It precedes you across the sky; you appear with it at noon above the city centre. You descend and are reunited with Rima, who has tired of Sludden. Happy ending. Well?"

Lanark had laid down his knife and fork. He said in a low voice, "If you give me an ending like that I will think you a very great man."

"If I give you an ending like that I will be like ten thousand other cheap illusionists! I would be as bad as the late H. G. Wells! I would be worse than Goethe.[7] Nobody who knows a thing about life or politics will believe me for a minute."

Lanark said nothing. The conjuror scratched his hair furiously with both hands and said querulously, "I understand your resentment. When I was sixteen or seventeen *I* wanted an ending like that. You see, I found Tillyard's study of the epic in Dennistoun public library, and he said an epic was only written when a new society was giving men a greater chance of liberty. I decided that what the *Aeneid* had been to the Roman Empire my epic would be to the Scottish Cooperative Wholesale Republic, one of the many hundreds of

7. This remark is too ludicrous to require comment here.

Column 3:

spirit, or if they did, in what likeness they received him? To this both made reply that of all the nights they had ever enjoyed, it was that night respectively wherein the spirit was most intirely communicative in feats of dalliance, and that he acted in the guise of the boy and chambermaid whom I had appointed to await on them as they went to bed. This confirmed me in my former opinion, which certainly increased when I heard a short time after, that the imagination of two had become a regular fornication of four; by which (though I caused to punish them all) the fantasists were totally cured, who afterwards becoming yoke mates in wedlock to the two servants of our house, were in all times coming sound enough in fancie, and never more disquieted by diabolical apprehensions.

PRO ME	CONTRA ME
Nation: Betwixt pole and tropicks there has been no great engagement wherein Scotsmen have not (by valiantly slaughtering each other on behalf of all the greatest Christian states in Europe) made their nation as renowned for its martialists as have its promovers of learning for their literary endeavour. I here set down the greatest names on all sides since the jubilee of 1600, instellarating thus * such as creep in from an earlier age, since it is not my custom to maintain a rank by excluding an excellence.	**Nation:** I will not enlist opposite the flaming sparks of their country's fame those coclimatory wasps of the Covenanting crue whose swarms eclipse it. I will discourse but generally, or by ensample, of those viper colonels who do not stick to gnaw the womb of the Mother who bears them, and of those ligger-headed Mammoniferous ministers, those pristinary lobcock hypocritick Presbyters (*press-biters* rather) who abuse learning in the name of God, as if distinct truths could oppose THE TRUTH.



...friend of mine." hate sex hate sex hate my sex I *SCORCHING*
yours is a can play no good games in this *SCORCHING*
any friend of tight suit which does not fit I *SCORCHING*
her in- cannot move I shit it sticks stif- *SCORCHING*
"Well, bring fens stinks I hate to sit in this *SCORCHING*
pig's outside! stiff state it does not suit man *SCORCHING*
mean the pig's woman brute bird turd word *SCORCHING*
"No! No! I name echoes fact act same noun *SCORCHING*
Who's coming? as verb like my shit and I shit I *SCORCHING*
"Why? Why? ache and my ache my scream and *SCORCHING*
"Hide, man! I scream I dream and my dream *SCORCHING*
balls made of is an echo echo echo echolalia *SCORCHING*
root- lovely word echolalia brain dis- *SCORCHING*
balls made of ease echolalilalilalilalilalilalila *SCORCHING*
What are foot- lilalilalilalilalilalilalilalilalilalilalilalilalilalilalilalilalilalilali

listen i am the mercy "Euphony! O euphony!" *Shhhhhhhhh*
you asked for the child screamed Hislop (you funny *Shhhhhhhhh*
and future you prayed little man). "Who will give me *Shhhhhhhhh*
for a new past is back a single euphonious line! *Shhhhhhhh*
ten look back the You are a gang of barbarians but *Shhhhhhh*
past is that foun- God knows I have toiled honestly to *Shhhhhh*
rain where all improve you, I have persistently dinned *Shhhh*
streams spring into your ears the purest verbal melodies *Shhh*
listen streams in English literature has *no* good come of *Shh*
you damned that? The lowland Scots have a native incapacity *Sh*
flow under for euphony but need they detest and reject what *S*
my ground they are powerless to produce? I will give a pound
dig here note" – he pulled one out and waved it about – "I will
for the give this pound note to the boy or girl who can repeat a
needed single euphonious phrase. Come! Two hundred and forty
water pence, an eighth part of your father's weekly wage for three or four words which will flow into the ear and give peace to the heart. You know the kind of thing I want. Now folds the lily all her sweetness up. Blue, glossy green and velvet black. Like swimmers into cleanness leaping. Or Mesopotamia! Or incarnadine! Or porpentine! A single splendid word will put this money in your pocket, surely, surely one of you has learned something from me that strikes them as beautiful?" and he twisted his face into a horrible parody of pathetic appeal and we were petrified because behind the parody we heard a real note of pathetic appeal. One of the

The Fall of Kelvin Walker, Canongate jacket, 1985

King Penguin jacket, 1985

Penguin jacket, 1985

space between. The earlier chapters of *1982 Janine* have two alternating voices, both the narrator's, until chapter 12 when they are joined by additional voices talking simultaneously. God and Satan alternate in small print to the left, his poor old body complains in capitals to the right, while masturbatory fantasy alternates with true memory between these. The babble ends in some blank pages representing welcome unconsciousness.

I had shocked myself by using my private fantasies in *1982 Janine* so expected reviewers to be equally

braver girls raised her hand. He nodded. She said in a small voice, "Bird thou never wert sir."
"Good!" he said in a delighted voice. "Bird I never wert. Who else finds that euphonious?"
Heather Sinclair, a friend of the brave girl and our best speller, put up her hand then all the girls did and most of the boys. The only ones who still sat with folded arms were myself and the other toughguys who no longer feared the belt and did not give a damn for Hislop and his stupid games. He paced up the passage between the boys and the girls muttering, "Wert. Wert. Wert. Wert" with every footfall. He stopped by an empty desk, produced a cigarette lighter and said, "Hands down. Agnes, doubtless, remembers me saying that Percy Bysshe Shelley pinnacled dim in the intense inane is one of our most mellifluous poets, but to my ear *bird thou never wert* sounds damnably ugly and a downright lie when we consider that wee Percy is talking to a skylark. But vox populi, vox dei. I must give Agnes something for trying."
He set fire to a corner of the pound note, dropped it on the desktop, quenched the flame after a minute with the flat of his hand, placed the charred fragment of paper ceremoniously in front of Agnes then went back to his own desk shivering and making an ach-ach-ach sound like a parked lorry in bad condition with the engine running. I feel fine. These pills are definitely harmless, there is nothing at all wrong with me. All the changes of heartbeat and temperture, the cold and hotsweatcetera were causeby nothnbut funkan, but funkanan (you gibber) THE SWEATS WERE CAUSED BY NOTHING BUT FUNK AND (GOD HELP ME) FUNKANANANANANANANANANANAN HYSSSSSSSSSSSSSSSSSSSSSSSSSSSSSSSSSSTERIA
good to see you again folks thought we had lost you back there just as things were getting interesting. "But Momma," says the Doctor, "the committee feels that a change of role may do you good. Of course at first you will not enjoy it, nobody ever does. But that phase is temporary. You have helped many girls through it. Do what our new director suggests!" "You are out of your mind if you think I'm taking that crap from you," says Momma shakily and walks to the door, it jerks open, she squeals for who comes in but coalblack naked sixfootsix ME with this huge erect dong and I

uncoil a thick black whip and say, "Momma I am gonna help you strip oh my oh my oh my oh my oh my oh my oh my oh my oh my HONEYMOOOOOOOOOOOOOOOOOOOOOOOONMUM

Age netic ist fel la told me we humans differ fr om othe r brutes by drinking w hen not thirst y, eating when not hungry, fuc king all round th e calendar regard less of climate and torturing and killi ng helpless creatur es of our own kind. In plain language, we have an inborn cap ability for intoxicati on, greed, lust, cruel ty and murder: a fact which your thinking mo ralist will always find m ore significant than out such bizarre containers of ourselves as the Polaris submarine, Sistine Chapel, and suspenderbelt.

*silky milky silky milky silky milky silky milky silky*CH
*milky silky milky silky milky silky milky silky milky*CH
*silky milky silky milky silky milky silky milky silky*ACH
round full cheeks chin soft smooth shoulders breasts ACH
bellyfolds thighs labia and buttocks overlapping AACH
caressing cuddling completing each other how AACH
else but by vile force can I get back into and AAACH
among warm soft mild eternal you? I want AAACH
to fill up and enclose you becoming your AAAACH
tampon and your corset your core and AAAACH
your rind your furniture your walls AAAAACH
the youshaped basket with the big AAAAACH
*spike holding and piercing you*AAAAACH
the boa constrictor entwining AAAAACH
*you whose head pushes right*AAAAAACH
through your cunt filling AAAAAAACH
*you up inside I want to*AAAAAAACH
be much too much for AAAAAAAACH
you whole absolute AAAAAAAACH
overwhelming and AAAAAAAACH
inescapable o o AAAAAAAACH
o this is hell AAAAAAAAACH
hell o please AAAAAAAAAACH

WHO IS THIS DAPPER CHAP APPROACHING *help o God* WITH MODEST ARCHANGELIC SMIRK?
I am o I
am I
SUFFUFFUFFUFFUFFUFUCKUCKUCKUCKATING
let me be
free as

THE SOCIAL DEMOCRAT FINANCING *sinking* a POOR GOD WITH COMMON DEVIL'S WORK?
let me be let me be let me be you are of me *stone going* OOOOOOOCH
for me making light by opening your
eyes building space with each move *down through* OOOOOOOOCH
ment reforming the world with each
thought for better or worse you cannot *your soft Pacif* OOOOOOOCH
stop being god by splitting into a *ic deeper than the* OOOOOOOCH
roman circus where sense feeling
memory hope dreams and reason *air is high the one* OOOOOOOOCH
fight bind torment each other to
amuse this forlornly plotting almo *eagle lost and lonely* OOOOOOOCH
st amputated head your weak

ness cowardice indifference create history as much as your strength courage intelligence but too muc h is made by default sliding dow n into depression pain scarping war poisoning seed you can in ...ake mend things no need to di e so come alive aloud remak e repair becoming me again st this waste of my whole well made lovely complet e world

floating in your endless OOOOOOCH
blue blue blue blue blue OOOOOOCH
the morning star shining in OOOOOCH
your black vacuum a solitary OOOOOOCH
baton rapping order order order OOOOCH
into your roaring symphonic chaos OOOOCH
God folks that is not how it is or FUCKEAS
ever can be when these highbrows get EFULDEA
sexy they go right over the top you're THFUCK
a lot safer with me lady my demands are CEASIN
all external and ritualistic so shake those GONMI
tits those hips Momma as you turn to run you DNIGH
know it is no good because out snakes my cruel TWIT
big black whip with stinging crack splits creamy HNO
linen across your plump hip and at last oh at last PAIN
you feel the trap bite trap bite trap bite trap biteTHIS
whipstattoosleatherLochgellytawsprickscuntsjeans ISF
bikinisfishnetstockingsblousesthreepiece UCKIN
suitscollarstiesdungareesoverallsex GMURDE
surveillancealarmdefencetrap RHELPPOLI
securefamilysalarytrap CEMUMMYDA
lovesecuritysex DDYMUMMYDA
happiness DDYMUMMYDADD
trap YMUMMYDADDYMUM

Listen come alive work as if you were in the early days of a better nation i can't like more from your are infecting me not by your vices but by your harsh wee virtues the way the truth the life rave like a damned scots moralist listen theres a hell of a good universe next door lets go quick to sink bend down hold on tight fingers in gullet let it come let it come let it come let it come let it come let it come

BOAK BOAK BOAK o BOAK BOAK BOAK
BOAK BOAK BO AK BOAK BOAK
BOAK BOAK BOAK e BOAK BOAK BOAK
BOAK BOAK BO y AK BOAK BOAK BOAK
BOAK BOAK BO a AK BOAK BOAK BOAK
BOAK BOAK BOAK y BOAK BOAK BOAK
BOAK BOAK BO a AK BOAK BOAK BOAK
BOAK BOAK BO a AK BOAK BOAK BOAK
BOAK BOAK BOAK y BOAK BOAK BOAK
BOAK BOAK BO a AK BOAK BOAK BOAK
BOAK BOAK BOAK a BOAK BOAK BOAK
BOAK BOAK BO a AK BOAK BOAK BOAK
BOAK BOAK BOAK · BOAK BOAK BOAK
BOA... BOA...
BOA. BOA.

1982 Janine, 1984, chapter 12, pages 183, 184 and 185, 15 x 22 cm

Page 222

*Second
New Start*

**Gentlemen of
the West** *by
Agnes Owens*,
*book jacket,
1984,
21 x 31 cm*

GENTLEMEN
OF THE WEST

AGNES OWENS

Lean Tales,
*1985, book
jacket and
metalled
hardback,
20 x 13 cm*

But fearing to seem a renegade to my native land I gave Canongate my fourth book, *The Fall of Kelvin Walker*, a novel based on my first TV play.

At a reading organized by St Andrews University I met Jennie Erdal, a reader for Quartet Books in Soho. She said Quartet were now sorry they had refused *Lanark*, and could I offer them some other fiction? Perhaps another book of short stories? I said I had some unpublished tales but too few to make a whole book. She asked if I knew other Scottish authors who might join me in it. I suggested James Kelman and Agnes Owens.

Agnes lives in the Vale of Leven, a valley of former small industrial towns between Dumbarton and Loch Lomond, a place of high unemployment. Liz Lochhead, conducting a writers' workshop there, met Agnes and introduced her to Kelman and me as a very good writer indeed. We agreed. Agnes, widow of a building worker, wife of another and mother of a third, had been a secretary at Westclox, an extinct local firm, and now worked as a house cleaner. Her stories, told in the voice of a young bricklayer, were bleak, sadly believable and very funny. They amounted to a novel she called *Gentlemen of the West*. I could not persuade Canongate to publish it. James Kelman got it taken by Peter Kravitz of Polygon, Edinburgh, the only British university press run by students. I submitted our stories to Quartet under the name *Lean Tales*. An editor (not Jennie Erdal) liked all but two of my stories, which she felt not fictional enough, so I offered the book to Liz Calder of Cape, who took it at once. I did not want the typography and cover of *Lean Tales* to look like other books I had designed, so adopted Jim Kelman's suggestion that it be printed in Gill Sans-Serif, a typeface usually employed in catalogues and scientific publications. The cover

shocked. A majority liked it. Then a Scots newspaper suggested that, after Canongate made me a known author, I had ungratefully got more money by shifting to a rich English firm. I had done so mainly because Canongate kept delaying pay, explaining that if they paid me royalties due they would not be able to pay the printers and would be forced into bankruptcy.

*Lean Tales,
three writers'
portraits:
James
Kelman,
Agnes Owens
and Alasdair
Gray, 1985,
ink on paper,
20 x 13 cm*

design was wholly abstract and each author's section had a frontispiece portrait with the writer's signature. I

was careful to make my self portrait no handsomer than how I drew my colleagues.

I was now a well-known writer, also a useful designer of magazine and book covers for literary friends who could pay

*Sonnets from
Scotland,
Edwin
Morgan,
22 x 13 cm;
A Bad Day
for the Sung
Dynasty,
Frank
Kuppner,
22 x 13 cm,
and The
Glasgow
Diary, By
Donald
Saunders,
Mainly,
21 x 14 cm*

Page 224

*Second
New Start*

*Shoestring
Gourmet, Wilma
Paterson*, 1986,
19. 5 x 26 cm

If budget eating means re-hashing your corned beef hash, you need this book! The impecunious epicure will relish Wilma Paterson's simple, classic, tasty but elegant dishes, which show that you needn't be a millionaire to make full use of good quality, fresh, seasonal ingredients. The witty illustrations suggest that sensuality is another ingredient that cooking need not lack.

SHOESTRING GOURMET

SHOESTRING GOURMET ▪ Wilma Paterson

CANONGATE

Wilma Paterson
Illustrated by ALASDAIR GRAY

ISBN 0-86241-110-6

£3.95 CANONGATE PUBLISHING
EDINBURGH, SCOTLAND.

me little or nothing, but no administrators of public galleries thought my paintings worth exhibiting, except Chris Carrel. He had replaced Tom McGrath as director of the Third Eye Centre, Sauchiehall Street. When my novel *Lanark* was launched there he had let me hang some of my work in a small side room. Carole Gibbons had been given a main gallery one-woman show in Tom McGrath's time, but few arts administrators in Scotland, especially the Scottish west, thought local artists deserved public exhibitions unless dealers were selling them in London. Chris Carrel thought I might be an exception to this rule. He scheduled a show for me in 1978 which he hoped might travel to a gallery in London and elsewhere.

Two years before I had visited an exhibition in the Third Eye with Alasdair Taylor, who was so enthused by the gallery's whitewashed brick walls that he asked, "How can I hang a show of my work here?" I said, "Ask Chris Carrel – here he is!" because Chris was just passing. I told him Alasdair deserved an exhibition of his own. Chris said, "You must ask my exhibition officer." He introduced the officer, who explained he could not yet visit Alasdair's studio to see his work because he was about to cross the Atlantic and arrange a show of work here by Canadian photographers. After some pestering by me he did visit Alasdair's studio in Portencross and agreed to his having a Third Eye show,

but without giving a date for it, saying "The problem is not *if*, but *when*." Months later he finally refused to give the show a few days before leaving Glasgow for a similar post in England, where he had been educated. He belonged to a new race of arts administrators with academic degrees in the subject. Until the 1960s the heads of art schools and public galleries had also been artists. Even art dealers with private galleries seldom had a university degree, having mostly begun as auctioneers and dealers in old furnishing. Lord Duveen started by helping his parents sell bric-a-brac in their London second-hand shop but became the richest dealer in the world, selling European masterpieces to the new

USA multi-millionaire class. Ramsay MacDonald so liked Duveen that he nearly made him a director of the London National Gallery, but was prevented because it was then thought wrong for folk who made money by selling art to manage public collections of it. Times have changed. The Third Eye Centre's new exhibition officer was also English and certain that no Scottish painters' work was worth showing without a successful London exhibition. He had formerly worked for the Tate Gallery. He had not at first wanted to work in Glasgow said Chris, who was glad to have changed his mind. I met him when my own Third Eye show was near, to ask about arrangements. He was pleasantly relaxed and languid, and left the talking to me. Knowing Chris had sent word of the show to London galleries and elsewhere I asked, "Have you had any …?" and remember pausing, perhaps because "hopeful responses to that correspondence" would have sounded pompous. He smiled and softly suggested, "Luck?" There had been no responses. An exhibition officer who let luck do his work was no use to me. With the fury of a scorned egoist I refused to exhibit in the Third Eye Centre unless Alasdair Taylor exhibited beside me, so my retrospective show did not happen there.

But the Third Eye put on a show of Stephen Campbell's paintings. He, Peter Howson, Ken Currie, Adrian Wiszniewski were recent Glasgow Art School students whose work was admired by a director of the School with the enthusiasm and contacts to promote it in New York, where it had sold very well. They were therefore offered a show in London where it also sold well, so they grew prosperous enough to live and paint in Scotland. This success story was spread by journalists and broadcasters. Scottish art had never received such publicity since before World War One, when artists and art dealers here showed and sold their work at home while exporting to, and importing from, England, France and Germany. I belonged to the time when Scottish art dealers had no more connections than local shop-keepers, so painters conscious of their talent mostly flitted to London. Yet I knew artists who stayed here and were, I thought, as good as or better than Campbell, Howson, et cetera. These artists were me (of course) and: **Alan Fletcher**, neglected because he had died young; **Carole Gibbons**, with three works in public collections and recipient of a Scottish Arts Council grant; **John Connelly**, whose biggest sculpture had been bought by Strathclyde University with a Scottish Arts Council grant; and **Alasdair Taylor**, whose work had been shown in Glasgow University's Hunterian Gallery and, like the other four, in local artists' co-operative exhibitions. None of us had been subsidised by work as art teachers, and two could not have continued as artists without the help of their wives. I thought that if I hired the whole McLellan Galleries for a big retrospective show of all our work at the end of 1986 I might (being now a well-known writer) get good publicity for it. I also found that early in the year after this big show could go to Edinburgh where Professor Duncan MacMillan would show part of it in the university's Talbot Rice Gallery, and Andrew Brown would show the other part in his 369 Cowgate gallery. Ian McKenzie Smith then undertook to show all five of us in Aberdeen's Municipal Art Gallery. I asked London's Serpentine Gallery if they would look at slides of our work with a view to the show, but they said they had exhibited Scottish artists the year before, which meant no, so I tried no more in England.

But renting the McLellan Galleries for a fortnight, recording all the works for a printed catalogue with colour reproductions, paying for their transport to and between the galleries and returning them to their owners would cost a lot of money so I applied to the Scottish Arts Council for financial aid. The official in charge of visual arts was at first helpful. He agreed to let the Council's address be advertized as a collecting point for mail when I announced the coming show in Scottish papers, and asked private owners of the artists' work for their addresses. (Makers lose track of many works, as these often change hands.) The form of application for aid asked me to name the exact dates and places of the exhibitions. I could give these for the Edinburgh and Aberdeen shows, but could only give them for Glasgow by first booking the McLellan Galleries. For this I paid in advance half the rent for the fortnight's show, which would be forfeit if the show were cancelled. My application was rejected in a letter saying the panel considering it "was particularly concerned about the basic concept of the exhibition". I never learned what this meant, apart from "no". The panel also felt the McLellan Galleries' rent was too high. Two years before, the National Library of Scotland had bought early manuscripts and typescripts of my plays and fictions. I now sold it 63 diary notebooks I had kept from the age of 16 till recently, and was paid all I needed to finance this big travelling show myself.

The firm that collected and shifted the art works was Art Moves, started by Angus Wolfe-Murray, my Canongate publisher's husband. It was now mainly a large van driven by James Kelman, one of several jobs he took over the years, being unable to support his family solely by writing. A new friend, Jim Cunningham, took colour photographs for the

catalogues I designed. They were typeset by Famedram Publishers, who was Bill Williams working in the Old Schoolhouse, Gartocharn, near the south shore of Loch Lomond. Bill was the first British publisher to work from home by linking a word processor to a printer. Like Jim Cunningham he charged me very little. The *Glasgow Herald* (nowadays simply called *The Herald*) printed a large article I wrote

to give the show advance publicity. We were given help in hanging, supervising and dismantling the show by three young artists who had started a new art gallery called *Transmission* – Malcolm Dickson, Gregor Muir and Carole Rhodes. Invitations to the big McLellan Galleries opening were posted, but Scottish radio and television ignored it, and Glasgow's popular press never reviews art shows

if the artists are not famously rich or shocking.

The McLellan fills a block on Sauchiehall Street, built in 1862 from the designs of James Smith, architect and father of Madeleine, perhaps Scotland's most famous poisoner. The grand canopied front entrance pierced the façade of Treron's department store in front of the gallery. Nearly a fortnight before the show opened Treron's was gutted by a fire. The whole Sauchiehall Street front was boarded up and our exhibition could only be reached through an obscure service door in a side street.

To advertize it we covered the boarded-up front with big hand-painted posters declaring that the galleries were still open with the Five Artists Show inside, with arrows pointing to the unfamiliar entrance. On the day after our opening we found the posters had been torn down overnight, so quickly made and put up new ones. This happened until the end of the show, with conscientious vandals tearing down every night signs we repainted and put up every morning. I never found why, but it may have accounted for the show's poor attendance. The only influential arts promoter who came to it was Richard Demarco. He entered briskly, looked around, said to me, "Wonderful. What tremendous energy! Why have I never seen any of this before?" I told him most of it had never been exhibited before, whereupon he left. Our McLellan Galleries show had a small entrance fee and sold catalogues. At a party for helpers at the end a couple in charge of the money told me they had been robbed of it half an hour before, the girl sobbing bitterly. She was the daughter of a friend, and when the police suggested she and her partner might have kept it I told them to investigate no further.

Photograph of artists: Alasdair Gray, Alasdair Taylor, Carole Gibbons and John Connelly around terracotta of "Alan Fletcher with French Horn" by Benno Schotz, 1986

CAROLE GIBBONS
An Appreciation by Duncan MacMillan

It is a common misapprehension that Scotland is a grey country. It is not a land of strong light and strong shadow, of black and white, but this does not make it grey. The evenness of tone that results from the soft clarity of the light can give brilliant intensity to the subtlest hues. Carole Gibbons' use of colour matches this. Superficially drab and even in tone, her paintings reveal startlingly intense colours rubbed and worked into each other all over the surface of the picture, creating almost iridescent patterns. She is however not an abstract or colour field painter. Within the picture certain objects emerge in focus or half focus, a brilliant green horse, or bowl of apples in a still life, the feature of the face on a portrait. This focusing does not involve any change of treatment, and the images formed remain at one with the ground from which they emerge. These objects link the world we inhabit to the painted world, and they reveal that the materiality and animation of the painted surfaces are not part of a self-justifying order of coherence, but a poetic commentary on the actual.

Superficially this kind of painting might be compared to the work of older and more academic Scottish artists in which the autonomy of pictorial structure achieved by twentieth-century artists is reduced to a whimsical rearrangement of appearance. But that would be quite wrong. Rather than providing yet another inappropriate northern variation on the southern art of Bonnard or Matisse, Carole Gibbons is working out an artistic position of her own from a truly northern perspective that has more in common with an artist like Emil Nolde. She is therefore a northern artist – not by sentimental association – but because of the nature of her perceptions.

Public Galleries Owning her Work
Scottish National Gallery of Modern Art
Aberdeen Art Gallery
Dundee Art Gallery
Inverness Art Gallery
Leeds Education Department
Edinburgh City Gallery
Glasgow Gallery of Modern Art

Carole Gibbons in her Glasgow Studio, 1998, photograph by her son, Henry

Self Portrait with Henry, circa 1974, crayon on paper

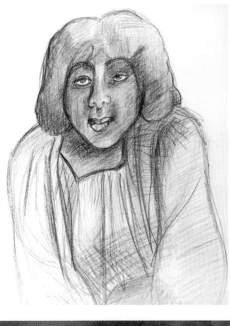

Woman in Long-Sleeved Smock, charcoal drawing

Still Life with Flowers, Book, Yellow Chair, oil on board

Portrait of Young Man, oil on board

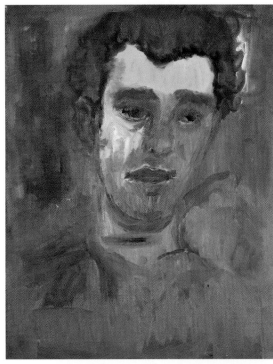

Alasdair Gray's Fantasy, 1957, felt-tipped pen on newsprint

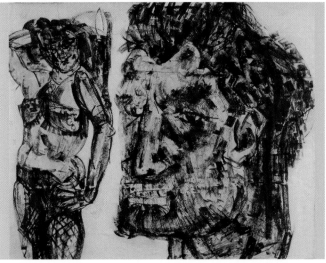

Henry the Cat

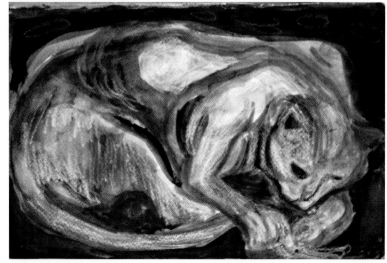

Curriculum Vitae

1957–61 Glasgow School of Art student. Exhibited with fellow students Alan Fletcher & Douglas Abercrombie.

1958–65 Showed with the Glasgow Group & others. Helped to initiate the new Charing Cross Gallery, which became the Compass Gallery.

1965 First solo show in her Renfrew Street studio. Sold four paintings to the poet J.F. Hendry.

1965–67 Encouraged by Hendry, lived & worked in Spain.

1968 Solo show of her Spanish paintings at Traverse Gallery, Edinburgh.

1971 Scottish Arts Council exhibitions in Charlotte Square, Edinburgh & Blythswood Square, Glasgow. Birth of son.

1972 Work in Arts Council "Spectrum" exhibition, Aberdeen Art Gallery.

1973 Retrospective in North British Gallery, Gartocharn.

1974 Exhibition in Edinburgh Commonwealth Institute.

1975 Solo show of recent work, Third Eye Centre, Glasgow.

1980 Solo show in 369 Gallery, Edinburgh.

1981 "Seven Scottish Artists" show, Third Eye Centre, Glasgow & Holesworthy Gallery, London.

1982 "Six Artists Show", Brewhouse, Taunton.

1985 "369 Gallery Festival Exhibition"

1990 21st Anniversary Exhibition, Compass Gallery, Glasgow.

1995 "Society of Scottish Artists", RSA, Edinburgh.

1997 "Scottish Contemporary Painters" show in Beatrice Royal Gallery, Southampton.

2003 "Beautiful Ground", Patriot Hall Gallery, Edinburgh.

2007 Glasgow Group exhibition, Royal Concert Hall.

WORK MENTIONED IN Duncan MacMillan's *Scottish Art in the 20th Century*, William Hardie's *Scottish Painting – 1837 to the Present*, and by David Irwin in *Apollo Magazine*, and by Cordelia Oliver in *Modern Painters*, Winter 1999.

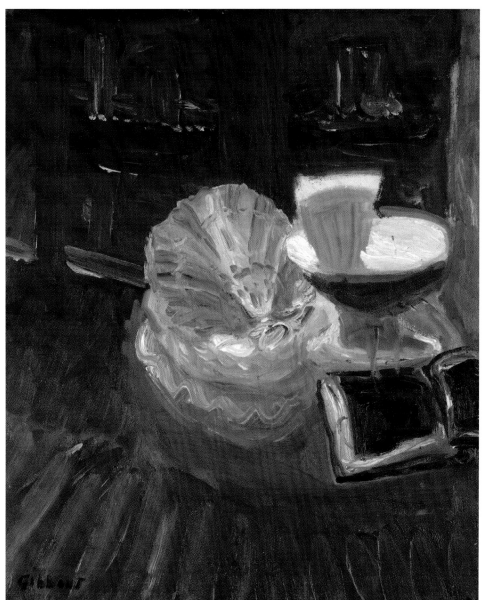

Still Life with Seashell, oil on board

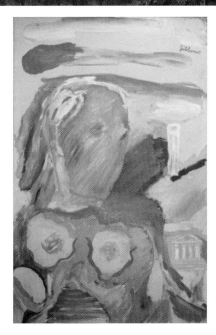

Mythic Figure in a Landscape, circa 1968, oil on canvas

Still Life Against the Night Sky, 1995, oil on board

*Second
New Start*

*John
Connelly and
**Embracing
Couple***, circa
1968, steel*

***Annette Connelly
(life-size)**,
circa 1968,
ciment fondu*

JOHN CONNELLY

An Appreciation by
George Wylie

***Burd**,
6.5 x 6.5 cm
and **Zozer**,
27 x 4.5 cm*

***Head of Denis,**
ciment fondu,
life size*

***Harold**, steel,
101.5 cm high*

*Dates of the
above unknown*

John Connelly is, quite naturally, a sculptor. He has been other things in his life, but the making of sculpture is a compulsion within him. "I want to, need to, got to", he says. How else then, in the sixties, in Glasgow, in Maryhill, in a Corporation flat, with a wife and four small children, and with all the disadvantage or advantage of being self-taught – how might it be explained why and how he commenced making sculpture with such passionate energy?

His work is directly in line with the welded metal sculpture of Julio Gonzalez and later David Smith, both one-time engineers. Quite naturally, John Connelly, an electrician in industrial Glasgow, continued the same art-engineering tradition. We knew and appreciated John's work in the sixties, then he left for Arran and we saw no more of it – until now.

As far as John is concerned there is no time lapse, and the work here is neither old nor new, but is the continuity of "feeling happy when I do it". He now lives in Arran, and because steel does not abound, as in Glasgow, he has made painted wooden sculptures there, and modelled a strong sequence of portrait heads in clay, casting them in ciment fondu. He insists that there is no conscious effort or decision in the making of his sculptures. It is like making up his mind to go for a walk. He "merely acts as a medium or funnel to express the good qualities of life". All quite naturally, John, I would say.

VIP, steel,
67 x 15 cm

Athena,
steel,
69 x 59 cm

*Elizabeth
Connelly,* 1962,
oil on board

Sun God, steel, 43 x 9 cm

Janice Connelly, 1962, oil on board

Curriculum Vitae

1929 Born in Maryhill, Glasgow. When 11 his parents died in a Clydebank bombing raid.

1940–45 Boarding school

1945–47 Apprenticed as an electrician

1947–48 National service

1952 Married Janice

1953–59 Underwent prolonged treatment for tuberculosis, and the removal of a lung. In convalescent periods he practised embroidery and painting. His oil paintings belong to this time and the next three years.

1960–61 Engineer with Duncan Low Ltd., makers of electrical heaters in Maryhill. With access to a welding shop and much scrap iron and steel, he made metal sculpture whenever possible, finding storage space for it by cutting a trap door into the floor of the lobby cupboard in the three-room flat where he lived with his wife and four children. Through this entry to the tenement's damp course (a four foot high cellar) art-loving friends and officials of the Scottish Arts Council were eventually escorted.

1962–67 Worked as a training officer with the Scottish Epileptic Association.

1962 One-man exhibition of work in the Chaplaincy Centre of Glasgow University, arranged by Alasdair Taylor.

1968–69 Exhibited in Hopetoun House, South Queensferry; in the Carnegie Trust Show, Pittendrieff House, Dunfermline; in the Demarco Gallery; and had a one-man show in the North Briton Gallery, Gartocharn, and a grant from the SAC, who also bought work. For the first time could afford to work in bronze.

1971 Exhibited with the Glasgow Group and in the Regent Gallery and I.R.A. Gallery, Glasgow.

1971–72 Worsening health obliged him to retrain as a watchmaker.

1972–86 has lived and worked in Lamlash, Isle of Arran.

1986 Took a studio in Brodick to make portrait heads. Exhibited in the RSA.

ALASDAIR TAYLOR

An Appreciation by Andrew Brown

Alasdair Taylor is a mainstream European artist living in a geographical backwater. William Johnstone and Joan Eardley are other examples. A Highlander by birth, he attended Glasgow School of Art where he trained in the Glasgow tradition of bold drawing and painterly technique, but the seminal influence of his early painting was Asger Jorn, a leading member of the COBRA group who Alasdair encountered in Denmark in 1959. COBRA is particularly relevant to contemporary painting, for though the movement developed parallel to American abstract expressionism, it never espoused the idea of a wholly abstract art. Pictures such as *Him in Black and White* painted during his twelve months in Denmark show that as early as 1960 Alasdair Taylor had assimilated COBRA's innovations.

On returning to Glasgow in 1961 he felt the need to work from models again and the lovely portrait of *John the Barman* and *Self Portrait as a Dustman* employ a delicious Soutine-like freedom of handling. But the real breakthrough came in 1965 when he moved from Glasgow to the isolated Ayrshire village of Portencross. Washed up on the beach there he found old bakers' boards and discarded planks which he cut into panels on which he painted mystical landscapes and "mood" portraits. The irregular weathered surfaces and the use of collage encouraged him to experiment with a variety of paint materials. These synthesized with the emotions of his subject matter to create pictures of an almost musical sensibility.

In the mid 1970s he simplified his technique and freed his inhibitions by making a group of wholly abstract canvases, sometimes using the ubiquitous

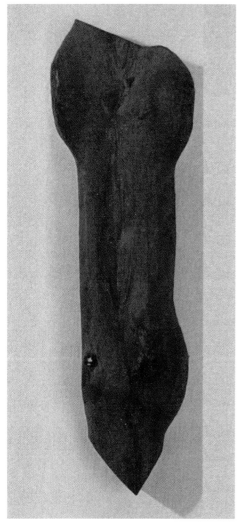

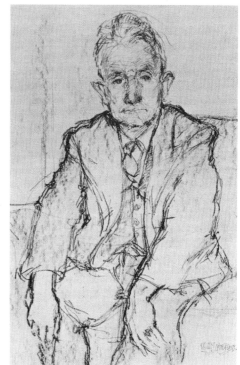

Alasdair Taylor, Northbank Cottage, Portencross, Jim Cunningham, "Seeing yourself via a fine photographer is a strange experience. Jim Cunningham is a quiet, generous man ... he seems to love photography as much as I love paintings."

Portrait of my Father, Alasdair Taylor, conte drawing, 61 x 51 cm "This drawing was done a few years ago, but my father looks more like the drawing now than he did then ..."

Egyptian Torso, Alasdair Taylor, carving, 71 x 20 cm "After weeks of carving a washed-up railway sleeper, a favourite model was rediscovered."

Madonna and Child, Alasdair Taylor, carving, 102 x 20 cm

The Gift, *Alasdair Taylor, oil on canvas, 117 x 69 cm "The Gift was an indescribable experience of flow and joy and insight ..."*

The Ageing Poet, *Alasdair Taylor, oil on board "In the Ageing Poet a dear friend Tom Buchan appeared walking in Portencross... Yes, he is there ..."*

spray-cans of that period. When he returned to mark-making paintings like *The Worshippers* series of 1977–78 he gained new lightness and freshness.

Alasdair Taylor's newest pictures, such as *Ghosts and Secrets* have the vigour and confidence of McTaggart's seascapes yet are completely contemporary in feel. Little gives me greater pleasure and excites me more than to find this artist's most recent work is his best.

Curriculum Vitae before 1988
1936 Born in Edderton, Ross-shire. Father a station-master, mother a school-teacher and amateur jazz pianist.
1955 Enrolled in Glasgow Art School.
1959 Received diploma in painting and Governor's Award. Offered a post-diploma year, but instead visited friends in Denmark.
1960 Painted in Danish Silkeborg and Aarhus. Married Annelise Marquard. Returned with his wife to Scotland, taught art for two weeks in a Greenock school, then joined Glasgow Cleansing as a dustman.
1961–66 Warden of Glasgow University Chaplaincy Centre, where he held exhibitions of work by his contemporaries including John Connelly, John Mathieson, Bob Methven and others.
1967 Moved with family to present home on Ayrshire coast, where he assisted his painting by freelance art criticism for BBC Scotland and by extramural lecturing for the Scottish Arts Council and Glasgow University.

EXHIBITIONS: 1961 Danish Institute, Edinburgh. 1966 Close Theatre Club, Glasgow. 1968 West Kilbride Town Hall. 1970 West Kilbride Community Centre. 1972 Pool Theatre Club, Edinburgh. 1975 Community Centre Ayr, 1976 Lake Placid Technical College, New York. 1988 Andrew Brown's 369 Gallery.

Andy's Picture,
Alasdair Taylor,
oil on canvas,
102 x 81 cm
"This was a
'one-off' that
carried me
along for days
in a composite
discovery of a
dear friend's son
and an uncle
who had died."

Alasdair Gray,
Alasdair Taylor,
1994, charcoal
and watercolour

You have now seen nine pages of my catalogue devoted to the three artist friends whose work appears nowhere else in this book. The list of galleries owning Carole Gibbons' work and her curriculum vitae has been brought up to date, but apart from that these pages are almost unchanged. A friendly acquaintance with a film camera had offered to record the McLellan Galleries show before it was dismantled. On the morning of that day my old friend Winnie Wilson had a stroke, needed me to fetch a doctor and see her into hospital. In my absence the film was not made, and one of Alan Fletcher's paintings was stolen, for which I had to reimburse the owner as none of the works were insured. In 1987 Jim Kelman's *Art Moves* firm carried our show to Edinburgh and then Aberdeen, growing smaller as it did so to fit the galleries hosting it. These galleries were free to the public, better attended, and had more notices in the local papers. Carole may have sold a painting. I doubt if anyone else did, but our enterprise may have led Duncan MacMillan to mention Carole and me in his *Scottish Art in the 20th Century*, published seven years later by Mainstream of Edinburgh. Financially speaking it was an expensive failure that deserved the attention we did not get – a better consolation than none.

Lismore Island,
Alasdair Taylor,
oil on canvas,
25 x 31 cm
"Lismore
appeared after
some time spent
with a fellow
painter on that
beautiful island."

Page 236

Second New Start

Old Negatives, 1989, front jacket, contents pages and three title pages to sequences in Gray's first book of verse, 23 x 13 cm

OLD NEGATIVES

4 verse sequences by Alasdair Gray

TABLE OF

CONTENTS

IN A COLD ROOM 1952–57

INGE SØRENSEN 1961–71

TO LYRIC LIGHT 1977–83

Seventeen: Third New Start, 1989–2000

FOR THE SEVENTH time in my life a forced flitting changed much else. Our landlord Glasgow City Housing Department "decanted" (it said) everyone in 39 Kersland Street, "temporarily" (it also said) in order to renew faulty wiring and plumbing.

On 5th November 1989 it decanted me into a flat with a fine view of the Kingston Motorway Bridge, in a high-rise block resembling the Great Wall of China. It had no room for my bulkier furnishings and three big paintings I never had time to finish since leaving Hill Street in 1968, so these went into a Housing Department store. Soon after this Bethsy found a man she preferred because he did not sometimes upset her by drinking too much. This left me innocent of rejecting a loving woman. At the time I was illustrating *Something Leather*. Apart from the scandalous chapter 12 every other worked as a short story about an episode in the lives of the book's four heroines, so each chapter had an initial capital enclosing the face of a relevant character. John Purser, musician and musicologist, was the businessman's face in chapter 5; Eddie Linden, poet and editor, was a boilerman in chapter 6; Agnes Owens the good housewife in chapter. 7; a self portrait was Dad in chapter 11. For

Donalda, the exploited single parent in chapter 4, I asked Morag McAlpine to pose. She worked in a bookseller's warehouse two blocks from my new home where she was in charge of library supplies, though we had met a year earlier. Since 1973 I had eaten

*McGrotty and
Ludmilla*, 1990,
book jacket,
19.5 x 13 cm;

*Blooding Mister
Naylor by Chris
Boyce*, 1990,
19.5 x 13 cm

**The Book of
Prefaces**, 2000,
marginal note
and translation of
Genesis preface,
19.5 x 13 cm

*Dog & Bone
Logo*, 1990, ink
on paper,
19.5 x 13 cm

675c GENESIS
**Attributed to CAEDMON
WHITBY, NORTHUMBRIA**

Here God is a strong, perfectly generous Anglo-Saxon king wanting nobles he has created to enjoy his gifts & glory. The row of 000000000s shows omitted lines which say how God's chief angel led others away to the heavenly north in a plot to take God's place. God builds Hell, & when the rebels attack throws them in. (Pagan Picts & Vikings raided Christian England from the north.)

WE are mighty right that to the sky-warden,
mankind's king, we lift up our words
with minds of love! He is greatest wealth,
chieftain of all the high creation,
lord almighty. None ever formed him
or protected nor now end come
to eternal rightness but he be a king-ship
over the heavenly seats. The highest throne
truthfast and strongformed sunbosomed he held,
then were seated wide on all side
through the realm of god splendours born of
the ghostly word. Having gleam and song
and appointed order angel legions
berthed in bliss. Was their glory mighty!

OOO

God now makes the world, not (as the Bible says) with light on day 1, sea & sky on day 2, land & herb on day 3 et cetera, enriching it all with goodness till it is fit for his last & best work. MAN — with woman as a kind after-thought. This God, with revenge in mind, first makes earth ugly as hell. Caedmon's tutors thought Satan's revolt explained why God had made the universe, but they only knew the Bible's Genesis from 2nd or 3rd-hand reports. Copying out a whole version of the Bible was a huge task. Abbey libraries would possess a 10 Commandments, Psalms & at least one

Then considered our commander,
mind conceiving how he the grand creation's
noble chairs again get filled,
by the sunbright seat with a better race
than who boastfully scorned the rejected chief
high in the heaven. Forthwith holy god
under heaven's hand (that mighty kingdom)
willed him that earth and upper sky
and wide water get set by his word
in a world created the bad to repay,
they that withheld from shelter given.
Nor was there yet unless darkly cold
creature bespoken, but this wide ground
stood deep and dim, sternly framed,
idle and useless. On that turned his eye
the strong king and the place beheld
soundless, seeing dark that work
as middle night black under heaven
blind and waste until this creation
through word got worth from the glorious king.

Christmas dinner as a guest of Angel Mullane (her baptismal name) and her husband, Chris Boyce. Bethsy had come to most of them. In 1989 Angel let me bring Morag. Soon after that Angel privately asked me to let her come to the wedding when I married Morag. I explained this would never happen because Morag and I had both married before, had broken our vows, so neither would make such a silly vow again. But I promised Angel that she could come to the wedding if I and my new lover ever *did* marry. For months Morag and I slept in my home or in her flat on the ground floor of Marchmont Terrace, Hillhead, near my old Kersland Street home, but on the other side of the valley down which Byres Road runs. Then the Housing Department broke their promise, said I could never return to my old flat because they had sold it to Hillhead Housing Association that was turning it into two or three new smaller flats, one of which could be mine. I was also told to take back what they had stored for me. With Angel's help I was preparing to assert my legal right to return to my old home when Morag told me she feared steep stairs – the seven flights up to my top flat would stop her visiting me there. I was tired of commuting between her house

**Dog
&
Bone**

*Spring
1990*

175 Queen Victoria Drive
Glasgow G14 9BP

and mine, so she suggested I install shelves for my books in her home and bring there my desk, easel, mapping chest and unfinished pictures. Though a two-room-and-kitchen flat, the rooms were as spacious and Victorian as those in Kersland Street, with 14 foot high ceilings, so I came to live & work there. Glasgow City Housing were no longer my landlord. The furniture it had stored was destroyed. It had combined well in my old home, but elsewhere could not have been sold second-hand or given away as gifts.

At home with Morag now I resumed work on a *Book of Prefaces*, whose advance from Canongate had been long since spent. This collection of other folk's prologues grew bigger the more I worked on it. Most pages had a wide and narrow column of print: the preface in black normal type beside a marginal commentary in small red italics. The *Lanark* Epilogue and one of my *Unlikely Stories* had two columns of type, but a book with over 500 pages of that could only be properly edited by me sitting

A SENSE OF SOMETHING STRANGE
By Archie E. Roy
Paranormal Studies
DOG & BONE

POEMS
tramontana
HUGH McMILLAN
DOG & BONE

THE GENESIS POEM
Attributed to CAEDMON
ABBEY of STREANESHALCH c675

Us is riht micel thaet we rodera weard
wereda wuldorcining, wordum herigen
modum lufien! He is maegna sped,
heafod ealra heahgesceafta,
frea aelmihtig. Naes him fruma aefre,
or geworden, ne nu ende cymth
ecean drihtnes, ac he bith a rice
ofer heofenstolas. Heagum thrymmum
sothfaest and swithfeorm sweglbosmas heold,
tha waeron gesette wide and side
thurh geweald godes wuldres bearnum
gasta weardum. Haefdon gleam and dream
and heora ordfruman, engla threatas,
beorhte blisse. Waes heora blaed micel!
00
Tha theahtode theoden ure
modgethonce, hu he tha maeran gesceaft
ethelstatholas eft gesette,
swegltorhtan seld, selran werode
tha hie gielpsceathan ofgifen haefdon,
heah on heofenum. Fortham halig god
under roderas feng, ricum mihtum,
wolde thaet him eorthe and uproder
and sid waeter geseted wurde
woruldgesceafte on wrathra gield,
thara forhealdene of hleo sende.
Ne waes her tha giet nymthe heolstersceado
wiht geworden, ac thes wida grund
stod deop and dim, drihtne fremde,
idel and unnyt. On thone eagum wlat
stithfrihth cining, and tha stowe beheold
dreama lease, geseah deorc gesweorc
semian sinnihte sweart under roderum,
wonn and weste, oththaet theos woruldgesceaft
thurh word gewearth wuldorcyninges.

whole Gospel, all in Latin which few priests read. Abbots & bishops who did so taught prayers & the mass by heart. Most Bible lore was passed by word of mouth.
 Note the value of seating. To Anglo-Saxons a well-crafted wooden bench raised the user's social worth as a tax-free company car with inbuilt fax & cocktail cabinet etc. exalts modern owners. Raiders stole them. (See Beowulf.)

The first English valued timber highly. Woodwork shaped their speech. Our modern **rod**, **rude** & **road** are from the Anglo-Saxon **rode** meaning: tree trunk branch twig club walking-stick measuring-stick measure of distance measure of land measure of cloth measure of liquid safe shelter safe harbour crucifix. **Uproder** meant sky. **rodera**, heavenly. As the Jews lifted up their eyes to the hills, so did Anglo-Saxons to the trees. (See **Dreme of the Rode**.)

STRANGLER
The CANONGATE
Angus McAllister
DOG & BONE

beside the typesetter giving instructions. Canongate found me a willing typesetter in an Edinburgh printers' firm, but commuting to and from it would have wasted three hours daily. So here came Angel Mullane! She provides solutions to every problem perplexing her friends, which annoys them if they prefer their problem to her solution. In this case I liked the solution. Chris Boyce, her husband, knew how to typeset books on a modern computer. She proposed to install one in her home, start a small publishing house to bring out Scottish books that would otherwise never see print, while also typesetting my anthology of prefaces for Canongate. And this came to pass. Angel was the firm's managing director, I the art and design director, Chris the technical expert. One member of the firm was paid a salary: our friend the poet Donald Goodbrand Saunders, an excellent typist who trained himself to be our typesetter. After much discussion of a name for the firm, my son Andrew hit upon Dog and Bone. With a few small changes I made

the company logo from an illustration in *Unlikely Stories, Mostly*. The firm lasted a year and a half and printed eight books, six with covers I designed. Each was an illustration framed by the title, the name

of the author and the publishing house, except for poetry books – in these the names were framed by a pattern of waves, sky and rising or setting sun but differently coloured for each author. The authors were all ourselves or people we knew, except for *Tramontana*, a book of poems by Hugh McMillan of Dumfries. This eased things financially as I think only he, Angus McAllister and Professor Archie Roy were advanced a sum of money. I brought some money to Dog and Bone by having Donald typeset *Something Leather* for Jonathan Cape, and my next book of short stories *Ten Tales Tall and True* for Bloomsbury. Our problem was book distribution. The first 2000 copies of my own novella (based on an old radio play) were distributed by an Edinburgh firm who thought they could sell another equally big print run. After it was printed they found the Scottish book market would take no more. Either their distribution did not reach England or English bookshops did not want Dog and Bone publications. These were almost wholly ignored by

The Book of Prefaces, *2000, Genesis preface, 19.5 x 13 cm*

A Sense of Something Strange: Investigations into the Paranormal *by Archie E. Roy, 1990, book jacket*

Tramontana *by Hugh McMillan, 1990, book jacket*

The Canongate Strangler *by Angus McAllister, 1990, book jacket, all 19.5 x 13 cm*

Poor Things: *Portrait drawing of Paul Currie (for the character Archie McCandless)*

Poor Things: *Portrait of the author (episodes from the early life of Archibald McCandless M.D. Scottish Public Health Officer),* *1992, ink and Tipp-ex on paper, 36 x 22.6 cm*

the English press, and not well reviewed in Scotland. At the start of 1992 Donald, our typesetter, went to Saudi Arabia and managed a newspaper for readers of English in an oil sheikhdom. This ended our little firm because Angel could not continue financing its losses. But on 26 November 1991 she witnessed the marriage of Morag and me in Martha Street Registry Office.

When Donald left, he had typeset 66 pages of my *Prefaces* book. They contained the first and most difficult of the book's nine sections, because the prefaces in Anglo-Saxon verse were printed on the left pages, with my modern translation facing on the right. This and marginal notes made the typography intricate. Where could I find, how could I pay another typesetter? With this job book at a standstill I designed jackets for other books and some theatre posters, mostly for a small company that could not pay for them, painted a big mural and began writing another book of short stories. Bernard MacLaverty had recommended a good London agent to me, who began negotiating an advance from Cape's new managing director,

Paul Currie by A.G.

THE AUTHOR

The Dear Green Pint: The Glasgow Real Ale Guide, *book jacket, 15 x 10 cm*

Bloomsbury 1992 Catalogue, *cover, 17 x 24 cm*

David Godwin. I met him in Glasgow when he was publicizing books by Scottish authors. He said, "I hear we are considering a book of your short stories." I said, "Yes. I need the money to finish my anthology of prefaces." He said, "What's that?" I told him about it. He said, "Are Cape not publishing it?" I explained that my books had to be published by alternate English and Scottish firms, the first because I needed steady money, the second out of loyalty. He seemed to understand that. My agent Xandra phoned me next morning, saying she would like to offer my book of stories to Liz Calder, now the director of Bloomsbury. I liked that idea. Xandra said, "But please don't tell Liz that you want an advance for the stories to finish your anthology for Canongate. David Godwin has been on the phone saying he doesn't see why he should pay a fucking advance to a fucking author so that he can write a different fucking book for another fucking publisher."

ILLUSTRATION BY ALASDAIR GRAY

ISBN 0 7475 1354 6

EPISODES FROM
THE EARLY LIFE
of a
SCOTTISH PUBLIC
HEALTH OFFICER

———

ARCHIBALD McCANDLESS M.D.

———

ETCHINGS by WILLIAM STRANG

———

GLASGOW: Published for the Author by
ROBERT MACLEHOSE & COMPANY
Printers to the University 1909

L O O M S B U R Y

DUNCAN WEDDERBURN

Since Liz was too adult to be upset by such a truth I told her at once. She was greatly amused.

While wringing my brain for new story ideas I woke one morning from a peculiar dream. In what seemed many years ago I saw a young woman, seated and staring out of a window at children playing in a back green between high tenements. A dim figure beside me said, "She will not be able to think before she has memories to think with", and I realized the young woman had only just come into existence. This suggested a version of the Frankenstein story without the horror. Thinking this might become a very short story I began imagining a Victorian genius who could fabricate such a woman, then the character of a less clever friend who would tell his story. Suddenly I was writing perhaps my funniest novel, Poor Things. As with 1982 Janine I kept thinking it would end with the next chapter or two, but after several

unexpected twists it only stopped on the 320th page. It blended areas of my life I had never expected to use – my love of the great Victorian radicals and Fabians, Victorian Glasgow with the coal-fired industries that flourished long after I was born in 1934 and my People's Palace days with Elspeth King and Michael Donnelly. When visiting Bernard MacLaverty for our monthly game of chess I also read him chapters of Poor Things. He suggested my heroine's brain should come from her unborn child. I first thought this a repulsive idea, then saw it was a necessary one. Like most imaginative workers I was also helped by accidental discoveries. Someone gave me Lessing's play Nathan the Wise, a plea for universal tolerance written in 1779. William Jacks, a leading Scottish industrialist, had translated it, paid William Strang to illustrate it, and Maclehose & Co., printers to Glasgow University, to issue it in 1903. Strang was from Dumbarton (Morag's home town) and a famous etcher and illustrator. I attempted pastiches of his illustrations for Poor Things, though these could not

Poor Things: (Episodes from the Early Life of Archibald McCandless M.D. Scottish Public Health Officer), 1992, 35 x 24 cm

Poor Things: Portrait of Duncan Wedderburn (Episodes from the Early Life of Archibald McCandless M.D. Scottish Public Health Officer), 1992, ink and Tippex on paper, 24.5 x 14.9 cm

The Child Within by Catherine Munroe, 1993, book jacket, 21 x 14 cm

*Poor Things:
**Morag as
Bella Baxter
(frontispiece)**,
1992, ink on
paper,
16 x 12 cm*

suggest the power and subtlety of his lights and shades. Beside a mastery of character, Strang was also a master of the grotesque. One etching shows a woman leaning out over the jaw of a huge skull.

As frontispiece of this novel I drew Morag in the same position. I caricatured Bernard MacLaverty to make a face for my huge scientific genius Godwin Baxter on the book jacket. The flayed hand and leg were cut out of *Gray's Anatomy*, first published in 1858 and required reading by Victorian medical students. I bought two cheap reprints in a Byres Road remaindered book shop and used its splendid woodcuts (more distinct than any photograph) to complete the book's period flavour by filling empty space on introductory pages and chapter endings. Like all my books except *Old Negatives*, *Something Leather* and political pamphlets, this novel was praised by reviewers, won an award and did well. The renewal of imagination behind it came from Morag, just as Bethsy was behind *1982 Janine*, though neither are characters in them.

'Not since Harry Harrison's *The Channel Tunnel, Hurrah!* has a work of light fiction amused me as much as Alasdair Gray's *Poor Things*. Gray, like Harrison, uses science fiction to resurrect England's Empire at its most spacious and gracious. Unlike Harrison he satirizes those wealthy Victorian eccentrics who, not knowing how lucky they were, invented The Emancipated Woman and, through her, The British Labour Party — a gang of weirdos who kept hugging and dropping the woolly socialism of their founders until Margaret Thatcher made them drop it for ever. The heroine of *Poor Things* is an oversexed blend of Eleanor Marx, Annie Besant and Alice in Wonderland. She meets her match in Harry Astley, the best type of English Conservative whose habitual reserve hides a warm heart and formidable intelligence. She is suitably punished for rejecting him by marriage to the spineless working-class Liberal who tells the story. A whole gallery of believably grotesque foreigners — Scotch, Russian, American and French — assist in her downfall, but my favourite character is Mrs Dinwiddie. This lightly sketched portrait of a faithful family servant stands comparison with old Nanny Hawkins in *Brideshead Revisited*.'

Auberon Quinn in *Private Nose*

'Although it is pointless to accuse a novelist of getting his facts wrong, it is hard to see why General Blessington (who supported home rule for Ireland *and* the Transvaal) is presented as the worst of British Imperialists. This and similar inauthenticities makes *Poor Things* yet another exercise in Victorian pastiche, a fictional genre which deserves to be neglected for a century or two.'

Paul Tomlin in *The Times Literary Implement*

Poor Things,
1992, hardback
book jacket,
35 x 48 cm

THINGS A

POOR GRAY ALASDAIR

ISBN 0-7475-1246-9

9 780747 512462

BL

Poor Things appeared in 1992, *Ten Tales Tall and True* in 1993. I had no ideas for illustrating the last, so designed a jacket of ten equal panels containing the zero digit **0** with a **1** in front. Not pleased with this, I put them side by side in the usual order with a tail in it belonging to an animal symbolizing the tales' characters.

A story about building workers had a beaver's tail in the jacket and title page, beaver's head on contents page and the whole animal in the tale's initial capital; a cat symbolized the suave heroine of another, a tyrannosaurus rex the evil society in a third. While carrying this out my ten stories turned into twelve. A verse justified keeping the original title: *This book contains more tales than ten so the title is a tall tale too. I would spoil the book by changing it, spoil the title if I made it true.* But I was still searching for a way to continue my anthology of prefaces, for which I needed a bigger advance from a richer publishing house than Canongate, though it was now starting to flourish under Jamie Byng, its new director. In return for the rights to

Poor Things: Sketch of Bernard MacLaverty (for the character Godwin Baxter), 1992, pencil on paper 19 x 13.5 cm

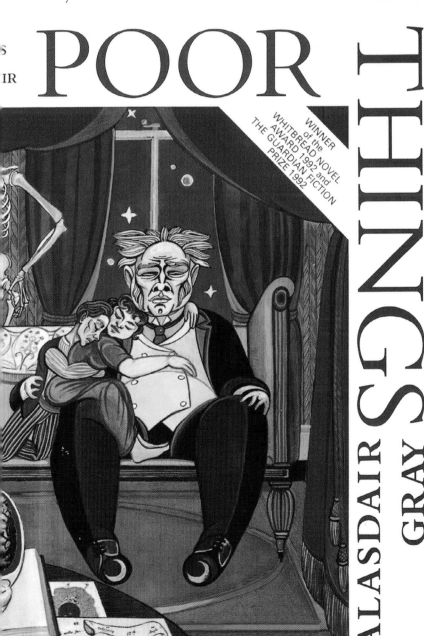

S
IR

POOR

WINNER
of the
WHITBREAD NOVEL
AWARD 1992 and
THE GUARDIAN FICTION
PRIZE 1992

THINGS

ALASDAIR GRAY

JRY

BLURB FOR A HIGH-CLASS HARDBACK

Since 1979 the British government has worked to restore Britain to its Victorian state, so Alasdair Gray has at last shrugged off his post-modernist label and written an up-to-date nineteenth-century novel. Set in and around Glasgow and the Mediterranean of the early 1880s, it describes the love-lives of two doctors and a mature woman created by one of them. It contains many unsanctified weddings but (unlike Gray's last novel *Something Leather*) no perversions — apart from those of General Sir Aubrey de la Pole Blessington, which are touched upon as lightly as the whims of a great national hero deserve. Nothing here would surprise Mary Shelley, Lewis Carroll and Arthur Conan Doyle, or bring a blush to the cheek of the most innocent child.

BLURB FOR A POPULAR PAPERBACK

What strange secret made rich, beautiful, tempestuous Bella Baxter irresistible to the poor Scottish medical student Archie McCandless? Was it her mysterious origin in the home of his monstrous friend Godwin Baxter, the genius whose voice could perforate eardrums? This story of true love and scientific daring whirls the reader from the private operating-theatres of late-Victorian Glasgow through aristocratic casinos, low-life Alexandria and a Parisian bordello, reaching an interrupted climax in a Scottish church. Unlike Alasdair Gray's last novel *Something Leather*, the good people thrive, while the villainous Duncan Wedderburn and General Sir Aubrey de la Pole Blessington get what they deserve.

£14.99 net

***Ten Tales Tall
and True**, 1993,
first jacket
design, final
jacket and
contents page;
pictorial initial
caps,
24 x 16 cm*

E IGHT MEN DUG a trench beside a muddy crossroads, and the mud made two remember Italy where they had fought in a recent

IN HER mid-twenties she does not move or dress attractively so only looks handsome when still, like now. She sprawls on floor, arms folded on seat

T HIS thirty-year-old college lecturer is big, stout, handsome, with the innocent baby face of a man used to being served by women, the sulky

B ECAUSE OF A mistake (though I do not know whose) someone was shut in a windowless room with nothing to look at but a door which

I DISCOVERED an odd thing about my left foot when about to pull on a sock this morning. In the groove between the second and third

the preface book I offered him another novel, which he gladly accepted. *A History Maker* is a science fiction novel made from a television play I began writing in 1965, then stopped because the crowd scenes would have been too expensive for the BBC.

It is set in a future where every home produced without expense all that is needed for a comfortable life, thereby abolishing money, governments and cities. Women and children live in the extended families Margaret Mead's *Growing Up in Samoa* describes. People who want eternal life are free to go for it on other planets, all of which lack the earth's beautiful variety. Men who prefer to stay here mostly occupy themselves with gladiatorial war games. Chris Boyce, over lunch in the Ubiquitous Chip, suggested how this future might come about and lent me a book describing how machines might one day be grown genetically in vats of chemicals. After this the novel came easily. *A History Maker* was published in 1994.

On 21 February 1995 I signed a contract with Bloomsbury, who promised to pay me £1,600 on signature

and £1,600 on the first of every month from 1 July 1995 to 1 June 1998. It also promised to pay Scott Pearson, a friend who took dictation from me on a freelance basis, a smaller monthly sum for his services. The first regular payment was five months in the future, allowing me time to complete a new mural painting started the year before.

It had been commissioned by Elspeth King, my former boss in the People's Palace local history museum. When Glasgow became European City of Culture in 1990 a new Head of our Art Galleries and Museums announced that her post as People's Palace curator was now vacant, but like others she could apply for it. No worthwhile applications came from people with gallery experience outside Glasgow, for they knew her 18 years of work for the Palace had put it among the five most visited buildings in Scotland. When a former employee of hers was promoted over her head, she and Mike Donnelly went to work in Dunfermline. The Carnegie Trust employed them to make a new local history museum in the Abbot's House, oldest building outside the grounds of the ancient abbey.

When possible Elspeth employs living artists, the Carnegie Trust was rich, so I became one of the mural painters, iron workers, stone carvers and landscape gardeners she commissioned. Carnegie, a poor handloom weaver's son, went to Pittsburgh with his family when 13, became a newspaper vendor and telegraph boy, and when US capitalism boomed during the Civil War, invested every penny he saved. On retiring from United States Steel in 1891, he owned the biggest private fortune in the world. From a merciless exploiter of workers he became a philanthropist funding concert halls, libraries and education grants on both sides of the Atlantic. He was especially provident to Dunfermline, his birthplace. Elspeth commissioned me to decorate the ceiling of the building's biggest room. On its longest sides the ceiling sloped down 18 inches to meet an equally wide strip of plastered wall above wooden panelling. The ceiling was too low for a complex painting to be seen as a whole. My assistant and near neighbour was Robert Salmon, painter and sign-writer. From roots surrounding names of prehistoric tribes we painted the stem of a huge thistle down the

centre of the ceiling. This symbolized Dunfermline's history. Each side was divided by horizontal off-shoots into ten equal spaces holding inscriptions and pictorial symbols for ten centuries, starting with the 11th A.D. when Malcolm Canmore, first king of united Scotland, made the town a royal capital and his queen founded the abbey.

PUBLIC EYE

PRIVATE HOUSES

WARRIOR WORK

PUDDOCK PLOT

THE HENWIFE

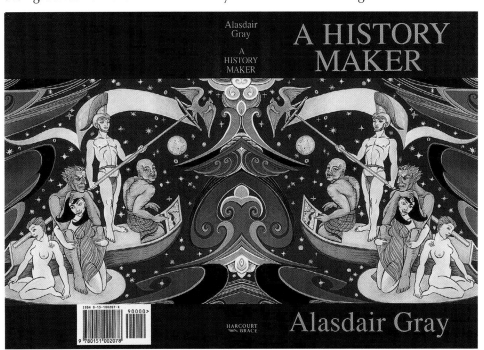

A History Maker,
1995, book jacket,
21 x 15 cm

History Maker,
American edition,
1995, vignettes

*Tree of
Dunfermline
History: Abbot's
House Ceiling*
emulsion & oil
on plaster
1994–96.
At top, frieze
of faces above
dado on south
wall; below
frieze of faces
above north
wall dado.

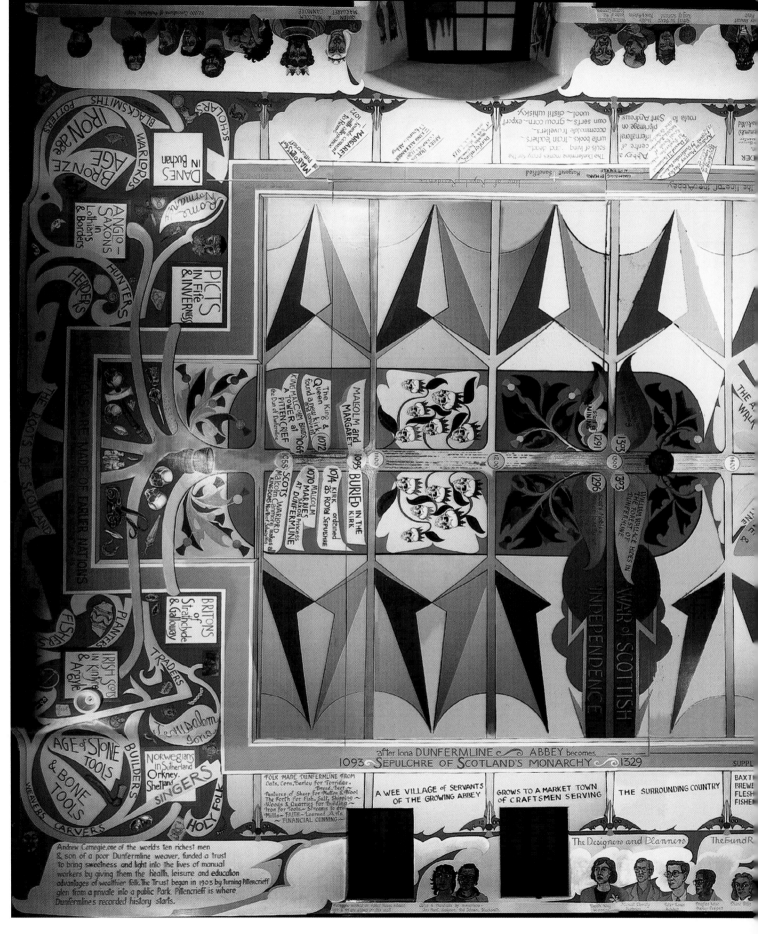

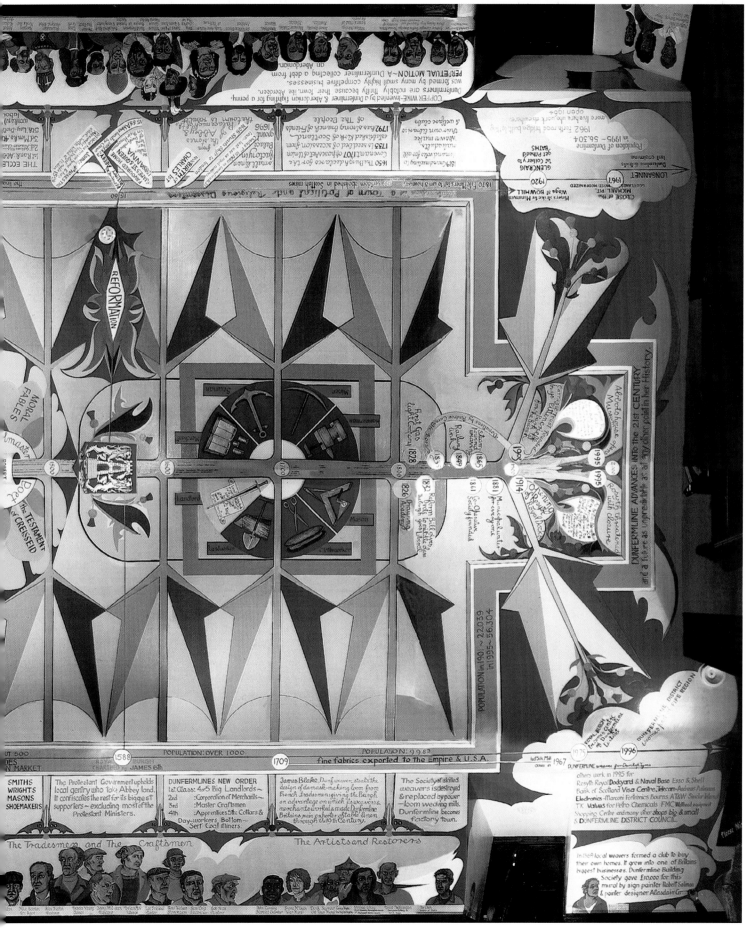

This represents Dunfermline's growth from prehistoric roots. The southern frieze shows people from Dunfermline's history, the northern has portraits of those who made a museum of the old building. They were drawn and cut out of paper, pasted to the wall and tinted.

*Dunfermline
Abbot's House
Mural*,
*1994–96,
drawings in
pencil on paper
with acrylic
and oils.
Folk from old
Dunfermline on
the south wall;
folk who made
the museum on
the north wall.*

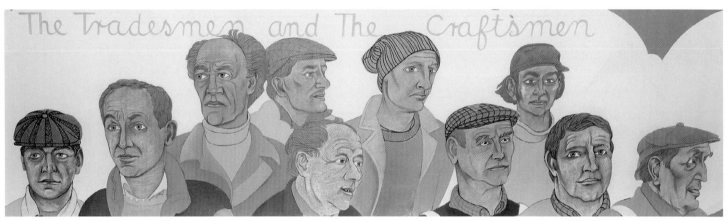

Elspeth King
Historian

Michael Donnely
Historian

Peter Ranson
Architect

In 1869 local weavers formed a club to buy their own homes. It grew into one of Britains biggest businesses. Dunfermline Building Society gave £10,000 for this mural by sign painter Robert Salmon & painter designer Alasdair Gr

Begun July 1994
Almost finished
4·1·1996

The south wall of the long gallery had a portrait frieze showing people active in Dunfermline's history. Before the 20th century I had only portraits of royalty to work from, so used the faces of friends for the rest. Top right is Bernard MacLaverty as an important abbot; to his left Ian McIlhenny as the monk who wrote Scotland's earliest history. The bishop in the yellow mitre, (a great hunter of Protestant heretics) is James Kelman. Their historical names, not shown here, are inscribed beneath. Far right of this top section I showed my daughter-in-law Libby and baby granddaughter Alexandra as a Bronze Age mother and child. On the north wall, with their real names beneath, were living folk who had made the old building a museum. I was too modest to entirely include my own name.

Annexe Theatre Company posters, average size 42 x 30 cm

Joe. Politics in the Park, 1987

Vodka and Daises by Lara Jane Bunting, 1989

Dolorosa by Peter Murray, C'mon Get Aff by Doreen McArdle, For His Namesake by Alan Hayton, 1990

The Unforgiven by David Kilby, 1991, poster

Tramcars & Greyhounds by Doreen McArdle, 1994

Cat and Mouse by Noel McMonagle, 1995

Coming Apart by Bob Adams, 1995

Spitting in the Face of Eve by Douglas Esson Moffat, 1996

"H" by Noel McMonagle, 1998

*Petra, Antonia
and Spike the Cat
at home in 175
Queen Victoria
Drive*, 1992,
acrylic, oil and
pencil,
48 x 67 cm

*A Working
Mother by Agnes
Owens*, front of
jacket, 1994,
19 x 11. 5 cm

*A Clockwork
Orange: Play of
the Book,*
1992, poster,
58 x 40.5 cm

*Scotland's
Relations With
England: A
Survey to 1707
by William
Ferguson*, 1994
,book jacket,
24 x 15 cm

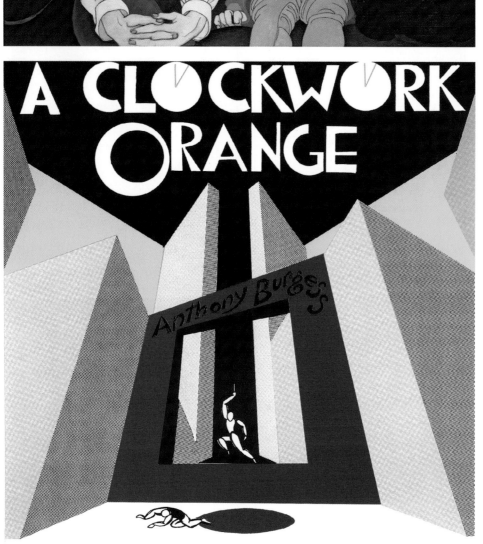

But I now needed a Glasgow typesetter to work with me on the *Prefaces* book. Jim Kelman introduced me to Joe Murray, an engineer who had become a poet, bookseller, then editor of the literary magazine *West Coast*, which he ran for

11 years until the Arts Council ended it and several other valuable journals by withdrawing their subsidies in 1998. Joe typeset the magazine in a Paisley Road West flat he shared with his partner and assistant, Jan Dalton, also enlarging his small income by typesetting for the Clydeside Press and periodicals like the Scots feminist magazine *Harpies and Quines*. His home near Cessnock underground station made him less than a twenty-minute journey from mine. He was both efficient and easy to work with, which was not his experience of me. My almost unending revision of pages drove this good-natured man (only once) to go on strike if I did not leave alone pages he had reset again and again and again. We remain friends. He has since typeset eight more of my books.

The freedom and relief of a secure income for three years enabled me (much to Morag's alarm) to do other work along with *The Book of Prefaces*, because without money worries more jobs are possible. I designed a song book that Mainstream of Edinburgh published in 1996. *Songs of Scotland*, a hundred of them, were chosen with marginal notes and musical accompaniments by my friend Wilma Paterson. The typesetter was Mary Anne Alburger, an American musicologist working from her home in Ballachulish when not lecturing in Aberdeen University. This was the most lavish book I designed before *The Book of Prefaces*, the typography in black and red, the illustrations in black, grey and red. In the same year Bloomsbury

SONGS OF SCOTLAND

EDITED BY
Wilma Paterson
ILLUSTRATED BY
ALASDAIR GRAY

Songs of Scotland*: jacket and metalled front board, 1996*

SKULDUGGERY AND SUDDEN DEATH

LOVE SATISFIED

EXILE

Songs of Scotland*, three chapter title pages, 1996, 29 x 49 cm*

Mavis Belfrage,
1996, book
jacket,
22 x 31 cm

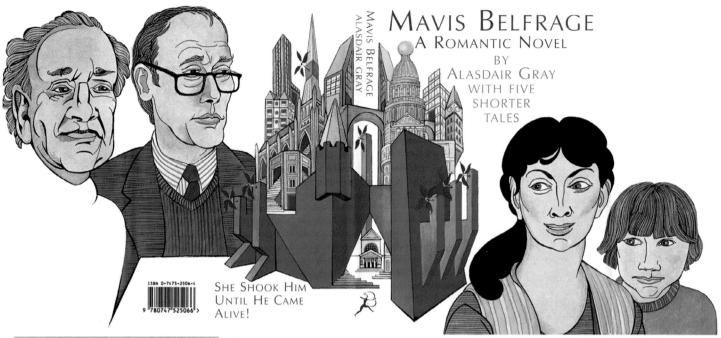

MAVIS BELFRAGE
A ROMANTIC NOVEL
BY
ALASDAIR GRAY
WITH FIVE
SHORTER
TALES

ISBN 0-7475-2506-4

SHE SHOOK HIM
UNTIL HE CAME
ALIVE!

*Why Scots
Should Rule
Scotland*,
1997, book
jacket,
19.5 x 13 cm

*The Bonnie
Broukit Bairn*,
1995, acrylic
on board,
91.5 x 61 cm

ALASDAIR & ALASDAIR

*The Two
Alasdairs*, 1995,
pencil and ink on
paper,
31 x 41 cm
invitation card
to exhibition
of work by
Alasdairs Taylor
and Gray in the
Nancy Smillie
Gallery, Hillhead

published *Mavis Belfrage: A Romantic Novel with Five Shorter Tales*. It had few illustrations, but Sheila Hind, Archie and Eleanor's youngest daughter, lent me her impish face for the cover picture of Mavis, while the poet Matt Ewart's face suited her stolid young man.

The illustration to MacDiarmid's great poem was commissioned by Doctor George Philp as a present for his wife, using money he had received from the Andrew Fletcher of Saltoun Award for promoting Scottish art through *Scotsoun*, his record company. The *Bonny Broukit Bairn* – neglected child in English – is described as poorer than such heavenly bodies as Mars, Venus and the moon, but only she has life so can drown their apparition in her tears. For the 1997 General Election, *Why Scots Should Rule Scotland*, my pamphlet supporting Scottish independence, was published by Canongate. It carefully defined Scots as everyone living and voting here, no matter where they or their parents came from. My cover design had the Scottish flag among others

of countries with roughly the same population (Israel, Finland, Denmark) or a million or two fewer (Norway, Ireland, New Zealand) and some with a few million more.

Through a friend of Morag's, Forest Alexander who suffers from multiple sclerosis, I was commissioned to write a play for Birds of Paradise, a drama company for disabled people. The result was *Working Legs: A Play for People Without Them*, which enabled the company to enlarge its paid staff and engage with 45 other drama workshops throughout Scotland, before taking the play on tour in 1998. The central figure in the poster is John Campbell, whose legs are artificial and who I wished to act my hero. The play's text was published by Dog & Bone, formed then only of me and Morag. Portraits of company members whose words inspired the play illustrated the book, with six of their faces on the jacket.

The end of year 1999 drew near when the Bloomsbury cheques for me and my secretary would end and the *Prefaces* book be delivered. I had meant it to

contain 20th-century writers but could not afford to buy copyrights from the estates of D.H. Lawrence, Keynes, Auden and others, so Wilfred Owen, Kipling and Bernard Shaw were as near as I could get to my own time. There were still 40 prefaces by fine authors that would need months of research to comment

on accurately and interestingly. To help end the book in time I asked every writer I knew for help, including some I knew very slightly. The only payment I could offer was the original of a portrait drawing to be reproduced with those of other helpers at the end of the book. Nobody I asked refused me so

People Like That by Agnes Owens,
1996, book jacket,
19.5 x 13 cm

Working Legs, A Play For People Without Them (Birds of Paradise Theatre Co.),
1998, poster, 41.5 x 29 cm

Page 254

Third
New Start

**Working Legs: A
Play for People
Without Them**,
*1997, jacket,
frontispiece and
title page,
19.5 x 13 cm*

I gave prefaces to folk who sympathized with their authors. Alan Spence's love of mystical philosophy made him a natural commentator upon Vaughan and Traherne's poetry, while Burke's *On the Revolution in France* went to the Tory philosopher Rodger Scrutton. A.L. Kennedy got Sterne and Darwin; Janice Galloway, Jane Austen and Charlotte Brontë; Tom Leonard, John Clare; James Kelman, Dickens; Edwin Morgan, Poe. Frank Kuppner's quirky intelligence and devout atheism made him right for Lewis Carroll and Gerard Manley Hopkins. Some editing was needed to fit my helper's commentaries to the short lines of the marginal column. Janice Galloway said hers finally had Gray fingerprints all over it, but I tried to ensure the editing did not reflect my own politics. The final text was finished in time.

This chapter says much about jobs I did while also working on the preface anthology. Here is another. A few years before Dan Healy, King and extraordinary builder, had introduced me to Colin Beattie, a publican unique

among businessmen because he personally employs local artists. For The Lismore, his pub on Dumbarton Road, he had commissioned the best modern stained-glass windows I have seen in any building. He now asked me to design stained-glass windows for an all-night literary café he was hoping to open in Partick, across the road from The Lismore. I said I would like to design these windows but had now no time for that because my preface book must be finished that year. He explained that he did not want large completed designs, just small ones suggesting the final general appearance, and would £600 be sufficient payment? Nobody had offered so much money for a non-mural piece of my visual art

since 1963 when Andrew Sykes bought the Cowcaddens cityscape, but I replied that stopping work on my book was impossible. We parted as friends and next day his cheque for £600 came through our letterbox in an unstamped envelope, with a note saying he looked forward to my designs. His faith in the power of money was justified. I took two days off work on the prefaces, designed the windows and cashed the cheque. Each design contained a writer who lived not far from Partick. Susan Boyd was closest. A television dramatist, she had written *Eastenders* scripts in London from the start of the series, but bought a flat in Partick and lived there when word processors were made so cleverly that writers could work for London establishments without being there. I meant to show Susan in her living room with a favourite cat, the rest with backgrounds suggested by their writing. *The Bus Conductor Hines* and *Glasgow to Saturn* by Kelman and Morgan were obvious suggestions. Lochhead and Leonard had written poems about the Kelvinhall Carnival and

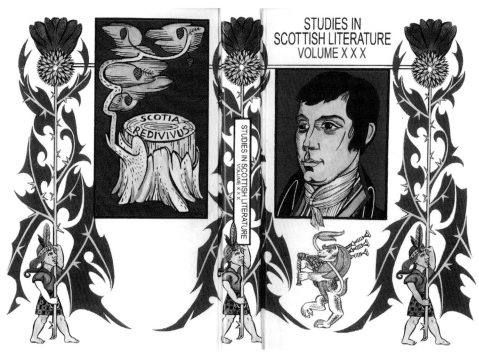

Studies in Scottish Literature: volume 30, edited by G. Ross Roy, 1998, book jacket

The World of C.L.R. James: His Unfragmented Vision by James D. Young, 1999, book jacket

Scottish schoolteachers. Colin Beattie showed my window sketches to Glasgow City Councilors with his other plans for the old building he wanted to preserve, but it was finally demolished and the site sold to Partick Housing Association, which built more flats there. This is worth mentioning because of what followed my final delivery of the text to Bloomsbury.

Alas, I had not yet designed the jacket and boards, drawn all the vignettes or fitted the various title pages to the book's

different sections. It would still be a good book if printed without them, but appear too heavily academic to please those who liked reading for fun. Liz Calder would give me a few more months to supply this visual garnish, but where could I get money to live on while making it? In the year of my birth the British Council had been founded to promote British culture here and abroad. It had recently paid me to give readings in London and the USA. I asked it for advice and was told that a firm

in Scotland had been specially created to put artists in touch with rich patrons. The firm's headquarters were in Glasgow, though on going there I was told that next week it would flit to Edinburgh. The young woman who received me explained that it dealt mostly with musicians, but she felt she owed me an interview because, when a student at Glasgow University, she had interviewed me for a student newspaper, and found me helpful. She gave me a list of companies and people

JAMES KELMAN SUSAN BOYD EDWIN MORGAN LIZ LOCHHEAD TOM LEONARD

Partick Literary café and bar, 1999, gouache on paper, 50 x 28 cm. Designs for stained-glass windows, portraits of local writers

who sometimes patronized the arts – it included Scottish and Newcastle Breweries and a famous merchant banker – and advised me to approach them with a curriculum vitae designed and printed by a firm specializing in such things.

 ENGLAND

 IRELAND

A Short History of Literate Thought in Words by Great Writers Of Four Nations From The 7th To The 20th Century LONDON AND NEW YORK 2002

THE BOOK *of* PREFACES

 United States

 SCOTLAND

Edited & Glossed by Alasdair Gray Mainly BLOOMSBURY PUBLISHING

The Book of Prefaces, 2000, portraits of those responsible, reproduced from page six

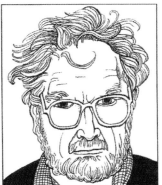
Alasdair Gray: designer & editor.

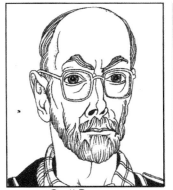
Scott Pearson: researcher & word processor.

Liz Calder: publisher.

Joe Murray: typesetter.

William Smellie, who conceived this book.

Jan Dalton: typesetter's manager.

Morag McAlpine: editor's manager.

Julie Cuzin: typist.

Colin Beattie: sponsor.

THE FIRST ENGLISH

ENGLISH REMADE

A SCOTS FLOWERING

BETWEEN TWO BIBLES

I went home in a melancholy state being 64 – my books lectured upon in Scottish and foreign universities – having designed two that had won awards for their publisher – and a firm created by government subsidy to help artists now advised me to hire an advertizer to help

me compete with other artists for the attention of examiners who might take months or years before one thought I deserved help.

I put Joe's printouts of the book in a parcel with a letter to Colin Beattie. It said that if he thought it worth supporting

and he could afford to do so, would he please give me seven cheques post-dated on the first of the next seven months, the first six for £1000 each, the last for £1500. I could give him in return an acknowledgement of his help in the book when it appeared, with his portrait on a

ESTABLISHMENT

THE DISTURBED ESTABLISHMENT

LIBERAL ENGLISH

The Book of Prefaces, six interior title pages, 2000, 24 x 16 cm

A Short
History of Literate
Thought in Words
by Great Writers
Of Four Nations
From The 7th To
The 20th Century
Edited & Glossed
by Alasdair Gray
Mainly

ISBN 1-58234-037-4

54995>

9 781582 340371

BLOOMSBURY
www.bloomsbury.com

THE BOOK
OF PREFACES
Alasdair Gray

THE
BOOK
OF
PREF-
ACES
*Alasdair
Gray*

The Book of Prefaces, 2000, book jacket and end paper detail, 24 x 16 cm

page with those of other helpers. Colin's office was then in the basement of his Lismore pub. I handed the parcel over the bar on Thursday evening. On Friday morning Morag and I returned from shopping and found on our lobby floor an unstamped envelope containing the seven cheques I wanted, and a note from Colin saying it was a privilege to assist the production of this book. *The Book of Prefaces* was printed in April 2000. I received an early copy through the post with a note from Liz Calder saying it had been well worth waiting for. It was widely and approvingly reviewed. I hope it sold well enough to repay Bloomsbury for their expense and my delays.

Eighteen: New Century, 2000–10

AT THE START of the 21st century I was 66 and Morag had retired from bookselling six years earlier. She had drawn on her savings to supplement my erratic income at times, so dreaded having to sell her home to feed us if I stopped earning money through health failure. My earnings after *The Book of Prefaces* appeared were very little, despite some portrait commissions and the publication of two wee books. I asked the Scottish Artists' Benevolent Association for money and got it, perhaps because George Devlin was on the committee, another of Miss Jean Irwin's former pupils. Then the administrators of the Scottish Arts Council and Lottery Fund announced a competition open to all artists, musical, visual or literary. From those who submitted a plan for a new work of art, ten would be selected and paid enough money to achieve it, if the medium they worked in was not

their usual. This daft competition would certainly assert the superiority of its administrators to the artists who entered, whether winners or losers, but I applied with a scheme I thought fitted the rules. I had recently been paid by North Lanarkshire to restore my Palacerigg mural, since rain penetration had partly damaged it. What if I asked to be paid to travel around completing or restoring the other murals? The paintings in the Bridgeton Church and Cathcart Synagogue had been destroyed with the buildings they decorated, but the war mural in Belmont Crescent had never been properly finished. Faces in the Greenbank Church Story of Ruth mural had been badly coloured by someone else – I was now confident I could do it properly. The Jonah mural in West Princes Street, Clyde Falls landscape in Kirkfieldbank were under wallpaper – with money I might persuade the present owners to let

me uncover and restore them. Parts of the black and white decoration in the Kelvin Drive stairwell had faded, and faces were starting to fade on the side walls in the Dunfermline Abbot's House history museum. The fact that I was more a known writer than painter and not known at all as a mural restorer might give me a chance. The application form needed names of referees. I asked Duncan MacMillan, art historian and Talbot Rice curator, if I could use his. "Certainly!" he said, "Are you applying to be retrained as a ballet dancer?" I was in the published list of applicants accepted for the competition, but finally rejected because the judges (said a letter from one) thought my application "had not quite met the competition's conditions". Then why had they accepted me as an entrant? Perhaps my name gave them some publicity. Organizers need that.

One day Bernard MacLaverty told

SIXTEEN
OCCASIONAL
POEMS
1990 — 2000
ALASDAIR GRAY

MORAG McALPINE
GLASGOW 2000

Sixteen Occasional Poems 1990–2000, 2000, book jacket, 19.5 x 13 cm

A Short Survey of Classic Scottish Writing, 2001, book jacket, 15.5 x 11 cm

A Twentieth Century Life by Paul Henderson Scott, 2002, book jacket, 24 x 16 cm

*A Poet's
Polemic by
John Burnside,
2003, pamphlet
cover,
19.5 x 13 cm*

me he had met a man on the Board of the Royal Literary Fund, who told him it existed to help authors like me. Bernard urged me to apply. As a Socialist Republican I disliked begging from a royal organization, but was told royalty had no say in this fund for distressed authors – its money came from successful ones. Somerset Maugham, Bernard Shaw and A.A. Milne had enriched it with their royalties, especially Milne, whose royalties included money from Hollywood animated films and toys derived from his books about a friendly soft toy. Many writers of work I love had been helped by the fund – Coleridge, James Hogg, Conrad, D.H. Lawrence, James Joyce. So I applied to what Morag always calls *The Winnie the Pooh Fund* and was awarded a pension of £10,000 a year after Eileen Gunn, the Secretary, had investigated our circumstances. Two years later I foolishly gave the pension up by taking a steady job.

In 1995 Philip Hobsbaum and sympathetic colleagues had started a Creative Writing course in Glasgow University, attracting so many students that in 2001 the Senate decided to

A POET'S POLEMIC
JOHN BURNSIDE

National Poetry Day 2003

make a Creative Writing Chair with a professor in it. Where would they find one? Creative Writing had so far been taught by lecturers in English literature. In England the first Creative Writing professors had been university graduates *and* novelists. The most well-known Glasgow author with an arts degree was James Kelman, winner of the Booker Prize and part-

time Creative Writing teacher in the University of Texas. He was told he might get the job if he applied for it, and was tempted. Like most authors the income from his books did not support him, but full-time professoring would leave him no time to write. Before refusing the job his wife Marie suggested he might share it with Tom Leonard and me. We were friends whose publications were known abroad. If we shared the job and salary Glasgow University would get three professors for the price of one. This happened, despite an oath I had once sworn to never, never, never teach again. I was moved by my dead parents' conviction that university teachers were among the highest forms of social life – they led the fight against ignorance, just as doctors led the fight against disease and Labour politicians against poverty, therefore businessmen, Royalty and most other people were inferior to these three. So I became a professor with Jim and Tom.

Our first academic year was frustrating yet exciting. Each of us found the job used much more than a third of our time but we

Alasdair Gray is a fat, spectacled, balding, increasingly old Glasgow pedestrian who (despite two recent years as Professor of Creative Writing at Glasgow University) has mainly lived by writing and designing eighteen books, most of them fiction. THE ENDS OF OUR TETHERS is the ninth published by Canongate.

Since 1981, when Alasdair Gray's first novel LANARK was published by Canongate, his characters have aged as fast as their author. THE ENDS OF OUR TETHERS shows the high jinks of many folk in the last stages of physical, moral and social decrepitude – a sure tonic for the young.

www.canongate.net

9 781841 954400

CANONGATE

THE ENDS OF OUR TETHERS
ALASDAIR GRAY

THE ENDS OF OUR TETHERS
13 Sorry Stories by Alasdair Gray

"A truly great collection - funny, righteous, full of sadness and good strong anger and unbelievably inventive with both. Gray is a necessary genius."
Ali Smith, author of *Hotel World*

£10

attempted innovations that looked like succeeding. Our students' work had been judged in exams that gave them marks out of 60 for their poems, stories or plays and out of 40 for their critical essays. We professors thought poems, stories, plays should only be marked *good*, *not quite good* and *improvable*, and only those who made no effort to improve should be firmly failed. The numerical marking system in the past had practically amounted to that. We suggested it be replaced by 1st, 2nd, 3rd class and failed. Critical thought and discussion are essential to good writers and many like writing essays, but we wanted all essays to be as voluntary as other student writings. Most lecturers prefer marking critical essays because it lets them give high marks to students who most agree with them, but that is no clue to a student's creative powers. By the second year we thought our system of marking was adopted, and by getting Liz Lochhead and Janice Galloway part-time jobs in the department it was no longer so top-heavy with old men.

Then the job went distinctly sour.

Portait of Edwin Morgan, 2003, acrylic, ink, pencil and watercolour, 30 x 42 cm

Our Creative Writing secretary left to have a baby and was never replaced. We found professorial decisions were being made without consulting us. The English Department we were part of wanted our course to enrol more students without employing more teachers. Since the Thatcher era all universities and colleges are under government pressure to become self-financing, profitable businesses, except perhaps Oxford and Cambridge which are these already. Tom, Jim and I hated the idea of discussing work with individual students once a month instead of once a fortnight, and compensating by taking much larger classes, nor did we think students working to be good poets, novelists and playwrights deserved doctorates in Philosophy. We had not thought that many were studying Creative Writing in order to teach instead of practising it. A small heart attack that hospitalized me in the spring of 2003 came as a relief. It came close upon news of a big mural decoration job that would suit me far better, and start in the autumn. I wrote to our department saying I would return to complete the academic year and then resign. The university saved paying me a month's salary by treating this as a letter of immediate resignation. Tom Leonard and James Kelman resigned as professors when the academic year ended, though Tom continued as a teacher of poetry because he got on well with his students. So had Jim and I, but we had taken professoring too seriously for a modern university.

At the corner of Byres Road and Great Western Road stood Kelvingrove Botanic Church, three minutes' walk from the home where I now lived and slightly nearer my old home in Kersland Street. At the end of the 1960s I had heard its carillon of bells play hymn tunes before Sunday morning service, sounds that pleased me like the university clock striking hours and quarters, and the cry of an owl at night in Kelvingrove Park. But the magnificent building ended as a kirk, became a Bible college around the time Inge and I separated and had been derelict for four years when Colin Beattie bought the property and began turning it into an arts and leisure centre. He equipped me with a safety helmet and took me there. The church interior for over a century had had the highest ceiling in Glasgow. It was now full of the noise and dust as tradesmen ripped out old pews, rotten woodwork, and decaying plaster from the walls. Colin took me up to the surrounding gallery where wealthy Victorians had once rented pews, the level at which a new floor would be built with a big pub underneath. This would be the floor of an auditorium for banquets, concerts, conferences and private events. Colin showed me plans of this future auditorium designed by Pete McGurn, whose children I had drawn 30 years earlier. They showed a big wide plaster panel above a bar at the western end – would I paint a decoration there? Yes (I said) but would have to know the whole auditorium's colour scheme, to make my painting harmonize. Colin asked me to suggest a colour scheme. Remembering the Belisle Street Synagogue decoration I suggested the arched auditorium ceiling be painted with a sky of stars, moons and clouds, with dawn breaking in a horizontal frieze at the top of the surrounding walls. A small sketch would give a bad idea of its final effect, so I asked for a large plaster panel on which a specimen section of the ceiling design could be painted.

A few weeks later a panel nearly 7 by 3½ feet wide was brought to the home Morag shared with me. I covered it with the painting on page 264, which has much in common with the sky behind my portrait of Edwin Morgan. Colin liked it and asked me to start work on the ceiling as soon as it had been evenly plastered and given an emulsion undercoat. We met in his Partick pub, The Lismore, to discuss terms of employment over a drink. The ceiling would be the start of so large a decorative scheme that for years nobody could tell when it would be completed, so how would I be paid? I said that if he bore the cost of materials, I wanted paid on Friday nights for my work in the week before, and paid at the rate of other skilled tradesmen. He called to a passing tradesman, "What do we pay you George?" George said, "£15 an hour plus insurance." Colin asked if that would suit me and I said yes, if my assistants were paid at that rate too. He said, "That's alright", which has been our arrangement ever since. Professional friends think he is getting my labour cheap, my assistants think it satisfactory. These are Robert Salmon, expert sign-writer who helped with the Dunfermline mural, and new helper, Richard Todd, a young man I had tutored in Creative Writing at Glasgow University. Like many students since Thatcher's government abolished university grants, he was paying the fees by working in a local shop. Hearing of this mural commission he had told me of his degree from Newcastle College of Art, and asked if he could help me.

My Jonah mural in a West Princes Street flat had been uncovered by a new owner. She had paid to have 38 years of wallpaper scraped off, damaging the paintwork beneath, but could not pay me for restoring it. I got money to do this by having the job recorded by Kevin Cameron, film maker, who made a television documentary about it for Hopscotch films. Robert Salmon helped me with the first phase of restoration and Richard Todd showed his ability by helping with the last phase. I found him an exact draftsman

Kelvinside Free Church, *later Kelvinside Botanic Church of Scotland, photograph as it looked when built in 1862. The building's interior when derelict, before reconstruction as the Oran Mor Arts & Leisure centre in 2001*

and meticulous painter. Helped by these two and, in the first few weeks, three journeymen painters, we began painting the ceiling of the Kelvinside Church in the autumn of 2002.

The tradesmen were still stripping the interior of the huge nave prior to renovating it and making the downstairs bar and auditorium above by building a new floor between them at the old gallery level. Slightly above the height of the long walls on each side what is called 'a dance floor scaffolding', a solid floor of planks, was built for us immediately under the vault of the ceiling – not rounded, but a vault with on each side a straight slope, then a less steep one, meeting at the central roof beam. Near that beam we could paint the ceiling standing up, around the middle of each side it could be done sitting on stools, near

Carved heads of Protestant heroes, 1862, in Oran Mor auditorium with name and date added in oil and gold enamel, 2005

the side walls we worked kneeling. Each morning we climbed to that floor by a sequence of three ladders, the two lowest so vertiginously long and steep that having reached the top I never bothered to climb down before the day's work was over. We brought up sandwiches and thermos flasks of hot drinks, and urinated in empty paint tins. At first I had meant to fill the night sky between the highest clouds with a random pattern of stars, but the ceiling was upheld by five thick semicircular beams resting on crossbeams that divided it into six nearly equal spaces – twelve if each side were painted separately. We put a constellation of the zodiac in each, with the largest stars united by astrological figures. Each figure had the month when it was dominant painted at the side. I used a modern guide to the zodiac published for children by Ladybird Books, so the traditional symbols did not conform to months named in fashion magazine What-The-Stars-Foretell columns. These conform to the astrology invented nearly 2,000 years ago when Capricorn (for instance) was ascendant in December. I had been childishly pleased to be born under Capricorn like Jesus, Dostoevsky and Henry Miller, so regretted that the goat with the fishy tail now dominated the night sky in September. I painted these figures without much preliminary drawing, as Alan Fletcher had wanted me to paint, applying to the deep blue night

Oran Mor Test Panel: Night and Day (Dawn Firth Series), 2002, acrylic, oil and silver enamel on plaster panel, 208.2 x 106.7 cm

Oran Mor auditorium, 2004. Colin Beattie originally asked the artist for a decoration on the white panel above the bar and beneath the gallery. This will finally be painted if Gray lives long enough.

sky thick brushes loaded with purple, black or paler blue colour, using big strokes of the arm from the shoulder and elbow. Richard or Robert then added outlines in silver enamel and details in gold. Along the central roof beam we made a stream of little stars and silver clouds representing the Milky Way, with the disc of a planet (Mercury, Venus, Mars, Jupiter, Saturn) in the middle of five main divisions – the division beside the apse at the west end was too small for one.

The ceiling was painted in time for the opening of the Oran Mor Arts and Leisure Centre in 2003, and while working on it I also planned a scheme of decoration for the walls beneath which I have ever since worked upon between doing other jobs, a scheme which in 2010 is still far from complete. Campbell Douglas and J.J. Stevenson designed the original kirk in 1862. They had carved heads of 12 Protestant reformers and 1 Catholic built into the side walls and east gable. Their identity was not obvious so I had names and dates added as above. As in the long gallery of the Abbot's House, Dunfermline, I meant to decorate the walls of the side aisles with faces of the kirk's founders, ministers and leading members, and of those who made it the Oran Mor. The masons, joiners, plumbers, painters, glazers, electricians who did the conversion were photographed by Kevin Cameron with their names attached. I will eventually turn these

Oran Mor auditorium, 2004, east end of ceiling, Orion in January, Twins in February, Saturn between. Orion caricatures Richard Todd, Gray's assistant.

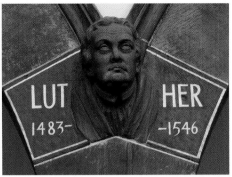

__Oran Mor auditorium__, 2004. Virgo (copied from angel in Correggio's Martyrdom of Four Saints, Parma National Gallery) is in May, the Dragon in June with Mars between them.

into portraits on the south wall, facing the owner, architect and staff recently added to the north wall. If spared I will also decorate the auditorium walls above the side aisles with a repeat pattern of tall trees growing up to the ceiling where the months are named, their leafage changing as indicated by the time of year. But first to be painted was the apse ceiling above a new balcony at the kirk's west end.

This ceiling is divided into three wedge shapes by great beams coming together at the end of the auditorium's central roof beam. Since the big middle division was in line with the Milky Way and our solar system's innermost planets it should contain the globe of our earth with mother earth on top and between her feet, Adam and Eve embracing as they had been in my long demolished Bridgeton Kirk mural and the title page to the *Love Fulfilled* section of *Songs of Scotland*. From the early 1950s I had loved Gauguin's work, especially his epic canvas, "*Where Do We Come From? What Are We? Where Are We Going?*". This shows a jungle clearing in which young and old folk ponder these questions which are the origin of every art, science and religion. I had wanted to make a modern version. This was my chance. In the left wedge was the Tree of Life, its red roots among skeletons and fossilized remains of the past. It emerges from earth as the navel cord

Oran Mor auditorium, 2004. Scorpio in July, Sagittarius in August. The Archer has Robert Salmon's profile. I saw from the floor when the scaffolding came down that his head was painted too small for the body.

of a baby being helped into life by a midwife, (as first shown on the spine of *Lanark*) then soars up behind her into a tree with spring blossoms and side branches supporting mothers and children first drawn for a chapter heading in *A History Maker*. In two corners are skulls out of which little winged boys are breaking, boys copied from a Blake engraving in which one breaks happily out of a shell. The treetop has a nest from which a new born phoenix arises against the background of an expanding nebula. In the right wedge my vertical shaft is the Tree of Knowledge of Good and Evil. Death is a Valkyrie on a winged horse, thrusting the shaft through the underground corpses of a husband and wife, where it roots among worms and, engendered like potatoes, skull-shapes containing winged embryos, the seeds of new life. The branches it bears above has withering autumnal leaves, ripe pomegranates, and a nest with the old phoenix sinking into flames against an imploding black hole.

Under the apse a spiral staircase descends to the building's front entrance hall. Colin Beattie got me to design the floor. It is in white and grey marble, the white tiles carved with WELCOME in 32 languages so that folk coming in can read it, and GOODBYE in the same languages facing people leaving. For words in the Roman alphabet I like the clarity of Gill Sans-Serif type but designed

Oran Mor auditorium, 2004. West end of ceiling, the Ram and Pisces, November and December. The upper triangular spaces are the tops of three panels in the ceiling of the western apse.

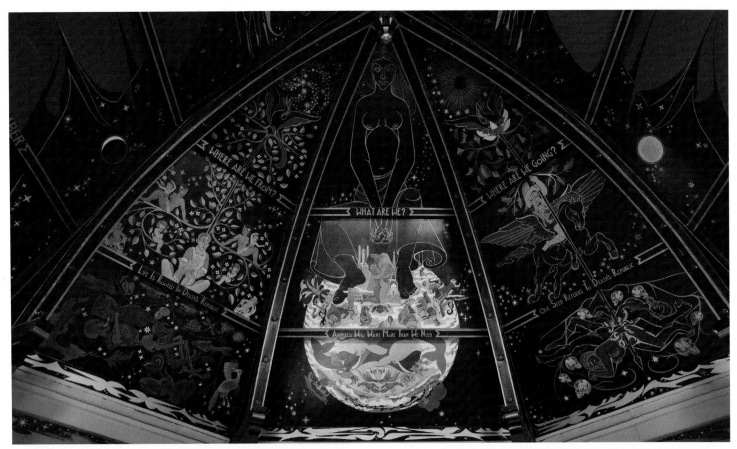

Oran Mor auditorium, 2004. Ceiling of apse above west end gallery. The right panels, not shown in detail, illustrate the question & answer: **Where are we going? All life returns to Death's Republic.**

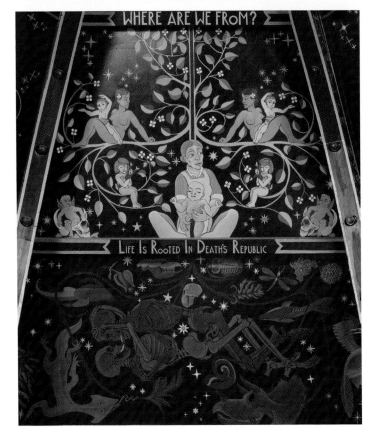

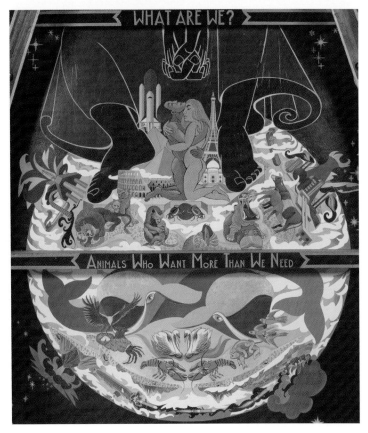

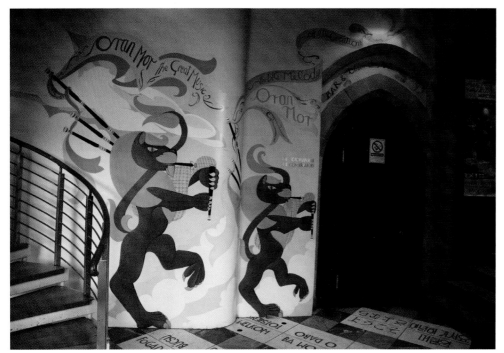

Oran Mor porch: Two Lion Pipers, 2004, oil, paint pens and acrylic on plaster; Marble floor carved with WELCOME towards the entrance, GOODBYE towards folk leaving, in 32 languages

sans-serif capitals which I think more elegant because the vertical and oblique strokes slightly taper upward. I call it Oran Mor Monumental. Oran Mor is Gaelic for The Great Music, meaning the music or harmony of all nature, but also of the pibroch, so for the walls of the entrance I made rampant bagpipe-playing lions.

On the north and south walls of the balcony are painted bronze statues symbolizing Peace and War, Philosophy and Art which stand on the north and south sides of a bridge over the Kelvin between Glasgow University and Kelvingrove Art Gallery. In 1941 a German landmine fell on the bridge, knocking Peace and War into the river. When retrieved War's right arm was missing, so the sculptor Benno Schotz (Alan Fletcher's old teacher) was paid to replace it. Thirty years later it was found by a retired shipyard worker fossicking in the Kelvin and passed through a scrap metal yard into Colin Beattie's possession. He wished to set it up as an anti-war memorial, so I painted the group it came from with the original

arm fixed to a plaque on the pedestal. A similar plaque on the pedestal of the group opposite is lettered with an account of the whole business.

The scheme of decoration for the walls of the side aisles had to accommodate ventilation ducts required by modern health and safety regulations, with between each pair a loud-speaker needed when the auditorium had musicians performing. My portraits of those running the Oran Mor were therefore put in framed mirrors above the dado between each pair of ducts. The background of the mirrors and dado was made strong red with silhouette in gold stencil – on the dado Scots thistles, English roses, the Welsh leek and Irish harp, above it woodland branches and leaves, and along the top of the side aisle wall a frieze strongly influenced by George Bain's book *Celtic Art: The Methods of Construction* published by William MacLellan. My designs were practically carried out between 2007 and 2009 by Nichol Wheatley, a near neighbour in Hillhead whose mural and interior decoration firm, Perfect

Circle, has had work commissioned by chains of hotels all over Britain and Europe. The marbling of the panels around the circular windows was done by Lucy Mckenzie, another even younger Scottish artist with an international reputation.

Painting the great eastern gable began in 2004, but the auditorium was soon being rented three or four times a week for concerts, conferences and marriages allowing no time to concentrate on it steadily for several days between putting up and taking down the tower scaffolding we needed. Unlike thousands of big and small firms the Oran Mor survived the financial disaster of 2009 by being constantly open for business. It is possible that in the next few years a film company will make a big documentary about my work, having raised enough money to rent the auditorium for a fortnight: in which case Colin Beattie would pay me and my helpers for completing the job at his usual generous hourly rate. Before that happens the long walls above the side aisles may be filled with the

*Oran Mor
auditorium, 2004,
mural. Details
from gallery walls
showing statues
on Kelvin Way
bridge. Left, north
wall: **Philosophy
& Inspiration**,
Glasgow
University
behind. Right,
south wall: **Peace
& War**, with lost
warrior's arm
pedestal*

tops of the great trees I want there, since Nichol Wheatley could put them up quickly if they were painted on canvas, a section at a time, in his Maryhill studio.

Meanwhile I was receiving more design commissions for which I was increasingly paid. In 1995 I had signed a contract to make *this* book for Canongate. Around 2004 I started thinking hard about it and began writing a new novel for Bloomsbury. *Old Men in Love* combined fantasies about being the sort of person I slightly am in four different centuries and nations, the first living in Periclean Athens during the Peloponnesian War, the last in 21st-century Hillhead during the Bush–Blair invasion of Iraq. Jobs like the portraits below can be finished quickly, but when working hard on a much bigger job I need to refresh myself by taking a break from it by tackling a very different one. The resulting delay always helps the final product. I now worked faster on books and visual art as I was employing an excellent secretary and artist assistants – who had to be paid, which meant that Morag still could

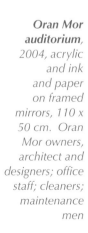

*Oran Mor
auditorium,
2004, acrylic
and ink
and paper
on framed
mirrors, 110 x
50 cm. Oran
Mor owners,
architect and
designers; office
staff; cleaners;
maintenance
men*

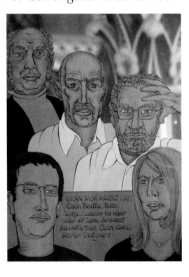

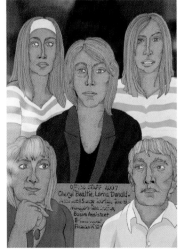

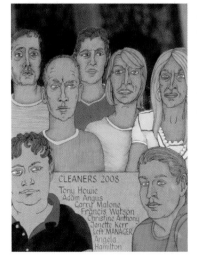

*Oran Mor
auditorium*,
*2004, mural.
Part of side
aisle wall. Gold
stencils cut
and applied
by Perfect
Circle, Nichol
Wheatley's firm;
with marbling
painted by Lucy
McKenzie*

not feel financially secure.

In 2002 Lucy McKenzie borrowed *Cowcaddens 1950, Snakes & Ladders,* some smaller pictures and a few of my illustrated books for an exhibition of work by Scottish artists she was curating in a Brunswick art gallery. Though 25 then, to me she appeared 10 years younger. Born in Glasgow, student of art in Dundee and Berlin, she was a new kind of arts graduate I had not realized existed. She had learned to deal on her own behalf through the internet, had work bought by Saatchi & Saatchi, recent solo shows in Hamburg, Warsaw, Gdansk and the London Tate. Her mural paintings showed mastery of drawing and tone. Critics called it Postmodern, yet she was using her international connections to promote me and John Byrne, late Post-Impressionists who she thought were being unfairly neglected. I knew many young people liked my writings, but was astonished that a painter 40 years younger than me liked my visual art. Like other Postmodernists her painting was often part of INSTALLATIONS and connected with PERFORMANCES. She made vinyl records (which I had thought obsolete) of Polish jazz musicians and me reading my verses, sold them to libraries and museums under the Decembrist label, the Decembrists being failed 1820 anti-Czarist revolutionaries. That

*Oran Mor
auditorium*,
*2004, acrylic and
ink and paper on
framed mirrors,
110 x 50 cm.
Banqueting
hall staff;
kitchen staff;
lunchtime theatre
playwrights
and producers;
decorators
Nichol Wheatley,
Alasdair Gray
and their main
assistants*

diversifying was common among young Postmoderns had not occurred to me, though I had seen doctored photographs, video films and digital imagery replacing drawings and paintings in art shows and galleries.

The diversity of my own work – mural, poster, illustrated book, plays (like *Fleck*) that I gave readings from since I could get no theatre to act them – had stopped most arts administrators and dealers of my own age taking me

seriously. Now it was making young folk think I was in the same often sorry business as themselves. By not changing my practice and techniques since the 1950s I was starting to seem *avant-garde*.

In 2006 I arranged with Glasgow's Print Studio for an expert silk-screen technician to work for me making coloured prints of the 1970s black and white verse illustrations. In two years we produced ten prints in limited editions that I numbered, dated and signed, paying the Print Studio by leaving with it a third of these, so that no money changed hands. The Print Studio is in King Street close to Glasgow Cross and the Tron Theatre. A Russian restaurant, The Café Cossachok, had opened nearby with a small picture gallery inside. I had not shown my pictures publicly for many years because sales had never paid for the cost of doing so, but the owners of the Cossachok, Julia and Lev, expected nothing but a small commission on sales if artists hung the show themselves. I hung some pictures there and sold one at a good price. Glasgow District Council was now promoting the value of properties near Glasgow Cross by advertizing them as The Merchant City, so organized a Merchant City Festival in 2007. For this Julia asked me to hang another exhibition in the basement of their Albion Street premises, a larger space; I made this a retrospective by showing old works beside recent ones. The Cossachok lent one of its staff to help with the hanging but I was also offered help (which I greatly needed) by Sorcha Dallas.

This stranger looked as young and beautiful as Lucy McKenzie and obviously belonged to the same generation. She arrived with a screw-driver, spirit level, hanging hooks and as good an eye for judging the spaces between pictures as for the

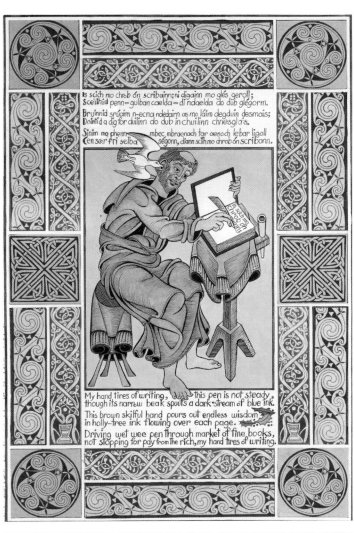

The Great Book of Gaelic, 2002, illustration, 26 x 22 cm

Triptych, 2007, brochure illustration, 15 x 15 cm

Ballads of the Book, CD cover, the original design in ink and acrylic, 15 x 15 cm

The Scottish Peace Covenant, 2006, acrylic and coloured ink collage, 62 x 49 cm

Old Men in Love: Athenian Acropolis with Alcibiades and Socrates, 2007, the original drawn on card, 40.5 x 80.9 cm

Old Men in Love,
2007, jacket, title
and frontispiece,
with double-
page illustration
of Hillhead,
Glasgow, the
original drawn
on card,
40.5 x 80.9 cm

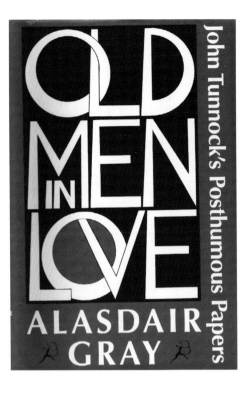

OLD MEN in LOVE
John Tunnock's
posthumous papers

introduced by
Lady Sara Sim-Jaegar

edited, decorated by
Alasdair Gray

John Tunnock
1940 – 2007

BLOOMSBURY
LONDON 2007

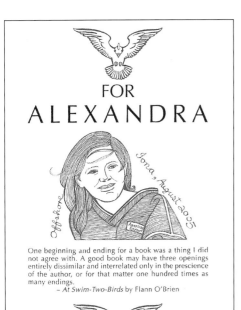

FOR
ALEXANDRA

Iona, August 2005

Offshore

One beginning and ending for a book was a thing I did not agree with. A good book may have three openings entirely dissimilar and interrelated only in the prescience of the author, or for that matter one hundred times as many endings.
– *At Swim-Two-Birds* by Flann O'Brien

TABLE OF CONTENTS

Old Men in Love, 2007, chapter list and dedication page. The Hillhead view beneath is more than half copied from a drawing by Nichol Wheatley.

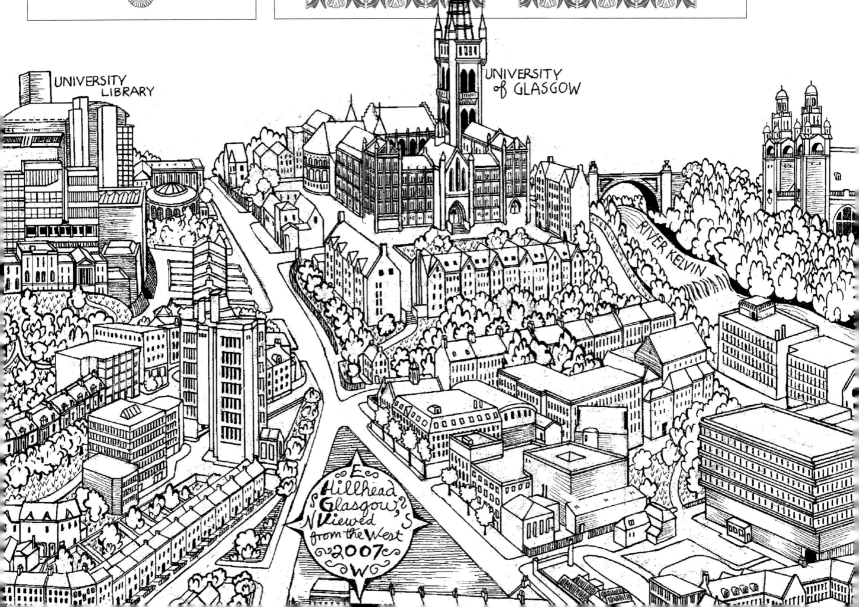

UNIVERSITY LIBRARY

UNIVERSITY of GLASGOW

RIVER KELVIN

Hillhead Glasgow, Viewed from the West 2007

That death will break
this salt-fresh cockle hand
is merely wisdom. Horror not, nor pain
poison the sunlight
though they haunt our brain.
The fact casts shadow
that has paralysed the will
in error, for a shadow cannot kill.
Fearing becomes reflection
rippled in a stream
of thought upon the sand
where death will break this salt-fresh
cockle-hand.

We will all go down into
the streets of water
& lose each other among
the fluid crystal.
When bodies join their reflection
both end
but it is common knowledge
that bones & memories lie
under the stream,
stirred by the moving water
when the heart is nowhere.
Ach Carole, my heart aches
that its ache for you maun end.
Dead regrets have no taste.
Under the water is neither sweet nor sour
& your sweet belly will become
only this memory.

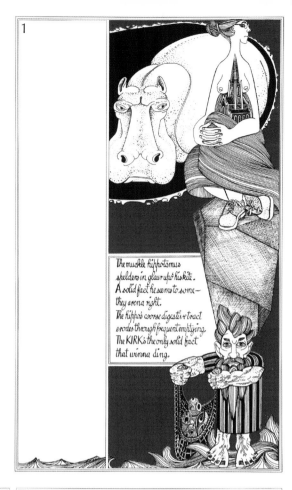

1

The muckle hippotamus
shelders in glaur upo his kite.
A solid fact he seems to some—
they arena right.
The hippo's coorse digestive tract
erodes through frequent emptying.
The KIRK's the only solid fact
that winna ding.

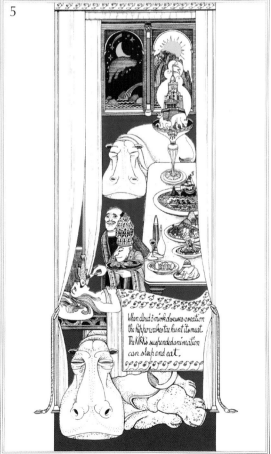

5

When dout o mirk obscures creation
the hippo wha has tint its meat.
The KIRK's suspended animation
can sleep and eat.

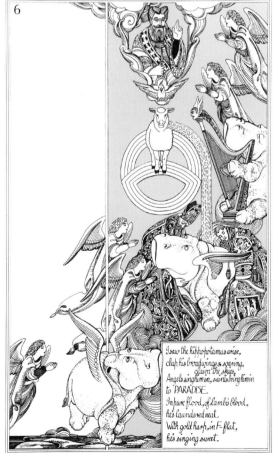

6

I saw the hippopotamus arise,
clap his broad wings & soaring,
claim the skies.
Angels singing him in, saints bringing him in
to PARADISE.
In pure flood, of lamb's blood,
his laundered meat.
With gold harp, in F-flat,
his singing sweet.

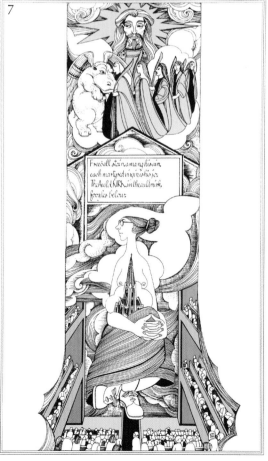

7

Flesh will stain, amang his ain,
each martyred virgin is his jo.
The Auld KIRK, in the auld mirk,
forsakes below.

*Fleck, 2008,
jacket, title and
first page,
21.5 x 14 cm*

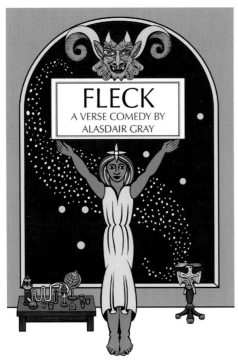

PROLOGUE

*SOUND: Grandly solemn chords of
religious music by Handel, Haydn or Bach
as, centre stage back, a rich dark blue
drop curtain slowly rises upon:
LIGHT: Backdrop of dawn sky with huge
crimson sun also rising.*

pictures themselves. Together we finished what, without her, would have been a long, hard job. During it she said that I should not have to be hanging my work on café walls, since curators should be hanging it in public galleries. By now I had learned she was a dealer in modern art with her own gallery nearby – a creature I thought died out in Glasgow between the two World Wars and had never expected would revive. I asked her if she would like to deal with my art. She has done so ever since, and began by first deliberately paying out a lot of money.

For the Glasgow International Festival of Contemporary Visual Art in 2008 she put on a show of my pictures for the unmade 1970s film, borrowing these from their owners at great expense for transport and insurance. She could sell none of them, but used the show to get my paintings known in London and abroad. She undertook the sale of my prints, got me portrait commissions, and for October 2010 arranged two Edinburgh shows – one in the university's Talbot Rice centre, the other in the Scottish National Gallery of Modern Art – to coincide with the publication of this book. She has given me the chance to

*Illustrated
stage sets for
the play's three
Acts*

finish pictures I started work upon many years ago. The seventh British Art Show is exhibiting some of them in 2010 in Nottingham, London, Glasgow and Plymouth along with work by other "esteemed contributors to contemporary art in the last five years" – a group of artists among whom I am certainly the oldest. Sorcha is arranging a big retrospective show of my work to be held in the Kelvingrove Art Gallery in 2014 when my 80th birthday falls if I live so long. Recently the architect employed by Strathclyde Passenger Transport and men in its management approached me through my more businesslike friend, Nichol Wheatley. They plan to modernize Glasgow's underground railways starting with Hillhead subway station, and for this they have asked me to propose a new decorative mural scheme. Paying for such a job at a time when greedy governments, local and national, prepare to keep their own wages inflated by cutting down those of humbler public servants, will and should cause a bit of a protest. I told Nichol and Sorcha that I would gladly work for this without payment, because I want my art to beautify parts of Glasgow that most people use and should own. They said my work would not be respected if I were not well paid, so Nichol is trying to raise the money from brokers and businessmen, Sorcha by asking the Scottish Arts Council and community improvement schemes. Good luck to them. I am eager for this great new job.

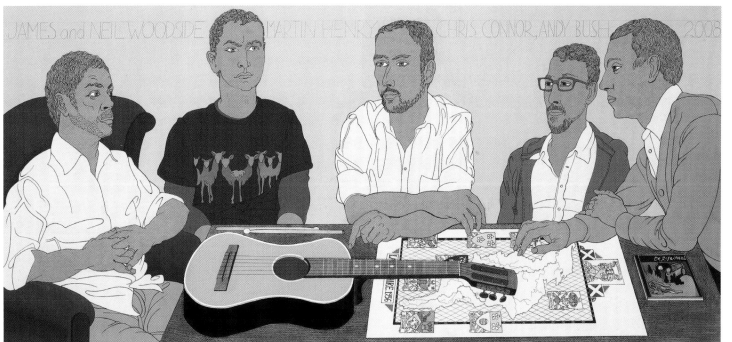

Portrait of
Sorcha Dallas,
2009, ink on paper, 29.5 x 20.8 cm

Phil and Hope,
2009, acrylic and pencil on brown paper on board, 77 x 64 cm

The De Rosa Band (Portrait for a CD cover),
2008, acrylic, crayon, oil, pencil and watercolour on brown paper on board, 61 x 132 cm

*A Gray Play-
Book*, 2009,
paperback
covers with
spine,
26 x 48 cm

LONG AND SHORT PLAYS
FOR STAGE,
RADIO & TELEVISION,
ACTED BETWEEN 1956 & 2009
WITH UNPERFORMED
OPERA LIBRETTO, EXCERPTS
FROM THE *LANARK* STORYBOARD
AND FULL FILM SCRIPT OF
THE NOVEL *POOR THINGS* BY
ALASDAIR GRAY

A writer of plays before a known novelist,
Gray has recently had new works staged.
Collected here, with prefaces, are more
than 50 years of them, making this book
the autobiography of a Scot's playwright.

Luath Press Ltd,
543/2 Castlehill,
The Royal Mile,
Edinburgh EH1 2ND
£25

ISBN 1-906307-91-1

A GRAY PLAYBOOK

A GRAY
PLAY
BOOK

Alasdair Gray

**LUATH
PRESS**

GRAY · COLLECTED
ALASDAIR · VERSE

GOOD
WORDS
GROW
GLOW
STRENGTHEN
AT LAST
INTO
EARTH'S
GRAVE
COLOURS

TWO RAVENS
PRESS

GRAY · COLLECTED
ALASDAIR · VERSE

GRAVE
COLOURS
OF EARTH
BRIGHTEN
TOWARD
AN OPEN
BOOK OF
LIGHT
UNSTAINED
BY WORD

BARCODE

*Collected
Verses*, 2010,
front and back
jacket,
20 x 12.8 cm

functions there and my work on other jobs, especially this book. It was first discussed for Canongate Books in 1986 with Stephanie Wolfe-Murray. In 1995, with the title *A Glasgow Picture Book*, I resumed negotiations for it with Jamie Byng. These broke down for reasons that need not be mentioned. In 2004 I signed a contract with Canongate promising that *A Life in Pictures* would be ready for publication in 2005. All big jobs know better than their artists how long they will need to be properly finished. I finish this one in 2010, years after using up my publisher's advance, partly because Sorcha's help enabled me to pay excellent helpers and work faster. Finishing this and books of my plays and verses feels like the approach of another new beginning. Combined with my increasing good fortune in other ways it also feels as if, like a big balloon, my inflation is near bursting point. I have no intention, indeed no *ability* to stop working, though

The other I hope to finish in this century's second decade is the Oran Mor auditorium decoration, which every year has had more work done to it despite interruptions from popular

future critics are bound to notice a deterioration of quality and mind before (if I am as lucky as Dad and Auntie Annie) a sudden stroke ends me as it ended them.

Postscript

SKELPINGS MENTIONED IN the foreword may partly explain my awful productiveness. If they began when I was nearly two in 1937 they certainly stopped when Dad left Scotland in 1939 or '40, for Mum never hit us. I doubt if I was skelped after 1941 when we reunited in Yorkshire. By then I enjoyed rice pudding and stewed pears, and perhaps Mum no longer served other pale foods. I might have forgotten the beatings if, years after Mum's death Dad had not suggested they had caused my asthma attacks. The hysterical fits and plunges in cold water following them perhaps made me flinch from being touched by others or touching them, except through words and ideas. My bodily sense of self was squeezed or condensed into a wee hard sadistic bit of my imagination, but most of it was left free for what Keats called *negative capability* – amazement at existence and a need to consciously grasp it while learning all we can. Goethe spoke of this when he said (though this translation may be imperfect) "Nobody owes more to others than very smart artistic buggers."

My sister was unscathed by the thrashings Dad was ordered to give her when he came home from work. She says that once perhaps they were deserved – she had flung a hairbrush at Mum which missed and broke a glass pane. Yet compared with me Mora was always healthy, sane and popular. As a trainee Physical Exercise teacher in Aberdeen she was judged the college's best student a fortnight before marrying Bert Rolley, a civil servant who analysed polluted water. Years later I was eagerly questioned for news of her by women who had known her at that college. They were surprised to hear she was still married with two daughters and working as a teacher. They had thought such a free-thinking student with so many boyfriends would have a more dramatic career. I have liked and envied her good, useful life. She likes and slightly envies my artistic one.

Though often ill I have always been tougher than I looked. Only love gives strength. After quarrels with Mum I got extra helpings of it from *her* mother, to whose house I ran for comfort, or so I was told much later, though I hardly remember Granny Fleming. Yet in the photos of my infancy she appears more than anyone else. Did her death make me determined not to lose more of the past? Start me trying to put all the past I could recall into a book? Make me want every home I lived in to be my last, though events made that impossible?

Both my Granddads were bread-winners who worked for more than

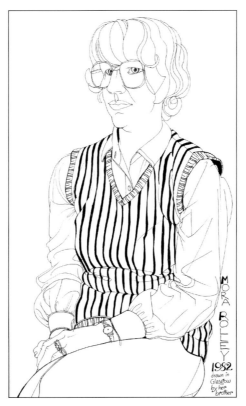

money. Mum's dad (a jolly man who died in 1945) was a Northampton boot-maker before his work for Trade Unions got him blacklisted by English employers. Mum remembered him bringing his wife and daughters to tears by reading them *Tess of the d'Urbervilles*. He also read Dickens to his family when late Victorian critics scorned Dickens and Hardy as popular entertainers who could not describe gentlemen. Grandpa Gray (dead long before my birth) cleaned his Congregational Church in Bridgeton and taught Sunday schools there for years without payment. Dad taught himself typing to do unpaid secretarial work for co-operative hiking and camping clubs. His respect for reading, his decision to answer all questions I asked as fully as possible made him buy books he would otherwise not have read.

I am a result of these people and the luckiest man I know, being a self-employed artist now being paid for work people have started to like. Like others whose work fully occupies their minds, when doing it I am in a continual present in harmony with past and future – ecstatic lovers know happier states, but folk absorbed by their craft have calmer, longer-lasting states they dislike leaving. Arshile Gorky said, "I never finish a painting. I just stop working on it for a while." The big painting I hope to finish is all the walls of the Oran Mor. With Dr Ellen McAdam of Glasgow's Kelvingrove Art Gallery, Sorcha is arranging a big retrospective exhibition of my work for my 80th year in 2014. I hope to finish for it three pictures begun in the early days of my first marriage.

An octagonal panel five feet wide has a view of chaos – The Deep from which Milton thought God made the

Mrs Mora Rolley, 1982, ink on white paper, 45.5 x 27.5 cm

*North Glasgow
Skyline, 1963,
oil on board,
25 x 65 cm*

*Dawn Firth with
Daffodils, 1963,
oil on canvas,
82 x 83 cm*

*Dawn Firth,
1974, oil on
canvas,
25 x 65 cm*

universe. It was suggested by an old woodcut illustrating Jung's *Psychology & Alchemy*, and I first painted it round the windows of Greenhead Church. My *Northern Birth of Venus* was suggested by a small square canvas abandoned by Douglas Abercrombie. He left it with the Gill family, craftsmen who ran the St Columba's Workshop, an arts centre in a converted kirk at Whiting Bay on the Isle of Arran. Douglas had begun painting the far shore seen from the beach before the workshop, then gave the job up. Being haunted by that view I added a dawn sky to it, the Firth of Clyde and a foreshore with slightly improbable daffodils. They were needed to harmonize with the Morning Star (as Venus is called at that time), painted above. This prompted a bigger painting on canvas, a Scottish version of Botticelli's picture. His Venus floats on a shell to a sunny shore where nymphs hold up a flowery robe for her. Under the dawn sky my Venus wades from cold waters to a beach where I meant to have a couple of women running toward her waving a pair of bell-bottomed jeans, a 1960s fashion note. I failed to blend in her all the women friends I thought beautiful, one of them Marion Oag, drawn with my painting behind her. The cut-off top of an earlier version became the painting below. This narrow composition is part of the *Dawn to Dusk* panel on page 264.

My biggest incomplete picture was begun at 158 Hill Street in 1963, after Bob Kitts arranged for the BBC to pay for my art materials. I stretched an eleven by seven foot canvas on my studio wall and, after many preliminary sketches and pictures, began painting north Glasgow, partly viewed from the studio window and partly from the tenement roof. The roof was reached through a trap door in our lavatory ceiling. Graham Noble, the very handy man with whom I painted Pavilion Theatre scenery, had taken a rope ladder from the Pavilion properties store and nailed the top to the door frame. On summer weekends he, his partner, Inge and I climbed into the roof's valley gutter where we sunbathed and I sketched between reading the quality press arts pages. The *Times* and *Guardian* had only two each with black and white photographs, because bulky British colour supplements did not exist – advertizing was not yet a great industry tied to money-lending and arms manufacture. The view at the top of this page was seen from the roof of that building demolished in 1969. It is a detail of the canvas that today (28 May 2010) is rolled and stored in the Hillhead home Morag shares with me. It will preserve a lot of past if I am spared to finish it.

Here come my thanks to all who helped me make this book by accepting postponements of deadlines and continuous revisions.

When I signed the contract in 2005, Helen Bleck was my editor. Three years later Francis Bickmore got the job of continually telling Jamie Byng, owner of Canongate, that I would not finish the book this year. They have recently improved its prose by getting me to correct ambiguous sentences. Since 2005 Sharon McTeir has typeset text and pictures wonderfully on her east coast cottage computer. Her work was not delayed by giving birth to Eva and Jacob in the same period.

At the Glasgow end of our computer link my main helper and secretary was Helen Lloyd, Doctor of Scottish Literature and (in her spare time) Examinations Assistant at Glasgow University School of Medicine. My pictorial assistant since 2003 has been Richard Todd, graduate of Newcastle Art College and Glasgow University Creative Writing course. Besides helping me paint the Oran Mor he helped restore the *Jonah* and *Upper Clyde Falls* murals in this book. Under my direction in 2009 and 2010 he finished painting many pictures begun decades earlier, and more recently helped the book through his computer skill.

Now for the photographers! In 1986 Jim Cunningham photographed the work in the Five Artists Exhibition catalogue, doing so beautifully for very little money. Before the end of the 20th century he recorded more of my pictures, collating several photographs into the ceiling shown on pages 246 & 247. Michael Kuzmak, Jim's teaching colleague in Glasgow's Printing College, supplied later photographs. Others were made by one of his best students, Petra Boyce, Angel Mullane's daughter. Ruth Clark photographed the *Oran Mor* ceiling, also the restored *Jonah* and the *Upper Clyde Falls* murals, though the end of that latter mural on p140 was photographed by Lindsay Addison. Robert Dallas Gray photographed and scanned smaller pictures and enhanced others. At the last minute Lesley Black photographed details of the Oran Mor side walls and Ubiquitous Chip.

The following Index gives titles of pictures in this book with their owners, where these are known. It is extracted from a website planned to finally list all my work with their mediums, dimensions and present owners. Sorcha Dallas is making this with the help of Sarah Jones, which contains several lost works which only exist as photographs, colour slides, or mere names in old exhibition catalogues. Any information that will make this more complete will be gratefully acknowledged if sent to info@sorchadallas.com. The current state of the Index can be seen on www.sorchadallas.com and www.alasdairgrayfoundation.org.

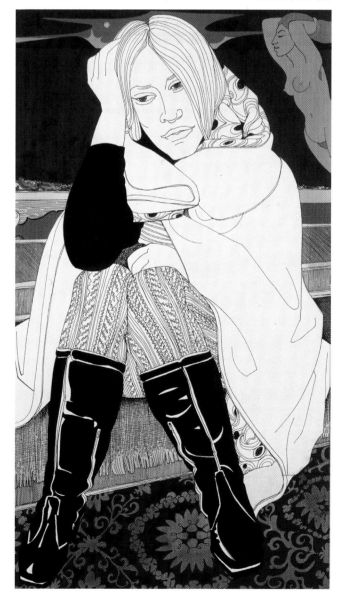

Marion Oag and the Birth of the Northern Venus, 1977, Indian ink on paper, 60.5 x 34.5 cm

Index of Owners 2010

The copyrights of the following pictures belong to Alasdair Gray, unless otherwise stated. An asterisk like this * beside a title indicates that he is also the owner of the picture. Other pictures are reproduced by courtesy of the present owners, where these are known, but Gray's failure to keep records of work and his increasingly bad memory have resulted in many owners' names being forgotten, and perhaps owners mentioned who have died and their pictures lost or passed into other hands. Will anyone who has accurate information missing from the following Index please send word to The Alasdair Gray Foundation mentioned at the end of the previous page.

ceiling, emulsion and oil on plaster, painted 1959, photographed 1972

78 Greenhead Church of Scotland mural: The Seventh Day of Creation – Eden and After, emulsion and oil on plaster, painted 1960–63, photographed 1972

79 Greenhead Church of Scotland mural: The Spirit of God moving upon the face of the waters, painted 1959, photographed 1972
Belisle Street Synagogue Ceiling, 1959–60

80 Woodland Near Milngavie, 1959, oil on wooden panel *
Holy Loch Sketches: USA Supply Ship with Nuclear Submarine; Dunoon Pier; Dunoon Town; War Memorial at Sandbank; Head of the Holy Loch, 1961 pencil on paper *

81 Holy Loch Landscape, 1961, oil on hardboard – Maureen Mellor
Decorated Door, 313 Byres Road flat, 1959, Indian ink drawing tinted with oils – Sarah Little
Decorated Door: safe door in West Regent Street office, 1961, Indian ink drawing on painted metal – owner unknown

82 & 83
Glasgow Triumph of Death, 1961, oil on canvas – Angela Mullane

84 Submarine Battle: Whale and Squid, 1961, silkscreen print – Alasdair Gray
The Painter and his Muse, 1961, silkscreen print – Alasdair Gray
Portrait of Rosemary Singleton, 1962, ink and wash on paper – Rosemary Hobsbaum
Portrait of George Singleton, 1962, ink and wash on paper – Rosemary Hobsbaum

85 Crucifixion, Alan Fletcher, 1957, sketch on paper – Carole Gibbons
Two Views of Mary Bliss, 1960, ballpoint pen on paper – Mary Bliss

86 Inge in Blue, 1964, gouache on paper – Iain A.C. Brown

NINE: PORTRAITS, 1961–2009

Page 87 Hugh McBain, Glum Satirist at Festival Late Nightclub, 1961, ballpoint pen on paper *

88 A Minister's Wife in Buccleuch Street, 1966, oil on board – owner unknown
Carole Gibbons and Flowers Between Still-Lives, 1964, ballpoint pen on paper – Craig & Jennifer McIlhenney
Netta with Fur Collar, 1965, pen and wash on paper – Angela Price
Portrait of Susan, 1960, ink and pencil on paper – David & Marion Donaldson

89 Mother and Baby, Monochrome, 1964, Indian ink on paper – owners & whereabouts unknown
Mother and Baby, Lightly Coloured, 1964, ink drawing with watercolour on paper – owners & whereabouts unknown
Conversation 1964: Sheila Tees, Ann and Bob Johnson, 1964, pen, watercolour, wash, enamel and newsprint on board – Sheila Tees

90 Marion and David Donaldson at Home, 1960, ink on paper – David & Marion Donaldson
Mary and Tony Bliss in Bearsted, Kent, 1960s, ink on paper – Mary Bliss

91 Bookseller Reinhold Dowes, 1974, pencil on brown paper – Annie Good & Ian Murray
Agnes Samuels with Pussycat, 1974, pencil on brown paper – Agnes Porter
Bill Hamilton Reading, 1970, ballpoint pen with wash on paper – Mary Bliss
Doreen, 1971, pencil on paper – Doreen Winning
Lorna Casey, 1972, pencil on paper – Annie Good & Ian Murray

92 Kate Gardiner and Sheena Rocchiccioli, 1969, pencil, watercolour and oil on brown paper – Sheena Rocchiccioli

93 Alastair Leigh at Table, 1980, Indian ink, watercolour and oil on paper – estate of Alistair Leigh, whereabouts unknown

94 & 95 The following 4 portraits owned by Stephen & Katherine Dando:
Stephen Dando: Student in Kingsborough Gardens, 1983, oil on paper on wood
Katherine Fraser, later Mrs Dando, 1983, pencil and wash on paper
James Dando, 2001, pen, watercolour and acrylic on brown paper
Katie Dando, 2008, pencil, wax crayon and oil on paper

96 Three Sisters, Andrea, Karen & Rhiannon Williams, 1985, oil on boards with acrylic ground – Susanne & Peter Williams

97 Dave, Pat and Kirsty Stansfield, 1980, oil and pencil on wood and paper – Dave Stansfield

98 Janice Lochhead and John Gow, 1980, pencil, ink and crayon on paper – Janice Gow
Aonghas MacNeacail and Gerda Stevenson, 1980, ink and watercolour on paper – Aonghas MacNeacail & Gerda Stevenson

99 Alistair and Ann Hopkins, 2009, ink, acrylic and oil on paper *
Diane and Alistair Kerr, 1990, pen, acrylic and oil on paper – Diane & Alasdair Kerr

100 Robert Blair Wilkie, 1979, pencil on brown paper – Janet Wilkie
Professor Ross Roy, 1994, hand tinted photoprint – University of South Carolina
Portrait of Walter Cairns, 1995, acrylic and pencil on paper *

101 Portrait of Robert Copstick, 2000, acrylic, crayon, oil and pencil on board – Robert Copstick
Dan Lynch: 70th Birthday, 1993, acrylic, ink, pencil and watercolour on brown paper – Dan Lynch

*What some call serendipity
and fatalists call Fate,
and Jung called synchronicity,
leaves me to contemplate
six unplanned final pages –
pages I need to fill.
Can I find stuff to put on them?
Don't ask. I can. I will.*

Post Postscript

NELLIMEG HIND AND HER THINGS AND SOME OF HER FOLK

Nellimeg's Book, ballpoint pen, felt tips, water colours on scrap book, 1989–2006

THIS BOOK has said too little about many close friends, the Hind family among them. Nellimeg, born 1957, was the first daughter of Eleanor and Archie. From babyhood she has suffered epileptic fits that made her unable to learn anything more after the age of 2, but left her able to walk about like many children of that age until she was 12. A change of home and doctor resulted in the pills used to limit her fits being far too strong, a mistake that has made her unable to walk ever since. Loving parents, brothers and an older sister prevented further suffering. Like many childish folk who have been kindly treated and not taught to be fearful she is usually very cheerful and pleasant. She is a Stoic in her response to the fits which happen every two or three weeks. They and any pain caused by occasional accidents end her cheerfulness for a while, but she does not brood on them, and never weeps or grieves. Death, for her, is the longer than usual absence of people she loves. Her brother Gavin died in the 1970s and her father, Archie, in 2007, and I think that if they entered her room today she would greet them with great delight but not much surprise.

When visiting the Hind family in 1988 I found among her possessions a scrapbook, felt-tipped pens and a child's water colour paint box, so turned it into a book for her, starting with the cover. Pictures were added on later visits until March 2006, when it was full.

At this time of writing (July 2010) Nellimeg is 53 years old and still lives with Eleanor, her mother, who is 75 years old. This has been made possible through the care of excellent social workers employed by the welfare state created in the five or six years after the 1939–44 World War, when Tory, Liberal and Labour leaders promised British people that they were fighting for a more just social order. Our rulers had also promised that during the 1914–18 war, a promise soon broken, as the biggest part of the nation remembered in 1944. Many Tories also thought it only fair that the new Health, Welfare, Education Grants and Legal Aid services should continue, paid for by a graduated income tax that left Britain with as few millionaires per head of population as are now in Sweden or New Zealand. Since the 1970s a new breed of leaders (Thatcher, Major, Blair,

Nellimeg's Chair and New Slippers, 1990

Nellimeg and Friend

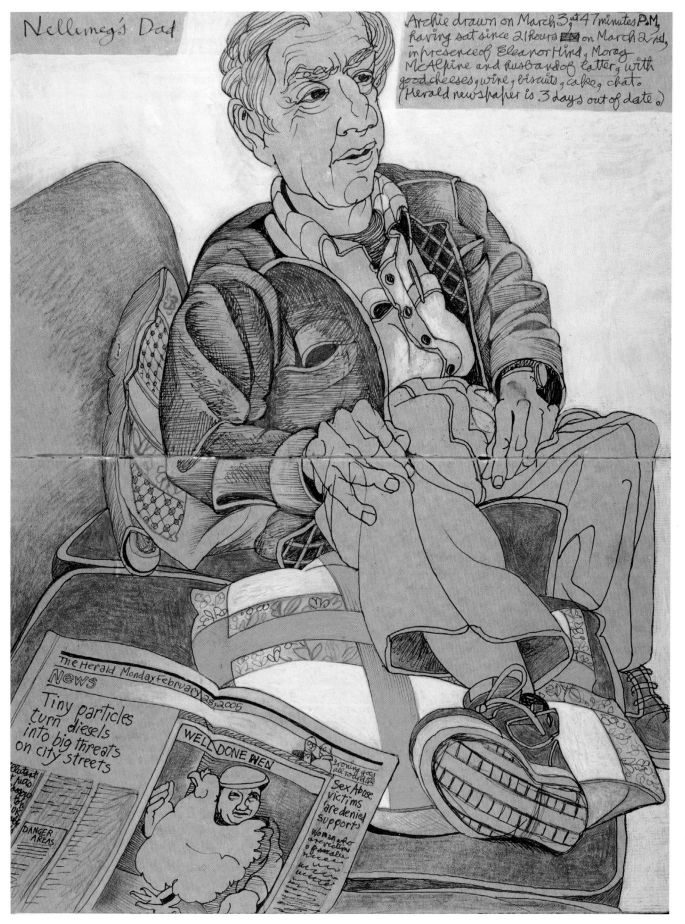

Nellimeg's Dad

Archie drawn on March 3, at 47 minutes P.M., having sat since 21 hours on March 2nd, in presence of Eleanor Hind, Morag McAlpine and husband of latter, with good cheeses, wine, biscuits, cakes, chat. (Herald newspaper is 3 days out of date.)

The Herald Monday February 28, 2005
News
Tiny particles turn diesels into big threats on city streets

WELL DONE WEN

Sex Abuse victims are denied supports

DANGER AREAS

Nellimeg's Dad, Archie Hind at home, 3rd March 2005

Brown) have been in the pay of the money market – an unstable Stock Exchange in alliance with pension fund robbers and disaster capitalists. Even before the Thatcher goverment the Welfare Services have been under threat. From now on their provisions, which made life not just agreeable, but possible for folk like Nellimeg, may be wholly removed from those who cannot hire nurses. Recently these services gave badly disabled folk a few weeks of *respite care*, in homes that allowed a holiday both for them and for the parents or children on whom they depend. These holidays have recently been halved. How soon before well-paid officials announce that the public can no longer afford them?

Nellimeg's Mother,
*Eleanor Hind, 6 March
2006*

Curious Reader
—Why, Mr Gray,
do you strike such a
discordant note near
the end of your book?
A few pages back
it seemed a success
story, with you about
to join that secure
class of people
you now seem to
deprecate. What is
up with you?

Cunning Author
—I am introducing
a sales pitch.
A facsimile of
Nellimeg's Book
is now for sale. It
contains 14 pages
illustrated in colour,
of which these are
samples. For £10,
including postage,
copies may be
purchased from
**ENABLE GLASGOW,
9 Lynedoch Street,
Glasgow G2 6EF,
Scotland,
Charity Number
SCO21077**

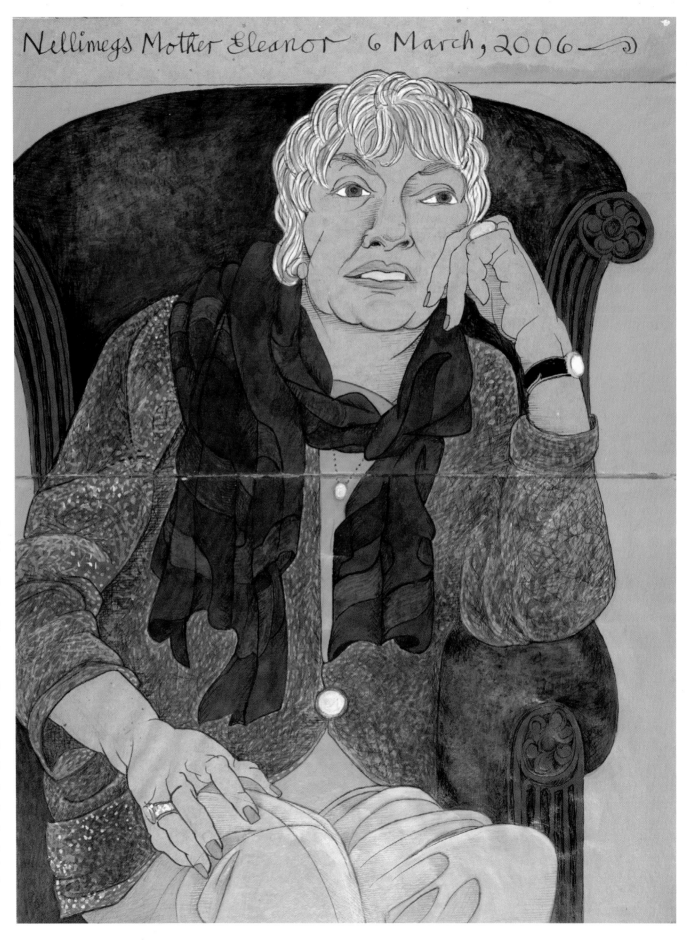

Nellimegs Mother Eleanor 6 March, 2006

*Dr Antonia
Boyce and Lev
Konstantinovskiy,
from the
invitiation to
their wedding on
31 May, 2006*

The women on this
page are daughters
of my friends Chris
Boyce whose face is on
page 199, and Angela
Mullane's on 200. Here
they are eighteen years
older than their portraits
on 250. Having known
me since babyhood
they regard me as an
uncle. Petra and Ian
became friends in their
Helensburgh secondary
school. She is now a
photographer, he an
army officer. I regret my
inability to give their
faces and hands the soft
fresh colours mastered by
greater painters.

PETRA BOYCE & CAPTAIN IAIN ROSS, ENGAGED to marry, 2008

*Petra Boyce and
Captain Iain
Ross, on their
engagement,
2008, ink drawing
on paper, tinted
with acrylic and
oil paint*

Alexandra Gray, 2008, Ink drawing on brown paper, tinted with acrylic, paint pens & oil, 87 x 56cm

My granddaughter, Alexandra was born of Libby Cohen and my son Andrew in 1995, West Hertford, Connecticut, U.S.A. where they still live. I have added as much pleasant colour as I dared to this portrait, while trying not to distract from the vivacity of the drawing.

Years ago my wife Morag suggested some of my illustrations might make money for us if reproduced on mugs and tea towels. Neither she nor I knew how to start such a business, but in 1996 a friend agreed to start it with us. I adapted and coloured images on a computer screen with the help of Richard Todd. She paid for their reproduction on specimen mugs and tea towels, and showed them to interested shop keepers. Alas, before the business became profitable it and our friendship ended because she and I disagreed on how profits should be divided. The page opposite shows some of these images. In 2011 I am working with my friend and colleague, Nichol Wheatley to make them part of a wall decoration for Hillhead station of our underground railway, or Subway as it is known in Glasgow. It should be installed in 2012.

Alexandra Gray 2008